DRAPERY

To Sean and Dave with lots of love. I look forward to watching you both play in the Premier League!

DRAPERY

CLASSICISM AND BARBARISM
IN VISUAL CULTURE

GEN DOY

I.B.Tauris *Publishers*

LONDON • NEW YORK

Published in 2002 by I.B.Tauris & Co Ltd
6 Salem Road, London W2 4BU
175 Fifth Avenue, New York NY 10010
www.ibtauris.com

ISBN 1 86064 538 0 hardback
ISBN 1 86064 539 9 paperback

A full CIP record for this book is available from the British Library

Project management by Steve Tribe, London
Printed and bound in Great Britain by MPG Books Ltd

CONTENTS

ILLUSTRATIONS

ACKNOWLEDGEMENTS

This book is one of the results of a larger research project which will eventually include a major exhibition and a conference. I want to thank my collaborator on the conference, which will be held jointly by De Montfort and Leicester Universities' History of Art Departments in Autumn 2002, Professor Alison Yarrington, for her help and the sharing of her knowledge of drapery, particularly in sculpture. If any readers of this book would like to participate in the conference, entitled *Drapery in Visual Culture: Contexts, Clothing, Corporealities*, please contact either Alison or me at the History of Art Departments of either Leicester University (Alison Yarrington) or De Montfort University, Leicester (Gen Doy). At the City Gallery Leicester, the initiating venue for the exhibition on 'Drapery in Contemporary Art', also in Autumn 2002, I want to thank Kathy Fawcett, Sylvia Wright, James Beighton and Mark Prest for all their professional help and enthusiasm. The exhibition will develop some of the themes examined in this book, and allow visitors to experience the power, seduction and variety of drapery 'in the flesh' as they encounter not just small black and white photographs of (often luscious) artworks, but real creative pieces, in all their tactile, visual and even perhaps aural glory!

In relation to this book, my thanks to the Arts and Humanities Research Board for a grant to help with the research and photographic reproduction fees for this publication. In addition, I would like to thank all the artists who generously helped me in my research, sent me examples of their work, corresponded with me and spoke to me. I was not able to include the work of all of them in this book, but I am very grateful to everyone nonetheless.

I also want to thank Philippa Brewster, my editor at I.B.Tauris for her patience in listening to my frustrated rantings, desires for a new job and her flattery of my ego. Her good advice as an editor is extremely helpful. Many thanks also to Liz Rideal for her helpful and generous comments to me and for reading the manuscript. To my colleagues at De Montfort University, thank you for your support, especially John

Rimmer, who always manages to cheer me up! I am grateful to the library staff, especially those working in the Inter Library Loans Service, and Rohit Tailor in particular. His efficient help and his friendliness are much appreciated. Many museum staff helped me during research visits to Paris. Their knowledge was invaluable and is acknowledged in appropriate footnotes. . . to all of them, very, very many thanks. You make a scholar from abroad most welcome, and my visits to you fruitful.

Thanks also to those who helped me with illustrations. I have made every effort, sometimes unsuccessfully, to contact copyright holders of the works for permission to reproduce them here. Please contact me through the publishers if you recognise your own work reproduced here without due acknowledgement and I will rectify the situation.

INTRODUCTION

I went out with my cheques in my pocket. For the last time, I looked at the front of the building, as wide as a river estuary. Berglevy Fabrics. Cottons. Silks. Woollens. Linens.

Cinema screens for projected dreams? Bed sheets for love? Shrouds, nothing else.

. . . Léo Malet, *Des Kilomètres de Linceuls*, 1955, from Léo Malet, *Les Enquêtes de Nestor Burma et Les nouveaux mystères de Paris* (Paris: Robert Laffont, 1989)

At the close of his latest case, Nestor Burma, socialist, anti-Stalinist and private detective, decides to give his fee to the two victims of crime who are still alive at the end of the novel – the girlfriend of a dead blackmailer and the orphan child of a prostitute. Burma looks thoughtfully at the façade of the building which houses the textiles business of the Jewish family in whose tragic affairs he has just been involved and muses on life and cloth. He tersely associates cloth with fantasy, sex and death, an apposite summary of the themes of the preceding narrative and an appropriate way into a book about drapery in visual culture, where we will encounter these same themes again.

The intriguing title of Norman Bryson's book on still life painting, *Looking at the Overlooked*,[1] could just as well be applied to the study of drapery in visual culture. Though drapery has appeared in many paintings, photographs and sculptures and is physically present in examples of clothing, both haute couture and high street, there is surprisingly little written on this topic in the history of art and visual culture. The subject of drapery and the issues surrounding it, has indeed been overlooked.

PREVIOUS WORKS ON DRAPERY

I want to look for a moment at the few works which do deal with the

topic of drapery in art, before going on to speculate on why this subject
has been virtually ignored and also why it now seems appropriate to
me to write a book on this seemingly marginal aspect of visual culture.
I will argue in the course of this book that it is not so marginal as might
be suspected, especially when we recall Nestor Burma's key associations
of cloth with such major social and cultural themes as fantasy, sex and
death.

When I first started researching this topic, I was surprised by the lack
of relevant books and articles by writers on art. There is considerably
more written by the producers of visual culture themselves, suggesting
that it was of interest to practitioners concerned with technical ques-
tions rather than to connoisseurs or historians. As a subject, it does not
fit very easily into any of the major 'approaches' to the history of visual
culture, whether these approaches are of the 'old' or the 'new' variety
– for example the monograph of the individual artist or designer, the
history of different succeeding 'styles' of art, feminist and/or women's
art history, or the social history of art. After all how easy is it for drapery
to be political, ideological or patriarchal? It seemed to me that I was
not just researching an overlooked area, but also that I was going to
have to approach it in ways which were a little different from those I
had used in my previous research and writings.[2] Drapery was a new
kind of subject for me to be interested in and, as I wondered why I
found it attractive, I also wondered why virtually no-one else had.

The most substantial publication I found devoted to the subject was
the book by G. Woolliscroft Rhead, *The Treatment of Drapery in Art*,
published in 1904.[3] Intended as advice to artists with proposals for
improving the teaching of art, this book is a general history of drapery,
from the antique to the late nineteenth century. The author remarks
that 'It is somewhat curious that this important subject should have
received so little attention from writers upon art' and continues 'So far
as the present author is aware, it has not, up to the present, been made
the exclusive subject of any published work.'[4] Rhead is dissatisfied with
the state of affairs in art schools, where drapery is not taught as a subject
in its own right, but only 'touched upon' in the exams on 'figure design'.
He proposes that drapery '*should, unquestionably, be made the subject
of a special examination*' and notes that, 25 years previously, Baroness
Burdett-Coutts had offered a £10 prize for the best study of drapery
executed by the students of the National Art Training School, but the
competition never took place as only one student put him/herself
forward to enter.[5] Rhead is a firm believer in combining study from

nature with the artist's vision, following the precepts of academic teaching: 'it is certain that in any cast of drapery, even on the living model, much that is accidental or irrelevant must be eliminated; it is the office of the artist to simplify, to arrange, to digest.'[6]

Rhead, quite typically, takes antique statuary as the most important source for the study of drapery, though he points out that later art, especially paintings, was able to surpass that of the Greeks in depictions of drapery in motion. He gives useful information on techniques used by artists in the later nineteenth century for studying drapery, including placing the model on the floor or on a sloping surface, so that the drapery can be more easily arranged in intricate forms around the figure, thereby allowing the student to study an approximation of drapery in motion. Alternatively, wet cloths could be flung upon the floor. Some artists, Leonardo among them apparently, made clay models and draped them with prepared muslin dipped in clay water, afterwards blowing them dry either with breath from their own bodies or a pair of bellows. Sometimes the model of a figure draped with muslin dipped in wet plaster of Paris was balanced horizontally on two trestles, which allowed the drapery to fall downwards. The whole thing was then blown dry with a bellows and the plastered drapery set into place, ready for study. Rhead questioned various artists as to their practice and use of drapery in their works. Not surprisingly, Lord Leighton, the Victorian classicist, is one of his most cited examples in this book. Drapery plays a significant part in his work and Leighton seems to have studied it in a traditional academic way, starting with sketches of the general composition of a painting, then drawing the nude model, proceeding to a study of drapery on the living model and sometimes making detailed studies of portions of the drapery that he found attractive.[7]

Victorian classicists such as Leighton, G.F. Watts and Albert Moore also provided the impetus for the first of two articles on drapery in the fine arts by A.L. Baldry published in 1909.[8] Baldry, like Rhead, stresses the importance of drapery in the fine arts, maintaining it is second only to flesh-painting in the painter's craft. He too bemoans the fact that the study of drapery is given an insufficient amount of attention in art schools. He sees the study of drapery as based on knowledge of a kind of 'anatomy of cloth': 'It is by the formation of the folds, by the way they hang and turn, and by their manner of shaping themselves in curves or angles, that the nature of the material of which the drapery is made can be explained. . .'[9] The remainder of his short article emphasises how important drapery was to the artists of the past and

the need to re-activate this tradition. This obviously supposes a particular choice of subject matter and its treatment by the artist, as becomes apparent in his second article where he discusses sculpture.

Given the materiality and weight (both ideological and physical) of sculpture as a medium, Baldry argues that the rendering of moving drapery is inappropriate in all sculpture other than bas-reliefs. 'Indeed, it can be accepted as a principle in sculpture that any departure from monumental simplicity and repose is dangerous.'[10] Full of praise for the statuary of the Greeks, he writes of their 'magnificent intelligence in the handling of draperies', 'elimination of those useless trivialities which would, if they were insisted upon, make less impressive the noble realism aimed at by those masters of the sculptor's art'. In addition to 'noble realism', he identified 'dignified simplicity', 'monumental restraint' and 'perfect harmony' as characteristic qualities of Greek sculpture.[11] This enthusiastic praise, reminiscent of the approach of eighteenth-century historian and aesthetician of classical art J.J. Winckelmann, shows neo-classicism to be alive and well in early twentieth-century England. Baldry goes on to discuss the problems that face the sculptor commissioned to represent figures in modern dress, using the example of the full-length statue of Gladstone executed for the City Liberal Club by E. Onslow Ford. 'Gladstone's coat and trousers rob him of all distinction and make the gesture he is using seem theatrical and affected. . .'[12] In classical dress, he would have looked strong, noble and endowed with 'dramatic grandeur'. The contrast between classical and contemporary dress, and the problems this raises for the artist trained in academic approaches to art, is an area of concern which is often referred to in writings about drapery. The 'modernisation' of drapery in the nineteenth century is an area of some interest which will concern us later.

THE END OF DRAPERY?

The above-mentioned early twentieth-century writings on drapery appear to me to be symptoms of the perceived demise of classical academic fine art training and practice in Britain. The lack of any similar writings over the next half century or so seem to indicate that drapery and its relevance for much fine art practice was not an issue which was seen as central to teaching, or to critical and historical writing about art. It is closely linked to the representation of human bodies clothed in particular ways shown in figurative art, and therefore

seems of little importance to modernist art, whether non-figurative or concerned with the representation of contemporary people in modern clothing. Although conventional notions of drapery never entirely disappeared from twentieth-century visual culture, for example in Picasso's classical period in the 1920s, the main concerns of many artists, photographers and designers lay elsewhere.

In a dictionary of art and art terms published in 1970, drapery is discussed in relation to Greek sculpture (of course), to medieval and Gothic art, Renaissance and Baroque art and to neo-classicism. Drapery is perceived as 'ending' as a topic around the time of Art Nouveau and the later nineteenth and early twentieth century.[13] Many of the subsequently published art dictionaries and companions simply do not mention drapery at all, or have a short paragraph referring to painters working as drapery specialists, often painting parts of more famous artists' works.[14] Elizabeth Allen states that the emergence of these specialist drapery painters was a result of the breakdown of the apprenticeship system, in which young workers were trained to do a bit of everything, rather than groomed as specialists in a particular area. She locates this shift, and an accompanying reliance on technical manuals by artists, around the mid seventeenth century in Holland but states that the pattern of development is less clear in other countries. She mentions J. Van Aken, a specialist drapery painter from Antwerp who worked in England during the eighteenth century for artists such as Joseph Wright of Derby, Allan Ramsay and Sir Joshua Reynolds. Clearly this made economic sense for the painters who received the commissions in the first place, for Peter Toms, a drapery specialist of the same period, normally got twenty guineas for painting the clothing, hands and accessories of a full-length figure, while Joshua Reynolds would charge his clients one hundred guineas and pocket the difference. While the drapery specialist worked on one picture, the more famous entrepreneurial artist could move on to the next commission thus increasing his earnings.[15] Hogarth and Gainsborough both commented on what they perceived to be the relatively easy life of the drapery specialist, as compared to the 'harassed' portraitist. Hogarth referred to the 'jour[n]ey men called Back ground and Drapery painters. . . these still life men in this one branch only do them in with great care and perfection at [as] easy a rate as enables the master to despatch a great deal of business and if industrious get more money in a week than ye greatest genious in any other branch of the art in 3 months.'[16] Gainsborough wrote to his friend William Jackson that 'There is a

branch of Painting next in profit to portrait, and quite in your power
without any more drawing than I'll answer for your having, which is
Drapery and Landskip backgrounds. Perhaps you don't know that while
a Face painter is harassed to death the drapery painter sits and earns 5
or 6 hundred a year, and laughs all the while. . .'[17] Drapery painting
was thus seen as an easy, less stressful and not particularly skilled
option, which the more famous artists could utilise to their own
advantage when necessary.

Shortly after the 1970 dictionary entry in the *Oxford Companion to
Art*, however, a small book on *The Draped Figure* was published by the
National Gallery, London.[18] Although the scope of this little book is rather
restricted – it is devoted solely to the analysis of drapery in chosen works
in the collection of the National Gallery – the author, Cecil Gould, offers
some general comments on drapery which are interesting, especially
when he points to the artificiality of the whole concept of drapery and
the draped figure: 'It is not the same as the clothed figure, even where
the clothes of the clothed figure are not tight-fitting. What it is, is the
body hung with fabric whose folds are disposed with a view to artistic
effect.'[19] However Gould's book is really not very different from the earlier
works on drapery mentioned above, in terms of its approach and even
the sort of language used sixty or so years earlier: 'We may therefore think
of the draped figure as a kind of dialogue between the body and the
material, or as a man and woman dancing together.'[20] He describes various
uses of drapery in paintings, concluding rather pensively that:

In the art of the present century the survival of the draped figure has been
precarious. Abstract art has naturally denied itself this luxury, together with
other elements in the humanist repertory. But it may prove sturdier than it
seems. Draperies have periodically occupied the thoughts of Picasso and
Moore, who, as the dominant painter and sculptor respectively, have had
enormous influence. The role of the draped figure as foil to the nude would
seem to ensure it a certain degree of indestructibility.[21]

Soon after Gould's book, Anne Hollander published an interesting
'survey' article on the role of drapery in art, but as well as reiterating
some of the familiar points already encountered (drapery is cloth made
into art, classical art is the main source for drapery as opposed to cloth,
drapery becomes outmoded by the end of the nineteenth century) she
introduces some suggestive new comments. For example she writes that
in Western medieval art,

the separation of the body from its dress, so contrary to the classical spirit, is behind the whole idealisation of cloth in Western art. It gives rise to the concept of 'drapery' as something which, while it conceals, yet confers an extra ennobling or decorative dimension upon the essentially wretched and silly human form.'[22]

Hollander makes much more of an attempt than previous authors to describe the developing functions of drapery and its relation to representations of the human body in terms of changing cultural, social and historical situations. She links the drapery of Renaissance paintings in Northern and Southern Europe to the rise of powerful merchant families and the cloth trade and locates the practice of depicting sumptuously draped and swagged curtains in paintings as a kind of 'drapery-rhetoric', evolved in the mid-sixteenth century for rich patrons 'for no other purpose than to take delight in the way it looks'.[23] By the Baroque period in the seventeenth century, she writes, drapery had begun to lose its moral and emotional meanings and was becoming an indispensable formal element for all artists, divorced from the detail of actual costume 'but absolutely necessary as the dress of painted figures.'[24] She interestingly points out that drapery plays a limited role in the life and depictions of the poor, but does not elaborate on this. I will discuss this and related issues in the last chapter, in which we will be able to see how the contemporary poor and victimised have come to be represented in relation to drapery. In her concluding remarks Hollander locates some survivals of drapery in visual culture, which she too sees as coming to an end in the works of Victorian classicists such as Sir Lawrence Alma-Tadema. She points out that drapery survives in still life painting, the theatre and cinema. 'Even if a curtain does not rise or part but only surrounds the action, the plenteous folds on either side indicate the presence of magic and myth, with the emotionally nourishing suggestion of luxury and excess.'[25]

By the 1990s, however, the few publications mentioning the topic of drapery had been broadened out to include a variety of new areas and themes to which Hollander had alluded only in passing.[26] In 1992 the education department of the Louvre Museum published a stimulating book for teachers with projects related to study visits to the museum's collection of classical statues. This publication, entitled *Plis et Drapés dans la Statuaire Grecque*, not only discussed Greek clothes and artworks but, in order to explore the ramifications of the topic into areas of relevance to a young audience, also addressed the work of French haute couture designers such as Alix (Mme Grès), the different meanings and

connotations of the words 'folds' and 'draperies', draperies in contemporary art and folds and draperies in geological formations.[27]

A similar kind of approach, broadening out the issue of cloth in art could be seen in the exhibition and accompanying catalogue *Starke Falten* (Strong Folds), which was held in the Museum Bellerive, Zurich, in 1995. Essays on nature, dress, architecture, the psychology of folds and pleats accompanied the display of works by artists, photographers, weavers and designers including Gaëtan de Clérambault, Lia Cook (both of whose work will be discussed later), Issey Miyake and Gerrit Rietveld.[28] One of the essays was an extract from Aldous Huxley's account of his experiments with mescaline in *The Doors of Perception* and indicates to what extend an interest in fabric in fine art had broadened out to encompass much wider issues and approaches.

Finally in this rather brief survey of writings on the topic of drapery in visual culture, I want to mention a recent essay by Bryony Fer.[29] Fer illustrates photographs and contemporary fibre art by Eva Hesse as well as more traditional examples of drapery by artists such as the Early Netherlandish painter Hans Memling. But the approach is new, and very much of the postmodernist late twentieth century. She points to the use of cloth in imagery to disrupt notions of the self-contained body and clarity of outline, to make us aware of time, of drapery as fetishistic lure, the jerking movements of cloth related to the convulsions of the hysteric, cloth in relation to memory and the ability of painted cloth to suggest at once the material and the immaterial. Clearly within the short space of this suggestive essay, Fer does not have scope to develop her remarks in much detail, but when I read the piece, some things began to fall into place for me as I saw duplicated here many of my own reasons for being interested in drapery and I started to realise why I had become aware of the topic at precisely this time.

AN IDEA WHOSE TIME HAS COME

Referring to Liz Rideal's sensuous photographs of cloth, Fer remarks that 'The more elaborate twists and contortions invoke 'drapery' rather than just cloth; that is, one of those overlooked aspects of painting to which an odd sort of anxiety has often been attached.'[30] The recent interest in drapery as related to folds, intricacies and details of cloth owes much, as we shall see, to the postmodern interest in the fragment, the detail and the localised, as opposed to the supposedly totalising master narratives of human culture and society produced by such modernist theorists and practitioners as Marx

and Freud. In particular the book first published in French in 1988, *The Fold: Leibniz and the Baroque*, by poststructuralist philosopher Gilles Deleuze, has had a significant impact on a number of artists and writers and has been cited in a number of exhibition catalogues in the past few years.[31] I discuss Deleuze's book in relation to contemporary theories and practices of visual culture in a later chapter.

Fer's reference to 'the overlooked' reminded me once again of the title of Bryson's book on still life. I realised that the reasons why drapery was no longer overlooked, and why my idea for a book on drapery had evolved, were indeed related to a prevailing climate of postmodern ideas in much cultural and academic life.[32] I did not and do not, however, want to write a postmodern book. I want to write about some detailed instances of drapery and its meanings in visual culture, but I also want to preserve an over-arching approach to visual culture which seeks to situate it within a wider perspective of particular social, economic and cultural configurations which allow us to attempt to understand *why* drapery does certain things in visual culture as well as *how* – what drapery is and what it is doing there. Also, I want to write the book in a way that approximates the movements of cloth and drapery, curtains and folds. By following the various connotations of drapery, patterns and crossovers emerge, which can be woven together or unravelled, according to the perspective of the writer and/or the reader. I want to invite the reader to follow the sometimes intricate interconnections between various meanings implicit in cultural productions. It may not always be immediately clear where I am going, but I hope that the reader's patience will be rewarded as various layers of cloth, or folds of curtains, are parted and moved aside. Patient un-covering of layers can be accompanied by sudden revelations, paral-leling the thought processes of research and its practical activities. Possibilities are suggested, but also truths are discovered – yes, some-times we do uncover truths beneath the layers of seductive drapery. Visual culture is not entirely made up of seductive surface appearances, which, according to postmodern views, merely conceal the non-existence of real depth beneath.

DRAPERY AND CLOTH

The connotations and meanings of drapery beyond just the represen-tation of cloth in fine art are wide-ranging and require some focus and definition. For example, the term drapery can be used as a geological

term for the translucent sheets of calcite formed when water flows down
the inclined ceilings of caves. Nowadays, its main everyday meaning
relates to home and business furnishings, and the bulk of the infor-
mation available on the internet is concerned with home-furnishing
shops and companies, careers in drapery and the use of drapes (or cur-
tains) in homes and workplaces such as hospitals. The old usage of
drapery as cloth transformed into art is nowadays far less commonly
found, but it is central to my study here, since it involves definitions
of 'art' and questions of culture, taste and value.

Since drapery is originally cloth, I found myself researching the
history of cloth production and the various changes this industry went
through due to social, economic and technological changes. Some of
my findings will be used in subsequent chapters in this book, but I
decided it was not my primary intention to write a history of cloth and
its meanings, as this would not be quite the same as drapery. Cloth of
various kinds is composed of materials (vegetable, animal or synthetic)
which have been transformed by human labour into a cultural product.
Drapery is cloth which has undergone transformation by yet a further
layer of human work and thus appears in an artwork, carefully arranged
or invented to look more than just cloth. In the case of the draped dress
in visual culture, we are also dealing with cloth which has undergone
various transformations due to labour, whether classed as art, craft or
manual labour.

Since cloth is also referred to as material, I also considered the question
of the materiality of cloth and drapery. It seemed tempting to literally
'materialise' the study of drapery, as if working against the grain of
prevailing trends in scholarly theory, which lately seem so enamoured
of the intangible, the ambiguous, the in-between and, to put it bluntly,
the idealist.[33] This is what I am hoping to do in the chapters that follow.

CURTAINS OR DRAPERY?

Although I eventually decided that drapery in the sense of home
furnishings was really beyond the scope of this study, I did locate some
interesting material on points of contact between the artistic and
decorative meanings of hanging cloth.

In his book *Le Rideau, ou la Fêlure du monde* (*The Curtain or the
Crack in the World*), Georges Banu sees the curtain in painting as a
representation of an interface between different kinds of perception.[34]
The curtain is on the cusp of the inside and the outside, the real and

the illusory, the seen and the unseen, the veiled and the truth, opening and closing. Banu's interest in the theatre leads him to concentrate mostly on the question of illusion versus reality, but his book, however suggestive, is more concerned with abstract philosophical concepts, rather than the materiality of cultural representation and meaning.[35]

It is, however, interesting to note the use of the curtain to protect or conceal painted images. It has been argued that the use of curtains to veil religious images for liturgical purposes tends to disappear towards the end of the sixteenth century and especially in the seventeenth century. About this same time, documents refer to the use of curtains to present paintings in private houses. The French painter Nicolas Poussin wrote that 'It is an excellent idea to cover your paintings and to exhibit them one by one, as it means that we shall not grow so tired of them for to see them all at once would overwhelm the senses too much'.[36] Often the covered paintings were erotic works. The curtain, therefore, often functions as a device which can control and regulate the sight of the paintings, whereas painted curtains are exploited by the artists to show their skill at surpassing reality and tricking the viewing subject. According to Stoichita, the curtain in seventeenth-century art always positions the spectator as a watcher, but a consciously aware watcher, since the curtain is being drawn aside for him (less usually her) to reveal at least part of the image to the viewer's gaze.[37]

A recent interesting discussion of household drapery, taste and gender in England since the mid-nineteenth century has been published by Penny Sparke.[38] In this fascinating book, Sparke shows how the owners and inhabitants of middle- and upper-class Victorian interiors draped items of furniture and curtained windows as if they were perceived as naked and requiring clothing. The cluttered atmosphere of draped sofas, chairs and tables was equated with feminine taste and attacked by male writers such as Eastlake and Ruskin, who advocated, says Sparke, the concept of 'design' rather than 'taste'. Draped fabrics in the Victorian interior were associated with privacy, comfort, concealment, quietness and a civilising influence. Yet the over-use of draped fabrics was derided by reformers, and Charles Eastlake commented in his *Hints on Household Taste in Furniture, Upholstery and other Details* in 1872 that such inappropriate draperies 'just represent a milliner's notion of the "pretty" and nothing more. Drapery of this kind neither is wanted nor ought to be introduced in such places.'[39] In 1841 Pugin had already attacked 'extravagant draperies' which attracted dust and vermin.[40] The modernists of the twentieth century wanted rid

of draped walls, windows and furniture, and Le Corbusier wrote in praise of clean and masculine functionalism: 'Everything is shown as it is. Then comes inner cleanliness. . . once you have put ripolin on your walls you will be master of yourself.'[41]

Sparke concludes her book by discussing drapery and the post-modern. Illustrating a typically elaborate ruched curtain from the 1980s, with its appeal of 'glamour, luxury and nostalgia', she argues that, though women's culture had become recognised as valid, the post-modern free-for-all meant that no more 'value' was attached to a choice of Venetian blinds or elaborately swagged or draped curtains. Both were merely equally valid options in a consumer-driven construction of multiple identities. She concludes that postmodern theory has treated women's issues in the same way – they are simply one available option among many varying discourses and identities.[42]

However it is not quite true to say that postmodernity views all cul-tural choices as equally valid. In a regular feature devoted to home fur-nishings in the British 'quality' newspaper *Guardian Weekend*, it was apparent that cultural choices are still viewed as examples of good or bad taste, linked to perceptions of class. On the same page were juxta-posed photographs of 'tasteful' modernist objects such as chairs, textiles and tableware, with simple lines and functional forms, and a small article on 'French drapes' which was illustrated with a drawing by Joanna Walsh. Blue curtains were shown draped to hang in elaborate swags tied with ribbons. 'The kind of person who is dedicated to hang-ing French drapes from their curtain rail is also extremely keen on playing Muzak compilation tapes and going on extensive walking holidays in the Austrian Tyrol.' They also, allegedly, like John Wayne films, home-delivery pizzas, louvre doors, television chat shows, local DIY superstores and Christmas fairy lights.[43] Perhaps this rather tongue-in-cheek description applied to more of the newspaper's readers than we might at first have imagined! So this, apparently, was household drapery in 1999 – tasteless, common and probably lower middle class. While in theory postmodernity gives us all equally valid cultural options, in reality some are better 'cultural capital' than others.

MODERN DRAPERIES

Plate 1 illustrates a photograph from the collection of the Bibliothèque Nationale, Paris, where it is catalogued as a photograph of the studio of the painter Alexandre Cabanel, taken by E. Benard.[44] The photograph

is not securely dated but is probably from about 1887.[45] Like the English Victorian interiors discussed by Penny Sparke, this room is covered with drapery – on the walls, around the mirror, hanging from the dressing table, on the sofa, around the plinth of the candelabrum and, of course, hanging from the woman's body. The claustrophobic coverings take over the space as if imbued with a life of their own. The decorative patterns on much of the drapery add to the cluttered impression and lack of space in the studio. Interestingly, the only space devoid of patterning and drapery is the mirror, where we see an oblique reference to a window and a world outside the room. Sparke quotes Janet E. Ruutz-Rees writing in 1881 as an advocate of this 'feminine' taste which was playful, decorative, soft and pretty: 'So many delightful possibilities are concealed by a curtain; not to mention the skilful hiding of defects made visible with such means, or the softening of angles and happy obliteration of corners.'[46] In the scene represented in the photograph, the model almost becomes a piece of furniture that can be made more rounded and less angular by the tasteful addition of drapery. Her dress is used as drapery, rather than clothing, as she is posed taking it off in such a way that the hang of the dress results in artistic folds which start to bunch out on the floor. The additional decorations on the dress itself are like mini-bunches of drapery.

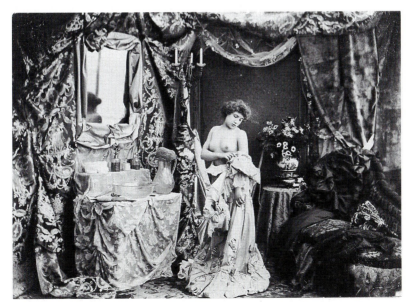

1. E. Benard (or Bernard?), Photograph of Cabanel's Studio, *ca. 1887, Bibliothèque Nationale de France, Department of Prints and Photographs.*

In another quotation from Sparke's book, Eastlake particularly takes offence at mirrors framed by drapery, which, as noted above, he links to the taste of 'milliners':

As a lady's taste is generally allowed to reign supreme in regard to the furniture of bedrooms, I must protest humbly but emphatically against the practice which exists of encircling toilet-tables with a sort of muslin petticoat, generally stiffened by a crinoline of pink or blue calico. Something of the same kind may occasionally be seen twisted round the frame of the toilet-glass.'[47]

This studio space therefore resembles the woman's bedroom (it certainly does seem an odd image of an artist's studio), although we do not actually see a bed in the image. The huge amount of cloth here gives us the impression that curtains are being drawn aside to allow us (gendered as masculine) to view a peep-show, where men are absent except as viewers of a feminine sphere, or else suggestively alluded to by fetishistic 'stiffened' appendages of the dressing-tables and mirrors.

Sparke points out that the English male writers' comments she quotes are evidence of standards of gendered taste at work as ideology. Women's taste is not the result of some sexually-based natural femininity. She points out that a number of women began to criticise the tastelessness of the domestic parlour as they began to enter the masculine sphere of the paid workplace.[48] It is worth noting that working-class women had entered the 'male' sphere of the workplace long before, so we are also speaking of a domestic space which is related to class as well as gender. The interiors discussed in Sparke's book are not, by and large, the domestic spaces of the poor.

It is easy to regard the furnishings of 'Cabanel's studio' as tasteless, but could we not also see this image as a representation of modern drapery? This photograph was taken at a time when department stores were well established in Paris, enticing large numbers of women to view and buy, and sometimes steal, the temptingly displayed goods. Femininity, consumerism and display were an integral part of the culture of high capitalism in both Europe and the USA. Clearly, the photograph does not represent a modernist setting, or a modernist artwork; nonetheless it is modern. Drapery is not seen in a neo-classical setting, but in a contemporary one. This photo dates from around the period when drapery as classical garb was becoming far less common in the visual arts and was increasingly utilised only by neo-classical painters and

for religious commissions, as well as in tomb sculptures. Around this period in the later nineteenth century, rather different perceptions of drapery began to emerge. Drapery was not just seen as belonging to fine art, but could be seen in photographs and department stores and was increasingly represented in the visual images of 'Oriental' dress worn by inhabitants of France's North African colonies, as well as those of other European colonial powers. As we will see later, drapery could be associated with civilisation or with so-called barbarism – and sometimes with both at the same time.

DRAPERY: CLASSICISM AND BARBARISM IN VISUAL CULTURE

As mentioned above, this book does not set out to offer a history of drapery, but to explore certain aspects of it and the ways in which it has been used in visual culture. Consequently my research will cover not only the fine arts, but also a wider range of visual culture, including dress and photography. As previously indicated, an important focus for this study will be French culture of the nineteenth and earlier twentieth centuries. Here we can locate and investigate the coming together and interaction of such developments as changes in retail sales practises and the display of goods, the industrialisation of textiles and clothing production, the tradition of neo-classical and academic drapery painting, the emergence and development of 'haute couture' fashion and the production of 'Orientalist' paintings and photographs. Obviously some of these developments take place in other European imperialist countries, and also in the USA, but nowhere, I would argue, are they embodied quite so effectively in visual culture as in France, where traditional academic high culture meets modernity with such interesting results. Thus much of the material pertaining to the central part of my book will be based on research in France. The earlier part of the book looks, far more briefly, at the Renaissance period, especially in Italy, where artists' workshops trained apprentices in the skills of drapery painting and its appropriate uses. In the later part of the book, where I investigate the survivals of drapery in contemporary art and drapery in contemporary news photography, I will be discussing examples of visual culture from Britain, the USA and Europe.

First of all, I want to continue in the next chapter to look at writings on drapery by artists, historians and critics in order to identify the main ways in which drapery has evolved in early modern and modern

Western visual culture. Drapery still survives today in its familiar role as artistic clothing, though with the demise of academic and neo-classical art it is not often encountered in its traditional guise. Drapery's classical associations, important in earlier periods of art, have now largely disappeared.

In the next section I will look at the question of drapery and commodification. Department stores, window displays and dress will be discussed in terms of new functions and meanings of drapery from the later nineteenth century to the mid twentieth century.

The section on fetishism and fabric deals with the photographs and writings of the French psychiatrist de Clérambault, whose works have been rediscovered recently, as a fascinating example of the way in which desire, criminality and 'otherness' combine around drapery. Of particular interest are his articles on some of his female patients who were taken into police custody after being found masturbating with stolen cloth in department stores. Drapery is not only to be looked at, but also to be touched, listened to and smelt. De Clérambault's interest in North African and Middle Eastern dress will be related to more recent writings, artworks and debates on the veil.

The following chapter will look at the interesting way in which certain developments in postmodern theory and cultural practice have been linked to a desire to revive a Baroque sensibility, as opposed to an Enlightenment rationalism. A key focus for this will be the content and influence of Deleuze's book, *The Fold*, and its relation to Baroque and postmodern draperies.

The penultimate chapter will discuss the survival and mutations of drapery as it appears in the work of contemporary artists. With the flourishing of women's art in the 1970s and 1980s, cloth became incorporated into artworks linked to the feminine, rather than repre-sented mainly by drawing or painting techniques. While two-dimen-sional representations of cloth did not entirely disappear, weaving, mixed media and installation works challenged the primacy of painting and sculpture, revealing that drapery and cloth functioned to question boundaries of art and craft, high and popular culture.

Finally, I want to look at what has happened to the meanings of drapery associated with civilisation, nobility and high culture. While drapery still survives in a new and modified form in contemporary visual arts, most of us are now more likely to come across drapery in adverts, for example slashed pieces of silk standing in for *Silk Cut* cigarettes. However there is evidence that in contemporary press

photography, drapery appears in visual culture as a sign of barbarism, death, poverty, massacres and various other kinds of 'disaster' in impoverished European or Third World countries. I will argue that, previously a signifier of civilisation, draped cloth is now much more commonly met within visual culture as a signifier of barbarism.

CHAPTER 1

REPRESENTATIONS OF DRAPERY
An overview

In this chapter I want to look generally at the development of drapery in visual art from the Renaissance to the present. I will attempt to show how little drapery changed over hundreds of years and, when it did change, what the reasons were. I will be referring to artworks and to writings about drapery by philosophers, aestheticians and artists giving advice to their peers, and also to art students, on how best to represent drapery. I want to pay most attention in this chapter to the later nineteenth and early twentieth centuries, for this is the time when attitudes to drapery and its function in visual culture really start to change, having remained virtually constant for centuries.

Once I began to study drapery, it became apparent that, although it was a marginalised topic in the sense that it was overlooked, indeed no longer 'seen' in works of fine art, drapery in fact was to be found in literally thousands of artworks in various media – for example in the *Venus de Milo*, Jan van Eyck's *Arnolfini Wedding Portrait* of 1434, Manet's *Olympia* of 1863, Bill Viola's video work *Nantes Triptych* of 1992 and Tracey Emin's 1999 Turner Prize entry *My Bed*.

In one sense, this is because cloth is found virtually everywhere in social and cultural life, but in other respects, the presence of (dis)arranged cloth in artworks has a long history of connoting 'art', embodying certain concepts of taste and relating to the represented (or even absent) body. Drapery connotes artistic display, alerting us to the presentation of a model, the patron whose portrait we see, or sometimes the artist's self-portrait. Tracey Emin's *Bed* combines the artist and the model into one absent person, whose traces and bodily imprints are seen on her discarded knickers and the used bed sheets. The absence of Emin in the work itself, however, is more than compensated for by her forceful presence in the art press and the visual media. This relationship of drapery to the body in artworks is clearly of fundamental significance and is one to which I will return often in this book.

DRAPERY AS STYLE

A useful general history of the evolution of drapery in European painting and sculpture is provided by Anne Hollander.[1] Starting with classical sculpture and ending with a painting by the Victorian classicist painter Albert Moore, from 1882, Hollander shows how

Draped cloth per se accumulated an immense sense of expressive visual power, first from its august origins in Classical sculpture, on through its medieval associations with holiness and luxury, and finally through its emergence as a purely artistic basic element, ready for use in any representational convention.[2]

Although Hollander's chapter is useful, her approach is basically to locate and identify *stylistic* changes in the representation of drapery, from antique art to the later nineteenth century, leading eventually to her conclusion that by the end of its evolution, drapery had become divorced from the bodies wearing it, resulting in a situation where 'The action of cloth, if it is conceived as only pictorial, makes any representation of it automatically self-conscious and false.'[3] For Hollander, this is the end of a long life for the 'classical' fine art drapery tradition. Her notion of 'empty' drapery, as opposed to drapery which clothes or accompanies a human body can be developed, however, and I would argue that the 'content' of drapery does not necessarily have to be that of a body. As we shall see, there are examples of drapery in contemporary artworks where the drapery stands in for the absent body, or connotes larger, more abstract concepts such as femininity, or even pictorial representation itself. Tracey Emin's *Bed*, for example, could be seen to relate to these concerns, as well as indicating the intimate functions which draped cloth fulfills in our domestic existences. Also, the fact that some critics perceived *My Bed* as rather sordid and vulgar indicated that the work undercut notions of civilised values and high culture which are still attached to drapery even now.

Hollander, however, says little about economic, political or social reasons for the evolution of fine art drapery in particular ways and this is a problem. She refers at times to religious reasons (in relation to the specific evolution of medieval and Baroque drapery), or general economic factors such as the increased production of cloth in early Renaissance Europe. As I noted in the Introduction, Hollander points out that 'Drapery has a limited role among the poor', but immediately

afterwards states that scenes of poverty and squalor can be dramatically illuminated by draped 'swathes of light and shade'.[4] Apart from this reference to poverty and dirt, the impression given is of a tradition of drapery representation which continues for centuries hardly troubled by everyday concerns of lower class life, since drapery, by its very definition, exists in the sphere of 'art', remote from the more worldly concerns of economics or politics. It connotes civilised values, nobility, grace and harmony rather than violence, low-life and barbarism.

Now there is a great deal of truth in this vision of drapery as a relatively unchanging signifier of wealth, nobility, taste and religiosity. One of the reasons that drapery in fine artworks seems to change so little is precisely because it existed in a sphere which was relatively abstracted from the actual historical and social conditions in which it was rendered by artists. A recurring theme in writings about drapery and the body is the stress on how important it is for the artist to detach the representation of drapery from contemporary life. Thus it cannot fail to be generalised and relatively immune from direct influences of its historical context. Of course drapery and its representations cannot be entirely divorced from the social and cultural contexts in which they were produced. . . they merely seem as if they are and are intended to be so. Thus it was no accident, as we shall see, that artistic methods for the representation of drapery changed very little for centuries. In this book, I want to look more closely at the contexts in which certain draperies were represented, for more is involved than stylistic change and in any case these stylistic changes are not greatly significant over long periods of time.

DRAPERY AND CLASSICISM

Another factor in the relatively unchanging nature of fine art drapery is the persistent allure of antique classicism as a model. As Hollander puts it: 'The original source and later justification for artistic drapery in the West has always been the variously interpreted example of surviving Classical sculpture.'[5] This gave rise to the

subsequent connection between draped cloth and lofty concepts or between the idea of nobility and the wearing of loose flowing clothes. . . the association of the idea of drapery with the idea of a better and more beautiful life flourished, fed by the accumulated art of the past with its thousands of persuasive and compelling folds.[6]

The English eighteenth-century painter Hogarth mentions the nobility of drapery in classical sculpture and the art theorist and historian Winckelmann, in 1765, wrote of 'the sublimest drapery' in examples of Greek statuary representing three female figures of vestal virgins.[7] Sir Joshua Reynolds, lecturing and writing for students at the Royal Academy, London, in his tenth discourse, delivered in December 1780, warned students against representing modern dress too closely.[8] This reiterated his advice in discourse four of 1771, when he warned that detailed rendering of drapery would never achieve 'grandeur of effect' since the drapery would not be generalised but would be *particular* drapery such as wool, silk or velvet. Painting detailed representations of textiles was the mark of craftsmanship rather than art and thus was to be avoided.[9]

Hegel's lectures on aesthetics, which he delivered to philosophy not art students, in the 1820s, considered the development of the embodiment of 'The Spirit' in art throughout history. For Hegel, art had reached its peak in classical Greece, where the Spirit was ideally embodied in concrete, sensuous form. Hegel stated that just as the portrait painter should 'omit folds of skin and, still more, freckles, pimples, pock-marks, warts, etc.', so drapery, as another kind of skin, should be generalised and avoid modern fashions which do not allow the body to move freely. Furthermore, modern clothes do not change their shape and the folds hardly move even when the body moves, unlike classical drapery.[10] Hegel links different sorts of clothing and drapery to different peoples, for example commenting that

The long wide robes and baggy trousers of the Orientals, on the other hand, would be wholly incompatible with our vivacity and varied activities and they only suit people, who, like the Turks, sit all the day long with their legs crossed beneath them or who only walk about slowly and extremely solemnly.[11]

However this piece of Orientalism does not imply that Hegel approves of modern European dress, which he finds 'wholly inartistic'.[12] Clothing should be like architecture, he argues, in that it is an environment in which we can move freely, while it dialectically interacts with the body it supports.

The principle for the artistic kind of drapery lies in treating it as if it were architectural. An architectural construction is only an environment in which we can nevertheless move freely and which on its side, being separated from

what it encloses, must display in its formation the fact that it has a purpose of
its own. Moreover, the architectural character of supporting and being
supported must be formed on its own account according to its own
mechanical nature. A principle of this kind is followed by the sort of drapery
which we find used in the ideal sculpture of the Greeks. The mantle especially
is like a house in which a person is free to move.[13]

Modern clothing fails dismally in this respect and 'For these reasons
the Greek clothing is the ideal model for sculpture and is to be preferred
by far to the modern.'[14] However Hegel is sympathetic to the practical
problems of the modern sculptor faced with commissions to celebrate
statesmen and the like, advising that some 'middle way' should be
found between the timeless and the contemporary.[15] Hegel also admired
the way in which certain classical sculptural figures were draped, rather
than always naked, as a means of signifying the superiority of the
spiritual over the material. He wrote that 'we get drapery where a higher
intellectual significance, an inner seriousness of the spirit, is prominent
and, in short, where nature is not to be made the predominant thing.'[16]
Culture is superior to nature, as the spiritual is over the material. Hegel's
admiration for Greek art was not unrelated to his hopes that the modern
state would emulate the Greeks' sense of commitment to community
(the *polis*). However he argued that the modern 'Germanic World' had
a superior concept of freedom for all, as opposed to the slavery existing
in classical societies.

It is worth looking briefly at some of the ideological meanings which
have been associated with classicism and its revivals in art, since drapery
has been so closely tied to its classical origins for many centuries. Des-
pite reliance on slave labour and the unequal position of women in Greek
and Roman society, classical societies were normally associated with the
values of freedom, culture and civilisation.[17] As Michael Greenhalgh
points out, classicism is a set of agreed values just as much as it is

a conglomeration of styles; and is dependent for its development, nurture and
survival on prestigious patronage from rulers or the aristocracy. It is at no time
a popular movement, for it often relies on involvement in the linked worlds of
scholarship and collecting, as well as education – that is, on the leisure that
only money can provide. This is logical, for antique art is also a moneyed or a
public art, without working class elements.[18]

He concludes therefore that 'It is certainly true that Classicism itself is

an authoritarian tradition, peculiarly fitted to the expression of political and dynastic superiority'.[19]

Now while this may be broadly true, we should take care not to tie cultural phenomena too closely to social groups in a kind of 'socio-logical' manner, and some modification of Greenhalgh's statements is in order. In the French Revolution, for example, neo-classical painting and its main exponent, Jaques-Louis David, became identified with the progressive democratic values of the radical French bourgeoisie, although neo-classical art had been fostered by the Royal Academy and the official arts ministers in the decades just prior to the political and social upheavals in late-eighteenth-century France. What has really caused most problems for the credibility of classicism as a cultural movement, however, has undoubtedly been the espousal of classicism in the visual arts and architecture by both German and Italian fascist governments in the earlier part of the twentieth century and it is undoubtedly the case that fascism had many lower middle-class and even working-class supporters, although it functioned to benefit big capital. Mussolini saw his fascist state as a successor to the eternal values of Roman civilisation and conquest, while Hitler located the German people in a heritage of Aryan values derived from the Greeks. Thus the period from the 1920s to the 1940s saw right-wing régimes in Europe merge classical style with modernism and in the case of Germany, also with medievalism. However the love of the fascists for classical culture resulted in rather more examples of massive heroic nude statues accompanied by bits of drapery, than by fully draped figures. This was because fully clothed classical statues had tended to be female, and considerably more emphasis was placed on the heroic warrior nude than on the female figure in fascist sculpture.[20]

However without actually being fascist, a significant number of artists in the period after the First World War moved away from non-figurative painting back to figurative work and returned to the authority of traditional art once more. The Old Masters were seen as sources of in-spiration once again as a kind of conservative, figurative modernism appeared in the work of painters such as Meredith Frampton in England, or Severini in Italy.[21] For example, in Ubaldo Oppi's painting of 1926, *Three Surgeons*, three men in long white overalls, whose folds are crisply and cleanly delineated, stand talking and smoking in a tiled, cloistered hall. One dangles his spectacles from a finger. They are obvi-ously contemporary figures (a collar and tie is visible on the central figure), but the static quality of the draped clothes and frozen gestures

identifies this type of picture as an example of conservative modernism, incorporating classicising references to antique drapery.[22]

The association of classicism with fascism and conservatism in the mid-twentieth century did not encourage a revival of interest in drapery by radical artists. Also, non-figurative art by its very nature had little use for drapery. In the 1930s, a less ideologically loaded form of classical revival was to be found in the draped haute couture fashion creations of designers such as Mme Vionnet and Alix (Mme Grès), of whom more later.

TEACHING AND DRAPERY

Stylistically, classicising drapery had a long life-span. Some of the reasons for this have already been suggested. Also important for this longevity were the methods employed to teach the study of drapery to students, which also tended to change little over the centuries, becoming enshrined in institutional instruction until the later nineteenth and earlier twentieth centuries.

In the early Renaissance, artists learned their trade as apprentices to masters who were members of a trade guild in a particular town and who had a workshop. Apprentices learnt a considerable range of skills and, in bigger workshops which received many commissions, were likely to gain a wide spectrum of experience. Workshops copied designs from pattern books and individual drawings were also used to teach or transmit good ideas and successful poses. In workshops, where knowledge was passed on by imitation and example, there was probably little need for more abstract theoretical writings on art. According to one expert, however, Alberti's writings on painting (1436) were evidence of a new development, as they achieved a balance between workshop technique and abstract theory.[23] Some of Leonardo's writings, to which I shall return shortly, were familiar to artists through handwritten copies, before being partially published in 1651. By this time, when artists' writings were beginning to be published, written knowledge was circulated not just among artists but to a wider interested public of patrons and educated amateurs.[24]

In Southern Europe, academies had developed out of the guild masters' workshops by the sixteenth century, while in Northern Europe academies for the teaching of fine artists were formed in the seventeenth century.[25] The Florentine Academy was founded in 1563 and artists were soon released from obligations to the guilds. Three masters were

appointed to teach *disegno*, which included not just drawing but structure and composition. Instruction in this area also included the study of drapery and the copying of antique and contemporary masterpieces.[26] In a decree of 1571 relating to the Florentine Academy, sculptors were required to prepare clay models to be used for drapery studies.[27] Sculptors at the Roman Academy (founded 1593) constructed copies of antique figures in clay or wax according to ideal proportions which were then draped for the pupils to draw.[28] The artist's education progressed from schematised outline drawings of different parts of the body, eg the eye, then to drawing after two-dimensional models such as prints, moving on to three-dimensional models and finally to nature. Development was from the part to the whole. Drapery studies were an important exercise in the rendering of light and shade and the transition from two to three dimensions. Drapery was an important element in an artist's vocabulary but since it was almost always a part rather than the entirety of a composition it belonged to a lower register of skills than managing a whole composition.

Gradually over the years academic teaching became so codified that it changed little for long periods of time. As long as religious and classical history painting remained at the top of the academic hierarchy of *genres* (types) of art, drapery and the study of drapery in relation to the human body seemed to change very little. Ruskin's advice to his students in 1857 sounds as if it might have been written in the Renaissance. Giving advice on how to carry out exercises in shading on a towel or a napkin he wrote:

your shades must be wrought with perfect unity and tenderness, or you will lose the flow of the folds. Always remember that a little bit perfected is worth more than many scrawls; whenever you feel yourself inclined to scrawl, give up work resolutely, and do not go back to it till next day'.[29]

However Ruskin was modern enough to advise the students to copy from photographs of draped statues. He also alerted them to the metaphysical reasons 'for the enjoyment, by truly artistical minds, of the changes wrought by light and shade and perspective in patterned surfaces.' Once the students had mastered the representation of static patterned drapery, Ruskin suggested that they might move on to the live version of this in the shape of a leopard![30]

Many of the techniques advocated for the study of drapery remained relatively unchanged for many years, for example copying the antique

and draping model figures as well as live models.[31] After copying the drawings of masters, plaster casts and the live model, artists were, in theory, trained to draw anything, either from memory or nature.

NAKED AND NUDE: CLOTH AND DRAPERY

The means to turn cloth into drapery through art, like straw into gold, were comparable to those used to turn an ordinary naked body into an artistic nude.[32] Although the structure of pieces of cloth was clearly less demanding than human anatomy, students studying drapery were advised to pay attention to the 'anatomy' of the fabric. One teacher in 1928 advised students to study the materials of the drapery, eg wool or silk, stating 'we will call it the anatomy of drapery'. Drapery was not just a surface: 'Realize, therefore, that you must never hope to draw the form of drapery itself. *You must draw the thing which makes the drapery*. The underlying cause of its existence.'[33] The point where a fold first bends the cloth is referred to as 'the eye of the fold' and understanding what causes this is essential for grasping the 'anatomy of the fold'.[34] Sometimes the words used for skin and drapery are the same and the drapery is perceived as a second skin.[35] Thus not only does the drapery clothe or accompany a figure, it is sometimes referred to as if it possessed a certain life of its own. The tension between animate and inanimate, body and drapery is an interesting one in the history of drapery representation, and as the drapery tradition becomes more and more irrelevant to art, the possibilities for the independent existence of cloth in other spheres of art, design and culture become stronger.

PERIODISING THE STUDY OF DRAPERY IN VISUAL CULTURE

It is tempting to try to periodise the development of drapery, but in practice this is quite difficult. When historians try to periodise their field of study, their aim is usually to clarify when and why, changes took place. Most periodisation in art history and visual culture, however, is based on stylistic similarities and differences, rather than on economic, historical or social changes, which are usually the most helpful indicators of the reasons for cultural change. When I attempted to periodise the evolution of drapery, I found that it was almost impossible to come up with a coherent framework. As noted above, this is partly

due to the many centuries when drapery in fine art changed very little, as well as the long-term prestige of religious and historical painting in which drapery was commonly found. An attempted division of drapery into pre-modern, modern and post-modern categories did not really fit with a corresponding historical and economic periodisation of European society. The main reason for this was that in the modern period, which we would tend to describe as the period dating from the French Revolution, the political and economic rise to power of the bourgeoisie, the industrial and agricultural revolutions, the development of capitalism, the massive increase in urban populations and so on, drapery in fine art still looked pretty much as it did in previous centuries. However by the later nineteenth century, other cultural manifestations of the use of drapery (eg window displays, 'Oriental' dress) were to be found alongside this enduring high art tradition. Periodisation is thus far less useful than an enlargement of the category of drapery and a willingness to look outside fine art media in order to locate potential changes in the meanings and representations of drapery. Also, although most of the twentieth century would be termed 'modern' by the majority of cultural historians, drapery in the twentieth century takes on very different forms and meanings than in the classicising fine art tradition still alive in the 'modern' nineteenth century. Whether we see the postmodern as beginning just after the Second World War or in the 1960s, it does not really help much as a concept for understanding the reasons for changes in drapery representation and use. Cultural productions tend not to be directly determined by economic and social factors (though ultimately this is where we should look for their genesis) but in the case of drapery the 'relative autonomy' of art from its economic foundations is more than relative – it is very loosely attached indeed. What I want to do then in the following sections of this chapter, is look at three aspects of drapery in fine art practice at different historical moments – Renaissance Italy, nineteenth-century France and, more briefly, the present.

LEONARDO AND DRAPERY

I want to centre this section on the theory and practice of the study of drapery by Leonardo da Vinci. Leonardo made a series of drapery studies most of which are executed with a fine brush and tempera paint on prepared grey linen. (plate 2) Although there is some dispute as to whether all of these extant works are by Leonardo, the scholars who

contributed to the catalogue which accompanied their most compre-
hensive exhibition generally agreed that they were by Leonardo and
mostly made between 1470 and 1480.[36] Fifteenth-century Italy had
several important centres of textile manufacture, as well as regulations
on certain types of cloth and who could wear it. The shirts of peasants
were of coarse linen or hemp, whereas fine linen for the upper classes
was imported from France or the Low Countries. Tailoring was a
relatively new craft in the fifteenth century: 'the ideal of producing the
effect of an "outer skin", rather than draperies which hung or lay over
the body, was a part of the change from the Gothic to the Renaissance
taste.'[37] Folded garments had tapes sewn inside to tie the clothes around
the wearer and keep the folds in place. The generalised nature of the
drapery in Leonardo's studies makes it clear that he is not attempting
to depict contemporary dress in them.

Fortunately Leonardo discusses drapery in some of his writings
intended for a treatise on the art of painting, which remained
unfinished. Leonardo emphasised that artists should always make clear
that draperies covered living figures and should pay close attention to
various kinds of fabrics and the way that folds behaved differently
according to the thickness of the cloth and the type of garment. He
discusses perspective and drapery and the behaviour of light and shade
on arranged cloth. Drapery should be graceful and not over-elaborate.
'I do not deny that handsome folds should be made, but let them be
placed upon some part of the figure where they can be assembled and
fall appropriately between the limbs and the body.'[38] He criticises artists
who put financial considerations above the need to study their art and
make new discoveries, implying that perhaps they would arrange their
draperies in a fanciful way to attract the superficial eye, rather than
spend time really learning about the behaviour of cloth in space and
light. Draperies cover not only the body (as in the light garments of
nymphs and angels) but other clothes beneath them (most human
beings) and this needs to be shown in the paintings. Leonardo's advice
is that

Draperies should be drawn from the actual object; that is, if you wish to
represent a woollen drapery, make the folds accordingly; and if it is silk or fine
cloth, or coarse material such as peasants wear, or linen, or veiling, diversify
the folds of each kind of material, and do not make a habit, as many do, of
working from clay models covered with paper or thin leather, because you
will greatly deceive yourself by so doing.[39]

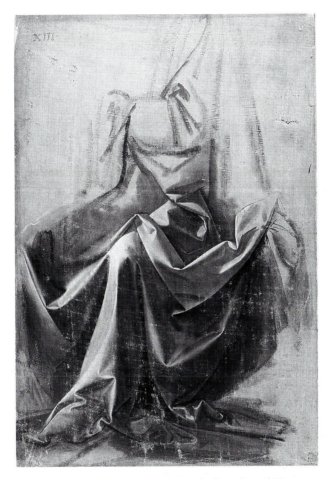

2. Leonardo da Vinci, Drapery Study for a Seated Figure, *grey-brown tempera with white highlights painted on prepared grey canvas, 13.9 x 22 cm, 1470s(?), RF41905, Louvre, Paris, photo R.M.N. Michèle Bellot.*

He adds that draperies should be appropriate for the age and status of the wearer and the antique provides a good model for draperies pressed against the body by a breeze.

In subsequent sections, Leonardo touches on a subject which many later writers on drapery also mention – the need to avoid modern fashion in favour of more generalised clothing. According to Leonardo, modern fashion not only looks stupid, but can actually damage the body. Artists should

as far as possible avoid the costumes of your own day, unless they belong to the religious group just mentioned. Costumes of our own period should not be depicted unless it be on tombstones in churches, so that we may be spared being laughed at by our successors for the mad fashions of men and leave behind only things that may be admired for their dignity and beauty.[40]

Leonardo's drapery studies have been related to a passage in the account of Leonardo's life, written by the Renaissance art historian and artist Giorgio Vasari, where the latter recounts that Leonardo 'would make clay models of figures, draping them with soft rags dipped in plaster, and would then draw them patiently on thin sheets of cambric or linen, in black and white, with the point of the brush.'[41] Leonardo may have done this early in his career, but as we have seen, his stated preference was for observing the draperies in their natural state, and presumably covering them with plaster would obliterate the subtle differences between different sorts of materials. In his series of drapery studies though, the cloth is not detailed in its texture, so it is hard to tell whether Vasari is correct, or whether Leonardo changed his mind about the best ways of studying drapery by the time he committed his thoughts to paper. It may be that he realised later, when he was writing his treatise, that his earlier methods were not the ones he wanted to recommend to young artists. Vasari himself recommends to artists that they clothe completed full-sized clay models with cloth soaked in thick clay, arranging the folds as they like. When this dries, he writes, it will be ideal for the study of drapery. Other advantages would include the static nature of the dummy and of course the financial savings over the price of a live model.[42] Also this procedure was a kind of inter-mediary stage in translating soft cloth into hard stone, making it easier for the sculptor as well as the painter. It may be that the practice of covering clay models with wet cloth to keep them malleable could have suggested this means of studying drapery to artists. Rodin is reported to have used drapery covered with plaster and sculptors used casts of actual cloth for drapery on their statues.[43] Some sculptors used cloth as part of their works, as in Degas' various versions of the famous *Little Dancer*, made in the early 1880s.[44] In a 'classic manual' for the sculpture student written in the early years of the twentieth century, the recommended methods had changed little. Students were advised to drape model figures in wet cloth so as to study the fall of the folds better and to experiment with arrangments of drapery on plastercasts.[45]

Leonardo's very small drapery studies are unusual in that they are on linen and not paper. No-one is particularly sure why this support was chosen, but it may be partly so that Leonardo could use a brush and paint in order to render the tonal values more effectively.[46] What is striking about these works is their small size, at variance with the impression of mass and solidity achieved. Art historians have proposed that studies of drapery were used in Florentine workshops in the late fourteenth century to train apprentices and also for copying by other artists to use in their larger paintings. The drapery studies were works in their own right, investigating light and shade, texture of cloth, compositional arrangement and so on, but also tools to be used in the workshop. These drapery studies could be utilised for religious paintings, where generalised drapery was the norm.[47]

Leonardo's extant drapery studies also show an interest in the lower half of draped figures, almost totally ignoring the area above the waist. Where the top half of the body is referred to, it is sketchily suggested at best. This allows a greater concentration of the fall of the folds to and along the ground and the projections of knees in order to better analyse drapery in space and render it in light and shade. Also the drapery is more detached from the lower body than it would be in a bodice. While it is tempting to read these fascinating drapery studies as relatively independent of the body, or still lives of drapery, this would be to go against the spirit of the artist's own writings on the subject, where he emphasises the importance of the body beneath the surface, interacting with it, and without which the drapery itself, although the centre of attention in these small and intense studies, would not be considered for inclusion in a finished painting.[48]

By the later fifteenth century in Italy, the rendering of drapery had become much less decorative and more realistic, as artists were concerned to communicate a narrative in a rational, intelligible and affecting manner, rather than merely arrange clothing as a decorative surface. As Alberti had advised in 1436, the figure should be drawn nude first, before being clothed.[49] This soon became the method of teaching for centuries to come. The figures were built up from an understanding of the skeletal structure through different layers, culminating in the clothing. Alberti advised:

it will help, when painting living creatures, first to sketch in the bones, for, as they bend very little indeed, they always occupy a certain determined position. Then add the sinews and the muscles, and finally clothe the bones

and muscles with flesh and skin. . . just as for a clothed figure we first have to
draw the naked body beneath and then cover it with clothes.[50]

In its turn, the clothed figure, on its own or as part of a composition,
was presented to the viewer enveloped in its own 'skin' of 'art',
idealised and composed from a basis of studies from nature.

DRAPERY AND THE FINE ARTS IN NINETEENTH-CENTURY FRANCE

In this section I want to look at the survival of high art drapery in
nineteenth-century and early twentieth-century France. Despite the vast
changes that separated Paris in the nineteenth century from Florence
in the fifteenth, drapery still appeared in many religious and historical
paintings as if frozen in time, divorced from contemporary life where
cloth was increasingly produced on machines, sold in huge department
stores and treated with new chemical dyes resulting in colours which
had never before been seen. The more 'everyday' life of cloth at this
period in France will be discussed in Chapter 2. I want to look here at
aspects of drapery, the fine arts and photography in the later nineteenth
century, in order to indicate some of the similarities and differences
between the functions and representations of drapery in French
nineteenth-century visual culture and those of the Renaissance.

Plate 3 shows a typical image from one of the many folders of prints
published in the earlier part of the nineteenth century as educational
aids for art students. This particular lithograph is by Julien, who pro-
duced a number of these print series and dates from 1834. It was
published, probably as an installment, in Julien's *Cours de Dessin* of
1835. The folder, with folio size prints, includes a mixture of outline
as well as shaded drawings of noses, eyes, ears etc. There are also male
and female nudes in rather contrived poses, known as *académies*. These
prints, known as *estampes modèles* (model prints) were used to
supplement instruction by teachers either in art institutions or
sometimes even in private homes. This was a stage through which art
students passed on the way to drawing from life.[51] Much of this instruc-
tion was common to both sculptors and painters. The influence of
academic teaching is apparent in the print, which shows a male model
in a rather unnatural pose reminiscent of French neoclassical art of the
previous generation of painters such as David and Drouais. The figure's
intense stare is related to academic 'expressive heads' (*têtes d'expression*),

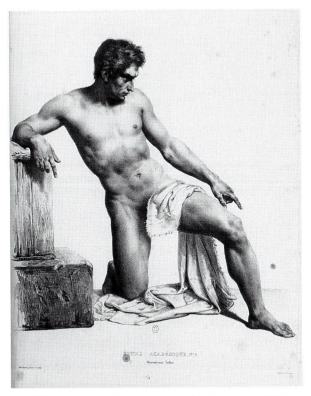

3. Lithograph by Julien, Etude Academique no.6, *1834,*
from Cours de Dessin, *by Julien, published 1835,*
Bibliothèque Nationale de France, Department of Prints
and Photographs, Kc 30 Fol.

which, along with expressive bodily gestures, communicated emotions and thereby narrative to the viewers. What is interesting here for our purposes is the cursory attention paid to the drapery. It is there merely as a fairly insignificant adjunct to the study of the nude and functions primarily as a covering for the model's genitals. In the drawing courses from the early nineteenth century that I looked at, this was fairly normal. Much more attention was paid to parts of the body and the nude body as a whole than was paid to any drapery or clothing.[52]

Both the so-called Petite Ecole (renamed Ecole Nationale des Arts Décoratifs in 1877) and the Ecole des Beaux-Arts in Paris carried out the same sort of practical exercises for students until the mid-nineteenth century, when the Petite Ecole responded to the increasing demand for

applied art for buildings, furniture and interior design.[53] The Ecole des
Beaux-Arts was much less affected by commercial pressures to reform
its teaching, so competitions for students continued to ignore modern
subjects and to concentrate on religious and classical subjects largely
based on the knowledge of the nude model, which was clothed at a
later stage in the evolution of the painting or sculpture.

An excellent example of the use of drapery in an academic painting
can be seen in Luc-Olivier Merson's *Soldier of Marathon*, which he
submitted for the Rome Prize at the Ecole des Beaux-Arts in 1869.
Thanks to a gift from his family, his preparatory drawings were be-
queathed to the School in 1921 enabling us to see the evolution of his
prize-winning entry, the final painting of which measures 114 x 147
cm.[54] The composition shows a highly finished neo-classical work
where a young naked athlete is about to die of exhaustion after
delivering the news of the Athenian victory over the Persians at the
Battle of Marathon. As he lies on the ground after the first marathon
run in history, he raises his head and his right arm, around which
billows an improbable piece of drapery. A drawing exists for the drapery
on the arm and also for the section of the same cloth which is seen
under the runner's legs. The drawings themselves are highly finished
and the part rendering the drapery round the arm has been pricked by
numerous tiny pin-points for transfer to the canvas. (Ground charcoal
or coloured chalk is dusted onto the surface and falls though the tiny
holes in the paper to leave a 'join-the-dots' outline of the drawing
underneath.) There are also detailed studies of drapery for figures in
the crowd, which were clearly worked on after the (nude) figures had
been drawn in position.[55]

While some artists in nineteenth-century France were obviously more
interested in developing new ways of representing modern costume,
and in looking for different locations in which to display their finished
paintings, academic painters were still able to get prestigious com-
missions for religious, historical and allegorical works in which 'old-
fashioned' drapery was important as a signifier of supposedly timeless
values of nobility, high culture and civilisation. In some ways, these
draperies were in a literal sense 'timeless' since artists were trained to
execute them regardless of contemporary changes in society, or even
physical differences in the manufacture of modern textiles. Another
collection of drawings in the Ecole des Beaux-Arts by Alexandre Hesse,
bequeathed by the artist, again shows how academic artists used
drawings of drapery in practice. In a letter to the Director of the Ecole

des Beaux-Arts in 1879, the Secretary of State for the Ministry of Public Instruction and Fine Arts stated his belief that the collection would be of great educational value to the students, who could learn from seeing what Hesse had done to execute his large religious and allegorical works.[56]

These are all working drawings, some on blue paper with black charcoal heightened with white or red, some are on squared tracing paper. Sometimes pieces of one drawing are cut out and pasted onto another. Sometimes a whole figure is done on tracing paper and then glued into place in the larger composition. There is virtually no spontaneous invention within Hesse's drawings. If he changes his mind, he does a detailed drawing and inserts it into another drawing by glueing

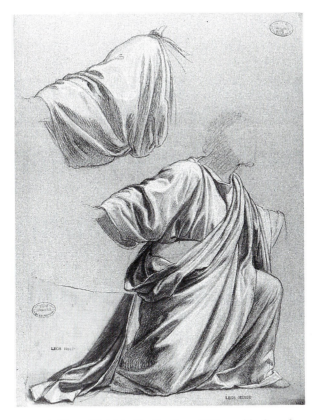

4. A. Hesse Christ in the Garden of Olives, *black and white chalk on tinted paper with drawing on tracing paper attached, 42 x 32 cm, 1863, Ecole Nationale Supérieure des Beaux-Arts, Paris.*

in the new piece done on tracing paper. This is what happens in plate
4. This is a sheet of preparatory drawings for the figure of Christ in the
Garden of Gethsemene executed for a church decoration.[57] Hesse tries
out two different versions of the draped arm, in which the folds and
chiaroscuro (treatment of light and shade) are quite different. This
suggests he may not have been working from a life model in both cases.
Similarly the drapery on the piece of paper he has stuck on to the
bottom left of Christ's robe is just an addition which seems to have been
selected to enhance the compositional effect, for how can it have been
part of a study of an actual draped figure when it does not even seem
to connect with the original drawing to which it has been added? Hesse
was concerned with the decorative aspect of his major works. He
worked out the general compostion and then did more detailed work
on individual figures. The folds appear to be part of the general decor-
ative effect, as well as being appropriate and decorous.[58] If we remember
that this work was executed in the same year as Manet's *Olympia*, its
Renaissance-style draperies seem a world away from the modern
drapery of bedcovers and shawl in Manet's representation of a model
posing as a courtesan.

HEUZEY AND CLASSICAL DRAPERY

Léon Heuzey, a specialist in the history of antique art, inaugurated a
course in oriental archeology at the centre for art historical studies,
Ecole du Louvre, from 1883 to 1886. However it is his work at the Ecole
des Beaux-Arts which concerns me most here. Heuzey himself taught
courses on antique costume from 1862 to 1884. Thereafter he was
helped by additional staff, but continued to carry out the practical part
of these courses until his retirement in 1910. This practical part con-
sisted in draping live models in imitation of examples of antique art,
whether paintings or sculptures. Students were then asked to draw or
paint from these models, with a view to understanding the real function
and purpose of draped clothing in relation to the body, rather than
merely copying antique artworks.

One student who participated in these lessons stated that Heuzey also
used engravings and drawings pinned to a blackboard, perhaps to
provide a comparison of antique works with the draped life model. The
professor also brought in boxes of clothes to use and models were
selected to correspond to the 'type' of people being studied, eg
Egyptians or Greeks.[59] Heuzey's idea was to keep antique culture alive

and relevant for the art students, but as we shall see, his efforts were part of a tradition in decline as far as fine art was concerned. He believed that drapery would always be of relevance as an accompaniment to the nude, concluding that 'Even apart from subjects taken from the antique, every time that the artist, by the force of his conception, rises above specificities of his time and race, to represent man and human beauty, drapery is for him a tool that it is difficult to do without.'[60]

Heuzey admired the kind of life that drapery could take on when animated by the figure, as well as the 'virility' of the ancient Greek males as a 'superior race' who devoted themselves to gymnastic and military exercises.[61] As well as students, his audience included writers, actors and actresses, who came to gain insight into classical culture. Classes took place in the famous Hemicycle lecture theatre of the Ecole, decorated by Paul Delaroche, and, for a time, also by a neoclassical work by Ingres.[62] Thus Heuzey's demonstrations of the survival of the classical drapery tradition took place surrounded by examples of the achievements of nineteenth-century French artists who had risen to the pinnacle of official success as great masters to be emulated by the students in the audience.

Heuzey's enthusiastic, even obsessive, interest in ancient dress and his love of draped cloth are testified to in the introduction to his book on antique costume written by Edmond Pottier who describes how 'It was enchanting to see the fine, slender hand of the master weigh the fabrics in his hand and manipulate them with delicate skill.' Pottier states that Heuzey was always eagerly searching out examples of rare cloth 'and what joy when he got his hands on some beautiful oriental fabric, on some mantle of an Abyssinian chieftain, put together and trimmed by native women just as in the time of Homer. These finds made him even more excited.'[63] Heuzey looked for survivals of antique cloth in the fabrics produced by 'underdeveloped' peoples and countries, and one of his favourite haunts for buying such cloth was at the International Exhibition of 1867, which he mentions several times in his book as a source for his examples of Indian, Turkish and Abyssinian cloth. In this modern age of colonialism and incipient Imperialism, however, Heuzey's bricolage of sources signalled the values of a dominating Orientalism as much as an attempt to recreate the antique. Specificities of individual cultures were lost in the attempt to construct a generalised 'otherness', difference and pre-modernity. In one instance, Heuzey posed his model using an Abyssinian cloak, a

shield from the Sudan and a lance from Madagascar![64] He also used
some cloth woven by Romanian nuns to drape his female models, as
well as fabrics from the Orient and Africa. He sought out cloth from
sources that were untouched by modern fashions and tailoring and
appreciated 'timeless' hand-made, rather than machine produced,
textiles. When he found a particularly interesting fabric, as for example
in an old dress from the early nineteenth century, he would have the
dress taken to pieces and the fabric reassembled in a plain oblong strip
so that it could be draped like ancient costume.[65] This was actually de-
historicising the cloth in a literal sense.

As well as his passion for 'ethnic' and 'non-modern' cloth, Heuzey
is notable for the enthusiastic use of photography in his books. As well
as several colour illustrations of painted sketches done in 1877 from
draped models by one of his students, Lucien Mélingue, Heuzey's book,
and a later one, is profusely illustrated by photographs taken in the
Ecole des Beaux-Arts photographic studio by the professor of anatomy,
Paul Richer. Heuzey stresses the usefulness of the photograph in provid-
ing 'sincere' factual information for the student and teacher interested
in this field of study. Clearly since the book was published in 1922,
long after Heuzey's retirement, it is a memorial to the author's teaching
in the past, rather than a record of contemporary events. Readers would
no longer be able to attend Heuzey's classes, but could get detailed
information about them from the (black and white) photographs.

The author of the photographs, Richer, is an interesting figure. He
had previously worked as an assistant to Professor Charcot, taking part
in the latter's famous investigations into hysteria at the Parisian Hospital
of La Salpêtrière. Richer was able to collaborate on the hospital's publi-
cations which were richly illustrated with photographs and this
doubtless gave him experience which he used later at the Ecole des
Beaux-Arts.[66] Many of Richer's photographs of models can be consulted
at the Ecole des Beaux-Arts, where he was able to combine his scientific,
medical and artistic interests under the umbrella of 'anatomy'.[67] I will
further explore connections between drapery and hysteria in Chapter 4.

The frontispiece of Heuzey's 1922 publication is a classic distillation
of attitudes to drapery by writers on, and teachers of, fine art in the
modern period. Heuzey, dressed in a professional, contemporary suit,
epitomising the tailored confines of modern dress, delicately, even
lovingly, manipulates the folds of drapery around the model's shoulder.
(plate 5) The nobility of the relationship of cloth to body is recreated
by Heuzey and the model in the late-nineteenth or early-twentieth

century, as a kind of homage to a disappearing classical tradition, just as contemporary ethnographers tried to save evidence of the culture of colonised peoples whom they believed would be 'swamped' by modern civilisation. This model, shown being draped in the style of the Roman toga, is particularly appropriately placed at the front of Heuzey's book, for the Roman toga was the dress of the mature male citizen with political rights and responsibilities. As one scholar has put it, 'First-century [AD] honorific statues show increasing convolution of the toga as a consciously difficult device for displaying aristocratic self-control through restraint of bodily motion.'[68] In his book, Heuzey discusses the work of the Roman rhetorician Quintilian, who, in his *Institutio Oratoria*, discusses how the male citizen making public political speeches should arrange the drapery of his toga in various ways so as to be both expressive and natural.[69] The elaborately draped toga distinguished the ruling-class man from the labourer and the slave, for whom the wearing of voluminous, unfastened garments was impractical. Unlike Greek clothing, the toga was not woven at home by the women of the wearer's household, but was a luxury garment made for men of the ruling class, waited on by slaves. As one costume historian remarks: 'To carry the toga was an art and selected slaves were trained as valets. . . The toga was a work of art, purposely designed to provide expression and effect through the play of light and shade on its folds.'[70]

A few years later, in 1931, a book on antique drapery by Repond praised Heuzey's classes at the Ecole, arguing for the importance of a knowledge of antique dress in order to appreciate Arab dress, Renaissance painting and bring about improvements in contemporary clothing.[71] In 1935, Heuzey's grandson Jean brought out another publication on antique costume based on articles written by Léon Heuzey. This book is the swan-song of the drapery tradition at the Ecole des Beaux-Arts, as we shall see. A hint of this is given in the introduction, where Jean Heuzey points out that he has followed the family tradition by posing live models in recreations of ancient costumes. However in this case many of the pieces of fabric have been provided by a contemporary manufacturer, Rodier, by then famous for knitted jersey material, which is soft, pliable and 'gives' with the wearer. Perhaps modern manufacturers could now provide equivalent quality to the 'ethnically produced' fabrics. Jean Heuzey comments 'Some of these [fabrics] possess precisely the suppleness, the weight, and the quality that is necessary to realise these draperies that are characteristic of oriental [antique] costumes.'[72] However Heuzey's grandson did not entirely do

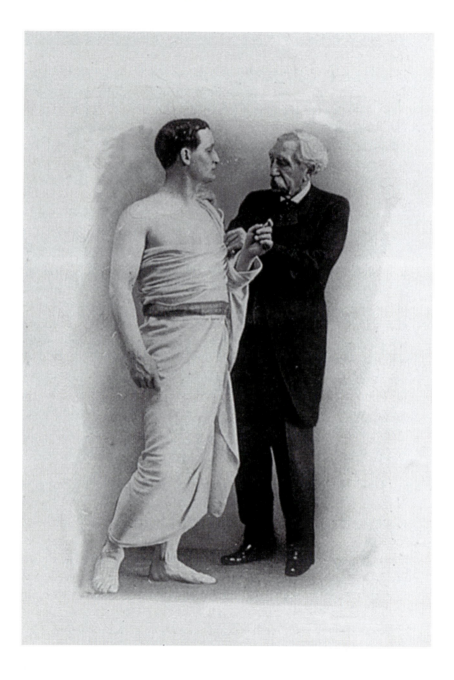

5. *Frontispiece, 'Heuzey Draping a Model', L. Heuzey,* Histoire du Costume Antique d'après des Etudes sur le Modèle Vivant, *Paris, Champion, 1922, De Montfort University Library.*

without examples of Indian, Abyssinian and other cloths. In his comments on a recreation of ancient Egyptian costume, illustrated by an old photograph created by his grandfather, Jean Heuzey quotes from the catalogue of oriental antiquities for the international exhibition of 1889 by Léon Heuzey, describing how the items used for this reconstruction are an Abyssinian cloak and a modern club 'taken from an Arab who attacked the encampment of M. de Sarzec'.[73] Colonial conquest and high culture come together in this evocation of the noble past of North Africa, in contrast to the North African present, which is to be conquered, disarmed and civilised.[74]

In plate XLII of the book (plate 6), an attempted reconstruction of ancient Sumerian dress, the photographs show a female model posing in simple draped clothing which is strikingly similar, as we shall see, to certain haute couture designs of the mid 1930s. The back view in particular, shows cloth falling at a slant from the shoulders reminiscent of the bias cut (cut diagonally across the threads) drapery of designers such as Mme Vionnet. In an interesting comment on the photographs, the date of which is uncertain, Jean Heuzey states that the model unfortunately had short hair so he was obliged to allow her to wear her usual headgear, a small turban, for the rear view photograph. This is odd, for she is wearing the turban in both views. Perhaps he felt the rear view with short hair would look too androgynous – too much like a 'new woman' rather than a reconstruction of an 'ancient' one.

THE HEUZEY PRIZE

By the 1930s, women pupils at the Ecole des Beaux-Arts were showing more evidence of an interest in antique costume than their male colleagues. In 1870, the Heuzey Prize was instituted for art students. The competitors were given an 'archeological' subject from 'The History of Civilisation' and had to execute a sketch representing the scene. Just a small amount of watercolour paint was allowed, and that was only permitted for use in the colouring of certain characteristic parts of costume and accessories. Sometimes the sketches were later executed as low-relief sculptures, depending on the favoured fine art specialism of the student. The prize-winning entries are preserved in a box at the Ecole des Beaux-Arts.[75]

Almost all of these drawings include examples of drapery. The example shown here is by the prize-winner for 1936, Mlle Beaufils, a pupil of Roger, (plate 7) and shows an interior with an Athenian woman

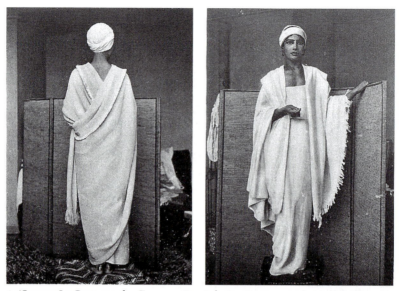

6. *'Sumer: Le Costume des Femmes:Essai de Restitution sur le Modèle Vivant'*,
pl. XLII from L. Heuzey and J. Heuzey, Histoire du Costume dans l'Antiquité
Classique: L'Orient. Egypte – Mésopotamie – Syrie – Phénicie, *Les Belles
Lettres, Paris, 1935, De Montfort University Library.*

spinning, surrounded by her servants. The draped costumes are cer-
tainly of the type that this student would have encountered in courses
such as Heuzey's, though of course by 1936 Heuzey himself would no
longer have been giving them. Since the production of cloth in ancient
Greece was done by women in their homes, this scene may have seemed
particularly appropriate in connection with a competition devoted to
the understanding of the costumes and customs of ancient peoples. The
role of the woman in cloth production obviously changed over the
course of history, but the connection of cloth and femininity is a long
and important one.

The position of women in the state institutions of fine art in France
had been an inferior one from the outset. After a long struggle, women
were finally allowed to enter the Ecole des Beaux-Arts and follow
classes in a special studio for women in 1900 and to compete in the
Prix de Rome in 1903. Although the Ecole always prided itself on its
democracy and equality of opportunity (for men), women had not been
included in this. Even after women were allowed to become students,
their numbers were restricted on the grounds that there was not
sufficient space for them in the designated studios.[76] It is curious,

7. Mlle Beaufils, pupil of Roger, An Athenian Lady in her home, spinning, accompanied by her Servants, *Winner of the Prix Heuzey and Second Class medal, black chalk or charcoal, 36.5 x 52 cm, 1936, Ecole Nationale Supérieure des Beaux-Arts, Paris.*

therefore, to notice a large number of female Heuzey prize-winners in the 1920s and 1930s – in 1924 (when only one person took part), 1925, 1927, 1928, 1929, 1931, 1936, 1937, 1938 and 1941.[77] It is worth asking why women seem to have been so successful at this competition. Is it because male students had lost interest in what may have been seen as an outmoded tradition and therefore did not enter? Could it have been because women were encouraged to enter because costume was seen as an appropriate field of study for women? There is not enough information about the number and the gender of the entrants to come up with definite answers to these questions. By the mid 1940s, the competition had ended, perhaps because there was no longer any interest in keeping the tradition of representing antique drapery alive in fine art training. Drapery had moved elsewhere.

A DIFFERENT TYPE OF DRAPERY

In Adolphe Braun's book, *Figures, Faces and Folds*, published in 1928, we see an example of how traditional drapery studies in European art

training had moved away from a purely fine art milieu and were now being related more to commercial concerns in the advertising and fashion industries. Braun recommends his book as a reference work for 'artworkers' in commercial art, fashion and graphics. The successor to his book *The Hieroglyphic or Greek Method of Life Drawing*, this work seeks to select the most beautiful 'type' of today's woman and to show her in a series of photographs in natural poses, demonstrating the underlying principles at work when women wear 'beautiful attire'. In contrast to the ethnic cloth bought in international exhibitions by Heuzey and to fabric woven by nuns, the cloth and accessories in this book came from Harrods department store and Mme Irma of Baker Street, London.

Plate 8 shows a typical example from Braun's book, with a nude model tastefully posed accompanied by an example of contemporary drapery. However Braun still refers to ancient Greece as a model for a lifestyle of hygiene, grace and rhythmic movement in clothing. 'The woman of today is a healthy, blithe being who wants to share man's joys in a healthy, blithe life.'[78] So much blitheness must have been impressive! Braun continued 'Modern dress is nothing more than the Greek tunic adapted to the mode of the day'.[79]

In the following section on anatomy and drapery, Hartley points out that drapery functions as a foil to the figure and sets it off, improving its natural proportions. Drapery, then, can be seen as an asset to the fashion designer or advertising artist who wants to entice the potential purchaser with images promising an improvement on nature. Hartley advises the student that the representation of drapery falls between still-life and the translation of inanimate objects into life and movement. He sees drapery as a vast field of interest for the artist, present in natural phenomena: 'The clinging and folding of growing things, the very colour and substance of light itself, have a quality of drapery'.[80] However, mindful of the practicalities of life for the modern designer and her/his clients, the authors advise the dress designer to visit the theatre, cinema and the races and to move in 'the best circles'. 'It is there that he meets those elegant people who wear their clothes with natural charm and utmost distinction. . .'[81] Here it is no longer supposedly uncivilised peoples who are the inheritors of antique grace and nobility in relation to cloth – it is a social elite of (probably) white Europeans who now wear the mantle of taste. The photos in this book are not particularly good examples of drapery in clothing, however, and concentrate much more on the nude female figure. Sometimes their relevance to the designer is so slight that the author provides a caption

light + composition

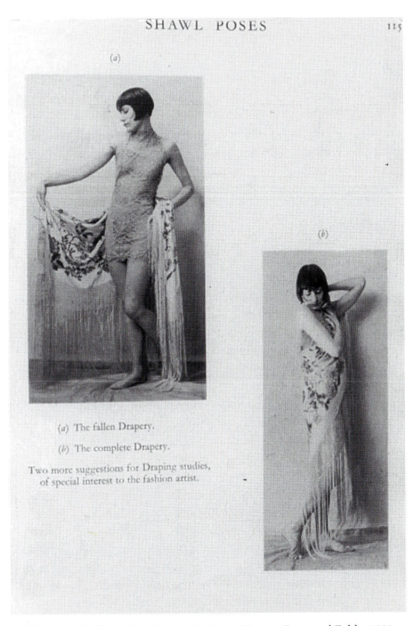

SHAWL POSES 115

(*a*)

(*a*) The fallen Drapery.

(*b*) The complete Drapery.

Two more suggestions for Draping studies,
of special interest to the fashion artist.

(*b*)

8. *Photographic illustration from A.A. Braun,* Figures, Faces and Folds, *1928.*

suggesting how the pose might be used. For example a nude woman
shown kneeling down opening a small chest is described as taking up
'a charming pose that could be employed successfully to advertise many
commodities.'[82] Braun and Hartley's book, while referring to traditional

representations of drapery and the nude, is well aware of the needs of
students to earn a living, perhaps in the contemporary fashion industry,
but perhaps also in the production of 'tasteful' soft-porn photographs.

PHOTOGRAPHY AND DRAPERY IN THE NINETEENTH CENTURY

Most of the photographs in the books referred to above, were used as
documents and records of arranged poses by models and intended as
teaching and reference material rather than photographic images in their
own right. The photographs were merely there to represent what was
in the images. Towards the end of the nineteenth century, however,
photographic images of drapery were not seen only as records of a body
draped in cloth or as a means for students and artists to avoid the cost
of paying a life model.[83] The main type of photograph to show bodies
and bits of cloth, or bodies lying on sheets in the later nineteenth
century, was of course pornographic photography, for which there was
a huge market. Here the photograph was successful in that it was
relatively cheap, but also the photographic medium was valued in a
different way from fine art media since the photograph implied reality
and the 'fact' of an actual person's nakedness. While pornographic
nudes could be made into art with the addition of tasteful draperies,
this was always undercut by the fact that the purchaser, in his imagi-
nation, was looking for sexual arousal through the image of a real
(though probably anonymous) woman's body, rather than a reference
to some battered old classical sculpture.[84]

In a group of fascinating drapery photographs by Goplo, we can see
a growing interest in what photography as a medium can do with the
draped figure, as compared to drawing or painting. Goplo (or Gopplo)
was active as a photographer in the 1880s and 1890s in Paris. The
examples of his work preserved in the Bibliothèque Nationale, Paris,
are mostly of young children, especially young girls posed on sofas.
One shows a young boy putting on a girl's boot. These coyly suggestive
images of skinny young girls on sofas are rather distasteful. Other
images show dogs or horses.[85] The most striking photographs in this
collection of his work are a draped figure (plate 9) and a photograph
of a lay figure dressed as a nun and holding a crucifix (plate 10).[86] In
plate 9, the draped figure seems to emerge mysteriously from the
surrounding space, as if it were a sculptural figure about to step out of
its niche. The figure is carefully lit to show the folds of the drapery

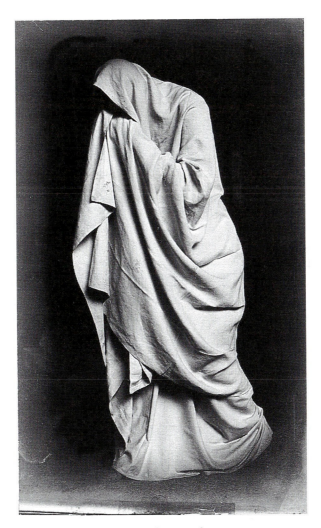

9. Goplo, Draped Figure, *photograph, 1880s, 23 x 14 cm,*
Bibliothèque Nationale de France, Department of Prints
and Photographs.

clearly. By this time in the late nineteenth century, generalised drapery
was disappearing from an increasing number of paintings in favour of
contemporary dress. In sculpture, generalised drapery was more
commonly met with and survived longer, in religious and tomb sculp-
tures.[87] This photographic image, therefore, represents the kind of
uneasy tension between the presence of the material forms and the
absence of materiality (ie death) normally alluded to in tomb sculpture
by immobile draped figures.

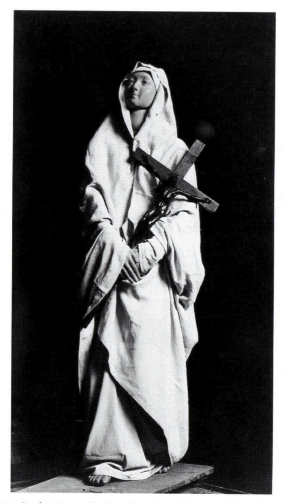

10. Goplo, Nun with Crucifix: Draped Figure, *1880s, 15 x
11 cm, Bibliothèque Nationale de France, Department of
Prints and Photographs.*

Goplo's photographs of the lay figure dressed as a saint are less
successful, though interesting as drapery studies and the vacuous face
of the figure makes it look like a cheap devotional figurine. The
emptiness of the expression seems unintentionally appropriate for a
time when religion was increasingly discredited, yet asserting its
influence through the veneration of various female saints and their
visions. By the later nineteenth century in France, Catholicism was
becoming increasingly feminised.[88] However the pious and melancholic
view of feminine catholicism was very different from the kind of active

religious works and visionary ecstacies of Teresa of Avila, for example, to whose sculptural representation by Bernini I shall return later.

After the defeat of the Commune in 1871, religion increasingly became the real focus for the politics of the traditional right. The church condemned secular education and, not surprisingly, many leading members of the clergy were royalists. Statues of the virgin were supposedly seen weeping – despairing at contemporary immorality and the absence of the Bourbon royal family as head of the French state.[89] The Republican anti-clerical sculptor, David d'Angers wrote perceptively in his notebooks about the difference in sculptural representations of religious figures in an age when religion expressed genuine struggle and spirituality and the mid-nineteenth century, when, he felt, religious expressions were merely masks concealing the interior spiritual lack of figures content to benefit from social and material power.

In the early period of faith the despotism of religion imposed a constrained and timid nature upon art. We can see it in the tight clothes in the sculptures, and in the rigid limbs held close to bodies like a timid man standing before an unyielding master. In our own age faith is no longer so alive, and we see draperies on statues that are full, we see figures with freedom of gesture, but because conviction no longer exists, these saints give the impression that they have sworn to honour something they no longer believe. Saints, as we know them, are like people who have acquired a social position which they wish to keep, just like the bourgeoisie of today. Earlier religious figures appeared totally absorbed in meditation. That was the reason for their existence. Now they are actors posing before the public, actors certain to have the esteem and approbation of the people. Once the expression on the faces of the saints bore the imprint of the roughness which man had acquired in the course of intense struggles. Now they walk gravely and securely in the midst of an abundant harvest, which they have planted and which they intend to reap.[90]

THE NUDE, DRAPERY AND NATURE

By the late nineteenth century in France, some pictorialist photographers were keen to take photographs of draped models outdoors, rather than in the studio. They produced images which looked like fine art prints, sometimes in sepia or sanguine (a dull red colour), using techniques like gum bichromate printing and developing. This was somewhat akin to certain print-making methods and involved exposing a coating of bichromated gelatin to light under a negative, then

[handwritten annotation: Photographers sought to alter the representation of drapery ↓ the physical properties of the photographic medium were different in quality to Painting and this in turn affected the way drapery was rendered.]

DRAPERY

developed with water. The areas of insoluble gelatin remained to give a positive. The result was an image that was soft, almost delicate in tone. These photographers thought that the draped figure should be liberated from the still, conventional poses of the studio and encouraged to roam outdoors. As one critic put it: 'for the first time for ages, peplums have been removed from the stores of theatrical props and allowed to float in the fresh air. . . This is not anachronistic. In putting the draped figure in an outdoor setting, photographers have redis-covered antique life.'[91]

Two of the photographers most noted for their experiments in this field are Paul Bergon and René le Bègue. Bergon (1863–1912) was a banker's son and trained musician and was interested in biology. He shared a studio with le Bègue and, like others before them, they bought 'oriental' props and costumes for their work at the International Exhibition of 1889. Their book, *Le Nu et le Drapé en Plein Air*, was published in 1898. They wanted to capture a vision of the antique free of sensual animality. They felt that ordinary photography was too 'materialist', and to attenuate this they recommended using slim models and slightly out of focus images, as well as the gum bichromate process. They recommended that 'aesthetic' photographers should train as painters first and take advantage of new technical developments to use faster exposure times for outdoor work. Special papers should be used for printing and 'personal' and subtle retouches were recommended. The whole point of their work was to aestheticise nature. Their book has no photographs of draped men, only of women.

The two photographers recommended avoiding complicated costumes and using a simple, long piece of cloth draped around the model, who should be naked underneath and free to move around. Alternatively the models could wear a long loose dress of light material 'folded in the antique manner' or open down the sides. These draperies could be tried out on a mannequin before shooting began in the countryside with living models, who could be professional or non-professional (the latter preferred). The authors describe the different textures of fabrics, the effect of light upon them and the changing movements of the textiles. The taking of the photographs should be freer than in a studio situation. The photographer should follow the model once she has been encouraged to roam freely outdoors, 'spy on her' and, as soon as he sees a good pose, take the photo quickly. Studio photo-graphy may be acceptable for portrait-sitters and families, they conclude, but will never be art.[92] Bergon and le Bègue clearly wanted

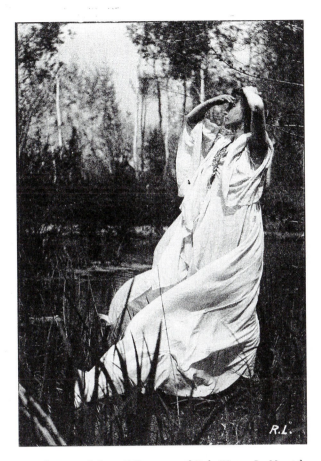

11. Photograph from P. Bergon and R. le Bègue, Le Nu et le Drapé en Plein Air, *Paris, 1898, Bibliothèque Nationale de France, Department of Prints and Photographs.*

to enjoy the possibilities of photography as a medium but were intent on avoiding its connotations as a mechanical tool for copying nature, and thus devoid of aesthetic ideals, both intellectually and technically. One illustration from their book gives a good idea of their work. (plate 11)

All indications of contemporary life are invisible, except for the photographic technique itself. The woman stands in long grass or reeds, the wind blowing her clothing to illustrate the effect the photographers prized so much when their models wore light cloth. The vision of free and unfettered movement of the draped body in nature seems to have been a largely feminised one as far as the two male photographers were

Photography + draping → seeking to capture moving bodies

concerned. What the professional models made of all this, and even more so the 'slim' women they noticed on the streets of Paris and invited to pose, is not known.

Although Bergon and le Bègue wanted their models to move around, many of the resulting images are somewhat static. Another photographer, who was more intent on recording moving bodies in this latter part of the nineteenth century was the American Muybridge. Quite a number of Muybridge's photographic series documenting human and animal locomotion show draped female figures, for example in volumes 6 and 7.[93] Some of these series give a strange impression of tension between scientific and technically ambitious images and much more generalised images covered with flowing pseudo-classical drapery. Women curtsey with fans, play tennis with a racquet and ball, dance and climb up and down stairs with a jug or a lamp, all wearing drapery.[94]

Interestingly, the still photographs of the draped figures in various stages of actions do not conform particularly well to the instructions in fine artists' manuals, which say that the various parts of the body, eg knees and elbows, which start the folds of drapery in their movements and provide tension points, will and should be visible beneath the cloth. Parts of the body are supposed to modify and/or support the fall of the cloth and fine artists tend to show this to emphasise their knowledge of anatomy but, strangely enough, despite Muybridge's scientific intentions, many of his photographs with draped figures fail to show the movements of the body beneath the cloth particularly well.[95]

Muybridge's male assistants posed for some of the photographs but he had real trouble finding suitable female models. Obviously educated middle-class women were not likely to take their clothes off or pose in transparent drapery for him:

I have experienced a great deal of difficulty in securing proper models. In the first place artists' models, as a rule, are ignorant and not well bred. As a consequence their movements are not graceful, and it is essential for the thorough execution of my work to have my models of a graceful bearing. I have the greatest difficulty, however, in inducing mechanics, at any price, to go through the motions of their trade in a nude condition to the waist only.'[96]

This interesting evidence of gender and class attitudes to nudity and semi-nudity shows that Muybridge was impatient with the working-

class men for refusing to display their bodies, yet he condemns the working-class women as ignorant for taking up employment which requires them to do so. In contrast to the French photographers who valued 'ordinary' women as their models, Muybridge sees good breeding and education as prerequisites for graceful movement. Eventually, a Mr Tadd, principal of the public school of industrial art in Philadelphia, supplied him with artists' models whom he found acceptable, especially a Mrs Cooper. Poor Mrs Cooper gained Muybridge's approval by submitting to muscle stretching treatments which caused her to go into involuntary spasms, allowing Muybridge to photograph her having (pseudo-hysterical) convulsions. The model was 'unusually intelligent and complied with the necessary details of the experiments.'[97]

DRAPERY, MOVEMENT AND PERFORMANCE

In the late nineteenth and early twentieth centuries, dancers such as Loïe Fuller and Isadora Duncan exploited the possibilities of moving cloth in their performances. Fuller would sometimes hold poles in her hands to extend beneath the draperies, swirling them around to form billowing, almost organic shapes as an extension of her clothed body.[98] As well as dramatically lit performances which took place indoors, the dancers performed out of doors, teaching their pupils to move freely in a natural setting and express themselves through movement and dance. Photographs exist showing Fuller, Duncan and their pupils, given by the performers to the sculptor Auguste Rodin who was interested in their work in terms of the movements of cloth and the body.[99] Duncan and her brother had studied antiques at the Louvre and the British Museum, in the hope that her dance would draw, like the Greek artists, 'from the great well of nature'.[100] For interior performances, both Fuller and Duncan used a simple dark draped backdrop to set off their gestures more clearly. Fuller in particular used coloured lights to enhance her performances, aided by a team of electricians directed by her brother. She sometimes danced on a floor of glass lit from below, or installed mirrors on the stage, to give an impression of an infinity of dancing, draped figures.[101] In this photograph, probably from the 1890s, (plate 12) Fuller is shown draped in a veil and cloth, mysteriously lit from below. During the performance, which lasted about 45 minutes, she would manipulate the draperies to create apparently stunning effects of movement, light and colour. She was sometimes carried exhausted from the stage afterwards. This

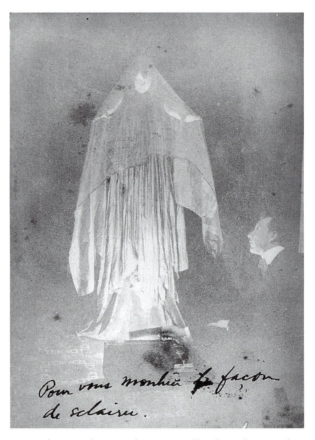

12. *Unknown photographer,* Loïe Fuller draped in a veil:
Scene with artificial lighting, *Photograph, (kallitype) 12.5
x 9 cm, 1890s, Musée Rodin, Paris, copyright Musée
Rodin.*

photograph, which was given by Fuller to Rodin, is inscribed, 'In order
to show you the method of lighting'. This photograph uses a process
(Kallitype) probably chosen to enhance the artistic image of Fuller and
her work, resulting in a soft, imprecise 'picture'. She has been viewed
not as 'a simple dancer' but as an artist.[102] The use of drapery to elevate
her clothed body from the dance hall into high art is important here,
as it mobilises connotations of high art and ideal physical grace and
nobility around the modern female body.

SURVIVALS OF DRAPERY IN POSTMODERNITY

Modernist art tended towards abstraction and away from figuration, or else represented figures wearing contemporary clothes which were often close-fitting and undraped. Draped haute couture fashion of the 1920s– 1940s is something of an exception in early twentieth-century culture and I will discuss this in Chapter 2. For much of the first part of the twentieth century, drapery was not a major concern for fine artists, as far as I can discover.

In the period since the 1950s, books on drapery for art students are also few and far between. Exercises in drapery drawing and painting persist in still life studies, in which the convention is to arrange objects on cloth, but interest in the draped body *per se* is unusual.

Barcsay's book of 1958 is intended to instruct students in how to understand the fall of drapery on figures and objects and to study the spatial and tonal effects of these forms. His book is a summary of well-known approaches to the representation of drapery. However he counsels students not to work from photographs or from clay figures covered with stiffly starched draperies, as these will not give a natural effect.[103]

Mario Cooper, member of various artists' associations and a former magazine illustrator, explains his system for representing drapery through a system of 'tension points' which can be applied to figures in modern dress as well as examples from ancient and Renaissance art. Conveniently, all his female figures appear to wear uplift bras and have erect nipples, so their 'tension points' are pretty obvious. In a parti-cularly striking diagram, he demonstrates how a slanting plane is positioned along a line running from the shoulders of a woman wearing a tight blouse to her nipples: 'Often the line from nipple to nipple and the slant to the shoulders form a plane that resembles the slant of a gable roof'. The figure of the woman is accompanied by a diagram of a construction that looks like a dog kennel to illustrate the point![104]

The most recent publication I have found devoted to drapery is that of Burne Hogarth, *Dynamic Wrinkles and Drapery*, published in 1995. Hogarth's book, says the introduction, is intended to fill a gap in art education, which largely ignores the clothed figure in favour of the nude. Hogarth advises treating clothing as a dynamic, looser new skin, that moves with the body. Given that artwork illustrating clothed figures is much more common than representations of the nude, Hogarth's career in art education and popular culture (as an illustrator of comics) is the source for his advice to art students on how to draw the draped

treating cloth as skin → drapery as a dynamic organ.

figure. The illustrations in this book cover a huge range of material, from frontiersmen blowing off snakes' heads with guns, wizened old sailors, cavaliers, Viking warriors, American football players and Romany dancers. It is odd to see classical drapery transposed into the 'second skins' of this motley crew of characters in a kind of kaleidoscopic selection of history turned into fantasy. Burne Hogarth acknowledges as sources

fashion artists of earlier eras and the scattered records of a more remote and distant historical past of attire and dress in many lands and diverse cultures – some found in obscure print media, some in painting and sculpture reproductions, going back to early classical times.

Much of this background reference matter I have deliberately reworked and scrambled (like military uniforms, for example) so that no specific geographic, national, ethnic, or political provenance can be attached or inferred. My sole objective is the strict adherence to solving the problems of wrinkles and folds.[105]

Once again, we have examples of drapery intentionally removed from precise historical, ethnic or historical contexts. In this, Hogarth remains faithful to the centuries-old rule of making particular and specific clothing into 'timeless' drapery. However in this case the ahistorical and the 'timeless' has come to merge with the postmodern free-for-all of hybridity, fragmentation and the rejection of a totalising historical narrative and/or positioning. Historical imagery becomes a kaleidoscope of positions and stereotypical roles we can 'buy into' in the context of popular visual entertainment.

In our supposedly postmodern era of digital communication, comics have been superseded as a vehicle for leisure-time fantasy by computer games as a profitable lure, both for adults and, especially, adolescents. Computer simulations in 2D geometical shapes, which adequately mimic the fall of soft fabric in 3D, have recently attracted the attentions of researchers.[106]

In fine art practice, drapery has been used very differently in the late twentieth and early twenty-first centuries, both as represented in two-dimensional art forms and as present in installations, videos or computer-generated images. As far as news/documentary photography is concerned, drapery is for dead victims of disasters, or Third World people. In virtually all aspects of contemporary visual culture, therefore,

drapery has lost its traditional function as an aestheticising signifier of high culture, civilisation and elite values. Some aspects of this metamorphosis of drapery will be examined in Chapter 5, dealing with drapery in contemporary art, and Chapter 6, which discusses drapery in contemporary news photography.

CHAPTER 2

COMMODIFICATION, CLOTH AND DRAPERY

In *Capital* volume one, Marx explains the nature of the commodity and its centrality to the capitalist mode of production and social organisation. Commodities are made to satisfy needs, but also, crucially, to be exchanged on the market. To explain how commodities embody both use-value and exchange-value, Marx uses as examples two commodities – a coat and a quantity of linen cloth. These are two instances where useful human labour transforms natural materials into something else by using qualitatively different kinds of labour – tailoring and weaving. Thus these two commodities can be exchanged with one another and express a value relation, 20 yards of linen = 1 coat, whereas the equation 20 yards of linen = 20 yards of linen does not. Marx goes on to demonstrate how gold (money) comes to stand as a different kind of commodity, the universal equivalent of expression of value (for the linen cannot express its own equivalent form of value). So the price of 20 yards of linen is not expressed as 20 yards of linen, but as, for example, 2 ounces of gold.[1]

In the following section of his book, Marx goes on to investigate 'The Fetishism of the Commodity and its Secret', a process in which, mysteriously

the definite social relation between men themselves. . . assumes here, for them, the fantastic form of a relation between things. In order, therefore, to find an analogy we must take flight into the misty realm of religion. There the products of the human brain appear as autonomous figures endowed with a life of their own, which enter into relations both with each other and with the human race. So it is in the world of commodities with the products of men's hands. I call this the fetishism which attaches itself to the products of labour as soon as they are produced as commodities and is therefore inseparable from the production of commodities.[2]

In this chapter I want to look at the issue of commodification in relation to cloth when it is turned into drapery through an additional layer of labour. Cloth is material transformed by human labour which can then be further transformed by a qualitatively different labour into clothing or art. In most of the examples discussed in this book, several processes of transformation by labour have occured. For example in a *Vogue* fashion photograph of an *haute couture* dress, the cloth is a commodity produced by human labour, the dress is produced by a qualitatively different form of labour and the representation of this commodity in a particular way, designed to enhance its fetishistic qualities which address the desire of the viewer/consumer, is produced by another specific form of labour, that of the fashion photographer. The photographic model also sells her labour in the process of representing and marketing the dress, as do the producers of the glossy fashion magazines. These different layers of commodification result in complex formations of visual culture, where the private and the social come together around the body and its intimate sensual relationship with cloth, or cloth arranged by 'art' as opposed to craft, ie drapery.

In the following sections of this chapter I want to look at some key instances where the process of commodification encounters drapery: the body and clothing; drapery, modernity and fashion; the display of drapery and shopping; and classicism, drapery and fashion in the work of the designers Vionnet and Grès in the 1930s.

SKIN, CLOTH AND THE BODY

A number of books have researched and analysed the relationship of clothing to the surface of the body, seeing clothes as a kind of second skin.[3] Francette Pacteau quotes Anatole France: 'There is no finer, richer, more beautiful fabric than the skin of a pretty woman', before going on to discuss psychoanalytical theories of the formation of the psyche in relation to the surface of the body and its coverings. She points out that Freud added a footnote to his 1923 essay 'The Ego and the Id', to the effect that 'The ego is ultimately derived from bodily sensations, chiefly from those springing from the surface of the body. It may thus be regarded as a mental projection of the surface of the body, besides as we have seen above, representing the superficies of the mental apparatus.'[4] The ego is thus formed by both the interior and the exterior of the material self. Pacteau goes on to discuss Didier Anzieu's notion

of the 'Skin Ego'. Anzieu shifts his emphasis to the surface of the body's exterior, arguing that while initially the mother and child share an imaginary common skin, the child is then obliged to tear him/herself away from this to form an individual 'skin ego'. The subject's attempt to form a secure 'skin ego' gives rise to the narcissistic fantasy of a second skin – given up by the mother to the child to guarantee its wholeness and inviolability. Pacteau writes: 'The subject may display its second skin through the metonymic mediation of clothing, or adornments that lure the eye.'[5]

However the protective enveloping skin must not be touched (Anzieu links this forbidden touch to a prohibition of incest). Pacteau concludes that 'when clothing takes on the status of a narcissistic second skin and becomes ostentatious display, the gaze is lured with the promise of something that is deferred by the act of contemplation. The prohibition on touching is now effected through the "sublimation" of touching into looking.'[6] This theory seems reasonably convincing when applied to haute couture fashion and especially fashion photography, which in any case can only be looked at. The viewer may of course touch a fashion photograph in a magazine, but the sensual stimulus afforded by this is considerably inferior to touching the actual clothes, let alone the model who is wearing them. When the clothes are made of stiff fabrics which make sounds when the wearer moves, the stimulus to approach and touch becomes even stronger. The sound of cloth and drapery is something I want to return to later in my discussion of de Clérambault and his writings on cloth.

Pacteau concludes that the woman who 'dresses up' displays her second skin, whereas the man is fascinated by the memory/desire of the maternal skin and he 'may nevertheless derive a vicarious comfort in his proximity to and identification with, the woman who possesses it.'[7]

Yolande Papetti-Tisseron also discusses clothing as a second skin, pointing out that cloth can provide reassurance and memories of union with the mother, but at the same time it recalls the pain of separation.[8]

Eugénie Lemoine-Luccioni, a more influential writer on this topic, discusses clothing as a kind of envelope or simple drapery. Cutting cloth, for example, pierces its infinite plenitude and consistency. The body is no longer perfectly limited and closed off from its surroundings and the subject begins to lose its consistency, as if it was leaking out of its container.[9]

For some writers, the body is inferior to the cloth which covers it, as the clothing is a kind of social discourse which articulates the

formlessness of the body and the mind. Kaja Silverman writes, for example, that clothing is necessary to make the body 'culturally visible. . . clothing draws the body so that it can be culturally seen and articulates it in a meaningful form. . . Clothing is a necessary condition of subjectivity. . . in articulating the body it simultaneously articulates the psyche.'[10] Similarly, a recent book by Warwick and Cavallaro seeks to examine the function of dress in 'its ambivalent status as both a framing boundary and a loose fluid margin. . .'[11]

The difference between 'empty' clothes and worn 'filled' clothes is also important. Such is the close relationship between the body and clothing that a sense of lack is apparent when we view clothes which are not being worn or displayed on models. Even when the clothing is not made for a particular body, clothing seems to be purposeless and has lost its use value when just seen hanging from a coathanger.[12] Clothing is to be looked at, as well as worn, but accomplishes its visual function best when seen on a living wearer.

Old clothes and second-hand clothes can function perfectly well as 'second skins', perhaps also bringing with them to the wearer memories of previous occasions when they were worn, or spanning generations: 'I look like my mother in this frock'.[13] In Beverley Pagram's short story 'Clothes have no memory', two friends argue over a dress in a charity shop.

'You said yourself that the reason we go to charity shops is not just for reasons of economy, but because the older things have unknown past lives, secret histories. . .

'Bullshit', I said. 'They're just dead ladies' draperies. Clothes have no memory.'

After a while, the purchased dress is torn and the friend who bought the dress, to the envy of the writer, confides that she was getting fed up with it anyway, as she could never get rid of its strange smell:

'Well. . . it's a bit musky like patchouli, a bit like cats, a bit like damp earth. . . a bit like the inside of a very, very old wardrobe. Really, it smells of HER. And that puts me off.'[14]

This story raises some interesting aspects of clothing, for it is not just to wear or to look at. It smells, perhaps of the wearer, perhaps of other things and cloth also emits sounds.

Cloth and clothing are at the height of their powers as commodity fetishes when they are part of the fashion market, rather than second hand, although, ironically they may be more unusual and original when found later, past their 'season' in a car boot sale or a charity shop.[15] The possible fetishistic aspects of second-hand clothing do exist, however. They may complete certain aspects of 'lack' – economic and emotional. They may be clothes belonging to dead members of our families, or the families of friends, rather than those of complete strangers. Some people refuse to wear second-hand clothing, while others actively seek out items that have already been worn. We can believe that a run through a modern washing machine, or even a good hand wash, can rid the clothing of the presence of a previous owner/wearer, or we can preserve the notions of previous wearing and ownership as part of the cluster of meanings and identities we engage with when wearing the item.

Psychoanalytic theories of clothing and the body tend to ignore the historical specificity of commodity fetishism, where clothes are produced for a market which stimulates the desire of purchasers to replace what is outmoded, rather than useless. Fashion, and fashioned, fitted clothing, also appears to be at odds with the relatively timeless nature of draped cloth and clothing, which is usually made from a single piece of fabric without tailoring which is arranged in certain ways around the body. Draped clothing mobilises different connotations to 'buy into' than form-fitting clothing with lycra. Both can function in fetishistic ways, but drapery still suggests a cluster of meanings around elegance, elite values and high culture, even when made from modern fabrics.

WOMEN, CLOTH(ING) AND WORK

The social and economic changes of the modern period altered the relationships of gender and class to clothing and its artistic counterpart, drapery. In France, the centre of fashion and modernity, the gradual mechanisation of the textile industry brought costs down for purchasers and ready made clothes became available in large shops.[16] In 1846, Michelet wrote: 'Little remarked on, but important; a revolution in cleanliness, an improvement experienced by poor households; body linen, bed linen, table linen, curtains, were all owned by whole classes for the first time in human history'.[17] By the mid-nineteenth century, adequate supplies of clean linen had become an important social and

cultural sign of decency. Roche explains how the frontier between the clean and the dirty was located in white linen, which was much easier to clean and stood up better to repeated washing than other types of cloth. Previously it had been very difficult to clean clothes properly without having to cope with fading and running dyes and damage to the fabric.

By the Second Empire period in France (1852–70) women of the high and lesser bourgeoisie were wearing drawers and by the last quarter of the century so were working-class women. The cleaning of this increased supply of industrialised linen (and cotton) was entrusted to a huge number of laundresses and ironers. By the end of the Second Empire, there were an estimated 70,000 washerwomen in Paris alone.[18]

Industrialisation also had an impact on the gender composition and disposition of the clothing industry's workforce. In the 1840s women were only 28% of those employed by 'made to order' tailoring businesses, but 60% of the workforce in large clothing enterprises and 71% of those doing piecework at home. Thus many male workers resented and felt threatened by women's participation in an increasingly proletarianised line of work. In large textile factories men, women and children were employed in equal numbers, whereas more men worked in smaller textile workplaces.[19] Women's wages were considerably lower than those of men doing the same work.

Women workers in the textile and clothing industries soon became involved in economic disputes and political activities, since their wages were important not only to their independent existences but to the support of their families.[20] Women worked long hours in textile factories despite government legislation limiting their time at work. Fines for employers breaking the law were derisory. Conditions were unpleasant and sometimes dangerous. In the early 1890s the average take-home pay per day of a woman in a large to middling firm in the Department (administrative region) of the Seine was 3 francs to a man's 6 francs 15 centimes.[21]

In the clothing industry, including the fashion houses, women formed the bulk of the workforce and had to endure long hours and bad pay. Women workers could be unemployed for long periods of the year and overworked at others. During the First World War, however, women were encouraged to move into munitions work (where they earned more pay) and skilled clothing workers became scarce. The situation was ripe for agitation over wages and conditions (a favourite demand was for the 'English Week' – no work on Saturday afternoons and Sundays)

which sometimes became politicised. Strikes by women workers in the clothing and engineering industries in 1917 and 1918 also gave rise to demands for peace and the return of men from the front.[22] After the war, the textiles and clothing industries had fewer women workers (men returned from the front seeking work and the need for cloth for uniforms dropped), while the numbers of women white collar employees rose sharply to 23.5% of the total female workforce by 1926.[23]

In the clothing shops, especially the large department stores which developed in the later nineteenth century, women workers were miserably treated, obliged to stand all day from 8am to 8pm, then facing either a long journey home to the suburbs or a lonely evening in a tiny room at the top of the store building with no washing facilities, where they were forbidden to receive any visitors. The commission system devised by the management pitted the saleswomen against one another and was designed to undermine the emergence of any sense of collective identification or solidarity.[24] Female customers could be demanding, keen to demonstrate their higher status by insulting the women sales staff. This is the situation in which Zola set his novel *Au Bonheur des Dames*, to which I will return later in this chapter. This period from the early nineteenth century till roughly the end of the First World War saw crucial changes in both the production and consumption of cloth and dress in the major European imperialist countries and in the USA and along with these developments related to class and gender emerged new roles and locations for drapery utilising industrially-produced cloth alongside the declining fine art drapery traditions.

FASHION, DRAPERY AND MODERNITY

How was fashion drapery related to modernity, and the specific modern conditions of its production, as opposed to antique civilisation and its connotations of timeless elegance and civilisation? How was draped clothing to present modern bodies of contemporary men and women as public spectacle? In exploring these issues, I want to look at some writings on clothing and modernity in mid-nineteenth-century France, before going on to discuss some recent paintings by Alison Watt, whose interest in the body and drapery in the work of the mid-nineteenth-century painter Ingres has led her to reexamine and redevelop representations of the female body and cloth.

While women workers made up the majority of those involved in the production of cloth and the fabrication of clothes and women were

seen as the main consumers of fashion, it was men who wrote the specific texts which we now associate with fashion and modernity in mid-nineteenth-century France.[25] The writer Théophile Gautier's pamphlet *On Fashion* was published in 1858 by Poulet-Malassis, who was also the poet Charles Baudelaire's friend and publisher. Baudelaire must have known of Gautier's work.

Gautier's interesting little essay discusses fashion, the body and modernity. He begins by stating that, since the nude has disappeared from modern life, clothes have become a kind of 'second skin', like that of an animal, for 'modern man'. The nude is so uncommon, he writes, that when you visit an artist's studio and see nude models, you feel as if you are looking at a different species. He feels that zoos should exhibit specimens of nude people (like those recently discovered in Central Australia), whom civilised Europeans can observe along with the other curious animals. When we look at the ideal figures of antique art, states Gautier, we no longer think of ourselves as belonging to the same race as they do. The nude no longer exists (and Gautier includes the obligatory drapery in his concept of the nude), but even in the Renaissance the nude was a convention: 'clothes were the visible form of man'.[26]

Modern artists are always complaining about modern dress, says Gautier, but this did not prevent Titian and Van Dyck from creating masterpieces representing their contemporaries in fashionable dress. Look at Ingres' great portrait of Monsieur Bertin (Louvre, 1832), writes Gautier. Don't the folds of his frock coat and trousers look as noble and pure as Greek and Roman draperies? Doesn't his body look vibrant under his prosaic clothing, just like that of a statue beneath its drapery?[27]

Gautier counsels artists to seek out 'distinction' in clothing as opposed to showy ostentation, thus avoiding some of the pitfalls of contemporary fashion:

These nuances escape artists, at least most of them, since they are in love with vivid colours, abundant folds, draperies whose fractured edges reflect the light like mirrors, torsos with neatly divided pectorals, and arms whose biceps stand out in relief.[28]

Yet even when men wear restrained and uniform dress, according to Gautier, it is possible to discern differences of class.

After some intoxicating passages in praise of women's hair and elaborate hairdressing, Gautier turns to women's fashions. The crinoline, condemned by many, excites his interest.[29] Women wearing them look

as if they are sculptured busts mounted on a huge plinth. They emerge from this abundance of folds, as if from the skirt of a whirling Dervish, he writes. The women pass by, trailing behind them waves of satin and taffeta. Only artists blinded by antiquity fail to see the beauty in this 'modern ideal'.

Just as painters use glazes to harmonise flesh and draperies, women whiten their skin, giving them the impression of marble statues, writes Gautier. Their rosy flesh, connoting physical appetites, becomes subordinate to art and intellect. Finishing off with enthusiastic praise of contemporary female evening dress at the Opera, Gautier scoffs at those who speak of the 'poverty of modern dress'.

Gautier's essay is interesting since it touches on many of the themes that Charles Baudelaire was to discuss in his more famous essay 'The Painter of Modern Life', written in 1859–60 and published in 1863. Baudelaire identifies two components of beauty in modern life: the eternal and the transitory. The latter, of course, is related to changing fashions of clothing and make up. Like Gautier, he is attracted to the particular sights and sounds of modern female dress, savouring the mouth-watering names of different types of cloth: 'The draperies of Rubens or Veronese will in no way teach you how to depict *moire antique, satin à la reine* or any other fabric of modern manufacture. . .'[30] If you steep yourself in the antique, he tells painters, you will lose touch with the present. Woman is the clothes horse for modern fashions and the idol (sometimes stupid) of the modern artist:

above all she is a general harmony, not only in her bearing and the way in which she moves and walks, but also in her muslins, the gauzes, the vast iridescent clouds of stuff in which she envelops herself, and which are as it were the attributes and the pedestal of her divinity. . . what poet, in sitting down to paint the pleasure caused by the sight of a beautiful woman, would venture to separate her from her costume?[31]

The male artist uses the woman as the raw material for his artworks, just as the woman can attempt to rise above her proximity to nature by adorning her body with clothes and make-up. But the essential barbarism and cruelty of woman in her natural state is never far below this surface decoration, writes Baudelaire. As the prostitute glides towards her client surrounded by petticoats, 'She is a perfect image of the savagery that lurks in the midst of civilisation'.[32] Beneath the silks, satins and velvets hide the awful secrets of her sexuality.

In contrast, most men (apart from dandies), seem to Baudelaire as if they are attending some vast funeral in their drab garments – their 'livery of affliction'. In a sentence similar to Gautier's reference to Ingres' portrait of Monsieur Bertin, Baudelaire writes of the 'second skin' covering the bodies of modern men: 'Look at those grinning creases which play like serpents around mortified flesh – have they not their own mysterious grace?'[33]

Other writings by men on fashion attempted to relate modern dress to antique costume. Debay, in 1857, surprisingly came to the conclusion that modern female dress was much simpler than Roman women's toilet and showed that great progress had been made, for example in using modern make-up that was less damaging to the skin.[34] Charles Blanc, writing in 1875, distinguishes between drapery used in art (to show off the nude) and drapery that made up contemporary clothing, which should always be separate from the body and not clinging to it. Different types of modern cloth and colours, responding to the light in various new ways, meant that contemporary clothing just looked different.[35]

The poet Mallarmé, arriving in Paris in 1871, soon found himself editing and writing most of a fashion magazine using various female pseudonyms including that of 'an Englishwoman', Miss Satin. Mallarmé's articles are totally convincing as he takes on the various personae of fashionable women with an eye for beautiful fabrics, hats, clothes and who enjoy visits to the 'Grands Magasins' – the big department stores.[36]

Towards the end of the century, with increasing demands for women's rights, some male writers were concerned at what they perceived to be a 'masculinisation' of women, as women wore clothes more suited to active lives and even took over items of men's clothing. One saw draped clothing as naturally 'feminine', preserving women from hideous androgyny:

Woman, because of her physical makeup, is made to be draped, not to be moulded. Anything that deviates from the drape and approaches the tight-fitting is antiartistic. In a man's suit, a woman is no longer a woman, and she is not a man: she is an androgyne, which is to say she's something undefined, unsexual, less troubling than odious.[37]

Clearly drapery was not easily transposed from 'high' culture to the culture of everyday life as seen in modern dress. The emergence of modernity and its characterisations by various cultural commentators

reveal tensions and debates in relation to class, gender, dress and the
body. Whereas classical drapery was always felt to be decorous and
seemly, modern drapery did not seem to always contain adequately the
gendered sensuality of the covered bodies. Drapery functioned in
classical art to present the physicality of the body for aestheticised
visual consumption. In mid-nineteenth-century France, draping of the
body both presented and obscured it and the relations between
revelation and concealment were fluctuating and complex. These
tensions between revelation and concealment, drapery and the body
are explored in the work of Alison Watt, whose starting point for
painterly research is the work of the French artist Ingres.

INGRES' PORTRAITS AND DRAPERY

Surprisingly, given his interest in fashion, Baudelaire said little about
the use of fashionable clothing and drapery in the work of the painter
Ingres. Gautier was perhaps more perceptive here. I want to look at
paintings by Alison Watt which take Ingres' works as their starting-
point, but seek to creatively analyse and develop his representations
of drapery and the body.

Ingres' portraits of both men and women of the French upper classes
are masterpieces of studied elegance and sensuality. Oddly enough, it
appears that Baudelaire never really saw Ingres' portraits of fashionable
society people for what they were – 'modern' portraits in which the
artist attempted to combine classical, timeless concepts of ideal beauty
(culled from antique and Renaissance sources) with contemporary
costume, pose and social presence. Ingres' portraits were for the well-
off. However as photographic portraiture became both more
sophisticated and cheaper as the century wore on, members of the
middle classes of society increasingly invested in examples of fashion-
able portraiture. One late-nineteenth-century American source, W. Gay,
advised women to 'Remember that fashion is a fickle goddess and in a
photograph which is to last for years it is best to have the dress such
as will produce the highest artistic effect.'

Ladies should be careful to dress in those materials which naturally fall in
neat folds, or drape neatly about the person, such as poplins, silks, satins or
reps. They should avoid that which has too much gloss, as this reflects the
light, but often the operator can overcome this by a proper disposition of the
light.[38]

Gay continued with detailed advice about which colours to wear when being photographed and a caution to avoid strong patterns such as stripes. 'Fine shadow pictures are produced with white drapery in deep folds.' Advice on the arrangement of hair is given, so as to improve the shape and outline of the face and, interestingly, women are advised not to go shopping before having their portrait photograph taken, since this stressful activity will make the blood rush to their faces and result in an unsatisfactory photograph.[39]

Ingres' painted portraits (for example *Baronne de Rothschild*, 1848, private collection, Paris, or *Mme Moitessier Seated*, 1856, National Gallery, London) share similar concerns about the arrangement of folds, hair and jewellery, but the colour in his paintings can be as lush and the finish as glossy as he likes, since he is not concerned with the technicalities of the photographic studio. Ingres did not say much on drapery and clothing in portraits – at least in the material that survives. However he did say, apparently, that he was against using the lay figure (an artist's wooden model) except for the early stages of portraiture. Once an interesting drapery shape was discovered by using a lay figure and cloth, the idea was to transfer this to nature, clothing the model with this preconceived drapery and setting down the movement of the folds and details of the cloth while a person was posed in front of him.[40] One contemporary reviewer praised the disposition of the draperies in the Rothschild portrait, remarking that it was difficult to paint female fashion as it did not easily fall into 'artistic' draperies. However in this case, we are told, Ingres has made such a success of representing the Baronne's dress that we have no cause to regret 'the majestic folds of the stola [Roman tunic]'.[41]

The tensions between the body and its drapery in Ingres' paintings of women and his portraits of individuals were also present in French poetry of the later nineteenth century. At a time when an important facet of modernity was fashionable dress, an over-valuation of clothing at the expense of the woman's body can be discerned.[42] This process, akin to fetishism, emphasises items of clothing at the same time as dematerialising the woman. Ross Chambers cites many examples of this, including Gautier's poem 'To a Red Dress', an erotic love poem, where the dress is alive like the woman's flesh:

And its pink folds are lips
Of my unsatisfied desires,
Clothing the body you have weaned them from
With a garment of kisses.[43]

The woman's body, in several of these poems by Baudelaire and Gautier, is covered with clothing which embodies the desire of the male lover, who is thus able to be close to her flesh all over her body – the second skin becomes the lover's enveloping desire. However at the centre of these poems is an unfathomable mystery – that of woman and her sexuality.

The mystery of women's sexuality reminds us of Freud's response to women's sexuality and, interestingly, Chambers closes his article by looking at Baudelaire's poem 'To a passer-by'. Dressed in mourning, this unknown (and unknowable) female, lifts up her skirts slightly to hurry along on her way 'Agile and noble, with her leg like a statue'. Chambers, rightly I feel, reads this poem as dealing with the interruption of life by death. Eros and Thantos, sex and death, are brought together in the image of the beautiful woman in mourning, unknowable and fugitive. This draped woman, hurrying along with legs like those of a statue, can be compared to Gradiva, the woman like a statue who is discussed in Freud's essay 'Gradiva' (1907) and whose name adorned the Surrealist Gallery in Paris when it opened in 1937. I shall return to Gradiva in a later chapter. Her active physicality is very different from the static and passive sensuality of Ingres' female figures, whether arrayed in richly-hued classical or sumptuous contemporary dress.

ALISON WATT

Alison Watt is a young British artist whose interest in Ingres' representations of women, dressed and undressed, has resulted in the production of a number of large oil paintings on canvas which are concerned with deconstructing the relationship between draped cloth and the female body. Many of these paintings are designed to be viewed as complementary pairs, representing the female body in one part and the drapery in another. The titles refer to the work by Ingres which provided the source material for the paintings and to the processes Watt herself is engaged in – fragmenting the pictures and examining details of them. For example one pair is entitled *A Serpentine Line* and *Fragment VII* (1997). Watt isolates a section of Ingres' pictures, for example the famous *Grande Odalisque*, or *Jupiter and Thetis* and enlarges this detail of drapery so that it fills the entire canvas. Still life is thus elevated to the same level as the study of the nude in high art.

Watt's aim is to undermine the hierarchy of *genres* of painting and in so doing she turns the drapery into what is almost a living mass,

while the female nudes become still lives. The examples illustrated here are *Thetis* and *Fragment IV*, 1997, both 60 x 72" (152.5 x 183 cm) which have as their point of origin Ingres' painting *Jupiter and Thetis*, 1811, Musée Granet, Aix-en-Provence. (plates 13 and 14) The female nudes are not copied from the Ingres paintings, but slightly modified and created from a combination of Ingres' figures, models and the artist's own body. After a period in hospital in the early 1990s, Watt decided that she wanted her works to represent 'the body' rather than her own body, which had been the case in some of her earlier work. While most artists who have written on drapery insist on the proximity and interface of drapery and the body, Watt takes the two apart, places them in separate canvases and then exhibits them together again, questioning their relationship, artistic hierarchies and the ways in which we read paint on canvas when it presents itself as verisimilitude. Her detailed attention to the cloth, its creases and folds, is paralleled by the way in which she paints the surface of the models' bodies, with its intricate

13. Alison Watt, Thetis, *oil on canvas, 152.5 x 183 cm, 1997, courtesy of the artist.*

14. *Alison Watt,* Fragment IV, *oil on canvas, 152.5 x 183 cm, 1997, courtesy of
the artist.*

details of veins and puckered skin. Successive layers of cloth, skin,
canvas and paint move in and out of focus for the viewer, as we fix in
turn on different aspects of visual representation and surface. Her choice
of oil on canvas is intentional – linking her work to that of 'old masters',
of whom Ingres of course is one.

Like many others interested in drapery, Watt searches out second-
hand fabrics from markets and other sources, appreciative of the
different way that old fabric hangs and drapes. The fabric takes on a
sensual, erotic role in her work, substituting itself for the body, while
the bodies, usually headless, seem distant, almost clinical and literally
detached from their sensual surroundings in the Ingres paintings – for
example the harem, the boudoir, the comfortably upholstered furniture.
The carefully arranged and detailed mounds of drapery are the scarcely
noticed supports of the body in Ingres' paintings. Here they take on a
different life and meaning – they bear the imprint of a body now absent,
or may conceal parts of the body underneath.

Watt's *Madame Moitessier,* 1997, (plate 15) loosely based on Ingres'
portrait of the same name in the National Gallery London (1856) is not
part of a pair and shows Watt moving away from the use of the nude
figure altogether. Now the body of the woman is completely superceded

15. *Alison Watt,* Mme Moitessier, *oil on canvas, 1997, 183 x 183 cm, courtesy of the artist.*

by the drapery which stands in for her.[44] Its folds suggest the intricacies of skin in the orificies of the body, while at the same time remaining cool, precise and 'finished', in the way that Ingres' oil paintings do. No traces of 'expressive' brushwork are seen, adding to the detached presentation of the cloth.

Alison Watt has stated that her interest in the lines of drapery and the lines of the body is intended to represent the body as outline, not as three-dimensional flesh. Watt's paintings suggest the pleasures of the flesh without specifically using the body to do so. This is an ingenious solution to a quandary which has concerned a number of women artists, though it was not necessarily Watt's intention to 'solve' this problem. In the 1970s and 1980s, some women artists felt that the naked female body, although a powerful site both of ideological inscription and

critical contestation, was simply too dangerous to represent. Despite the artist's intentions, the spectator could read the image of the woman's body as objectified and as a spectacle which invited an active, dominating look. Watt's images suggest a particular solution to this problem. However it is perhaps relevant to note that some female viewers felt uneasy with her representations of certain female nudes which she represented without pubic hair.[45] Ironically, in the nineteenth century, when Ingres was working, the decision not to depict pubic hair was considered less offensive. Nowadays it perhaps suggests a sexual interest in young girls and thus may have connotations of coercive and exploitative (male) sexuality for certain female spectators.

As we shall see later, Alison Watt is one of a significant number of contemporary artists whose work has been discussed in terms of postmodern theories of the fold, mostly inspired by Deleuze's book *The Fold*, published in English in 1993. In the introductory essay to the exhibition catalogue of Watt's work, also entitled *Fold*, John Calcutt puts together a textual collage of quotations from Deleuze, Lyotard, Derrida and others, interspersed with his own comments. A rather disturbing aspect of this essay for me was the frequent references to cutting (cloth and skin) and violence, all taken from male writers. Woman, her sexuality and the interior of her body, is a mystery or an 'abyss', shielded by the hymen, which 'stands between the inside and outside of a woman, and consequently between desire and fulfillment. As soon as one has recognised the fold of the hymen one has read the endless multiplication of folds. . .'[46] Note this other quotation from Derrida:

The hymen is a sort of textile. Its threads should be interwoven with all the veils, gauzes, canvases, fabrics, all the curtains. . . it is neither desire nor pleasure but in between the two. Neither future nor present, but between the two. It is the hymen that desire dreams of piercing, of bursting, in an act of violence that is (at the same time or somewhere between) love and murder.[47]

Despite the gloss of novelty and ambiguity on the surface of such postmodern writings, at their core is the same old theme of the woman as enigma which the male urge for knowledge and satisfaction of desire dreams of possessing by force. Woman is associated with cloth, weaving and textiles. The very part of her body which marks her passage from virginal to sexually experienced is like a textile. The fashionable vocabulary of postmodern 'in-betweenness' does little to disguise the rather oppresive views of women offered by Derrida. In his own

concluding remarks, Calcutt writes of the 'cut which destroys and liberates' and the way in which Watt's works 'lead me through the gateway to the marvellous'.[48] Male and female spectators are likely to read the eroticism of Watt's paintings in different ways and therefore use different language to articulate their responses.[49] While Calcutt is correct in emphasising the sensuality of Watt's work, I feel somewhat uncomfortable with the quotations he chooses to articulate his responses, given their insistence on femininity (and drapery) as something which motivates a desire to penetrate or tear open.

AU BONHEUR DES DAMES/THE LADIES' PARADISE

First published in serial form in 1882, Zola's novel centres around a huge department store is set in Paris during the mid-1860s. Central to the novel is the theme of commodification – female customers are seduced by the irresistible sensual displays of drapery and other goods. The sight, smell and touch of these fabrics can overwhelm even the most virtuous women. Zola's book is a classic examination of the themes of seduction, femininity, desire and commodification set in the context of high modern capitalism and draped cloth plays an important role in the imagery and symbolism of the novel.

By the early 1880s, there were several 'grands magasins' in Paris, selling an impressive variety of goods under one roof, displaying fixed prices, cutting profits on individual items to sell in bulk and offering customers the possibility of returning goods. Some of these merchandising tactics had already been tried by larger shops during the period of the July Monarchy (1830–48), but as urbanisation, industrialisation and the development of banking continued to develop, Paris of the Second Empire became associated with the department store as a site of leisure consumption, primarily for women, and a modern way of retail profit-making.[50] By the end of the century, larger stores were making nearly 100 million francs a year.[51] Young women from the provinces were preferred as shopworkers to native Parisians and young Jewish women, but in fact the vast majority of the salespeople were male.[52] Members of the department stores' clientele were situated one step down from the hereditary rich and were mainly from the moneyed bourgeoisie and financial, professional and administrative middle classes, though *La Samaritaine* had a more working-class group of customers. Rich women would come to select cloth and then have it made up by their own dressmaker.[53] The development of the railway

system meant that a mail order service could easily be run through the selection of goods from catalogues. Illustrations showed ladies of the bourgeoisie and their children wearing clothes in a series of scenes which seem to come straight out of Impressionist paintings by artists such as Berthe Morisot. For example, the 1880 *Au Bon Marché* catalogue showed women on a bench in the garden, women in a park, women holding parasols and fans, women painting and girls chasing butterflies.[54] Seasonal sales, such as the 'white sale' in January, were promoted by seductive and eye-catching displays, where a mass of commodities overwhelmed the female consumers by their sheer numbers, repetition and imaginative juxtapositions. The store became a machine-like woman, clothed in commodities. The *Au Bon Marché* secretary wrote to his employer, Mme Boucicaut in 1887 that: 'As always the store was marvellously adorned, her banisters lined with white calico and flowing with pillow lace, her columns wrapped with white muslin.'[55] These white sales emphasised the indispensability of linen to the bourgeois way of life, as well as the 'femininity' of the shopping environment, clothed and draped with textiles.

Concern began to be expressed over the number of 'respectable' women caught shoplifting from the stores. After some debate, they were deemed to be suffering from an illness, not criminals. Many felt that the temptations put in the way of women customers were just too strong to resist. A spokesperson for the League for the Defence of Work, Industry and Commerce, which was an alliance of small shopkeepers opposed to the department stores, said in 1888, 'These are not merchants that you are visiting; you are visiting artists, *fantaisistes*, idealists, psychologists, the inventors of tricks, the disciples of Dr Charcot, the emulators of Robert Houdini.'[56]

Zola's novel tells the story of a virginal young woman from the provinces, Denise, who arrives in Paris with her two brothers. She ends up marrying the owner of the shop, M. Mouret. Mouret is a 'ladies man' in all senses of the expression, having become the owner of the store by marrying its previous owner, now dead. He sees himself as the seducer of his female customers (as well as a seducer of real women), a man who understands only too well 'what women want' and if they don't already want it, they certainly will once they have been lured into his shop by the dazzling lights, the hum of the machine-like building and the over-the-top displays of goods from all over the world. The novel is full of sensual writing, where Zola tries to convey the seduction of the female customers. When Denise first sees the shop, it

appears to her as if the fabrics and goods displayed almost come alive and the commodities at the heart of capitalism display their key function – relations between people become relations between things.

And the stuffs became animated in this passionate atmosphere: the laces fluttered, drooped, and concealed the depths of the shop with a troubling air of mystery; even the lengths of cloth, thick and heavy, exhaled a tempting odour, while the cloaks threw out their folds over the dummies, which assumed a soul, and the great velvet mantle, particularly, expanded, supple and warm, as if on real fleshy shoulders, with a heaving of the bosom and a trembling of the hips.[57]

Once the crowds of female customers enter the store, commodity fetishism and sexuality draw closer. Even Mouret is carried away in an ecstacy of excitement to experience new sensations, buy new things and make more money. 'He lost his breath deliciously, he felt against his limbs a sort of caress from all his customers.'[58] This isn't really on a par with a visit to my local supermarket, I feel!

The novel is full of ecstatic and sensuous descriptions of window and interior displays of goods, too many to mention here. The commodities for sale become animated, silk stockings show the roundness of their calves, some are flesh-coloured, 'soft as a woman's skin'; gloves with their fingers and palms have 'that rigid virgin grace which characterises such feminine articles before they are worn.'[59] The lifts to the upper floors are lined with velvet, the Oriental rug gallery is like a harem, 'satined pekins [a type of silk] soft and supple as a Chinese virgin's skin' (p224) and from the store rises a kind of fine dust 'laden with the odour of woman, the odour of her linen and her bust, of her skirts and her hair, an invading, penetrating odour, which seemed to be the incense of this temple raised for the worship of her body.' (p226) One of the climaxes of the novel, almost literally, is an effusive description of the white sale, ironically combining virginal symbolism ('it made one think of a broad white bed, awaiting in its virginal immensity the white princess' p353) and sensual intoxication ('Starting from the dull shades of the calico and linen, and the heavy shades of the flannel and cloth, there then came the velvet, silk and satin goods – quite an ascending gamut, the white gradually lighted up, finishing in little flames at the breaks of the folds. . .' The customer, and the reader, experiences this near religious visionary ecstasy at 'the altar of this religion of white.' (p353) The white sale is linked to the mystery of the

woman's body, its adornment and concealment. The fetishism of the woman's clothes as commodities is almost stifling:

all this cambric and muslin, dead, scattered over the counters, thrown about, heaped up, was going to become living, with the life of the flesh, odorous and warm with the odour of love, a white cloud become sacred, bathed in night, and of which the least flutter, the pink of a knee disclosed through the whiteness, ravaged the world. (p354)

As the store drives the smaller shops in the neighbourhood out of business, Denise, briefly employed in one of them, pensively closes up shop one evening and brings down the shutters: 'She went and turned the winch, the wheels of which gave out a plaintive cry, the sheets of iron slowly descended, like the heavy draperies of a curtain falling on the catastrophe of a fifth act.' (p337)

The painter Degas, no doubt taken with the sensual qualities of Zola's writing, as well as an interest in young female shop-workers, suggested to a publisher friend the idea of bringing out an edition of *Au Bonheur des Dames* with samples of fabrics and lace on facing pages, so that the reader could literally see and touch some material embodiment of the visions created by the novelist. Unfortunately this proposal came to nothing.[60]

WINDOW DRESSING

One of the recurring images from Zola's novel is the display of commodities in an attempt to seduce the consumer into parting with money so as to satisfy her desire (although sometimes the consumer's desire is expressed by shoplifting). The idea of 'dressing' the naked window is an important one in the marketing of textiles and also women's fashions.

Tag Gronberg has shown how the display of fashionable commodities in 1920s Paris was different from the methods of the 'grands magasins' founded in the nineteenth century. While Paris was still marketed as a 'women's city', with women's clothing as a major export factor in the French economy, the modern woman of the 1920s was different. Nineteenth-century draped Victorian apartments (and draped Victorian women), with their veiled femininity, had now given way to lightness, fresh air and a healthy life-style – different, but still feminine, according to one view of the 1925 exhibition of decorative arts:

In the days when women covered their faces with thick veils, apartments were
dark and the windows blind. Today's sporty women love light and easy
ventilation. Their desire for floods of light has prompted decorators to
discover light colours and architects to open up large bays in the walls.

Even the shape of furniture changes according to women's fashion.[61]

High-class boutiques were constructed as 'commercial tabernacles', with
the designer Réne Herbst concerned to integrate their shopfronts into
the total façade of buildings. Instead of abundance and repetition, the
commodity was now to be displayed as if a mysterious relic:

Now it [the boutique] closes in on itself and absorbs the profusion of fabrics
and food. It shrouds itself in mystery; all it offers to the layman's gaze is a
blank facing, pierced by a small porthole behind which reposes a solitary
jewel, a bibelot, a binding. In certain cases, there is no better mode of
presentation: precious objects need to be isolated and in any case, abundance
is vulgar and repellent.[62]

The desire to seduce the customer by overwhelming them with a
profusion of commodities was now seen as lacking in taste. However
by this time the department store customers came from all walks of
life, not just the various layers of the bourgeoisie. The department stores
continued to construct elaborate window-displays and magazines and
manuals were devoted to recording the best displays and to training
future window-dressers.[63]

One such manual, with interesting photographic records of window-
displays from both Britain and abroad, is *The Art of Draping*, published
in 1936. This is written by Hilda Gibson, a window dresser for Rowntrees'
Department Store in Scarborough, Yorkshire. The brief introduction (by
Sir Frederick Marquis), commends window-dressing as a new form of
industrial art, dedicated to attracting the consumer and selling the
goods. He praises Miss Gibson's book and her knowledge of 'this job
of draping'. The frontispiece shows Miss Gibson at work draping a
figure. (plate 16) Despite the fact that Miss Gibson is a woman, the
window-dresser is referred to throughout the book as the 'display man'.
However she emphasises her desire to create windows 'for the entice-
ment of women in particular' and stresses 'how important it is to study
the feminine point of view and probable reaction when designing
displays'. She points out that this has been neglected in the past since

'major executive positions in stores and shops are usually the preroga-
tive of men'. She also mentions the recent popularity of 'figure-draping',
ie arranging the cloth on a dummy, so that female customers can see
what the fabric looks like.[64] Her book provides written advice and
photographic examples of both figure-draping and the arrangement of
loose fabrics in imaginative and thematic displays. She is obviously a
skilled designer and also understands that customers are interested in
practical information such as the care of the fabrics. She is committed
to a modern form of window dressing and regrets that 'thousands of
shops still display their fabrics in Victorian style'. (p8)

The numerous photographs in her book, as well as diagrams showing
how to drape fabrics, demonstrate how effectively drapery has taken
on a new life in the shop window, when it has all but disappeared from
the outmoded classical subjects of high art. This was indeed drapery
for the middle classes and displayed on the high streets for all to see.
As Gibson writes in her chapter 'Draping in Action':

The shop window might be termed 'The People's Picture Gallery': it is, as I
believe Mr. Austin Reed once said, the most expensive canvas in the world.
Just as in the galleries of the world's greatest cities national artistic tendencies
are clearly portrayed, so in international display these same tendencies
appear.

However, Gibson feels that the British have tended to lag behind in art
due to conservatism, adding that

It would, of course, be excellent if some style of draping could be acheived
which exactly represents the British spirit in art, if we may be said to have
one, but up to the present no such thing has happened, and we can only
advise the display man to keep himself very much *au fait* with the displays of
as many nations as possible, and from the best of these adapt for his own uses.
(pp70–71)

Thus window-dressing is seen as a kind of art-form for a wider public,
who can buy the commodities displayed in the window, but not the
actual window-display, which changes periodically. No-one owns or
collects the window-displays as artistic commodities, so their status
as art objects is not the same as works of 'fine art'. However, recognised
artists and designers gradually became more interested in contributing
to these spectacular ephemera of display. Drapery continued to play a

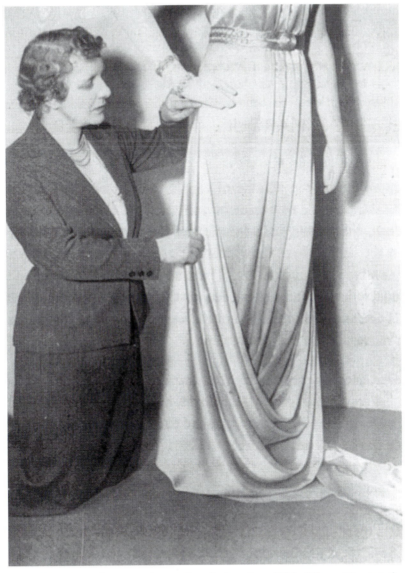

16. 'Hilda Gibson draping a figure', frontispiece from Hilda Gibson, The Art of Draping, *Blandford Press, London, 1936.*

major part in window-displays, suggesting a theatrical mise-en-scène revealed by curtains, a luxurious boudoir, or simply an overwhelming profusion of coloured and textured fabrics. The main point of the

window-display was to attract the desiring gaze of passers-by and convert that desire into the need to purchase.

WINDOWS AND MANNEQUINS

Draped cloth in shop windows can be displayed on its own or accompanied by mannequins. In the 1920s and 1930s, designers experimented with new types of dummies for window-display. Critics began to notice the figures as well as the materials they helped to display. In 1925, at the Exhibition of Decorative Arts in Paris, dummies could be seen 'carved with an axe and daubed with gold', unlike mannequins which were intended to be life-like. Opinion was divided about these new developments. However one magazine article remarked 'These figurines are an intelligent synthesis of modern femininity for it is true that artistic fiction comes closer to truth than servile reproduction. They will portray our era for future generations.'[65] Other types of experimental mannequins included those designed in 1927 by the fashion photographer Hoyningen-Huene which were covered with fake soft skin. Perhaps the most impressive though were those designed for the fashion pavilion of the French contribution to the 1937 international exhibition in Paris, created by Robert Couturier. These were giant figures, six feet tall, like terracotta figures (actually constructed from a mixture of plaster and oakum):

I wanted tragic silhouettes that were intentionally devoid of any of the pleasantness, the gentleness, that usually go with elegance. Their defensive, frightened gestures, their featureless faces, their badly balanced bodies, recalled the inhabitants of Pompeii surprised by a cloud of ashes rather than the habitués of the Faubourg Saint-Honoré or avenue Montaigne.[66]

An article in the *Revue des Deux Mondes* stated: 'This pavilion is peopled with mannequins that are not mannequins but rather sketches, terra cotta figures crudely made but which embody our dreams... Synthesis of all the veiled Aphrodites and Artemises belonging to a midnight Louvre and to such extra-human ghosts as Greta Garbo, Marlene Dietrich, Brigitte Helm'.[67] The dress designer Mme Grès (Alix) draped one of these figures in an evening dress. *Harper's Bazaar* commissioned the Surrealist artist Wols to document the pavilion.[68]

It was appropriate to commission Wols to take the photographs, given the interests of the Surrealists in dolls, mannequins and Freud's theories

of the 'uncanny', put forward in an essay in 1919.[69] The 'uncanny' relates to repressed memories that can make the everyday and the normal feel threatening – the familiar becomes unpleasant through alienation and repression. Symptoms of the uncanny are repetition and doubling, which occur, for example, when a dummy or a doll is made to replicate a human figure. However when a young girl desires or fantasises that her doll may come to life, she does not fear this. In adulthood, things are different. 'Our conclusion could then be stated thus: an uncanny experience occurs either when infantile complexes which have been repressed are once more revived by some impression, or when primitive beliefs which have been surmounted seem once more to be confirmed.'[70]

In the 1970s and 1980s, the artist Colette developed her work around such concerns as shop-window-displays, mannequins, the public and the private and the opposition of fine art and commerce. Colette was born in Tunisia, spent her childhood in France and moved to America where she spent her teenage years in New York. Her work is multimedia and her installations and projects cross the traditional boundaries of fine art, design and craft practice. Rooted in both autobiography and fantasy, her creations exploit different aspects of drapery – its domestic functions of comfort, display and seclusion, the sphere of high fashion and also its role in fine art. In her own words 'My art (fragments of my living environment, curtains, bed spreads, tablecloths) is turned into fashion. And then my fashions are recycled into art.'[71] Her live window work from the 1970s included her taking on the guise of various famous women from art and mythology (such as Manet's Olympia, David's Mme Recamier and the character of Ophelia). In 1978, the artist 'killed herself' in a performance and was reincarnated as Justine, executor of Colette's estate and head of the 'Colette is Dead' company. Traditionally, prices for artists' works rise after their deaths since a finite number of their products now exist and will eventually become scarce. In several of her window exhibitions, the artist lay as if asleep or dead, surrounded by 'walls and ceilings abundantly enveloped by bolts of crushed silk and satin undulating with tactile luxury and luminous resplendence.'[72] She also created a display mannequin in her own likeness for some of these performance windows. Another window exhibition of Colette's was 'entirely lined – including floor and ceiling – with dancing waves of a light-colored, silk-like material. The smooth mass of tissues is organised into fatty layers, sheath-like structures, soft and elegant curves. The material is at times spongy and yielding, at times firm and steady.'[73]

Colette designed clothing for Fiorucci and promoted a record album (which in fact was nothing more than the cover), bringing these products to the verge of market success only to withdraw them and exhibit them in art galleries. Despite her fame, she found it difficult to find sponsors for her artwork, yet backers were keen to market objects associated with her as commercial fashion commodities.

In her *Ripping myself off: Window work no9*, New York, Soho Boutique, 1978, Colette appeared in a window posing with busts, dummies and items of clothing from her personal life. Under the window was written 'Clothes, Jewellery, Objects for sale by the Colette is Dead Co.'[74] Colette took the marketing of femininity to its conclusions, exhibiting her self and possessions for sale like the commodities in the seductive displays of the fictional *Au Bonheur des Dames*. The title *Ripping myself off*, aptly links notions of tearing off of clothes or skin and commercial exploitation of the artist (by herself?), in a tableau presented for public view in a shop window. The artist inserts herself into the configuration of spectacle and commodification in an active way denied to the female consumers of Zola's department store.

DRAPERY, CLASSICISM AND HAUTE COUTURE

Around 1907, Mariano Fortuny and his partner, Henriette Négrin, developed the 'delphos' dress, which was patented in 1909. This tubular dress, which hangs from the shoulders, was made of fine silk with pleats (similar to the hand pleating thought to have been done on ancient Greek garments) made by laying the wet folded silk on heated porcelain tubes. Sometimes Chinese crystallized egg was used as a fixative. Fortuny's inspiration came from Greek statues and Oriental costume. Fortuny's clients included the dancer Isadora Duncan and her adopted daughters.[75] Fortuny was more of an artist than a couturier and did not produce seasonal collections. He sold his clothes through a carefully selected number of small boutiques.

Much more a part of the high fashion world were the main designers of draped clothing, Mmes Vionnet and Grès (Alix). Particularly in the 1930s, their sophisticated clothes were part of a revived interest in classicism as the epitome of purity, elegance and élite taste.

Despite the growth in ready-made clothing, couture fashion was still of great importance to the French economy even in the later 1930s during the depression.[76] France was not so immediately affected by the economic crisis, since it was a far more agricultural country than Britain

or the USA. However by 1938 Vionnet was making only half of the number of dresses she had been producing ten years earlier.[77] Workers' expectations for reform from the Popular Front government in the mid-1930s were partially fulfilled and improved holidays and social security benefits had increased the employers' costs. During the German occupation of France, restrictions were brought in regulating the amount of cloth which could be used by the fashion houses. This caused difficulties for some of the designers, including Alix and Vionnet, whose classic draped designs of the later thirties used at least five yards of material. During the thirties the use of artificial silk was promoted, as a 'patriotic' solution to bringing down costs (it had been invented by a Frenchman, the Comte de Chardonnet, and was made in France).[78] Despite numbers of rich clients including royalty, the aristocracy, the Rothschilds, Mme Clemenceau and Mme Citroën (wife of the car manufacturer), Vionnet closed her business in 1939. A plain Vionnet dress cost about 3,500 francs in 1938. This was not outrageously expensive, but would have been the equivalent of months of work for the women employed in Vionnet's workshops. In 1930 the average price of a Vionnet dress was 5,130 francs. Compare this to the wages of a saleswoman with Vionnet in 1934 for a fifty-seven hour week (9–7 on five days a week and 9–4 on Saturdays) she would receive 400 francs a month and a 0.25% commission with one month's paid holiday.[79] By 1936 gains made during the period of the Popular Front government had increased wages and lowered the number of hours in the working week, though in some industries employers merely made workers produce more in a shorter time. This strategy was not particularly suited to a highly skilled workforce producing luxury items, where every stitch had to be perfect.

Some clients would order many dresses each season. For example Baronesses Edouard and Eugène de Rothschild each bought 14 dresses in 1928 and Mme Rosembert bought 51 designs.[80] Some women clearly had so few financial concerns they had no exact idea what their Vionnet clothes cost. Mme de Carbuccia, a member of the Corsican nobility, pointed out that she never paid her own bills: 'Either my husband or my secretary did. I think they were from 10,000 to 15,000.'[81] Although Vionnet's dresses looked deceptively simple, the help of a maid was needed to put them on properly, rather like the Roman toga.[82]

I want to look now in more detail at the draped designs of Vionnet and Grès (Alix), relating them to high art drapery and also to their general social and cultural context of the 1930s.

MME VIONNET

Vionnet was born to a rather poor family in 1876 and was taken out of school at the age of 11 to be apprenticed to a seamstress. She worked her way up the fashion trade, learning to create designs directly on the figure and cutting without a pattern, following the example of one of her teachers, Mme Gerber of the Callot sisters' fashion house. Vionnet became her 'première' (or first hand), whose job it was to translate the original idea of the designer into an actual dress. Vionnet used a lay-figure, similar to those used by students at the Ecole des Beaux-Arts, dressing it in muslin, a thick cotton material in a plain weave similar to that found in silk and wool. Thus the fine art and fashion creation of draped figures share common working methods in this instance. In Vionnet's work, however, the final 'support' for the drapery became a live model and then an individually identified client. Vionnet worked directly on the mannequin, cutting the fabric into shape, usually on the bias, which helped the elasticity of the fabric and the 'hang' of the drape. Thus from the very beginning of the design process, Vionnet brought together three- and two-dimensional forms. Patterns were then made from Vionnet's original ideas and clients would chose their clothes from those made up and modelled by actual women. The clients would then return for fittings so that the dresses would fit their particular bodies perfectly. The hem was finished last, according to the body shape and height of the wearer.

Vionnet disliked cutting and sewing material too much, seeing her craft as allowing the fabric to follow its own hang and shape, supported by the body. She would wrap, loop, drape and twist the fabric rather than cut and sew it. In nineteenth-century draped dresses, there is usually a structured garment or support underneath to provide a basis for the dress. In Vionnet's work, the dress and body are in close contact and Vionnet rejected the idea of corsets and other foundation garments. Sometimes specially made underwear was bought to remain invisible under the clinging bias-cut fabric, or else no underwear other than a specially made underdress was worn.

The importance of a smooth, pure outline and unblemished surface which this type of clothing helped to create can be seen in an advert for Southall's sanitary protection from 1937. (plate 17) This gives a good example of the coming together of the classical and the modern on the surface of the woman's body. Leaning against a pillar on which is drawn the naked figure of a woman dancing with a piece of drapery, a

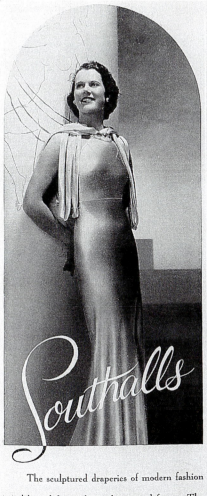

The sculptured draperies of modern fashion reveal by subtle emphasis the natural form. The easy and harmonious movement of the modern woman is achieved by the confident knowledge that not the smallest hint mars this perfection. *Southalls* have satisfied the most particular for nearly 60 years.

17. Southall's Advertisement, *1937, De Montfort University Library.*

contemporary model with short hair and make-up looks off beyond the spectator. Her arms are behind her, throwing out her breasts and exposing the front of her lower body. Soft folds fall from the bottom of the dress, while her upper body from the knees to her neck is almost

painted by the fabric, so liquid and covering does it appear. Additional
fabric is draped in folds from her neck and shoulders. The natural and
the artificial are brought together on the surface of the female body,
clean, pure and hygienic, with nothing to mar this 'perfection' with an
unwelcome stain of bodily fluid. The boundaries of the body and its
'second skin' remain secure – the 'abject' is kept at bay by social norms
of high-class taste and hygiene. Bodily signs of essential femininity are
absent, so that the skin ego can function effectively. The woman's body
is whole, phallic and impenetrable in her closely draped 'skin' of silk
jersey; a pure fetishisation of desire where signs of actual femininity
(menstruation) are banished, so that an abstract symbol of femininity
can be triumphantly presented to the viewer.

Vionnet's desire to sculpt and drape the fabric on the body in her
afternoon and evening dresses was similar to her suits and capes for
streetwear in that she was reluctant to cut the cloth and tailor the
garments. Her sense of the inviolability of the fabric did relate her work
in some ways to Greek draperies and other forms of dress where the
garment is created from one large piece of cloth hanging from the
shoulders. However in terms of women's dress in the 20s and 30s,
Vionnet's work has been read as an attempt to dress women *as women*,
rather than in ways which are masculine. Some women adopted
masculine forms of dress in the street at this time, drawing attention
to themselves and making visible their right to leave the domestic
sphere. In Vionnet's suits, it has been argued, women do not draw
attention to themselves and the woman 'marks her presence in public
by discreet absence'.[83] Evans and Thornton read Vionnet's work as a
'brave attempt to undetermine the female body' from the social and
cultural construction of particular notions of femininity.[84]

This is a slightly exaggerated claim, I feel, given the haut bourgeois
standing of most of Vionnet's clients. Her work creates a particular kind
of classical modernity, a seamless construct of a particular definition
of femininity where body and clothing become one – the woman's body
is not concealed *or* revealed by the cloth but is both at the same time.
The woman's body becomes a pure form made up of nature and culture.
In contrast, the designer Elsa Schiaparelli's *Tear-Illusion* evening dress
of 1937, in the collection of the Victoria and Albert Museum, is made
in silk crêpe hanging gracefully from the figure, with a veil draped over
the head, but the printed design (by Salvador Dali) on the cloth makes
it look as if the fabric has been ripped apart. As Caroline Evans argues:
'Whereas in, say, Vionnet's designs the masquerade of femininity is

seamless, Schiaparelli tears the veil, pulls the masquerade away, and shows its workings by manipulating surface signifiers that she layers, or plays with, on the body.'[85]

The fabric which Vionnet often liked to use was crêpe romaine, invented in 1918 and custom-made for Vionnet by Bianchini and Ferier of Lyon in special widths from two to two and a half metres. Crêpe is made of twisted yarns which give it more elasticity and although it is light it has lots of 'body'. Due to new dyeing and production techniques, Vionnet was able to get the ideal modern material (49% silk and 51% acetate) to create her classically draped dresses of the 1930s.[86]

In 1939, one of Vionnet's backers, Bader, the owner of the Galeries Lafayette department store, decided to sell ready-made copies of Vionnet's and other haute couture designers' work. She sued him and won. However Bader was the majority shareholder in her business and the price he demanded from her to be bought out was too much. She had to close down.

In fact Vionnet had fought hard for some time to protect her work from copyists. In 1921 she went to court to safeguard her designs, backed up by supporters and clients who argued that her work was art and that they would not buy articles that were not exclusive, therefore the copyists were damaging Vionnet's business and driving away her high-class clientele.[87] In the following year she succeeded in winning a judgement that recognised all couture designs as 'works of art' with copyright protection, a great step forward, but hard to police in practice, since much of the copying was done in America. Vionnet had photographs taken of her clothes, partly to provide legal evidence of her designs if necessary. These photographic records are preserved in the archives of the Union Français des Arts du Costume in the Musée de la Mode et du Textile.[88] There are some early designs, but most are from the period after the later 1920s, when the models are posed in front of a special mirror. (plate 18) In some of the earlier photographs, three separate pictures were taken showing different views, then put together so that they could be folded out like a triptych. Some dating from the early twenties have painted backdrops similar to those used in photographers' studios. These copyright albums show the design numbers and the date of the collection. In some ways, these photographs, many of which were taken by Alles, are reminiscent of the nineteenth-century photographic images of criminals, or people supposedly representing racial types, posed in profile and full face as scientific specimens, documented for further study. In this case, however, it is the clothes

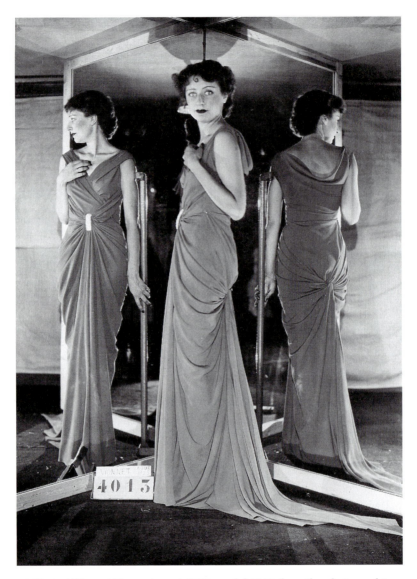

18. Draped Vionnet Dress, *August 1935, model 4013, from the photographic archives of Mme Vionnet, Musée de la Mode et du Textile, coll. UFAC, Paris.*

that are being documented and identified. Here the model is taken once, posed looking at the camera, but with her body twisted round to move the fabric. The mirror does the work of showing the different views at the same time.[89]

The photograph plays an important role in high fashion. First there are photographs for internal use in the company, then there are the legal copyright photos, photos of fashion shows and photographs in glossy magazines by famous fashion photographers. I shall return to the last of these shortly. Before that, I want to look at drapery in the fashion designs of Mme Grès.

MME GRÈS (ALIX)

Mme Grès (Alix) was born in 1903. She started work as a *modiste* (milliner) for the Bon Marché department store and by 1932 had opened her own fashion house. She eventually retired in 1987. Her social background was rather different from that of Vionnet and she was trained in music and sculpture. She said in a later interview, 'I wanted to be a sculptor, but it was not considered proper for a girl at that time. So I had the idea of making living sculptures, and I started dressmaking without knowing it'. 'I never use sketches; I work directly on a live model with linen. I feel more inspired that way. I cut it, work at its contours, look at the way it falls, study the balance of the masses. There are common points between dressmaking and architecture.'[90]

In her work, she attempted to make the body and cloth a seamless entity and stated that this made her clothes different from utilitarian dress (where the dress is made to serve the body) and the spectacular dress (where the body is only the support for the created costume).[91] She stated that her clothes were created by the cloth itself – she allowed the fabric to fall into place as if of its own volition . . . and spoke of feeling the cloth in order to know its character and soul.[92] Silk jersey called Derjsyl, Dersatimmix and Djersafyn was specially made for her by Rodier. She claimed not to have been particularly inspired by the antique, but that she was enabled to create her draped designs through the invention of the appropriate material: 'When this fabric did not exist, I had no idea of creating draped clothes, but as soon as I had it, the fabric just fell into place by itself. Greek sculptors made their statues from the materials that lent themselves to it.'[93]

Alix's clients were the rich and famous. Yet she dressed some customers all their lives for nothing, in order to have her work seen. Some of her clothes took 300 hours of labour to construct.[94] She spoke of some of the fabrics created for her as 'masterpieces', including a silk lamé produced by Bianchini in 1938 decorated with Persian miniature motifs and produced at the rate of six centimetres a day. In those days,

said Alix later, workers devoted themselves to their work, producing a quality that can no longer be found.[95] She saw haute couture fashion as a force for the preservation of luxury, beauty and civilisation, centred on the 'elegant woman', sophisticated but restrained: 'She knows what to wear in any circumstance; she is at ease everywhere. She has taste and sensitivity, and she recognises quality'.[96] This model of good taste and breeding was the ideal Alix created for.

In a photograph taken in the Louvre Museum in 1948, a model is posed wearing a typical Alix creation. The dress is backless with a draped front bodice and wide draped skirt with a bow at the back.[97] The viewer/photographer is situated on a stairway looking upwards at the woman posed in profile wearing the draped dress. She in turn looks upwards to the left of the image at the statue of the Venus de Milo on top of a marble plinth. The marble figure looks off to the right of the image over the living woman's head. The two figures, marble and flesh, are highlighted against a dark background, which shows off the sharp folds of their draperies. Antique and modern classicism confront one another through the sculpted and coutured female bodies. Elegance, high culture, taste and whiteness are linked. Modern French creative art looks towards Greek civilisation, but is not seen as inferior. Alix saw French haute couture as a contribution to world civilisation and in need of government protection:

> . . . It would need help from the government, even a Socialist one. It is a
> question of survival – survival of a culture and a civilisation. But so far, we
> have only been more and more taxed. Today, luxury is confused with waste
> and excess and its only value for the authorities is that it is exportable and
> therefore brings in foreign currency. But beauty has no price; it must be
> protected.[98]

Beauty, high art and civilisation are conceived as timeless and priceless – and beyond politics.

THE FASHION PHOTOGRAPH AND DRAPERY

In the British edition of *Vogue* magazine in the mid-1930s, there were numerous examples of fashion and advertising photographs representing drapery, usually but not exclusively linking it to classicism. Drapery was also occasionally linked to India, the trousers of a Nubian slave(!) (26 June 1935, p33), or to Turkish trouser legs (20 January 1937,

p32 with reference to a dress by Alix). However the majority of the references linked drapery to classicism. A model wearing a Patou dress was referred to as 'like a slim column of satin' (2 May 1934, p89), a photograph of a model displaying jewels was shown with a male classical statue (30 May 1934, p77), a woman wearing a Vionnet evening dress is 'a slender column of black crêpe' (26 June 1935, p37) and an advert from 2 October 1935, page 19 describes how 'Vionnet's deft shaping endows you with classic splendour in this softly sweeping gown with its shirred plastron and sculptured folds in black or white crêpe romaine, fourteen and a half guineas.' The issue for 10 November 1937 carried an advert for a dress available from Lydia Moss, New Bond St: 'Liquid drapery and supple folds made a model of sculptured grace in blue jersey at thirteen guineas.' (p115) These draped women, compared to the hardness and durability of classical columns, yet liquid and 'giving', are examples of the fetishised and phallicised woman. They are masculine (strong, columnar and hard) but at the same time acceptably feminine (softly draped and supple).

Drapery also appeared in fantasy images of the cloister and the middle ages in an amazing double-page spread of gowns by Vionnet and Lanvin on pages 74–5 of the issue for 11 November 1936. On the left hand side, a model is shown wearing a Vionnet 'nun-like bridal dress of heavy white crêpe' where the long skirt doubles back over her head to become a long veil. On the right, a model wears a similar nun-like dress with a coif over her head and neck, but the elegantly draped fabric and collar studded with rhinestones is far from vows of poverty! A painted backdrop for the two figures shows a large draped curtain blown by the wind, exposing a (painted) view through a window to a turretted castle perched on a steep cliff as if in a scene from a Gothic novel.

Notions of purity and whiteness are recurring themes in the photographs (mostly black and white) representing drapery and classicism. On 13 June 1934, p64, there is an excellent example of this in a carefully composed photograph by Hoyningen-Huene, where a woman wearing a draped gown with feathers sprouting from the sleeves sits elegantly on a seat covered with a leopard's skin. Behind her is an image of two huge white classical sculptured heads, profile and full face, complementing the face of the model. The caption to this photo reads in large letters 'The Prestige of White'.[99]

A small book of Hoyningen-Huene's photographs was published in Berlin in 1932. The images emphasised the purity, clarity and whiteness

of classical art. The introduction, by H.K. Frenzel, stresses the links between classical civilisation, high capitalism, the social elite of the thirties and the cult of the physical:

The ancient world celebrated its entry into Montmartre to the beat of jazz. Ionic columns rose alongside of factory smoke-stacks, Greek temples alongside railway tunnels and depots. Monte Carlo became Hellas, Hellas became Monte Carlo; and the ladies and gentlemen from Paris, London, New York, and Biarritz enjoyed the sunshine among pedestals from which the gods of ancient Greece looked down in naked silence, between snorting stallions and muscular heroes.[100]

Perhaps the most concentrated image of drapery can be seen in this photograph from the British issue of *Vogue* 15 May 1935, p65, showing two models in Lucien Lelong's salon. (plate 19) The caption compares both dresses to classical drapery (the toga and classic folds). The two women are echoes of one another, the dark and the light, front and back. The spectator is invited to identify with the women as if looking into a mirror along with the woman in white. However the image plays with illusion and reality in an 'uncanny' way, for Lelong's salon is decorated with plaster drapery, not fabric. This again suggests the dual natures of draped couture clothing in the 1930s – hard and phallic, a skin moulded to the body it covers and yet softly falling and inviting a gentle touch. An advert for Lelong's perfume, 'Indiscret' (7 July 1937) shows a woman's disembodied hands gently touching a bottle of the perfume highlighted against a dark background. The bottle is in the shape of a draped female figure with no shoulders, arms or head. It is as if the dress stands up on its own. The top of the bottle where the woman will put her hand to undo the lid is made of two shapes of breasts with soft swollen-looking nipples and a dark area of the areola around them. The woman is invited to fetishise a commodified objectification of the female body by using a product which will, in turn, make her own body desirable. The two women in the Lelong advert from 1935 confirm one another's desirability in a suggestion of lesbian chic, as they legitimise the female spectator's desire to look like, be like, or possess them.

BARTHES AND THE FASHION PHOTOGRAPH

Roland Barthes wrote *The Fashion System* during the years 1957–63. In tune with his interest in linguistic structuralism, he saw fashion as

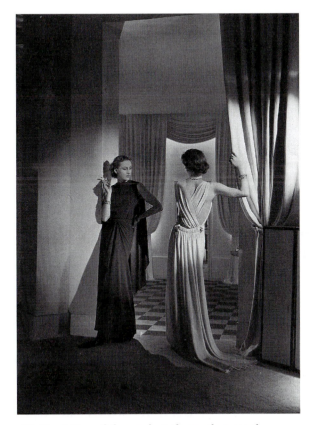

19. Horst, Draped dresses by Lelong, *photograph
published in the British Edition of* Vogue, *15 May 1935,
copyright Condé Nast Publications Inc.*

constituted by discourse, not primarily as a cultural phenomenon based
on commodities created by human labour in a capitalist society. He
analysed in this book the 'rhetoric' of fashion, the ways in which
clothing was spoken of and written of and how 'it is not the object but
the name that creates desire' for fashion clothing.[101] Barthes savours
the language used to speak and write about fashion – the names of items
of clothing and the names of different sorts of fabrics. He sees the words
as a kind of caress, which arouses desire in the reader of fashion
magazines: 'She wears flat heels, collects little scarves, and adores her
big brother's plain sweaters and those bouffant, rustling petticoats.'[102]
Just as there is a difference between clothing as worn and clothing as
written/spoken of, so there is a difference between clothing as
experienced through wearing and clothing seen in fashion photographs.

Barthes' points about fashion photographs are interesting and largely borne out by examples from *Vogue* during the 1930s, some of which have been discussed above. The fashion image can provide women with a dream of identity and role-play:

It appears that this reader dreams of her own name while delegating her identity to several personalities who complete the pantheon of usual stars, not because they proceed from an Olympus of actresses, but precisely because they have a name; *Countess Albert de Muhn, Baroness Thierry van Zuplen*; doubtless the aristocratic label is not free of connotation, but it is not determinant; the name does not summarize breeding but rather money.[103]

The viewer can play at choosing identities, since her subjectivity, in true postmodern fashion, is rich enough to be multiple, in Barthes' view.

Barthes' arguments recall Hegel's position that the naked body cannot signify, being too close to nature. It must be clothed to go beyond feeling and enter into the realm of meaning. Barthes asks which body the fashion garment signifies and comes up with three answers: it resolves the passsage from the abstract body to the real body; it decrees annually which bodies are 'in fashion'; and it transforms the real body into a signifier of fashion's ideal body.[104] Most of the images showing draped bodies in 1930s *Vogue* belong to the first category. The images propose an ideal individual, who is sometimes at the same time an actual named person. This generalised, abstract body is there to display the garment and foreground it. The photograph plays the role of fusing the concept of the 'fashionable body' and the actual materiality of dress and model posed in the studio. Barthes states that the imagined yet specific situations like the Gothic castle or convent in which the 'abstract' model is sometimes placed, are in contradiction with the generalising image and threaten its structure. I would argue that the images of models wearing classically draped dresses succeed in overcoming these tensions, as the classical allusions underline the timeless, abstract and generalising qualities of the image which can then be read as pure, distilled culture, untouched by any historical time and event.

In the conclusion to his book, Barthes discusses fashion photography as a language. In fashion photography, the world is imaged as a backdrop, a theatre. He sees fashion photography in the late 1950s and early 1960s as increasingly substituting a garment-in-action, for the 'inert presentation of the signifier' (much more common in the 1930s). First we have a literal representation, eg travel clothes worn by a woman

travelling. The second type of image is romantic: 'It turns the scene into a painted tableau; the "festival of white" is a woman in white in front of a lake bordered by green lawns, on which float two white swans (*"Poetic apparition"*); night is a woman in a white evening gown clasping a bronze statue in her arms. Here life receives the guarantee of Art, of a noble art sufficiently rhetorical to let it be understood that it is acting out beauty or dreams.' The third style is that of excess, carica- ture or mockery. Barthes suggests an example where the woman raises herself onto a pedestal like a statue.[105]

Barthes sees the function of these strategies as making fashion's signifieds unreal. By this he means that the less real the mise-en-scène of the images, the more real will the garment appear – 'nothing plausible remains but the garment'.[106] He concludes that 'Fashion effects that sort of shock to consciousness which suddenly gives the reader of signs the feeling of the mystery it deciphers.'[107] But in fact the fashion image does not decipher any mysteries, it helps to keep the mystery secret. And what is this mystery? It is that of the commodity, which Barthes is not particularly concerned with in his book, but which is at the heart of fashion photography and advertising. The mysterious 'otherness' of the black and white photographs from 1930s *Vogue*, created in the studio with largely anonymous models (the dresses are never anonymous, always identified and, unlike the models, they often have an 'address' where we can locate and purchase them) are truly a representation of a space where relationships between people have become relationships between things.

In his chapter in *Capital* on 'The Fetishism of the Commodity and its Secret', Marx sets out to demystify the secret strangeness, the queerness of the commodity. He explains how a table is made out of wood by human labour, but once it becomes a commodity for the market, 'it changes into a thing which transcends sensuousness. It not only stands with its feet on the ground, but, in relation to all other commodities, it stands on its head and evolves out of its wooden brain grotesque ideas, far more wonderful than if it were to begin dancing of its own free will.'[108] The table transcends its sensuous nature as a bit of wood, once it is positioned in relation to other commodities on the market and to constructed human desires. The same happens when a bit of cloth becomes an evening dress by Madeleine Vionnet; it becomes Greek drapery, a nun's habit, a phallic column – it has a name, an address, an identity – it dances of its own free will.

CHAPTER 3

FETISHISM, DRAPERY AND VEILS

In this chapter, I want to look at theories of fetishism in relation to drapery and cloth. First of all I will discuss Freud's essay on sexual fetishism and his analysis of the novel *Gradiva* in relation to drapery and fetishism. Secondly, the question of fetishism in relation to cloth will be examined in relation to the work of the French psychiatrist de Clérambault and his work on female shoplifters. I will also be discussing his research on draped clothing in North Africa in the early twentieth century, which he documented with thousands of photographs. Finally in this chapter, I want to look at how the Orientalism implicit in de Clérambault's work around the covering of the body with cloth in North Africa relates to recent writings on women and veiling. In particular, I am interested in the ways in which certain contemporary women artists have used cloth and images of veiling in their work. The veil can be a metaphor for ideological self-delusion, as well as the obscuring drapery of an (unattainable) object of desire, as for example in the work of Zineb Sedira. In a discussion of the above issues, I hope to show how new aspects of drapery outside the fine art tradition contributed to the survival of drapery in everyday life both within European societies and in the societies that they sought to colonise and 'civilise'.

FREUD

The key piece of writing by Freud on fetishism is his essay 'Fetishism' of 1927.[1] In this, Freud puts forward the argument that the (male heterosexual) fetishist transfers his erotic desires onto an inanimate object, or even a fragment of the women's body, since he perceives the woman as lacking, as castrated. In order to deflect the threat of castration from himself, he unconsciously attempts to find something to make the woman 'whole' again – to return to a phase when he saw his mother as phallic, complete, powerful and an example of total plenitude. Fetishism is thus linked for Freud with a repressed child-hood experience; the occasion when the male child realises that the

mother's body is not like his. The fetish also indicates the splitting of the ego in the sense that the fetishist *at the same time* can believe 1) that the woman does not have a phallus (sexual, cultural, economic and political power) and 2) that she has, after all, not been deprived of something fundamental. Drapery is interesting in this respect, since it can be perceived as covering something and *at the same time* as revealing, or about to reveal, something. Drapery, it could be argued, is ideally suited to fetishistic representation. The spectator of the artistically constructed image of drapery oscillates between different viewing positions, and positions of knowledge, in a similar manner to the fetishist, whose splitting of the ego allows him (or sometimes her) to maintain two contradictory perceptions.

Freud comments that the foot can be a preferred example of a fetish, and mentions the pre-revolutionary Chinese custom of foot-binding and mutilation as an example. In a later essay from 1931, Freud pointed out that the woman does not happily accept her symbolic castration; on the contrary 'she rebels against this unwelcome state of affairs.'[2]

Since Freud wrote on fetishism and on male and female sexuality, there have been many attempts to update his theories, primarily with reference to straight women and to lesbians and gay men, since Freud concentrated mainly on fetishism and heterosexual masculinity.[3] Apart from mentioning fur and velvet as fetishes (noting their association with female public hair), Freud said nothing about the fetishistic possibilities of cloth.

Other writers on fetishism mentioned cloth and clothing in relation to fetishistic practices, but did not share Freud's analysis of the sexual and social significance of fetishism in its role as making the 'castrated' woman 'acceptable' as an object of sexual desire. For example Krafft-Ebing stated that we (meaning he) knew very little about female fetishism, but supposed that it was similar to men's fetishistic behaviour.[4] He mentions a (male) fetishist who admitted to masturbating with starched linen when he was a boy, others who cut pieces off women's clothes and another who enjoyed fondling women's clothing in drapers' shops and looking at window displays. This latter also 'found partial satisfaction in holding and studying fashion magazines'.[5] He also mentions a silk fetishist who would become sexually aroused and ejaculate at the touch of silk.[6]

Havelock Ellis, another famous sexual 'researcher', briefly mentions the theft of a piece of silk or similar cloth by 'offenders', 'usually a woman and often in good circumstances', for sexual release. Ellis

believes this is not true kleptomania, since the subject is not insane, but is rather a 'morbid form of erotic fetishism'.[7] I will return to this shortly in discussing de Clérambault's writings on sexually-motivated shoplifting by women.

However if Freud did not discuss any fetishistic appropriations of cloth by any of his patients, classical drapery does enter his work in the form of his 1911 comments on a novel by the German writer Wilhelm Jensen, *Gradiva*, which was published in 1907. Freud also had a plastercast of the Gradiva relief from the Vatican Museum, representing a woman in classical drapery with her head covered, walking quickly along with her rear foot almost perpendicular. (plate 20) Freud first saw this relief in Rome at the museum in September 1907. He received a plastercast copy of it as a Christmas present from Karl Abraham in late 1908.[8] There are some differences between the original relief and the copy. The latter is framed by a decorative border, which gives the impression that it is a self-contained entity, rather than a broken fragment. The original is cracked near the figure's rear foot and the tip of her nose is broken. These defects are disguised in the plastercast, so that she becomes more 'complete', less lacking.[9]

As noted above, the French Surrealists were interested in Freud's essay on Jensen's novel, and the essay was translated into French in 1931. *Gradiva* ('she who advances') was used as the name for the gallery they opened in 1937, the purpose of which was to display works embodying 'the beauty of tomorrow'.[10]

Jensen's *Gradiva: A Pompeian Phantasy*, tells the story of a young man Norbert Hanold, an archaeologist, who discovered an interesting relief sculpture of a walking woman in a Roman museum. He obtained a plastercast of this sculpture and hung it in his study in a German university town. The relief showed 'a fully-grown girl stepping along, with her flowing dress a little pulled up so as to reveal her sandalled feet. One foot rested squarely on the ground; the other, lifted from the ground in the act of following after, touched it only perpendicularly'.[11] Hanold, who is not attracted to living women and has transferred his interest in females to those represented in bronze or marble, then undertakes the 'scientific' task of comparing 'Gradiva's' walk with that of contemporary women. Especially in wet weather, he looks eagerly in the street at women's and girl's feet as they lift their skirts.[12] He clearly is unconsciously fascinated by women's sexuality, but has repressed his erotic urges and transferred them to both the sculptures of women and the particular walk of the sculptured woman. Fetishism

20. Sigmund Freud's plastercast of Gradiva, *given to Freud as a present in 1908, Freud Museum, London. Photograph Freud Museum.*

is clearly present in his behaviour. Hanold visits Italy, but still feels restless and dissatisfied: 'He felt that "he was discontented because he lacked something, though it was not clear to him what"'.[13] He sees a girl who resembles his classical sculpture and cannot decide whether she is a real young woman or a fantasy reincarnation of that sculptured figure: 'was not our hero's infatuation for his Gradiva sculpture a complete instance of being in love with something past and lifeless?' (Freud p47) She turns out to be Zoe, a former childhood friend, who wanders 'her foot lifted almost perpendicularly at each step' through Pompeii (Freud p53). Freud surmises that Hanold has suppressed his childhood erotic urges towards her and directed them towards sculptured women. Freud warns against too simplistic a classification of Hanold's behaviour as foot fetishism. Nonetheless, it is difficult to discount this completely. What Freud is more interested in is the process by which Hanold has come to be fascinated by the particular way of walking of a woman in a sculptural relief and his reluctance to accept the presence of Zoe (who is, in fact, a modern woman who has qualified as a doctor) as a real woman existing in contemporary historical time and place. Freud sees an interesting parallel between the archeological interests of Hanold and his own practice of psychoanalysis, which tries to excavate the buried memories in the subject's psyche so that the subject may engage more fully with life: 'It was right that an antique, the marble sculpture of a woman, should have been what tore our archeologist away from his retreat from love and warned him to pay off the debt to life with which we are burdened from our birth.' (Freud p74)[14]

In recent years, contemporary artists have been invited to collaborate with the Freud Museum in London in the production of installation works which engage with key issues in Freudian theory. One recent installation at the museum by the artist Sophie Calle entitled 'Appoint-ment' was composed of little pink typewritten notes scattered around, supposedly offering true confessions from the artist's past. Sometimes these were accompanied by possible fetish objects, for example a wig, a shoe, or love letters and the artist's wedding dress, 'draped with transgressive impropriety over the Holy of Holies, Freud's consulting couch.'[15]

Calle's work over the years has involved her following strangers and photographing their movements, becoming a stripper and pretending to work as a chambermaid in order to pry into hotel guests' private lives. Oddly enough, the main 'discovery' of de Clérambault, the symptom

named after him, concerns the erotic mania displayed by someone who (mistakenly) believes him/herself adored by the object of his/her desires. This erotomania can manifest itself in the obsessive pursuit of the loved person ('stalking'), travelling to follow the person, a mixture of self-centred pride and eroticism and the interpretation of the facts of the relationship in an imagined, rather than a reasonable, manner. All these traits can be related to projects by Calle. Her work is concerned with voyeurism and role-playing, sometimes reversing the usual relations of gender power but sometimes not. In *Autobiographical Stories* (1988), large photographs document images of her clothing and her body: a crumpled wedding dress whose folds suggest skin and intimate spaces of the body, worn on her first night with a new lover; a hanging dressing gown of white towelling, with which another lover from her youth had hidden his genitals from her sight; a nude drawing of her posing as a life model, the surface of which is slashed by a knife wielded by the draughtsman she posed for.[16] Texts accompanying the photographs recount autobiographical incidents associated with the images, perhaps true or perhaps fabrications of fantasy. The presence of the photographs with framed texts, rather than the actual objects, suggests a process of documentation, exhibition and scrutiny, where the fetishistic possibilities of the photographs are offered to the spectator.

The photograph, according to the film theorist Christian Metz, captures an absent or dead person or object, yet asserts its presence at the same time. It can also be scrutinised at leisure by the viewer, unlike the moving image of the filmic drama, making it more open to fetishistic appropriation.[17] The white silk of the wedding dress with its small train, the white towelling of the dressing gown, suggest the feel of different textures of cloth against the skin, their functions of erotic stimulation, concealment or cultural symbolism. The nude drawing of Calle in the life class is not accompanied by any drapery, which appears in the other photographs divorced from the wearer, objectified, aestheticised and fetishised. The lack of drapery in the image of the nude woman modelling in the life class reveals that she has not been treated as an 'aesthetic object', draped, idealised and distant. Her representation has been attacked and mutilated as the visual embodiment of a real woman threatening and alien to the (male) viewer. When the wedding dress turns up in the 1999 installation draped over Freud's couch, we are left to wonder whether it stands in for Sophie Calle, one of her alter egos, or a symbol of the socially and culturally constructed nature of heterosexual feminine sexuality, religiously draped over the couch like

a veil, or the sheets used to cover furniture in houses where no one lives any more. It could also be read as the partial covering over, by feminised drapery, of the essentially masculine milieu of Freud's couch and study. The draping of the couch thus functions in a fetishistic way. Does it conceal some essential and totalising meaning of psychoanalysis and the secrets of the consulting room, or does it reveal a lack of certainty about psychic processes and the impossibility of discovering clear-cut answers, which Freud himself often remarked on? For the person who comes to Freud (and Freud's museum) looking for straightforward solutions, the draped wedding dress suggests that we may have to accept ambiguities in place of watertight, or skintight, certainties.

DE CLÉRAMBAULT

Draped cloth was central to the researches of Gaëtan Gatian de Clérambault who was born in 1872 into a family of minor nobility in the French provinces. He was interested in art but, after undertaking various studies deemed more suitable by his father, he became a doctor. From 1905 until 1934, the year of his death, he was a psychiatrist employed in the service of the Parisian police to assess the mental health of a variety of vagrants, prostitutes, thieves and others arrested in Paris. This work was interrupted by his service in the First World War. He was wounded, and transferred to Morocco where he recuperated from 1917 to 1919. During this period, he developed his existing interest in North African clothing which he had also observed during a visit to Tunisia in 1910. It was in Morocco that he took almost 6,000 photographs (estimates of the numbers vary considerably) of people wearing draped clothing. These fascinating photographs include both outdoor and interior series of images showing figures moving around carrying out their normal activities, or else photographed specially posed at various stages of putting on their draped body and head coverings. Though some of the figures are male, most of the photographs which remain are posed by women. About 400 of these sepia coloured photographs (no negatives) exist in the photo library of the Musée de l'Homme, Paris, to which they were given by de Clérambault himself. The photographs vary in size from quite small prints used in the longer sequences, to larger prints probably intended for public exhibition and use. His papers are preserved in the library of the same museum.[18]

In the mid-1920s, de Clérambault gave a series of lectures on drapery to the students at the Ecole des Beaux-Arts, Paris, following in the

footsteps of Heuzey. These were abruptly terminated by the authorities, for reasons I shall discuss shortly. His eyesight failing badly, de Clérambault decided to commit suicide, shooting himself in the head while sitting in front of a mirror at his home, in November 1934.[19]

De Clérambault's writings and photographs deal with, and represent, such fascinating material that it is easy to be seduced by them, forgetting the 'author' who produced these texts and the power relations within which he was situated as a participant in organisations of the French state – the police and, for some time, the army. I do not want to suggest here that his writings and images 'express' oppressive right-wing ideology or anything as simplistic as that. What I do want to do is alert the reader to some of the material conditions in which the subjects of de Clérambault's researches encountered the doctor.

De Clérambault never took on female doctors as interns and had a low opinion of women, according to an interview with one of his pupils.[20] Another of his interns spoke of how he would treat his patients as objects on display during his public 'demonstrations', held every Friday. He referred to one young woman whose behaviour was uncooperative as a 'shrew'. When she then became angry and protested, he turned to his audience and said 'There you are, what typical behaviour!'[21]

De Clérambault filled in cards with detailed analyses of the people brought to him at the police clinic, where the suspects were also photographed to document their identity. This was fairly usual police procedure. However de Clérambault abused his position as a doctor whose first concern should be the welfare of his patients. A letter from him exists, dated 28 January 1914, in which he asks another doctor to keep an attractive women patient for a few more days so that she can be photographed. But this is not a strictly official photograph. De Clérambault stipulates that the woman should have her hair undone, without any pins, so that 'it is sticking up everywhere' ('bien hérissée de toutes parts').[22] The woman is not yet at the clinic, so clearly de Clérambault has been on the lookout for 'picturesque' women (as he puts it) and knows when they will arrive. The woman, perhaps completely innocent, will be kept for a few days longer just so that she can be photographed for de Clérambault's pleasure. There seems to be no question as to whether she wishes to comply with this or not.

Examples of the notes he made on his patients reveal his right-wing ideas. For example in 1922 he saw a photographer, Zéliq Mazu, and noted, among other things, 'Signs of degeneration, Polish Jew.' In the same year he examined a homeless Czech Jew whom he assessed as

mentally retarded: 'Mentally deficient Speaks Yiddish and German. Undesirable subject'.[23] These attitudes to economic migrants and homeless people have, alas, not entirely disappeared even in the twenty-first century.

In an article written in 1910–11, de Clérambault argued for the necessity for partners of alcoholics, the morally corrupt, drug addicts and the incurably mentally ill to divorce them. The future of the race was important here, he argued: 'We must not lose sight of the fact that the psychiatrist is the defender of the Race, and not just of the Individual.'[24]

In Morocco, in addition to taking his thousands of photographs, de Clérambault was sometimes called on to give advice to the colonial governor, General Lyautey. It is true that the French colonisers attempted to give medical care to the Moroccan people, since they saw that, as well as carrying out a humanitarian duty, they would be undermining existing practices of indigenous medicine which they regarded as uncivilised. However the racism underlying the French presence in North Africa was quite clear in de Clérambault's case. Asked by Lyautey whether he felt the Senegalese troops could be trusted to side with the French against the Arabs, the psychiatrist replied:

The Negro is the appointed policeman of the Arab. The Negro will always march alongside the European against the Arab just as the dog accompanies the man against the wolf and the fox. This is because of: 1) the profound feeling of European superiority; 2) the traditional scorn of the Arab for the Negro (less, however, in Morocco that in other regions).[25]

The Europeans are men; the colonised are various types of animals.

WOMEN, CLOTH AND EROTICISM

De Clérambault's other major encounter with cloth arose from his dealings as a police surgeon with women brought to him accused of shoplifting. In Zola's novel, *Au Bonheur des Dames*, an upper-class woman is caught stealing from the store. She is not prosecuted, but told that her written confession will be returned to her when she donates a specific sum of money to charity. This fictional episode was based on evidence of a rising number of thefts from French department stores by well-off women, especially from the 1880s onwards. At this time, forensic medicine emerged as a specialisation, with qualified doctors giving advice to courts on particular suspects, though the majority of

these cases involving well-off women never actually came to court. These predominantly bourgeois women, who stole things which they could afford and did not 'need', resulted in a redefining of the causes of theft, at least for bourgeois women. Whereas the poor stole because of need, bourgeois women must be ill, since they had the money to pay. Women caught shoplifting were said to be frequently enduring some physical process to do with their bodies, eg menstruation, the menopause, pregnancy, or the production of breast-milk. Heredity and sexuality of the culprits was investigated and in a minority of cases theft was linked to sexual gratification. Shoplifting was linked to hysteria, even in the small number of men who were caught. However these new approaches to theft were not so often applied to working-class women as they were to better-off thieves.[26] The behaviour of working-class women was already thought to be morally and sexually suspect; it was this new development found in upper- and middle-class women which seemed transgressive to the bourgeois respect for property which needed to be investigated.

De Clérambault's analyses based on case studies of four of his patients who stole pieces of fabric for sexual gratification were originally published in the *Revue des Archives d'Anthropologie Criminelle* in 1908 and 1910.[27] De Clérambault's interest in cloth took various forms. As well as this study of women's erotic interest in cloth, his passion for the study of drapery resulted in his own collection of fabrics and a number of mannequins (some small some full-size), which he draped with various pieces of cloth to demonstrate his theories. He used these, as well as living models, for his public lectures. In addition, he published an article in 1929 discussing weaving as a therapeutic type of work suitable for the mentally ill.[28] Clearly cloth was of central interest to de Clérambault for a variety of reasons, and his researches into drapery brought together diverse spheres where drapery functioned in contemporary life, both in France and in North Africa.

PASSION ÉROTIQUE DES ÉTOFFES CHEZ LA FEMME

In the late-nineteenth and early-twentieth centuries, doctors had already published material on sexual fetishism, but, as we have seen, this was thought to be largely, but not entirely, a male perversion.[29] One of de Clérambault's aims in his researches was to discover if women who stole bits of silk from department stores and masturbated with it were in fact fetishists. De Clérambault discussed three case studies in his

1908 article and a further one in 1910. I will give a short account of
the four cases and a summary of de Clérambault's conclusions.

First of all, I want to point out that the women are being interrogated
by him. He refers several times to his first patient, 'V.B.', breaking down
under questioning and being reluctant to answer. He never suggests any
treatment for the women, or tries to put forward any ways in which to
help them. He also treats them with suspicion and expects them to lie
if necessary. They are simply the 'specimens' available to him as a police
doctor. In all four cases, he describes the women as suffering from
hysteria and some take drugs and drink. However what makes them
really interesting to him is that they all have stolen pieces of silk, which
gives them intense sexual pleasure, far more than any penetrative sex
they ever had with men. In all four cases, he looks at their family history
to see whether they have inherited any 'degenerate' tendencies, for
example do they have relatives who committed suicide, suffered from
mental illnesses, or spent time in prison. V.B., aged 40, had been preg-
nant 17 times, had had four miscarriages and only five of her children
were still alive. During her last term in prison, her ex-husband had put
three of the children in an orphanage, claiming they were not his. We
can only imagine the life this woman must have endured. However de
Clérambault shows little sympathy. The doctor also spoke to her
husband, who supposed that silk appealed to her because she had been
a seamstress and also she liked the sound of it. Like the other patients,
V.B. was far more interested in clitoral than vaginal stimulation.

The second case study, 'F.', described as a 'hysterical degenerate', was
caught stealing in a department store in 1902. This patient also regularly
shoplifted along with her daughter, as well as stealing silk and faille (a
kind of thick silk). She preferred the latter for its touch and sound. She
felt as if the touch of silk on her skin was like being soaked in it: 'no
sexual pleasure for me is as good as this.'[30] Stealing it was 'delicious'.
Gifts of silk from her children had no effect on her.

Case number three, a widow, 'D.', aged 45, also described as hysteri-
cal, was drinking ether and other sorts of alcohol. She too loved to steal
silk. Other types of fabric such as canvas or linen did not 'cry' like silk.
Hearing such fabrics tear would have no effect on her.

The fourth case, described in 1910, 'Marie D.', also a widow, 49 years
old, a hysteric, had been involved with several men who beat her. She
had stolen silk and dresses made of silk from department stores, mastur-
bated and, like all the other women, lost interest in the stolen fabrics
after that. She was only interested in silks that were stiff and 'stood

up'. (p105) She also gained satisfaction from masturbating at other times while thinking of the feel and the sound of silk. De Clérambault notes coldly that this woman shows no remorse, since she merely remarks that if shops did not display silks in a tempting manner, she would never bother to steal them. Alain Rubens remarks that women who are 'properly' socialised into capitalist culture and its market economy, know that they must 'mediate' the desires that have been aroused in them by the presentation of commodities. They either buy the goods or put off their gratification until later when they have saved enough money to purchase them.[31] De Clérambault's patients are demonstrating that they have not internalised the behavioural codes of bourgeois society, either economically or sexually. In fact they are merely responding to the selling tactics of the shop-owners by taking them to their logical extremes. In *Au Bonheur des Dames*, Mouret, the owner, says he wants to seduce women by exciting them with his displays of commodities. But de Clérambault's patients do not see the solution to their sensual excitement as parting with money. They seek a pleasurable release from this over-excited state in orgasm. After they have accomplished this, they throw away the piece of cloth (the commodity) as worthless. It no longer has use value for them and they never entered into any relation with its exchange value. When they have gained sexual release, they throw away the object that helped them achieve it, as many women have been seduced and rejected by men. Thus these women's behaviour is totally at odds with bourgeois ideology of property and female sexuality. Also, the shop-owners have made no profit from their behaviour. No wonder they were classified as criminals and/or insane by police doctors.

De Clérambault notes the 'frigidity' of all four of these women (presumably this means their dislike of penetrative sex with their partners and husbands) and clearly finds them deviant. He assesses their enjoyment of clitoral stimulation as a 'neutral' sexuality, neither involved with men or women. In his 1908 article he discusses whether the behaviour of these women is a form of fetishism, deciding that it is not. It may be a 'shadow' of fetishism, but not 'the real thing' which is male in essence. (pp71–2, 97) Male fetishism, he says, is active (for example a male fur fetishist feels that the fur demands an active caress), whereas the response of the women to the silk is passive. I cannot really see how stealing the silk and masturbating with it in a department store is particularly passive, but this is his argument. Whereas the male fetishist keeps the object, since it takes the place of a woman, the female

shoplifters discard the cloth after using it for sexual gratification. The male fetishist uses the fetish as part of a possible relationship, says de Clérambault, whereas the women do not fantasise about men when masturbating with the silk. Their sexual activity is with the silk which does not stand for anything else – it is just silk. In a revealing section of his 1908 article, de Clérambault argues that the male fetishist's masturbation represents intercourse, which masturbation with silk does not do. The male fetishists also dream and fantasise in an imaginative way; they celebrate the fetish with drawings and writings; they imagine 'splendid scenes' and they 'enrich and ennoble' reality with their imaginations. (pp58–9) The women do not do this and therefore their experience is inferior to that of the male fetishist in all its 'sensory, aesthetic and moral complexity'. (p60) In his 1910 article he does speak of women's fetishism, but as inferior compared with men's: 'the fetish, for the woman, is only a bit of matter, it is not a personality.' (p109) From the evidence of these articles, de Clérambault seems to treat his patients as objects rather than individuals with a personality, so perhaps he is speaking from experience.

On de Clérambault's death, the Surrealist Robert Desnos wrote an article denigrating his work and arguing that the doctor had been more mad than his patients. The Surrealists were more interested in Freud's analysis of the psyche, which they found creative, rather than the oppressive attitude to mental patients practised by de Clérambault in his role as a police doctor. His shoplifting patients were not bourgeois women, since the latter were rarely taken to court and sentenced, but women from the lower strata of French society. Far from seeing 'deviant' and disruptive women as ill or criminal, the Surrealists hailed hysteria as a productive state of mind which broke down the artificially created ideological barriers that repressed the subject in the name of bourgeois morality.[32] The hysterical woman, for example, was in unconscious rebellion against the 'law of the father'. In 1933 the Surrealists also honoured the Papin Sisters, by including them in their publication *Le Surréalisme au service de la Révolution*, no. 5. The Papin Sisters, convent-educated, had been placed by their mother as servants in a bourgeois home. After suffering the humiliation and exhaustion of working for their unreasonable employers for six years, they finally cracked and murdered them, tearing out their eyes and smashing their heads. As Fer puts it: 'The sisters' action, the massacring of their oppressors, also stood, for the Surrealists, as the ultimate protest against a social structure in which they were imprisoned and enslaved. Such

instances of madness could be regarded as a protest against the family, against Catholicism and against sexual and social oppression.'[33] Thus although the Surrealists did not break away completely from stereotypical views of women, they (not surprisingly) evaluated manifestations of women's psychic instability and criminality completely differently from such representatives of the French state bureaucracy as de Clérambault.

SILK, SIGHT AND SOUND

In 1846, the scientist Chevreul published the results of his researches on the optical effects produced by silk. He had been commissioned by a group of representatives of the Lyon silk industry to discover the different ways in which light reflected on silk materials due to their varying structures.[34] Chevreul divided silk into four main categories and concluded that much of the pleasure to be gained from the sight of silk was due to the fact that it seemed to move. To get the full benefit from the sight of silk, therefore, the woman wearing the silk had to move, or the viewer had to move around the person wearing the dress, in order to see the light falling on the fabric from different directions.

Moving around in silk, however, enhanced the sound of the fabric as well. In Zola's *Au Bonheur des Dames*, there are instances where the sound of the silk suggests the sensuality and even danger of the department store. When the heroine Denise first takes off her old woollen dress and dons her black silk saleswoman's uniform, she walks downstairs and 'she looked at the shining skirt, feeling ashamed of the noisy rustling of the silk.'[35] Later in the novel, the mistress of the owner of the store is also described as wearing a silk dress whose sound is as significant as its sight: 'She went out, and her black silk dress, rustling against the door, produced a noise like that of a snake wriggling through the brushwood.' (p277) It is as if the dress is alive, and the woman is associated with danger and temptation, although she may also be their victim in the context of the department store.

I was unable to find much on the sound of drapery as I researched this book, but this is an interesting issue to bear in mind. In the film *Tales of the Taira Clan* (dir. K. Mizoguchi, Japan, 1955), women are shown dyeing silk, weaving it and then moving through the rooms with the fabric rustling to signify their presence and the contribution of their labour to the family wealth. At other times, women are shown wearing the valuable silk robes as a sign of luxury, or even corruption. De

Clérambault's patients mention the sound or 'cry' of the silk, as something which excites them. This 'cry' of silk is mentioned by several writers on fashion and textiles. Mme Doresse, in her book on identifying and caring for cloth, writes that 'artificial silk is *less supple* than natural silk and does not have the same sound, the "cry" of the latter.'[36] Madeleine Chapsal writes that couturier(es) can tell with their eyes shut what the different fabrics are: 'The squeaking of silk, the crackling of faille, the rubbing of wool, the purring of velvet, without mentioning the tinkling of embroideries' are all different sounds made by fabrics in movement.[37] Before the labelling of contents of fabrics, purchasers would have to decide on the particular qualities of the cloth by feeling it, instead of reading what it consisted of. Thus although I have been concentrating in this book about the appearance of cloth in arranged folds and drapes, the scent, touch and sound of cloth is often important in its cultural meanings.

LE CRI DE LA SOIE

In 1995 a feature film by Yvon Marciano was released, whose main character, Dr Gabriel de Willemer, was modelled on de Clérambault. This film is based on careful research; for example there is a mention of how Heuzey was a forerunner of de Clérambault in his interest in artistic drapery. There are Fortuny dresses in de Willemer's collection, he is a police psychiatrist, he convalesces in Morocco and takes photographs of drapery and he eventually commits suicide due to his blindness. However the actor playing the part of de Willemer is a reasonably handsome person conforming to our expectations of a romantic male lead, unlike de Clérambault (who was plain, short and wore thick glasses), and the film revolves around the doctor's sexual relationship with one of his female patients, an illiterate seamstress aged 28 called Marie Benjamin. She shoplifts, masturbates with the stolen silken fabric and sometimes lives with her husband. While in Morocco, de Willemer more or less rapes a young woman, tearing her white robes while telling her not to be afraid. His attitude to the female characters in the narrative is not very progressive. At one point he drapes a professional model with cloth in his studio, encourages her to pretend to become sexually excited by the cloth and then forces her into intercourse.

He does briefly succeed in sexually consummating his relationship with Marie Benjamin, which they can achieve only by lying on silk, her masturbating with silk at the same time that penetrative intercourse

takes place, or she drapes herself in cloth and he excites both of them by biting open the knotted cloth with his teeth. The poster for the film (plate 21) shows Marie and the doctor lying down attempting intercourse, while caressing each other with silken draperies and cloths of gold, blue and white. The dramatically lit folds and deep colours

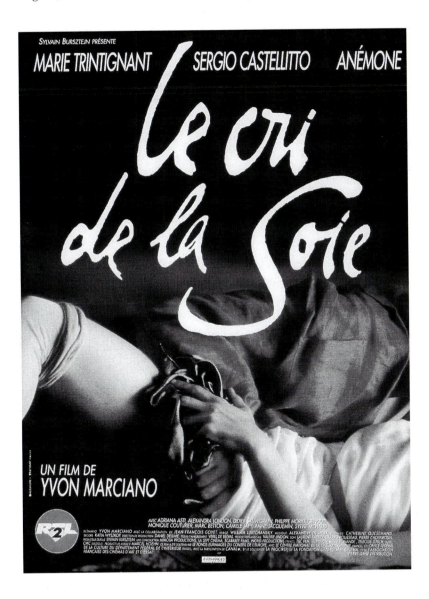

21. *Benjamin Baltimore, poster for Marciano's film* Le Cri de la Soie, *collection BIFI (Bibliothèque du Film), Paris, with kind permission of the artist.*

make the figures look like a detail from a baroque oil painting. The letters of the film title look like silk ribbons, or perhaps tears in the 'fabric' of the poster's surface. The noise made by the silk as it moves and tears is certainly treated in an erotic way in the film, which could appeal to both male and female spectators, but I felt rather uneasy watching certain scenes as the line between enjoying the cloth sensually and experiencing discomfort at seeing (and hearing) the cloth being torn as a metaphor for the tearing of skin and forcing apart of vaginal lips was a rather fine one.

In reality, de Clérambault's sexuality was not obvious. One of his earliest biographers tried to exaggerate his sexual encounters with women in order to scotch rumours that he was a homosexual, but in fact we have no secure information about any sexual relationships he experienced.[38] This modern film attempts to explore aspects of sexuality suggested by, but largely suppressed in, de Clérambault's personal life, but approaches sexuality from a clearly heterosexual position.

MOROCCO AND ORIENTALISM

At the time when de Clérambault began his studies of North African drapery, various European imperialist powers, Spain, France and Germany, were interested in establishing their dominance over Morocco. Eventually in 1912 France made Morocco its protectorate, while Tangiers was established as an international zone. This followed an uprising in Fez in 1911, the killing of a number of French settlers and the bombing of Fez by General Lyautey.[39] Lyautey, an old-fashioned authoritarian and paternalistic colonialist, then became the first Resident General. His plan was to train up a Moroccan French-speaking élite to administer the country alongside the French (this policy was abandoned by his successor). Large French companies were encouraged to invest in Morocco. Lyautey did have some respect for Moroccan culture and attempted to preserve the character of the old towns, situating new buildings outside the existing habitations.[40] Successive French administrators attempted to exploit possible divisions between Berbers and Arabs and fighting against the French continued until 1934. By this time, however, the political activities of nationalist groups were increasing. De Clérambault's time in Morocco from 1917 to 1919 thus coincided with the early consolidation of French domination of the country. His skills as a doctor were to be put to use in colonial service.

The writer Edith Wharton visited Morocco in 1919, as a guest of General and Mme Lyautey, and her account of her tourist visit gives some idea of Morocco seen through the European eyes of the General's entourage at this time.[41] A military car and driver was put at her disposal every morning. All of the people who gave her information about Morocco were foreigners, and the native people generally feature in her account as objects of her touristic gaze. She obviously praises her host, Lyautey, his supposedly tactful administration and respect for Moroccan culture, pointing out how the natives allowed their buildings to fall into ruin and 'happily' the French arrived to repair them.

She finds her first encounter with a veiled woman 'exciting': 'All the mystery that awaits us looks out through the eye-slits in the grave-clothes muffling her.' (p26) Her patronising view of people in her host country is apparent. During a visit to a house in Rabat she is introduced to the women of the family: 'but for the vacuity of their faces the group might have been that of a Professor's family in an English or American town, decently costumed for an *Arabian Nights* pageant in the college grounds.' (p146)

At various points, she makes the usual comparison between antique dress and the contemporary costumes of the North Africans. Meeting a Berber woman she writes: 'Her dress was the usual faded cotton shift, hooked on the shoulders with brass or silver clasps (still the antique *fibulae*), and wound about with a vague drapery in whose folds a brown baby wriggled.' (p45) Later she compares Greek art and architecture to the remaining

> privileged scenes where the fall of a greengrocer's draperies or a milkman's cloak or a beggar's rags are part of the composition, directly related to it in line and colour, and where the natural unstudied attitudes of the human body are correspondingly harmonious, however humdrum the acts it is engaged in. . . The instinct of skilful drapery, the sense of colour (subdued by custom, but breaking out in subtle glimpses under the universal ashy tints) make the humblest assemblage of donkey-men and water-carriers an ever-renewed delight. (pp129–30)

These bearers of the heritage of classical culture are also described in the most stereotypical examples of Orientalist language: 'greed and lust', 'fetishism and fear', 'blind hate of the stranger', 'fierce tribesmen', 'mad negroes', 'consumptive Jews with pathos and cunning in their large eyes and smiling lips', 'lusty slave girls', 'secret hate', 'mystery and menace' – and this is all from one paragraph of the book! (pp112–3)

Of course we cannot say that Wharton's attitude was necessarily exactly the same as de Clérambault's, but her book is indicative of the visitor's view of Morocco in the early years of the French protectorate.

DE CLÉRAMBAULT'S DRAPERY PHOTOGRAPHS

De Clérambault did not see himself as a tourist in Morocco, but as an employee of the state and a man of science, investigating Moroccan dress as part of an ethnographic and artistic study. The photographs he took served him later for conference papers and lectures, and in 1922 he exhibited 40 large prints of his Moroccan drapery photographs at the colonial exhibition in Marseilles. A significant section of his desired audience for this work on drapery was composed of French colonial personnel and Orientalist scholars. When he gave his first lecture on drapery at the Ecole des Beaux-Arts, among those he invited were General Gouraud, a high-level military advisor to the French Government and Military Governor of Paris; Louis Massignon, Professor of Muslim Sociology at the Collège de France; and General and Mme Lyautey.[42] To his great disappointment, however, most of these senior governmental and academic figures did not bother to attend.

De Clérambault's Moroccan photographs are clearly part of a body of Orientalist photography, which by the early twentieth century was quite large. Ethnographic photographs, postcards and studio portraits all displayed in supposedly objective verisimilitude the exotic nature of North Africa and the Middle East.[43] However his photographs are in some ways very different from the usual *genres* of ethnographic and exotic photography. Some of the latter concentrated on attempting to record 'racial' characteristics of peoples who were about to 'disappear' due to the pressures of modernity, industrialisation and relations with other ethnic groups. They were not photographed primarily as individuals but as representatives of 'racial types'. Some others, usually entitled 'scenes and types', showed picturesque local costumes or people carrying out activities or trades. Still others were intended for the soft porn market, emphasising the body of the Orientalised 'other'. De Clérambault's photographs do not do any of these things, despite their firm anchorage in Orientalist discourse. (plates 22–24)

All the individual photographs form part of larger series, taken to demonstrate the fall of drapery in Moroccan clothing, the ways in which draped clothing is put on and arranged and the ways in which drapery moves when the body performs various activities. De Clérambault

hoped his photographs would scientifically document and demonstrate the dying art of draped clothing, of interest both to ethnographers and artists. Some of the interior pictures seem to have been taken in de Clérambault's North African home.[44] The people in the photographs are there basically as actors, as one element in the image. They are neither subject nor object – simply instruments necessary to the photographer's purpose, which is to photograph the draped clothes which hide the body, but reveal its submerged movements.[45] This attitude to the body is quite unusual in ethnographic photography.

The series of eleven photographs mounted together, (plate 22) taken in the village of Fas Bali in the Province of Fes, are intended to show drapery and its movements on the right-hand side of the figures. Most of his photographs are identified in this way – by place and by the purpose of the photographs in relation to what they are meant to show about drapery. In notes made in 1919 in Morocco, he records details of the clothing, places and dates and also the measurements of the cloth, accompanied by sketches.[46]

De Clérambault referred to his photographs as 'vues cinémato-graphiées', showing different moments in the process of putting on draped clothes and wearing them. Clearly the thought of filming drapery had occurred to him for he remarks that, although the photographic series can help to give an idea of the movement of drapery through successive moments in time, 'we did not have further resources'.[47] In the same lecture, he mentions that his researches were made easier by the fact that he was a doctor, so Arabs were more willing to talk to him. His interest in documenting drapery is due to his belief that draped clothing will eventually disappear. Already Arab clothing is being sewn, rather than draped, he maintains. Modern life, he says, affects the decreasing use of drapery since it is unsuitable for wearing in trams, cars or trains. Ideal conditions for the wearing of draped clothes are the absence of dirt, lack of objects likely to catch and tear the cloth, lots of space and a local lifestyle without much travelling. Each community has its own drapery style, transmitted from village to village either by women of high birth or prostitutes – the only women who travel very much. Curiously he does not mention the mobility of men, who also wear draped clothing, and which we might suppose to be greater.

The text of his lecture on drapery emphasises the ingenuity of drapery as an example of human culture, distinct from the history of costume. His researches are dedicated to the establishment of the study of drapery

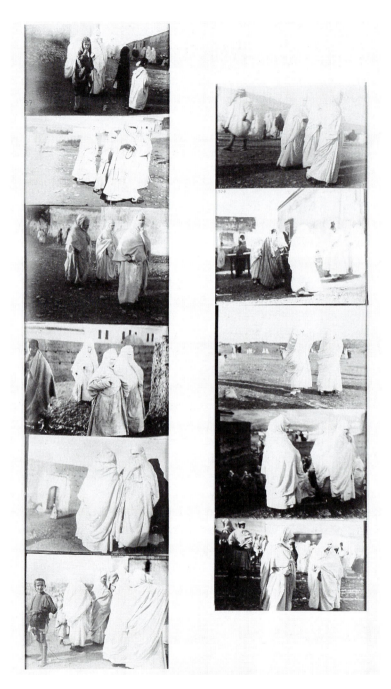

22. de Clérambault, series of 11 drapery photos on original mounts, Drapé vu du Côté droit, Province de Fes, Fas Bali, *each photograph 8 x 11 cms, Morocco, 1918–19, Musée de l'Homme, Paris, photograph Musée de l'Homme.*

as an autonomous discipline. To this end, he states that he began his researches in Tunisia in 1910 and continued them in Morocco in 1918–19, taking more than 5,000 photographs, 600 of which he intends to publish. His lecture was illustrated by examples of his photographs and drapery on a living model.

In 1922 some of his photos were seen at the colonial exhibition in Marseilles by Paul Léon, who was Léon Heuzey's successor at the French Institut (a kind of equivalent of the British Royal Academy) and Under-Secretary for State for the Fine Arts. He contacted de Clérambault who then attempted to secure an invitation to instigate a course on drapery at the Ecole des Beaux-Arts, Paris. De Clérambault was pleased that Léon had seen in his photographs not just 'superficial effect' but 'a whole order of ideas which underlies them', giving rise to 'laws of composition and aesthetics'. De Clérambault wrote that Heuzey had been interested in his work and like him, he would base his teaching on demonstrating the art and science of drapery on the live model.[48] In a later letter to Léon, de Clérambault writes that his work will benefit artists in understanding the real principles of drapery. Orientalist painters, he writes, show rich elaborate cloths, not plain draperies, harmonies of whites and different fabrics. The problem is that artists have been instructed in how to represent drapery in general, not particular draperies, their lines, surfaces, interior movements, their 'translucid cloth' and lighting. This is what he tried to capture in his photos, he writes. His teaching could encourage this introduction of real, lived-in, drapery into Orientalist painting and found a new approach to Orientalist sculpture. It is interesting that de Clérambault refers to his North African drapery researches as a means to particularise and contextualise drapery, as compared to a a view of drapery as time-less and generalised. However his notion of contextualisation was a narrow one and omitted any wider social, economic and ideological considerations. De Clérambault felt sure that his work would be welcomed in cultural milieux, colonial circles and 'even' in the Muslim world.[49] In 1923, he wrote again to Paul Léon promoting his courses on drapery, arguing that as a doctor he was especially qualified to re-search the life of drapery as it was a kind of biology.[50] Eventually it was agreed that de Clérambault could do this without pay for the academic years 1924, 1925 and 1926.

In his 1924 lecture he presented photos, dressed mannequins and four live models, of which three were women. In this lecture, he speaks of drapery as a live thing, which has to be closely analysed in its

movements, its subtleties, fluidity and complexity. At one point in the lecture, he almost composes a poem in honour of the fold and its sensual attractions in draped cloth:

We have drawn the attention of artists to the diverse forms of the fold: the fold as garland, puckered, like a nest, a groove, a fan, agitated; folds falling and rising; active and passive folds; folds that spurt, folds that are constricted; folds of traction and suppressed folds, all these forms in relation with the texture of the cloth (if not by their origin at least by their modalities). We have pointed out the schematic flexion of thick cloth, the transparency and limpid tones of thin cloth, the back-lighting seen in interiors or outdoors, the effects of wind, the association of spiral forms to the large movements of the human body, and finally the gestures, unconsciously regulated, of the construction of drapery, as inexhaustible themes of art.[51]

Despite the success of the lectures, they were stopped in 1926, much to de Clérambault's chagrin. It appears that problems associated with de Clérambault's medical work may have played a part in this. In 1926, a landlady from the grande bourgeoisie had an argument with her tenant, a young actor named Pierre Daltour, because he objected to his rent being raised. He ended up arrested by the police and interrogated by de Clérambault to determine the state of his mental health. His relatives were refused the right to see him. Human rights groups became involved, and it transpired that Daltour had been locked up without an official order being prepared. In May the press took up the issue, and in June de Clérambault was told that his invitation to give lectures on drapery at the Ecole would not be renewed.[52]

De Clérambault's photographs have, not surprisingly, been received with great interest since their rediscovery in the 1980s. His interest in drapery and the fascination for folds, as demonstrated in the passage quoted above, could be related to such postmodern approaches to culture as those seen in Deleuze's book *The Fold*, which was translated into English in 1993. These photographs of unknown people, whose bodies are largely invisible, wrapped in cloth which covers them and marks them off so clearly from their surroundings, have been seen as fetishistic images, where the photographer's relationship is with the cloth – the desire to penetrate its structures, its movements, to understand the depths of its being – rather than with the person wearing the cloth. (plate 23 'Technique of the fold on the shoulder') This impression is heightened when individual photos are taken out of their

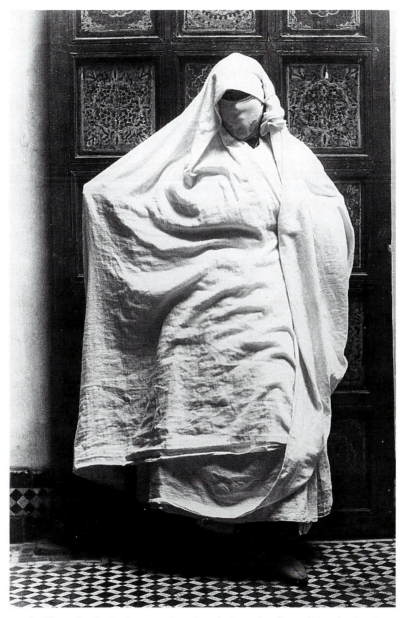

23. de Clérambault, Le Costume Drapé: technique du pli sur l'épaule: Province de Fes, Village de Fas Djedid, *Morocco, 1918–19, Musée de l'Homme, Paris, photograph Musée de l'Homme.*

sequence and viewed separately. In my opinion, this bears out Christian Metz' argument that the single photograph has far more potential to be seen in a fetishistic way than the filmic image.[53] While de Clérambault's photographic series are not truly cinematic, they do attempt to represent a process occurring in time, rather than a frozen moment to be viewed on its own. I feel that the isolation of individual prints gives rather a different view of them, though they are no less interesting. It is also noticeable how different the photographs appear when the face of the person is visible.

In plate 24, 'Two phases of the construction of a *redda* (head drapery) at Azemour in the Province of Casablanca', the woman has a slight smile on her face and looks at the camera. Thus a reading of her image is opened up which relates to Orientalist images of exotic women, hidden away from the sight of all but the photographer and the viewer. However the look on her face seems in total contradiction to her pose, which is a demonstration of the complicated manoeuvres required by her hands, arms and mouth to put on the drapery. She is not taking things off for us, as the women in many Orientalist photos do – de Clérambault appears never to have been interested in showing us photographs of that – all his women and the smaller number of men he photographs are always showing how to put things on, or demonstrating how the clothes work once they are on. Perhaps this is where some of the tantalising fetishism of the images comes from in their readings by modern viewers. We know we will never see the bodies because de Clérambault's 'biological' and artistic studies are not about bodies but about *drapery itself* and making drapery into a subject of scientific investigation. In his letter of 4 September 1922 to Paul Léon, he talks of his drapery studies as 'Archeology before the things are dead.'[54] Drapery is therefore a thing to him, but it is a *living* thing.

In his folders of newspaper cuttings, photographs, drawings and images, de Clérambault collected examples of a world heritage of drapery. His stated aim, as noted previously, was to discover the underlying, essential principles of draped clothing. This approach meant that the particularities of drapery in its larger historical and cultural contexts tended to be ignored, despite his hope that he would 'de-generalise' drapery, in favour of an essentialist search for the deep structure of drapery based on the close study of particular examples. His files contain some really interesting and diverse material, For example plate 25, a cutting from the Newspaper *L'Evénement*, 23 October 1921. This photograph shows a woman wearing contemporary

24. *de Clérambault,* photograph *from* Deux Phases de la Confection d'un Redda, Drapé de la Tête: Province de Casablanca, Azemour, *photographs, Morocco, 1918–19, Musée de l'Homme, Paris, photographs Musée de l'Homme.*

dress, in charge of costumes for a dance company, helping to arrange the drapery of a 'Greek' dress. This 'immobile dancer' is standing on a small box in front of some antique statues, probably plastercasts, and the reproduction of a classical building. In her visit to the museum to study the movement of drapery in classical art, says the text, this dancer and her costumière are following in the footsteps of Isadora Duncan. De Clérambault was probably attracted to this short feature and its photograph since it showed an attempt to arrange draped cloth on the living figure and also showed the persistence of a culture of drapery in everyday life and in popular culture. However his own preferences were for high art and the values associated with high culture, shown by his attempts to lecture in prestigious institutions.

Another cutting is the first page of an article on 'Masculinism'. This article notes the rise of feminism and the modern Women's Movement, whose supporters, both male and female, have had to struggle against 'the vague, massive, inert forces of an order which had indeed made the world in an undue degree "a man's world," but unconsciously and involuntarily, and by an instrumentation which was feminine as well as masculine.' However now that feminism is achieving its aims, a new attitude, 'masculinism' is appearing. 'Masculinism' appears to be a movement to affirm the neglected rights and functions of manhood, as compared to feminism. However here the article breaks off at the foot of the page, and we are given no more information on either 'masculinism' or why it has been illustrated by a draped, noble Roman wearing a toga and showing us his cultured patrician profile. This suggests that de Clérambault was interested in the image, rather than in the content of the remainder of the article on the following page, which has not been saved. It is interesting to see how, in this cutting, the essence of 'masculinism' is represented by a member of 'the race that wears the toga', the epitome of noble and virile citizenship.[55]

The Arabs may have preserved the drapery of the classical past, but they are not even citizens in their own countries under French rule. For de Clérambault, the North Africans are not interesting in themselves – only their drapery is. It is their backward society which denies them equal political rights and status with the French colonists, but which has also preserved their draped clothing. What de Clérambault thought of the achievements of feminist campaigns referred to in the article, one can only imagine, but given what we know of his attitudes to women, he was probably a lot more sympathetic to the notion of 'masculinism'.

25. *Cutting from* L'Evénement, *23 October 1921, 'A l'Ecole des 'Danseuses Immobiles', from de Clérambault's files in the library of the Musée de l'Homme, Paris, photograph Musée de l'Homme.*

'THE SARTORIAL SUPEREGO'

In her essay on de Clérambault's Moroccan photographs, Joan Copjec argues that they represent both his fantasy and his fetishisation of cloth. His ego is split, since at the same time he positions himself 'as the colonial subject confronted with an objectified image of his own loss' and also 'as the gaze of the Moroccan Other'. 'Entering into a kind of complicity with this Other, photographing the cloth to meet the satisfaction of its gaze, he turned himself into an instrument of the Other's enjoyment.' The cloth is presented in the photographs as stiff, material and, above all, *present*: 'a solid *presence*, a barrier against any recognition of loss'. However Copjec argues that since, as a fetishistic photographer, de Clérambault refused to recognise the division in his ego (between acknowledging his loss and covering it up), he nevertheless made himself an agent of this division through his photographs. She concludes that the authorities who terminated his lectures on drapery and folds at the Ecole des Beaux-Arts 'saw only too clearly what de Clérambault meant, that his doubling and splitting of his project into a consideration of cloth's usefulness and his fetishisation of its useless, overbearing presence were precisely the problem.'[56]

Given that these processes, even if embodied in de Clérambault's Moroccan photographs, would be unconsciously mediated, it is highly unlikely that what were basically a group of old-fashioned bureaucrats had much of a clue about psychoanalytic aspects of the photographs. Furthermore, Heuzey had been doing similar courses at the Ecole for decades, where drapery, photography and medical knowledge had also been linked. However it is true to say that the medical knowledge previously utilised at the Ecole, by Paul Richer for example, had been knowledge of the body and sometimes the bodies of sick people in Richer's case, rather than the study of their minds.

The sort of uncomprehending attitude towards de Clérambault's photographs by many who saw them can be illustrated by the official response when he tried to donate 1112 9 x 12 cm photos to the photographic archives of the Ministry of Fine Arts in 1924. He received a letter of reply on 4 August from the archivist, informing him that 530 of the photographs were interesting and the others 'which are defective or completely alien to art will be destroyed, unless you want to collect them.'[57] I think this is the response of some narrow-minded person who finds the photographs rather boring and/or technically inept, rather than someone who thinks they are subversive manifestations of fantasy and

fetishism. The rudeness of the response must have also been quite dispiriting for de Clérambault.

I think it is fruitful to consider the manifestations of a split ego embodied in de Clérambault's photographs from an ideological point of view as well as a psychoanalytical one. The underlying tension and contradiction present in the images is based on the way the people and their actions are mere supports for the draperies as specimens and objects of study, but *at the same time* the images are aestheticised and fetishised as remnants of ancient culture, which is dead and yet not dead – the North Africans are civilised and not civilised at the same time. The work of French colonial ideology is to try and stop these incompatible positions from splitting apart a particular world view. Also, the photographs isolate the drapery and its mode of wearing from any kind of social and historical context. The drapery is worn and used in the modern world – it still exists – but at the same time it is in a kind of timeless Orient. These contradictions, related to, and embodied in, the physical presence of these photographic images, whose potential for fetishism is so strong, are what make de Clérambault's remaining photographs so fascinating as traces of an even more powerful and vibrant reality, long disappeared.

DRAPERY, EXHIBITION AND OPPRESSION

The results of de Clérambault's interdisciplinary researches were, as we have seen, not particularly welcome in the official institutions of Fine Art in France. De Clérambault himself left his papers and remaining photographs to the Musée de l'Homme, the French equivalent of the British Museum of Mankind. These and other similar museums have, in recent years, been the subject of some criticism because the original premises of these collections, based on colonialist ideologies and practices, now seem dubious, to say the least. Many of these museums house not just artefacts, costumes, textiles and photographs of 'other' cultures, but skeletons, skulls and other pieces of bodies belonging to native peoples. For example as recently as July 2000, the Australian Prime Minister asked for the repatriation of the remains of two thousand aboriginal people housed in museum and university collections in Britain. Some of these remains were taken to Britain as late as the 1930s.[58]

Leaving aside the gender issues relating to the title Museum of Man(kind), it is still clear from the responses of many contemporary

artists who are descended from colonised peoples that the collections
and displays of such museums need to be critically appraised, rather
than accepted as scientific truths.[59] One of the reasons, I feel, for the
interest in, and ambivalence of, de Clérambault's drapery photographs,
is that they visually transcend the modes of so-called documentary and
scientific photography more usually found in such museum collections.
They are truly inter-disciplinary and thus scholars trained in one
particular discipline may find them difficult to categorise or 'read'. In
fact an effective way of critically analysing and rethinking these
museums and their collections is to try to break down the boundaries
of scientific and intellectual 'pigeon-holing' which occurs in the
collection and preservation of cultural and human 'specimens'. This
is one of the liberating aspects of researching drapery. You cannot
possibly do it in a mono-disciplinary way. De Clérambault's project to
found a discrete discipline of drapery study, was, by its very nature,
never going to work within an old-fashioned official academic frame-
work of specialists, departments and unified academic subject areas.

One contemporary artwork which invites spectators to critically
approach the exhibition of 'Oriental' cultures and their textiles in
museums is the performance by Karun Thakar outside the Museum of
Mankind, London on 18 March 1997 (plate 26). This performance also
suggests that draped and wrapped figures can also be those 'orientalised'
bodies who are trapped and made speechless and invisible in their
clothing. Once colonial culture and its scientists and photographers
have presented us with a particular view of colonised 'Orientals', the
latter become trapped in that particular vision. Outside the museum,
the artist was wrapped and tied up in various different sorts of material,
including a nineteenth-century Indian bedcover and string. Other
smaller bundles of textiles were also placed on the pavement. The artist
had originally hoped to work inside the museum, in critical dialogue
with the collection. However when the museum declined to give
permission for this, Thakar decided to undertake a performance work
outside with a number of collaborators. This involved the artist being
wrapped up in oriental textiles turned inside out, to show their worn,
practical side. Usually the richly embroidered side is exhibited in
museums as if the textiles were pictures. The tears and worn bits of
the textiles were exposed to view. Collaborators of the artist knelt down
beside him on the pavement to examine close up the 'specimen' before
them. The climax of the performance was completely unplanned by
the artist. As passers-by gathered to watch the performance, police cars

26. Karun Thakar, Performance outside the Museum of Mankind, London, *March 1997, courtesy of the artist.*

arrived on the scene and a full-scale bomb alert ensued since someone had reported a 'suspicious package' in the area. This turned out not to have been the 'wrapped' artist, but a package in a litter bin.

A second photograph of the performance shows an interesting juxtaposition of the artist and a collaborator in front of the museum facade beneath a statue honouring the French natural scientist Cuvier. Cuvier is clothed in a combination of nineteenth-century costume and classical drapery, which is added to give prestige, authority and nobility to both his personal appearance and his scientific discoveries. Cuvier was among a large number of scientists who believed in an evolutionary hierarchy of 'races'. In the early nineteenth century, he performed an autopsy on the body of the so-called Hottentot Venus, Saartjie Baartmann, who had been exhibited in European cities for several years before she died in 1815 in Paris. As Gilman puts it, 'Cuvier's presentation of the "Hottentot Venus" [autopsy findings – GD] forms the major signifier for the image of the Hottentot as sexual primitive in the nineteenth century.'[60] Her large buttocks and well-developed genitals were seen as scientific proof that black people were closer to animal nature and therefore on a lower stage of the evolutionary ladder than whites.[61] The

two artists dressed in 'oriental' textile clothing stand beneath Cuvier, whose theories 'proved' that their biological identity was inferior. Cuvier's statue shows him posed like a Roman of the 'noble race' wearing a toga as he stands to deliver a rhetorically refined exposition of his theories, while resting his hand on a human skull, another part of the body which could be measured and classified along with the cultures produced by colonised peoples.

Karun Thakar is also aware of his own position as a seller of oriental rugs and textiles, which helps to support his work as an artist. His position as someone who makes a living from the Western interest in oriental artefacts, and who, at the same time, is critically aware of colonialist culture, is a complex one which informs his art practice. In particular, in relation to the photographic images of de Clérambault, his performance indicates how oriental draperies and textiles can, in certain situations, function as an oppressive aspect of culture, which functions to muffle and imprison people in particular situations. Of course the main type of oriental drapery which has caused most debate over its oppressive and/or liberating functions is the veil.

VEILING

In de Clérambault's photographs, many of the people are veiled. However the use of the word veiling has become rather generalised. Connoting mystery and Orientalism, the word has come to refer to the covering of the face and head by cloth suspended from the head. In fact coverings for the body and the head are not just veils but are described by a number of different terms. The veil, which has a long history, has been worn by European as well as Arab women, most obviously by brides. Veiling, although sometimes referring to a process in which the face is covered by opaque cloth, is more accurately a process by which the face is only partly obscured. Used metaphorically and symbolically, the veil refers to a partly concealed truth, which can be perceived by the lifting of the veil, not only by its complete removal. The lifting of the veil opens up the possibility of understanding. The veil signifies revelation and concealment at the same time: 'Thus the veil veils and unveils, hides mystically and reveals – and at the same time it *shows* this oscillation'.[62]

The veil has often been used as a metaphor for concealment, which, at the same time, indicates that knowledge exists behind it. Marx, in *Capital*, states that religious ideas are like veils, through which only

reflections of real social and economic relations can be perceived. 'The veil is not removed from the countenance of the social life-process, i.e. the process of material production, until it becomes production by freely associated men and stands under their conscious and planned control.'[63] For Marx, the veil of ideology can be brushed aside and a deeper knowledge can be gained. For others, the removal of the veil can never ultimately reveal knowledge. Different layers of veiling can be removed, but a distance will always be maintained: 'The text reveals itself before us, but never allows itself to be possessed.'[64]

However while the subject gazes at the veiled object or person, the gaze is returned by the object or person being looked at. For Lacan, for example, this shows the subject as constituted by the desire of the Other. The attempt to penetrate the veil to discover and understand what is behind it, is, for postmodernists, doomed to failure and bound to frustrate and enflame desire rather than satisfy it. Since for postmodernism there is no single 'truth', or even relative truth, and all is contingent, desire replaces truth as what is suggested behind the draped cloth which gives us tantalising hints of what is beyond. The veil is the ultimate postmodern drapery.[65]

In an often repeated tale of classical Greek painters, Zeuxis and Parrhasios make two *trompe l'oeil* illusionistic paintings. Zeuxis' picture deceived a bird who pecked at a painted grape. Parrhasios' work deceived the other painter, who attempted to draw aside a painted veil to see what was behind it.[66] In Lacanian psychoanalytical terms, this story deals with an example of the veiled phallus, the object which will endow the subject with complete wholeness and pleasure, which the subject seeks but, having lost it in childhood through separation from the mother, will never regain. For Lacan, the phallus is always veiled and cannot be represented.[67] The phallus is missing, a lack, therefore how can this missing object of desire be represented other than veiled? Neither the man nor the woman can ever possess the phallus (it is a symbol), though, according to Lacan, they have different positions with regard to its absence. The man's relation is related to 'having' and the woman's to 'being' the phallus (for the man).

These two approaches to the veil – as a cloth which hides truth and knowledge and as a covering suggesting unattainable desire – sometimes overlap. Given that the desiring subject and the seeker for knowledge have been generally gendered as male and the obscured object of science and desire as female, it is clear that the image of the veiled Oriental woman, much more than the veiled Northern African man, has

occupied a long-standing point of attraction for a particular kind of European fantasy.

ORIENTALISM AND VEILED WOMEN

There are different ways in which cloth is used to conceal the face and body in various Middle Eastern countries. Among these are the face veil, the head scarf ('hejab' in Iran), the 'chador' (a floor-length cloth from head to toe usually accompanied by a face veil) and also the 'burqa' (an all-concealing cloak with a filigree panel over the eyes which restricts the wearer's vision).[68] This varies according to region, religion and often class. Many peasant and lower-class women, for example, did not wear face veils, whereas upper-class women did and do. However in contemporary Afghanistan, for example, all women from puberty onwards are required to conceal their bodies and faces, regardless of class. The veiling and covering of body and face is linked to the control of women's sexuality, which is seen by certain Muslim clerics and their supporters as a threat to the relationship between man and Allah. Devout men should not be tempted by women to look at them. In the words of the Iranian Ayatollah, Ali Meshkini: 'Looking is rape by means of the eyes. . . whether the vulva admits or rejects it, that is, whether actual sexual intercourse takes place or not.'[69]

In some sections of Muslim societies, women are seen as fundamentally flawed creatures, who must be disciplined by men and punished for their sexuality. In Pakistan, for example, there have been instances where women have been killed by their families when suspected of any relationship disapproved of by their relatives. A reporter visiting Pakistan commented 'Under the guise of this apparent protection (of *purdah*) I'd found women incarcerated, tortured and murdered in numbers so alarming that if it were happening to a racial minority the world would see it as a violation of human rights. Because it's women, it's judged as cultural; and because it's Islam, it's sensitive.'[70] Chapira Sunic, who used to work as a beautician in Afghanistan, told how she saw a young Taliban shoot a woman dead because when she was riding on the back of her husband's bicycle, her ankle was visible. He shot the husband in the foot.[71] Another woman in Kabul recounted how she was beaten up in a shop because, although she had covered herself, she was not accompanied by a male relative.[72] This kind of persecution is completely different from cases where women choose

to wear veils and scarves as an expression of their culture and identity. However in Iran, for example, some young women wear the scarf as a fashion statement and a provocative accessory, attempting to subvert the religious imposition of the garment.

In Saudi Arabia, women university graduates now outnumber men, though they represent less than 2% of the workforce. The Saudi rulers have suggested a more liberal attitude towards women working, since it would also help the economy. Also women own 70 per cent of the liquid capital in local banks, which could be exploited as business capital if women had more freedom. At least one woman has resolved this problem by making considerable profits from her dealings on the New York stock exchange via the internet. Saudi religious leaders have spoken of the 'harlotry' and 'destruction of the family' that would ensue from women's increased participation in public life. Sheikh Abdul-Aziz al-Aqil, a court advisor, denounced 'deviant' Muslims who wanted 'to feast their eyes on women, unveiled and naked as in the west and some other [Muslim] countries. The Muslim woman is a precious jewel whom only her rightful owner can possess, for he has paid dearly for that in accordance with God's instructions.'[73] Surely such attitudes are also demeaning to many men, since they imply that men are beasts who want to rape evey woman they set eyes on. Now clearly it is not only women who suffer under extreme right-wing regimes, nor is it the case that European men do not murder their wives and partners because of sexual infidelity, real or suspected. However I mention these instances of violence against women linked to the covering of their faces and bodies because the wearing of the veil continues to be debated by women themselves. The veil is sometimes seen as empowering, a way for women to have some privacy, or a means by which a 'national' identity can be expressed in opposition to perceived exploitation by imperialist economic and cultural power. The classic example of this was during the Algerian war of liberation against France in the 1950s, where women, having been forcibly unveiled by the occupying forces, donned veils and 'chadors' to conceal messages, bombs and weapons for the liberation struggle led by the FLN, the Algerian National Liberation Movement.[74] The key text on this is Frantz Fanon's 'Algeria unveils herself' (wrongly translated almost everywhere as 'Algeria Unveiled'). Algerian women are equated with the nation, but the question of agency is important. Algeria/Women are unveiling themselves, not being veiled or unveiled by some outside force which ignores their own desires.[75]

Now since this is not a book on the veil, I do not want to go into a long discussion about the pros and cons of veiling here, but I do want to critically assess some recent views on this question, since this is significant for an understanding of contemporary artworks by women artists which deal with aspects of veiling and draping of the body. M. Yegenoglu, in an otherwise interesting book, links the opponents of veiling to the 'Enlightenment project' which wants to respect the 'individual subject', reason and the search for truth and progress. Her sympathies with postmodern theory ('power produces effects of truth, which are in themselves neither true nor false' p16) no doubt lead her to these conclusions. Even if we accept her very generalised concept of the 'project of the Enlightenment', this is rarely linked to historically specific economics, class relations or imperialism within the countries where the veil is worn, apart from in one chapter on liberation struggles mentioned above.[76]

In her recent book, F. El Guindi discusses the various forms of face and body covering worn by women in the Arab world and gives a useful etymology of the term 'veil', which has no single equivalent in Arabic.[77] She argues throughout the book that the veil is a progressive aspect of women's experiences in the Arab world: 'I argue for the centrality of the cultural notion of privacy, as one that embodies the qualities of reserve, respect and restraint as these are played out in the fluid transformational bi-rhythmic space.' (p96) Anyone who does not agree with her poeticisation of what is, in many cases, forced on women in certain regions of North Africa and the Middle East, is termed a 'feminist with Euro-Christiano-centric perspective'. (p25, 36) She also argues that no positions or suggestions for reforms on the question of veiling are possible without 'direct access to the primary Islamic knowledge in Arabic'. (p182) Clearly that rules out of court most objections from most 'Euro-Christiano-centric feminists' and it rules me out too! Even Muslim women writers who oppose the forcible veiling of women, such as Fatima Mernissi, are condemned as victims of Western brainwashing. The fact that many men are against right-wing clerical fascism, and many female opponents of the veil are not feminists, Jews or Christians, does not appear to concern the author, who sees the veil as empowering, signifying 'activism, egalitarianism, identity, privacy and community'. (p145) It seems to me that these two authors, in their (correct) antagonism to Orientalism, have left little room for criticism of women's oppression and exploitation by men and the ruling sections of society in countries where veiling is practised.

In contemporary Britain, an increasing number of young Muslim women are adopting the veil, as a film recently broadcast on British television showed. Directed by Aysha Rafaele, *The Veil*, screened on BBC2 on 20 May 2000, was an interesting and provocative examination of women who wear veils and the perceptions others have of them in contemporary East London. Ironically, the actual women refuse to appear, since their decision to wear the veil means they must remain invisible, so their words are spoken by an actress. Basically the film presents wearers of the veil as devout, serious young women, who, in a racist and exploitative society, wear the veil for seclusion, empowerment and to increase pride in themselves and their religion. Radical Muslim clerics appear in the film, attempting to convince their female pupils (successfully it appears) that capitalism is a Western evil that has demeaned and commodified women and the anti-capitalist answer is therefore to turn to Islam. There was no mention of any Islamic capitalist businesses or individuals in the film. The young women whose words are used in the film see women who do not wear veils as 'slaves to their lust' and victims of a false sense of freedom. For me, the overwhelming message of the film was pretty depressing. There are serious problems with any society in which conditions of everyday existence convince young women that wearing a veil is the main way to a free and fulfilled existence as a human being. However we have to look to factors which were omitted from the film to understand fully what motivates such choices by young British women from Asian family backgrounds.

Clearly the debate on the veil in real life as well as in academic texts is an important one which arouses strong views. Scholarly debates on veiling as metaphor and symbol in literature and visual culture generate interesting material. However it is important to realise that these discussions should not be primarily about 'texts', 'subjects constituted by discourse' and academic theories. For many women who experience racist violence in Europe, and sexist violence in their own societies, these issues are important real-life issues. Pieces of draped cloth in this instance are not just artefacts and exhibits in a fine art museum, but part of everyday experiences and struggles.

SABERA BHAM AND ZINEB SEDIRA

I want to look now briefly at two female artists who have dealt with the veil and veiling in their work, Sabera Bham and Zineb Sedira. The

first sees veiling as empowering, the second is highly critical of the effects of veiling on women.

Bham's exhibition, *Concealed Visions: Veiled Sisters*, was on show at several venues in England in 1998 and 1999. In a darkened gallery, cotton screens were hung from the ceiling onto which were projected colour slides of the artist's photographs of women who have chosen to wear the veil. All the women return the gaze of the camera, refusing to be objectified. Bham suggests that the gaze is returned even though the spectator cannot see the whole face, or even sometimes the eyes, of the women. Bham's view is that wearing the veil does not oblige the woman to efface herself. When the viewer tries to look at the source of the images, the slide projector, their eyes are blinded by the glare of the lamp, 'providing a metaphor of the kind of moral retribution which may result from a covetous glance.'[78] While Bham's images are striking (particularly the young woman in a blue silk chador and face veil) and suggest the complex meanings of the gaze returned to the viewer in undermining the oppressive positionings of 'otherness', the exhibition also suggests a culture of surveillance, which in such societies as Iran and Afghanistan results in a climate of intimidation for many people which involves violence towards political opponents of both sexes.[79]

My own preference is for the approach of the Algerian French artist Zineb Sedira who now lives in Britain. Born in 1963, her work was recently (1999) shown in a touring exhibition of contemporary Arab women's art.[80] Sedira's work is interesting in that she is motivated by the issues raised not just by the veiled face and body, but also the veiling of the woman's mind, in my view equally if not more important. Some writers on veiling discuss the way in which the woman's body becomes one with its covering, the veil becomes the skin. Yegenoglu, for example, argues that the veil mixes up the secure boundaries of the body, becoming an 'in-between' term which disturbs binary oppositions and categories of thought in true postmodern fashion. The veil, no doubt, is postmodern. Yegenoglu writes: '*Her body is not simply the inside of the veil: it is of it; "she" is constituted in (and by) the fabrication of the veil*'.[81] The agency and consciousness of the woman disappear beneath the veil constructed for them by discourse, which is of course the whole point of coercive veiling. When the woman genuinely chooses the veil, then the question of agency is clearly present despite (or even because of) the veil.

Sedira's view of the effects of the veil on body and mind is much more materialist than that of Yegenoglu. She states:

'Because of my everyday experiences, I became interested in the veil or hijab, the scarf worn by Muslim girls and women. I then took it further and looked at the concept of 'veiling the mind'. The concept of veiling the mind permeates my work and is a complex metaphor for censorship and self-censorship. The physical veil is relevant to understanding the mental veil because it functions like a code for Muslin women – personal, cultural, religious and political – a puzzling emblem of progress, then of backwardness; a badge now of status, then of domination; a symbol of purity and a sign of feminine silence and constraint.[82]

Sedira's concern for the 'censorship of the Muslim female experience' is explored in videos and photographs. Her work brings together the two aspects of veiling discussed in this chapter; the veil as a metaphor for ideological self-delusion and self-censorship and the veil as metaphor for suggesting an (unattainable) object of desire.

Her work *Don't do to her what you did to me No. 2* is a series of seven colour photographs which also appear in a video.[83] In this series of images, the artist does not look directly at the camera. She is engaged in putting on and then taking off again, a headscarf. In the central large image, her hair is completely covered as she bends forward, her head downcast. However the scarf she is wearing is one made by the artist herself and is covered with photographic prints of Sedira herself, with her hair down without a scarf. Her actions of putting on and taking off the headscarf to satisfy an 'other' are therefore superfluous. The series of photographs documenting stages in a time-based process also recall the Orientalist and ethnographic photographs by de Clérambault. It's true that after looking at these images we would have a good idea of how to put on a headscarf, but do we want to? If the image of the bare-headed artist is already on the cloth, isn't the whole process of putting it on and/or taking it off just going through the motions – a required ritual performed without conviction, merely through social conventions?[84] Also, the act of putting on the scarf to cover the head refers to Sedira's aim of representing the veiling of the mind, as well as the surface of the head.

The title, *Don't do to her what you did to me, No. 2*, seems to be addressed as a command or warning, not a plea, to someone or some people, who want to make Sedira cover her head. It also includes another woman, perhaps a sister, in the equation. This is important, for Sedira's work, though based on personal experiences, is not confined to the limits of her own individual subjectivity.[85]

In terms of both fetishism and voyeurism, draped cloth in the nineteenth-century department stores of Paris – or in what appeared to be their opposite, the recently colonised sites of 'otherness' in North Africa – embodies many disparate and sometimes contradictory meanings. It can embody the highest point of the seductiveness of the commodity, or signify a disappearing survival of classical culture. Nowadays, as we shall see in more detail in Chapter 6, draped cloth still relates to a kind of Orientalism, albeit a postcolonial and post-modern one. Very often it also relates to, and is used as a (partial) cover for, the desires and sexuality of woman constituted as an enigma. One of the reasons why Sedira's contemporary photographic work is so interesting is that she so determinedly emphasises auto-biography, agency and consciousness, all of which work against the reading of her as an 'enigmatic' sign of otherness – someone who will always be a mysterious stranger since she is draped and veiled.

CHAPTER 4

THE FOLD: BAROQUE AND POSTMODERN DRAPERIES

Drapery is a topic which can reveal much. It spans many centuries and is found in artworks of an enormous variety. Metaphorically, drapery, folds, veils and curtains can suggest forms of discovery, knowledge and methods of conceptualising and understanding the world. The further I went with the research for this book, the more I began to think that there was nothing alien to drapery in the entire field of visual culture. Although this is something of an exaggeration, it is true to say that there are some links which can be made through drapery which can really illuminate connections between apparently unrelated issues. In this chapter, I want to show how drapery and the fold relate to recent revivals of interest in the baroque and the implications this has for approaches to issues such as subjectivity, history and our positioning in the social and material world. Strange though it might appear at first sight, drapery is concerned with all of these wider concerns, especially when the drapery is baroque or neo-baroque. I want to look at drapery and the fold in selected baroque and postmodern artworks, as well as examining writings which have drawn parallels between the age of the baroque and the latter part of the twentieth century. A key text here is Deleuze's book, *The Fold*, which is often mentioned in discussions of artworks which use drapery, either as painted drapery or actual cloth. Folding is conceived of in Deleuze's work not just as a pictorial and representational device, but as a way of thinking and understanding the world which is different from Enlightenment art and science, supposedly based on rigid frameworks of reason and logic. The fold permits a different kind of perception, creativity and knowledge, argues Deleuze.

In critically assessing the suggested parallels between the baroque and the postmodern, I will look at David Reed's so-called neo-baroque non-figurative paintings, Bernini's sculptural group of *St Teresa*, the question of gender and hysteria and finally the work of the French artist Orlan. Orlan's later work which includes her surgical operations is more

well-known, but I want to look here at her use of drapery in per-
formances from the later 1970s and early 1980s in which she de-
constructed notions of virginity, saintliness and femininity by
re-appropriating baroque images of female saints and the Virgin Mary.
I hope to show that recent interest in, and enthusiasm for, the baroque
is linked to the vogue for postmodern theories of the rejection of so-
called 'master-narratives' of history, the fragmentation of the auton-
omous subject and even the redefinition of matter and the material.

THE BAROQUE AS POSTMODERN

Several cultural historians and critics have linked the baroque period
and its culture to the present day. In a 1999 exhibition review, Jonathan
Glancey decided that 'The baroque is relevant once more.'[1] A conference
in Vienna in October 1996 was devoted to 'Baroque Revisions', and a
new book, *Reflections on Baroque* by Robert Harbison, is described in
the publisher's blurb as a work which 'demonstrates that the baroque
impulse lives on in the twenty-first century imagination.'[2] As we shall
see, the main reason for all this interest in the baroque is the desire to
link the baroque period (around 1600–1680) to the postmodern period
(supposedly 1960s to the present), as periods in cultural history situated
respectively before and after the Enlightenment, which is seen as
dominant in the eighteenth, nineteenth and first half of the twentieth
centuries. One writer refers to the difference between the baroque and
the Enlightenment which displaced it, with obvious preference for the
former: 'Everything that was illusory, sensual and magical is disavowed
in favour of the scientific, impersonal, intellectual, and philosophical
study of the represented subject.'[3] Thus present-day advocates of
postmodern theories, which attack the Enlightenment as fixated by
reason, a belief in human progress and in an autonomous individual
human subject and logical frameworks, see the baroque age as a pre-
Enlightenment precursor to the postmodern, with which it shares an
interest in the theatrical, the fragmented, the irrational, the chaotic, the
unfinished and the hybrid.

Perhaps the most seductive new book on visual culture to suggest
parallels between the postmodern and the baroque is Mieke Bal's
Quoting Caravaggio: Contemporary Art, Preposterous History.[4] In this
beautifully produced book, Bal invites the reader to collaborate with
her in a project of 'preposterous history', which entails the reversal of
'pre' and 'post'. Thus what comes before as cause and precedent, is now

what comes after, as Bal starts from examples of contemporary art (eg by Ana Mendieta, Amalia Mesa-Bains and David Reed) and looks back at Caravaggio's paintings. Thus, she argues, contemporary art allows us to 're-vision' the old, upsetting the usual historical methods and assumptions of causality.[5] This 'preposterous history' produces 'productive uncertainties' and also allows us to see the similarities between the baroque and the 'contemporary baroque'. Bal never quite explains why the baroque is such a focus of interest for some contemporary radical cultural historians, rather than the Medieval period, or even the Renaissance. The baroque is all-powerful, according to Bal. Baroque artworks and their forceful address to the senses constitute us as subjects: 'The baroque fold emblematizes the point of view in which the subject must give up its autonomy', (p39) and artworks take over the authority and agency of the deposed human subject: 'This is the way this painting thinks.' (p40) Bal links the pre and post manifestations of baroque as part of a transhistorical baroque phenomenon, that stands against Cartesian models of space, time and subjectivity. Bal condemns what she sees as the dominant and fallacious method of art historical study, the social history of art, (p247) and sees semiotics as a far superior approach. This approach allows her to engage in 'a dialogue of seductive politics'. (p.265) Her book is certainly seductively produced, with fine colour illustrations of sensually rich artworks, and her analyses of artworks are subtle and insightful, but I was not at all sure what I was being seduced into. It did not seem like politics to me. What seems to happen in Bal's 'preposterous' historical method is that many interesting parallels are drawn, but issues of agency, causality, as well as explanatory and epistemological factors in the study of the past in relation to the present, are completely turned upside down. An example of this topsy-turvey method occurs when Bal states that Mona Hatoum's work 'explains' Caravaggio's radicalism. (p138) Now clearly it is often productive to approach historical and cultural material from original perspectives, and chronology is not to be fetishised, but I do not think it is helpful to do this at the expense of preserving a sense of history and the explanatory productivity of historical research in terms of an understanding of both past and present. However given Bal's stated antagonism to the social history of art as a project, her choice of alternative approach is perhaps not surprising.[6] She views her alternative approach to past and present as more productive and stimulating.

Many of these cultural parallels between the seventeenth century and the late twentieth century are rather superficial, as may be imagined.

We are speaking of a pre-industrial society whose social organisation in Europe was based on estates (ie the nobility, the church and the aristocracy, with everyone else labouring in some shape or form) and where wealth depended on the ownership of land and receipts of taxes. The church was heavily involved in government, especially in Spain and Italy. Science was also largely controlled by the church and used in its service, a situation which was to change dramatically during the Enlightenment. Emerging secular forces were in cultural conflict with the Protestant Reformation and the Catholic Counter-Reformation. As one writer on the baroque points out, the equilibrium between secular and religious forces 'was to be upset before the close of the seventeenth century by the growing force of empirical science and the weakening of the metaphysical view of the world. The triumph of science and reason represented by Newton's *Principia* (1687) and Locke's *Essay concerning human understanding* (1690) also foretold the end of the baroque.'[7]

It is not surprising that a number of contemporary writers in addition to Mieke Bal have drawn parallels between the postmodern and the baroque, most clearly in an attempt to reject the rational materialism associated with the Enlightenment.

In his book comparing the baroque and the Enlightenment periods, Saisselin describes the baroque as a period in which absolute monarchies ruled, the church and the state were closely linked and merchant capitalism was powerful. In opposition to this, the Enlightenment was associated with religious tolerance, economic liberalism, reform and modernisation of the state and an optimistic and secular view of human destiny. Whereas in the baroque period aesthetics and economics were linked, in the Enlightenment these were conceptualised and studied as separate spheres, according to Saisselin. Aesthetic experience in the Enlightenment became a 'profane form of the mystical experience of the baroque saints.'[8] Saisselin argues that the Enlightenment differed from the baroque in that rational productivity was emphasised and capital accumulation was linked to productive investment rather than the luxury and deficit spending characteristic of the ruling classes in the baroque period.[9] He likens modern consumerism to the luxury spending of the baroque period, but points out that it is more widely spread in society.

The Spanish scholar Maravall similarly links the culture of the baroque age to absolutist monarchies. He sees baroque culture as the product of social crises, in which repressive and propagandist mass

spectacle seeks to integrate individuals into an estatist structure. The 'public' is invited and seduced into sharing the values of the ruling nobility. In this culture of 'incompleteness', characterised by the irrational, complicated, obscure, the transient there was:

Nothing of novelty. . . so far as the sociopolitical order was concerned; but, on the other hand, there was an outspoken utilization of the new in secondary, external aspects. . . that allowed for a curious interplay: the appearance of a daring novelty that enveloped the creation on the outside concealed a doctrine – here the word *ideology* would not be out of hand – that was inflexibly anti-innovation, conservative.'[10]

We can see why it is tempting to compare the baroque and the post-modern; most of the cultural 'buzz-words' are similar and the superficial appearance of novelty masking a conservative reality seem rather familiar in many examples of 'millennium' culture from the Dome to the *Sensation* exhibition, which in 1999 travelled from London to New York. The novel architecture and concept of the London Dome have not made up for the fact that much of it seems to be driven by corporate interests, and the works in the *Sensation* exhibition did not seem to focus on very radical issues, for the most part.[11]

Christine Buci-Glucksmann's analyses of the baroque, modernity and postmodernity are more complex. She sees some of the contradictions of the baroque, where 'the Counter-Reformation and modern science bizarrely come together', and has a sharp eye for *how* they work together in practice, as in baroque perspective which is at the same time a representation of the science of optics and of fantastic illusionism.[12] In her later book, *Baroque Reason*, she traces the baroque and its survivals through the nineteenth-century Paris of Baudelaire and the twentieth-century avant-garde, intent on charting the failure of the 'humanistic adventure' of the Enlightenment and Marxism and discovering 'a form of modernism radically different from the 'ideologies of progress', one which nearly always emerges out of the depths of a crisis.'[13] The baroque is compared to the postmodern in its destruction of the co-herent ego, fixed notions of masculinity and femininity and the undermining of notions of totality in favour of the fragmented. Modern urban life renews a characteristically baroque perception of the world: 'Permanent catastrophe and not straightforward progress, loss of any stable referent in history and not the subject as bearer of an already accomplished meaning.'[14] While some superficial formal resemblances

in culture during the two periods can indeed be noted, I get the feeling that the great attraction of the baroque for some postmodern writers is the fact that it is not modern or postmodern but that, actually, it is *pre-modern*, there is no proletariat, no Third World and imperialised countries, no Marxism and, really, no problems similar to those faced by contemporary human society. Culture then issued an invitation to the individual subject to immerse and surrender him/herself to religious/emotional experience. I mean by this that all the apparently insoluble problems of the so-called postmodern age are not problems for the baroque because the problems did not exist then; the baroque was a completely different historical, economic and political period from the cusp of the twentieth/twenty-first century. It means that scholars and critics can draw interesting parallels between the culture of the two periods, but in terms of explaining why at first sight they look similar, but actually why they are very different, nothing much is said. Above all, nothing is offered in terms of solutions to the fragmentation of society, the self, the collapse of narratives of progress and history. These are all symptoms of a society in crisis, like the baroque, but since the most extreme of the postmodernists reject the Enlightenment as a big scary bogey-man whose blind faith in reason and logic ended in the Holocaust and the gas chambers, revisiting the 'way out' which opened up after the demise of the baroque is not going to be an option for present-day society, that is, if we are to believe the more extreme postmodernists.

A book which determinedly argues that our supposedly postmodern era is the 'neo-baroque' is *Neo-Baroque: A Sign of the Times* by Calabrese. In fact he proposes getting rid of the term postmodern and replacing it with neo-baroque. Calabrese's argument is more subtle than some others, as he does not state that there is a resemblance between the culture of the baroque and that of contemporary society, but that the underlying 'forms' beneath the surface appearance of things are similar: 'My general thesis is that many important cultural phenomena of our time are distinguished by a specific internal "form" that recalls the baroque.'[15] These forms are the same in art and science and, in addition, the motives behind the phenomena are the same, he argues. He seeks to identify 'a spirit of the age': 'It is easy to say what "neo-baroque" consists of: a search for and valorization of, forms that display a loss of entirety, totality and system in favour of instability, polydimen-sionality, and change.'[16] The baroque and neo-baroque destabilise categories, excite the system, and thus 'the system' suspends 'its ability

to decide on values'. (p26) The neo-baroque is neither revolutionary nor avant-garde, but excites and experiments with excess without actually changing or calling into question anything fundamental. While arguing that he is interested in identifying 'the spirit of the age', he denies that he, or the art historian Heinrich Wölfflin (a famous precursor in defining the Renaissance and the baroque as examples of 'the spirit of the age'), are ahistorical in their approaches. He writes: 'I have in a sense rewritten Wölfflin's basic idea, which in the course of time has been variously refuted in the name of a presumed "metaphysicism" or "metahistoricism". Perhaps it is time we treated it with the justice it deserves.' (p18) However Calabrese's search for the same 'deep forms' which he argues appear in cultural phenomena of the baroque and the neo-baroque (the postmodern) is, despite his disclaimer, deeply ahistorical. He summarises six key methods of his investigation, the first of which is to examine cultural phenomena as texts and refuse to look at any extra-textual explanations:

As we can see, the historicity of the objects is restricted to an 'appearing-in-history', both in terms of surface manifestation (variable within and between epochs) and of the effect produced by morphological dynamics [the dynamics of the 'deep forms']. It is no longer a question of comparing, even formally, a series of distinct moments of historically determined facts. (p21)

Calabrese argues that 'new science' encourages us to see the universe as something which cannot be contained within unified models. The universe is 'a fragmentary multiplicity, in which many models confront and compete with each other.' (p171) This instability and multiplicity can also be discerned in the 'deep forms' of neo-baroque culture. However although we must dispense with models derived from 'Euclidian' unifying vision, this does not mean that we become irrational or unrigorous, says Calabrese. He clearly feels his own method avoids idealism or irrationalism. However since this method is within the neo-baroque, his attempt to rigorously investigate 'deep forms' seems devoid of value judgements. As he points out, the neo-baroque operates at the limit, but is not inclined to upset categories of value; indeed 'our criteria of judgement are suspended, blocked, out of scale.' (p67)

Now while Calabrese's book is interesting in its comparison of the baroque and the postmodern on the level of the similarity of formal traits in science and art, its refusal to investigate any historical, social (extra-textual) reasons for this situate his book, for me, as an example

of the postmodern/neo-baroque itself, rather than offering much of a perspective on it.

I want now to look at how theories linking the baroque and the contemporary (supposedly) postmodern period have been related to contemporary artworks, taking as an example paintings by the American artist David Reed.

DAVID REED

The paintings of David Reed of the 1980s and 1990s have been described as examples of postmodern abstraction. (plate 27) This particular example, *Number 275* of 1989, done in bitter greens, yellows, oranges and black, looks like a long frieze of layers and levels of swirling folds and cloth, or close-ups of organic forms from some scientific computerised photographic data. Details of David Reed paintings appear on the cover of Mieke Bal's book, together with details of a draped figure from a baroque painting by Caravaggio. Reed has become something of a pivotal figure for the coming together of the baroque and the postmodern, and his works can be read as a (post)modernisation of baroque drapery. Yet unlike many postmodern paintings which utilise figurative representational techniques, Reed's work can be located in the tradition of Greenbergian modernism, in which non-figurative painting concerns itself with the development of sophisticated means of representation on a flat surface. Reed himself relates his work to Greenbergian notions of modernism, but states that Greenberg had a tendency to 'mistake methods for ends.' He argues that Greenberg's valorisation of flatness restricted the possibilities of painting. According to Reed, there are other ways of achieving immediacy besides flatness. He also criticises Greenberg's linear historical approach as too limiting. However he basically agrees with Greenberg's cultural analysis in the latter's essay 'Art and Kitsch'. Popular culture can be utilised by the avant-garde, but really the two have different constituencies. Reed adds: 'Elements of popular culture can have an interesting, invigorating effect on avant-garde painting. I'm interested in pigments that until recently have been used for painting cars and other practical and commercial uses. . . Caravaggio would have given anything for tubes of phthalocyanine blue and green'.[17] In some of Reed's paintings, areas of the pigment are sanded down (as in painting a car, for example) and then repainted in slightly different colours which 'jar' with the surrounding areas, giving the pictures a highly sensual and sometimes even lurid appearance. He mixes oil paint with alkyd to achieve these effects.[18]

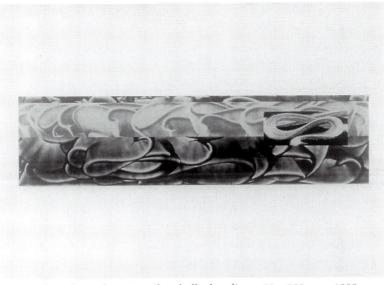

27. David Reed, Number 275, *oil and alkyd on linen, 66 x 259 cms, 1989, Collection of Linda and Ronald F. Daitz.*

Critics have written of the 'skin' of Reed's paintings and the way in which the viewer is invited to 'caress' them. The shapes of swirling paint and 'ribbonlike forms' are put on with flat blades and soft brushes. Sometimes the edges of the forms are treated with a spray-gun.[19] Meike Bal writes of the waves and folds of Reed's images, quoting, of course, Deleuze in *The Fold*.[20]

Bal's interesting article, which owes much to a previous piece by David Carrier, argues that Reed's works are 'a theoretical statement taking sides in the cultural debates and fights over epistemology, modes of vision and ways of being.'[21] Bal is rather disappointed with Reed's own definition of his art. In his essay on his favourite film, Hitchcock's *Vertigo* (1958), which is pretty near the top of my list as well, Reed writes of his desire to create two bedrooms for the principal characters of the movie, male and female, in which his own paintings are hung over the beds. Bal comments: 'His essay on *Vertigo* is quite touching in its engagement with the sadness of illusions, even though it leads to Reed's ambition to become a "bedroom painter", not only because "then my paintings can be seen in reverie, where our most private narratives are created", but because "all changes begin in the bed-room"'.[22] I do not find a problem with Reed's desire to be a 'bedroom

painter', as, fortunately, it appears to be more related to my interest in the study of drapery than to Bal's concerns about narrative and subject positioning in her article! Reed claims that all his paintings are 'bedroom paintings'. Their swirling, erotic shapes have been described as both Manhattan and Las Vegas Baroque.[23]

However it is also true, as Bal argues, that Reed's works engage with debates about illusion, reality and truth. Jeremy Gilbert-Rolfe agrees that Reed's paintings are certainly baroque in their blend of illusionism, light, colour and in the way they overwhelm the spectator with direct emotional appeal, but argues that Reed's illusionism must not be read as suggesting that there is some 'truth' to be revealed once the various skins and layers of paint/cloth have been removed. 'One would want, rather, to think in terms of there being another sign behind every sign, behind every myth another myth, behind every reality another reality.'[24] Gilbert-Rolfe's approach is clearly postmodern and approves of the way in which Reed's paintings (allegedly) construct anti-Enlightenment spatial configurations. However we should not lose sight of the painting itself. What we have actually got in Reed's paintings, is evidence of the building up of the painting in different layers by the artist; layers which he sometimes almost obliterates to paint on top of. In the midst of all the semiotic and postmodern theory, it is easy to forget that paintings are constructions made by labour. There wasn't much there before the painting was constructed; just the raw materials of linen and paint and the potential labour of the artist. The theoretical structures of myriad myths, signs and realities are constructs of Gilbert-Rolfe's brain and these personal constructs do not necessarily correspond to what the painting actually is in a material sense. In fact it could be argued that what actually took place in the making of the work is very different to Gilbert-Rolfe's perceptions, since there are layers in the painting and the basis of it is actually the surface material the paint rests on. It may for some people represent the illusion of multiple layers without any foundation, but this illusion needs to be distinguished from the reality of the constructed artwork itself.

I want to finish this brief discussion of Reed's work by looking at the article he wrote with David Carrier on baroque art and abstract painting, published in 1991. They argue that the critic Clement Greenberg and American Abstract Expressionist painting can be compared as a historical parallel to Giorgio Vasari and Renaissance Art in Italy. The postmodernist artists of the post-Greenberg period are the new baroque. 'Painting circa 1990, as circa 1590, involves the spatial and temporal

relation of a spectator to the image. The aim of the Baroque was to reestablish contact with the spectator, which cannot be done within a literal space.'[25] Since the spectator cannot literally be in the painting space, the authors argue that the best way to engage the spectator in space, time and narrative through painting is by painting in a non-figurative way: 'Within a single isolated panel, contemporary abstract art aspires to create imaginary spatial and temporal relations that have all the richness of the changing imagery of film and television. . .' (p48) These are the comments, and the proposed ways forward, for art in 1990, which they see as a time of real uncertainty, even crisis, for the future of art. 'In 1990, as in 1590, the idea of an ongoing tradition becomes problematic.' (p45) Non-figurative painting has been cleverly reinvented as modernist in appearance, but without belief in a tradition of historical development (of the Enlightenment or any other). The sensual attraction of a superficially baroque-looking painting is compared to a time in Europe before the bourgeoisie came to power, before science came to serve notions of progress and before reason, logic and social utility (from the bourgeoisie's point of view) came to be seen as key concerns of eighteenth-century art producers and critics.

DELEUZE AND *THE FOLD*

An excellent example of the convergence of the neo-baroque and the postmodern (which in this sense backs up Calabrese's argument discussed above) is Gilles Deleuze's book *The Fold*, first published in 1988 in French.[26] In this book, Deleuze focuses on the thought of the German pre-Enlightenment philosopher Leibniz (1646–1716), seeing him as the key exponent of a baroque way of thinking, which is not tied to the historical period of the baroque, but is valid throughout history. Indeed Leibniz and the fold are used by Deleuze to construct a new politics of the fold for our times. The concluding sentence of the book reads: 'We are all still Leibnizian, although accords no longer convey our world or our text. We are discovering new ways of folding, akin to new developments, but we all remain Leibnizian because what always matters is folding, unfolding, refolding.' (p137)

Deleuze begins his book by stating that 'The baroque refers not to an essence but rather to an operative function, to a trait. It endlessly produces folds. . . Yet the baroque trait twists and turns its folds, pushing them to infinity, fold over fold, one upon the other. The baroque unfurls all the way to infinity.' (p3) The fold is everywhere; in the

natural world, human culture, even the soul. It is a way of constructing as well as perceiving the universe. Architecture, nature, the soul, mathematics, de Clérambault's photographs of the 'Islamic Baroque' of Moroccan women's draperies, (p148, n27) literature, politics, in fact everything, is folded and unfolded to infinity. Cartesian distinctions of mind and body, human and inanimate matter are reconceptualised and dissolved in folds and pleats. Deleuze constructs an image of a baroque chapel, a windowless room 'decorated with folded draperies that are as much figments of the mind as pendant festoons of fabric.'[27] Whether something (in this case drapery) actually exists or not is seen as unimportant. This is an anti-Cartesian room, a metaphorical opposite of the Euclidian room where Descartes thought, therefore existed. Deleuze's mystical hymn of praise to the baroque fold is truly post-modern in its refusal of unifying frameworks, historical specificity and in its advocacy of the basic interchangeability of everything:

the infinite fold separates or moves between matter and soul, the façade and the closed room, the outside and the inside. Because it is a virtuality that never stops dividing itself, the line of inflection is actualised in the soul but realized in matter, each one on its own side. Such is the baroque trait: an exterior always on the outside, and interior always on the inside. An infinite 'receptivity', and infinite 'spontaneity'. (p35)

For Deleuze, all this is not confusing or disorientating, but empowering. The subject is dissolved into a 'chaosmos', co-existing with its environment in a 'play of folds'. There is no distinction between self and environment, and, in any case 'the whole world is only a virtuality that currently exists only in the folds of the soul which convey it'. (p23) The methods of thinking and being of 'possessive individualism' are destroyed and the way is paved for 'elaboration of sensibilities not under the yoke of liberal democracy', as the translator puts it in his introduction. (pxvi)

As I mentioned previously, quotes from this book abound in recent writings on visual culture. Indeed the trope of 'the fold' seems to be in the right place at the right time in our postmodern era, where liberal humanist hopes of progress and freedom for all are confronted by wars, famines, indeed barbarism of all kinds within Europe itself, accompanied by hostility to much scientific research, and the emergence of critiques of science based on 'new science' approaches such as chaos theory and fractal geometry.[28] Once again, we see how a postmodernist

such as Deleuze is happier returning to a pre-Enlightenment thinker for inspiration, thus avoiding all the problems of a modern, international, class society.

But was Leibniz really such a liberating thinker? Admittedly Walter Benjamin found him interesting in the period before he became more interested in Marxism. In 1925 he professed an interest in Leibniz' theory of 'monads', which Benjamin summarised as follows: 'The idea is a monad – that means briefly: every idea contains the image of the world.'[29] Leibniz's theory of 'monads', elaborated in his *Monadology* of 1714, 'argued that the world is made up of irreducible monads which perfectly express all other monads, and exist in complete harmony with each other.'[30] Leibniz also tried to reconcile the existence of God and his goodness with the proliferation of violence, exploitation and suffering in the world, in a similar framework of harmony. As Turner puts it, Leibniz' doctrine that we live in the best of all possible worlds was 'often received by other philosophers as a cynical justification of absolutism and arbitrary government.'[31] Perhaps the most famous and effective demolition of arguments for the existence of God and the view that we live in 'the best of all possible worlds' can be found in the brilliantly ironic tale *Candide*, which the atheist Enlightenment philosopher Voltaire published in 1759.

DELEUZE AND POSTMODERNITY

Gilles Deleuze (1925–95), in his own books and in those written in collaboration with Félix Guattari, is fairly typical of postmodern philosophers in that his admiration for Nietzsche and Heidegger was accompanied by a real dislike for Hegel's philosophical method and dialectics.[32] This goes some way towards explaining why Deleuze's view of the world as a process – as moving, becoming and unstable – is never understood by attempting to see some lawfulness in the constant flux of reality by the application of a dialectical method. Instead Deleuze develops the notion of the rhizome, a growth which develops radically and horizontally, like the growth system of irises and which, like the fold, works in a different kind of unrestricted space. The other main concepts in his work are that of the desiring machine and the body without organs. The unconscious, contrary to the Freudian view, is seen by Deleuze and Guattari as a factory for producing a kind of productive and affirmative desire, not a desire based on lack. As for the body without organs (a term taken from Antonin Artaud), it is not an organic

body but a body 'like the body politic, one that is always in the process of formation and deformation'. It is 'rhizomatic' and not engendered.[33] For Deleuze, the fact that social revolution is no longer a possibility means that people must now believe in the body: 'We must believe in the body, but as in the germ of life, the seed which splits open the paving stones, which has been preserved and lives on in the holy shroud or the mummy's bandages, and which bears witness to life, in this world as it is.'[34] Deleuze sees the dematerialised signs of art as superior to actual things existing in the world and follows Nietzsche in seeing truth as a matter of interpretation and creation, typical of many postmodern thinkers.

Also, like many other postmodern writers, his language and thought processes can be obscure, and he is one of the postmodernists castigated in the book *Intellectual Impostures* for the ways in which they abuse concepts taken over from maths and physics. Alan Sokal, one of the authors of this book, caused something of a scandal when he knowingly sent off an article containing ridiculous scientific and mathematical arguments to an American journal, *Social Text*, with the aim of proving, in line with the theories of the more extreme postmodernists, that physical reality is merely a social and linguistic construct.[35] In his book *The Fold*, Deleuze, like many postmodernists, enlists mathematics to demonstrate the brilliant creativity of Leibniz' ideas and the way the world can be conceptualised as infinite folds, refolding and unfolding on themselves. Sokal is dismissive of all this and, discussing another example from Deleuze and Guattari's book *What is philosophy?*, he comments: 'This passage contains at least a dozen scientific terms used without rhyme or reason, and the discourse oscillates between non-sense. . . and truisms.'[36]

NIETZSCHE, VEILS, TRUTH AND WOMEN

I want to return briefly to the article 'Veiling over Desire' by Mary Anne Doane.[37] We encountered this in the context of de Clérambault's photographs and the draped veil. However I want to come back to it again now because of the excellent way it brings together questions of gender, representation, veiling and Nietzsche. When I read this article, lots of things suddenly fell into place as to why Deleuze chose the image of folded and pleated cloth as a key to understanding the universe and why, at the same time, his approach would never be, for me, an adequate means of understanding the natural world and human society.

The German philosopher Nietzsche has greatly influenced several postmodern, and even postcolonial, theorists, for example Deleuze and Edward Said, mainly due to his approach to the question of truth. As Doane puts it, Nietzsche's project was to 'dismantle a philosophy of truth'. (p119) His attempts to collapse depth and surface, appearance and reality, have clearly endeared him to those postmodernists who believe that everything is text or discourse and there is nothing which exists independently outside speaking/writing of it. Doane quotes from the preface of the second edition of Nietzsche's book *The Gay Science*, written in 1886:

Oh, those Greeks! They knew how to live. What is required for that is to stop courageously at the surface, the fold, the skin, to adore appearance, to believe in forms, tones, words, in the whole Olympus of appearance. Those Greeks were superficial – *out of profundity.*[38]

Doane adds: 'The real does not lurk behind the surface; it resides on that surface or exists as a play of surfaces.' (p120) Thus behind the drapery and the skin of Greek statues, there is nothing. However Nietzsche still believes in the notion of deception and therefore we can deceive ourselves into thinking that we can discover some truth behind its various coverings. But the seeker for truth is male. Woman is an enigma who deceives men into thinking that she conceals some knowledge or reality behind her mask of femininity. For Nietzsche, woman does not want truth, about herself or anything else. As in ancient Greek society, women are seen as inferior by Nietzsche, who admires Greek aristocratic culture because it privileges 'a leisure class whose members make things difficult for themselves and exercise much self-overcoming. The power of form, the will to give form to oneself.'[39]

Doane continues her discussion of the veiled woman by explaining how the latter is seen by the postmodernist theorists Derrida and Lacan. She discusses Lacan's reference to Bernini's statue of *St Teresa in Ecstasy*, which I will discuss in more detail shortly. Lacan states that the woman represented in the statue is obviously having an orgasm, but, like a mystic, while she can experience this *jouissance*, this immediacy, she cannot know it or understand its significance: 'there is something, *jouissance*, which makes it impossible to tell whether the woman can say anything about it – whether she can say what she knows of it.'[40] For Lacan the destabilisation of the visual is the function of the

phallus, but the woman (eg St Teresa) offers, in some ways, the security of the visible. However the real historical St Teresa did believe that she understood her visions, convinced the Catholic Church that they actually happened and described them in her autobiography. Whether we believe in them or not is another matter. Doane points out that for Lacan the woman mystic, St Teresa, 'becomes emblematic of the subject who is duped by the unconscious, of the nonknowledge of the subject.' (p133)

Doane concludes by discussing the representation of Marlene Dietrich as she appears veiled in several films, notably *The Scarlet Empress*, directed by Joseph von Sternberg in 1934. In a short scene after the Empress Catherine (Dietrich) has given birth to her son and is resting in a bed surrounded by transparent drapes, the camera moves closer and closer to the woman's face so that she almost disappears and can only be read as merged with the cloth, which is in turn merged with the cinema screen. Thus the woman is no longer merely the object of the gaze but becomes the support of the cinematic image. What was behind the veils becomes the surface. Doane sees this as a parallel with the way in which, for Lacan and others, the woman is the support of their discourse, the carrier of their philosophical demonstration, even though she cannot understand it herself. Doane concludes that the woman 'takes up the slack and becomes the object of a desire that reflects the lack that haunts theory.' (p141)

In some ways, this is correct, and for many postmodern theorists, perhaps influenced by Nietzsche, the woman is the lack that haunts theory. In fact the woman is the ultimate lack in this kind of theory because these theories are so idealist. Woman has, in many examples of scientific and cultural texts, been associated with the material, with reality and with nature, while the intellect and culture were gendered as masculine.[41] Many postmodern philosophers have not broken from this ideological designation of the material world as the feminine. Thus for them the material is indeed a 'she' that is repressed, but keeps coming back from their unconscious, struggling through the morass of idealist writing they produce, which can only refer to the material (and to woman) in the most oblique, refracted and convoluted ways. Significantly, the material world is not gendered in Marxist theories of knowledge, since Marxists have no reason to gender the material one way or the other, they have no wish to repress it and human society and culture is not seen primarily as a conflict between genders.[42]

THE FOLD AND VISUAL CULTURE

The notion of 'the fold' can be related to postmodern sensibilities, as can be seen from a number of articles discussing visual culture and the fold, written both before and after the publication of Deleuze's book in 1988 and its translation into English in 1993.[43]

Joan Key's essay on the concept of the fold and visual culture, published in 1997, uses two works in an exhibition, a plastercast of an inflated airbed by Rachel Whiteread and a painting by Bridget Riley, to muse upon folds and unfolding.[44] This rather odd article starts with a quotation from Deleuze's *The Fold* and examines possible points of connection through folding, between the two works which, the curator explains, had been placed together simply due to their superficial resemblances: 'It is the very superficiality of their resemblance that is so important, so fascinating'.[45] Key thinks this is of great importance and argues that 'if they are together because they just happen to look good/get on together, that suggests an excess of "pleasure" over reason or "function" and not the appropriate workings of "judgement". . . could there be imprecations of obscenity in "the fold"?' (p197) To reach this conclusion (or question), she returns to Copjec's essay on de Clérambault's photographs, agreeing with the latter's statement that the authorities at the Ecole des Beaux-Arts terminated de Clérambault's lecture courses on draperies and folds because they perceived the excess pleasure and even obscenity of cloth manipulated 'threateningly outside the bounds of utility'. (Copjec quoted by Key, p193) Whiteread's plastercast is said by Key to recall the use of plaster by artists in the reproduction of antique sculpture, thus returning us to the 'subtle inflections to this folding/unfolding. . . a sensation that hints of desire and relation in excess of the contemplatice utility of art.' (p194) I am not entirely convinced by the parallel between de Clérambault's work and the pieces discussed in this essay, which, in any case, are taken completely out of context and discussed in relation to Deleuze's concept of the fold, which is also fairly ahistorical.

More interesting, though problematic in a different way, is Yve Lomax's essay 'Folds in the Photograph', published in 1995, which is accompanied by illustrations of her own photographic work, which attempt to embody the concepts of folding she evokes in her essay.[46] Lomax investigates the fold, unfoldings, becomings, multiplicity and their antagonism to rigid views of the world as based on binary oppositions. In this she invokes the French philosopher Henri Bergson

(using Deleuze's book on Bergson), Deleuze's *The Fold*, Emmanuel Levinas and Lyotard, to name but a few of the writers who have influenced her thinking. She enthusiastically welcomes postmodern notions of multiplicity (she argues in favour of 'an ethics of multiplicity – an ethics which demands an infinite responsibility towards relations') (p57), becomings and inbetweenness. She loves the 'messy and the uncontainable' and hates the way the world has been forced by 'logic' into binary oppositions. To view the world through the blinkers of 'binary oppositions' is to maintain that everything that is not-A must be A, that the Other is the negative value of the One. There are no overlaps, contradictions and nothing can contain its opposite. The 'baker's logic' (a mental process analogous to folding dough over and over on itself) is what can overcome this, argues Lomax. 'In terms of perfecting the baker's logic we have to knead binary opposition: to make the two terms fold in such [a way] that it is shown that both sides implicate each other and that as such they become, as Derrida would say, "both and neither/nor". Neither positive or negative, neither one thing nor the other.'[47] She writes 'In order to have being, we negate. A is not B. Negate the relations. Negate the AND.'[48]

What I found interesting here, was that what Lomax seemed to be trying to do was to understand the world by means of dialectics, which perceives and understands the inter-penetrability of opposites, the play of contradictions and the process of negation inherent in phenomena. However Lomax's reliance on postmodernist philosophers means that her perception of the world as flux, interpenetration and becomings, does not seem to lead her to an interest in Marxist materialist dialectics, one of the most fruitful modern applications of dialectics, but rather away from this into a more idealist theoretical approach.[49] She is rightly suspicious of dualism, but materialist dialectics is apparently not perceived by her as a viable or stimulating alternative. Postmodern theories are far more accessible and available than materialist dialectics in the present intellectual and cultural climate. There are many examples of postmodernists who speak of becomings, inbetweenness, contradictions and so on, but resolutely ignore all that writers coming from a dialectical materialist position have published on these topics.[50] Yve Lomax accepts postmodern arguments that there is no 'depth' behind the surface of representation, but also adds that this means that we can no longer entertain the notion of a 'surface'. Thus she does not want to pursue images as things which 'replace the real world but rather understanding the effectivity of images *in* the world'.[51] The consequence

of this should be to participate in life with 'a fluid ethics', so as to avoid relativism and the notion of multiplicity collapsing into 'anything goes'. It seems doubtful, however, as to whether the theoretical basis for Lomax's practice will have this result, though Lomax may achieve this as an individual in practical terms. It appears to me that postmodern theories with their vague notions of inbetweenness, hybridity, rhizomes, folding and the like, are not terribly useful in terms of understanding social or historical developments, or as a guide to political positions or activities. What they appear to do very well though, is to motivate writers and visual artists to make creative use of these, largely meta-phorical, concepts. Yve Lomax's photographs seem to me to be much more convincing embodiments of her rejection of dualism, than are the postmodern concepts and writers she refers to. Her work is not unique in this – it is something I have noticed in much of the visual culture inspired by concepts taken from the work of writers such as Deleuze. I suppose the conclusion I should draw from this is that weak philos-ophy, when it works through suggestive and imaginative metaphors and other figures of speech, can inspire really interesting artworks!

BERNINI AND BAROQUE DRAPERY

In view of the significant impact of Deleuze's *Fold* on a number of recent artworks, it is useful to look at some actual examples of baroque folds in addition to the conceptual folds created by Deleuzian theory. Drapery in Italian baroque sculptures is frequently executed with virtuoso skills, resulting in an impressive display of sensual materiality, coupled with a theatrical spirituality.[52] Many of Bernini's sculptures, including his famous group of *The Ecstasy of St Teresa* (plate 28) of 1647–52, share these qualities. While some of the figures are plain marble, many combine with larger sculptural groups or architectural settings utilising coloured stone, gilt, bronze, painted elements and stained glass. This white marble group of the Saint and angel is illuminated by a window with amber glass in surroundings of great visual and plastic richness.

While Bernini's virtuosity was praised in his lifetime, later writers on art found his draperies unnatural and irrational and a bad model for young students.[53] Certain nineteenth-century cultural critics found the sensuality of Bernini's female figures disturbing and read them out of context of the religious ideas of High Counter-Reformation Rome. An American lawyer and writer visiting Rome in the mid-nineteenth century saw St Teresa as a 'vile statue', and a book on Bernini published

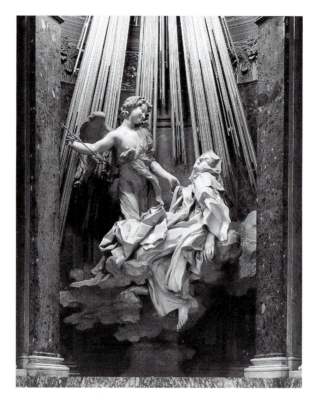

28. G. Bernini, The Ecstasy of St Teresa, *sculptural group from the Cornaro Chapel, 1645–52, S. Maria della Vittoria, Rome, photograph by James Austin, Wysing Arts.*

in 1900 said of the figure of Charity on the Tomb of Pope Alexander VII:

The allegory of Charity is an enormous baroque statue, abounding in opulent flesh and drapery so rich, so disorderly, and so vulgar, that it almost seems possessed by a frenzy of fecundity. She contrasts in particular with the serene and solemn aspect of the pontiff: she has a prominent nose, long tousled hair which seems like skeins of string, and a neck almost sausage-like. The drapery heaves on her breasts as in the angels of Bernini, and the modelling of the fine gown reveals her legs in a confused way.[54]

This view of Rome as a voluptuous Catholic city, the very opposite of repressed, Protestant middle-class culture and ideology, is also apparent in George Eliot's *Middlemarch*, where the young, newly-wed heroine

Dorothea visits art collections, while her dry and emotionally useless old husband stays at home with his notebooks and research. One day in the Vatican Museum, two young men are observed as

they passed lightly along by the Meleager towards the hall where the reclining Ariadne, then called the Cleopatra, lies in the marble voluptuousness of her beauty, the drapery folding around her with a petal-like ease and tenderness. They were just in time to see another figure standing against a pedestal near the reclining marble: a breathing blooming girl, whose form, not shamed by the Ariadne, was clad in Quakerish grey drapery. . .

The two men compare the marble, lifeless but sensual female with the breathing vibrancy of Dorothea's form, and one of them remarks: 'here stands beauty in its breathing life, with the consciousness of Christian centuries in its bosom. But she should be dressed as a nun; I think she looks almost what you call a Quaker; I would dress her as a nun in my picture.'[55] However Dorothea is less comfortable with the art of Rome than the young artist and his companion. In later years 'in certain states of dull forlornness Dorothea all her life continued to see the vastness of St Peter's, the huge bronze canopy, the excited intention in the attitudes and garments of the prophets and evangelists in the mosaics above, and the red drapery which was being hung for Christmas spreading itself everywhere like a disease of the retina.'[56] This sensual drapery encroaching on her sight, threatening her, becomes a scarcely repressed trauma in her Puritan, yet emotionally volatile, psyche.

Rome in the seventeenth century was an expanding city with a rising population, though many of these were beggars and prostitutes who had come to the city from country areas. Land was cleared for new development, the militant Catholic Church orchestrated a new religious fervour of Counter-Reformation, and the Pope and his relatives lavished spending on churches and palaces and their decoration. For example the Chapel housing the St Teresa group cost 12,089 scudi, compared to 11,678 for the whole of the Church of San Carlo alle Quattro Fontane by the architect Borromini. New religious orders, the Jesuits, Oratorians and Theatines established their mother churches in Rome from the 1560s onwards, and pilgrims flocked to the city. These new religious orders competed for recruits, money and power. Bernini was particularly close to the Jesuits and is said to have attended mass every day for the last 40 years of his life. The Counter-Reformation sought to control art as effective propaganda for the Catholic Church, and saints

were canonised partly as political moves to satisfy nations loyal to the Pope. For example in 1622 Jesuit and Spanish Saints (Francis Xavier and Ignatius Loyola) were canonised and also Saint Teresa of Avila.[57]

One Bernini scholar, Careri, has argued, like Winckelmann and others, that the drapery on Bernini's figures does not logically relate to the body beneath. He reads the drapery, in this case of the figure of Ludovica Albertoni, as purely a 'surface for the inscription of pathos.' This sign, this surface can be drapery, or it can be emotion, or it can be skin, an ambiguous and shifting signifier in tune with postmodern sensibilities, but this reading rather depends on us detaching it from its context: 'The folds, speckles, and veins vibrate together, varying with the changing of the light and with every shift in point of view, echoing the chromatic and morphological variations in the folds of Ludovica's gown.'[58] Distinctions between inside and outside are dissolved in the virtuoso marble cutting of the folded drapery. As Perniola puts it: 'Saint Theresa's body disappears in the drapery of her tunic'; her body is 'engulfed' and 'transformed into fabric.'[59] In these readings the perceived eroticism of the body is displaced onto the fabric (as in Alison Watt's paintings discussed earlier). The draperies in the figures of Bernini's Ludovica and St Teresa provide possible opportunities for a postmodern reading asserting the triumph of the spiritual over the material in a way which parallels the triumph over the real material world by postmodern philosophical theories.[60] Similarly the sculptural group does not differentiate between the spiritual (the angel) and the human being (the saint), both of whose bodies and draperies are rendered with the same arresting combination of naturalism and artifice. This confusion of the real and the immaterial is another reason for the attraction of works such as this from the baroque period for postmodern cultural critics and philosophers.

BAUDRILLARD AND ECSTASY

Although he does not mention Bernini's St Teresa, Jean Baudrillard's essay 'The Ecstasy of Communication' muses on what ecstasy might be in contemporary society by way of references to Marx and the commodity, baroque spectacle, hysteria and schizophrenia.[61] In contemporary life, says Baudrillard, the relationship of people to objects has changed. The previous capitalist system of production and consumption analysed by Marx has given way to a network of general interfaces, of empty screens, on which the self is no longer projected.

Advertising in its new version – which is no longer a more or less baroque, utopian or ecstatic scenario of objects and consumption, but the effect of an omnipresent visibility of enterprises, brands, social interlocuters and the social virtues of communication – advertising in its new dimension invades everything, as public space (the street, monument, market, scene) disappears.[62]

These 'giant spaces of ephemeral connections' could perhaps be seen by those who compare the baroque and the postmodern as linked to the culture of the baroque as authoritarian, yet attempting to communicate with a mass audience.

Baudrillard then states that the dissolution of boundaries between the public and the private in contemporary life (eg 'fly-on-the-wall' TV documentaries or the notorious *Big Brother* programme) results in a kind of obscenity, which arises when there is no more spectacle, since everything becomes visible and is possible media fodder: 'we live in an ecstasy of communication. And this ecstasy is obscene.' (p130) Information technology and imagery becomes pornography in 'the obscenity of the visible'.[63] Pathologically, hysteria (linked to the staging of the subject in a previous historical period) and paranoia (existence in an overly structured society) have now given way to schizophrenia, according to Baudrillard. The (male) schizophrenic 'with no halo of private protection' is now a pure screen for the playing out of the instantaneity of things.

Baudrillard's view (it is perhaps incorrect to call it an analysis) of a postmodern society driven by new technology and communications sees the subject as estranged and exposed to the constant assault of images and information. Whereas St Teresa's ecstasy represents the union of the soul with God, giving meaning to her life and the lives of all good Catholics, Baudrillard's postmodern schizophrenics are seen as bereft of salvation from God, social revolution or anything else. They have no agency, little subjectivity and are merely victims, 'the obscene prey of the world's obscenity' in a society of ecstatic communications. (p133) The emptiness of the postmodern subject reveals an important difference between the baroque and the postmodern, despite superficial cultural similarities.

ST TERESA AND BERNINI'S *ST TERESA*

St Teresa of Avila (1515–82) became a Carmelite nun at a time when religious zeal made Spain one of the bastions of the Catholic Church.

Spain had 9,000 active religious houses, and one third of the population
was in the service of the Church. In the first part of her life, Teresa
was troubled by ill-health including bouts of catalepsy. In one attack,
a four-day cataleptic seizure left her paralysed and she had to be carried
around in a sheet. Her paralysis lasted three years. Apparently when
she was aged about 45 her health became much better (possibly due to
her menopause?) and she embarked on the reformation of her religious
order by founding the Discalced (Barefoot) Carmelites, dedicating them
to poverty and good works.[64]

However St Teresa is also famous as a mystic visionary, and Bernini's
statue represents the saint experiencing one of her visions which she
describes in her writings as occuring on 27 August 1559. In fact some
visionaries were just as likely to be murdered by the orders of the
Inquisition as made into Saints. Some suspected Teresa's visions were
of satanic origins.[65] In the later nineteenth century she was more likely
to be seen as a hysteric. Weibel's book on Bernini (1909) suggests that
Bernini made 'clinical studies' of hysterical or epileptic seizures to
achieve the 'naturalism' of his group, arguing that visionary states
would be described by modern science as pathological. Weibel also
points out the interesting fact that a Jesuit priest wrote a book in 1906
in which he claimed that St Teresa was a hysteric. This was immediately
placed on the Index of books condemned by the Catholic Church and
all copies of the French version were recalled.[66] Given the supposedly
outrageously sexual behaviour displayed by hysterical women in some
stages of an attack, the Church would not care to have a Saint diagnosed
as suffering from the same ailment as Charcot's (lower-class) patients
at La Salpêtrière.

NUNS' CLOTHES

The religious clothing worn by the saint in Bernini's statue is ideal for
drapery in that it is relatively timeless and unfashionable. Although it
is contemporary, it is not so different from the drapery worn by the
angel who is about to pierce her entrails with the arrow. The headscarf/
covering that she wears is also generalised enough to resemble oriental
clothing. Nuns' clothing was traditionally selected as being of poor
quality rough cloth and was sometimes sewn by the nuns themselves.
Despite the need for Carmelites to bring a dowry to the convent before
they could fully enter the order, once inside, all ties with worldly
fashion and display were severed. During the Reformation era, some

orders became open to poor women as well as those from richer families. Once a member of an enclosed order, the woman would be exempt from taxes and immune from secular law. During the Counter-Reformation, the Catholic leadership decreed the enclosure of nuns (following the Council of Trent in 1563), and by 1566 Pope Pius V had stipulated that all religious women would have to take vows to live enclosed lives, or their order would be disbanded. The Church opposed active religious women who worked outside their convents.[67]

Specific items of nuns' clothing were symbolic. The veil signified chastity and obedience; the belt justice and purity. The veil was apparently also thought to ward off the evil eye and was taken over from early Christianity where it symbolised the constancy and fidelity of the betrothed woman (who as a nun was now the bride of Christ). Various rules forbade those born illegitimately as well as epileptics from entering convents. (Epileptics were thought to be possessed by devils.) Dowries were only abolished fairly recently, in the twentieth century.[68] In the early 1970s, one English teaching sister, who felt that many of the regulations were part of the Church's attempt to neutralise women, said: 'And we co-operated. . . we built heavy walls, covered ourselves in drapery and made ourselves some kind of middle sex.'[69] This was despite reforms dictated by the Vatican in 1962 which allowed women in non-enclosed orders to wear secular fashions. Many women felt that their individuality was smothered by religious dress and that they were defined merely as social types.[70] However many nuns were unsure as to what to wear, and one group even called in an image consultant. One former nun commented: 'I can't help thinking that nuns are trying to find a new image, when what they want is a new reality'. One great bonus, apparently, was a relief at being rid of the connotations of traditional nuns' clothing as a signifier of repressed sexuality.[71] As I was researching this topic, however, I looked up nuns' clothing on the internet, only to find that hundreds of pornographic websites about women un/dressed as (virginal) nuns existed. The reading of Bernini's St Teresa as an expression of female orgasmic pleasure has contributed to a particular legacy of male sexual fantasies which are still circulating in, as Baudrillard puts it, the obscenity and ecstasy of communication.

ST TERESA'S ECSTASY

In her account of her visionary experience of the union of her soul with God, the Saint describes her 'ecstasy', 'raptures', 'moans', 'contractions

of the body', 'sweetness' and 'bliss'.[72] Lacan, who wrote that she was obviously 'coming', was only one of a number of writers who read the statue in sexual terms. Hippolyte Taine, Stendhal and Zola were all taken with the voluptuous representation of ecstatic bliss.[73] Baudelaire suggested that representations of the Saint's ecstasy should be included in a 'Museum of Love', along with portraits by artists such as Delacroix and Ingres of 'great pale women, drowned in satin'.[74]

However there has been some debate among feminist writers as to whether Lacan's view of St Teresa's 'jouissance' is a negative one as far as women are concerned. For Jacqueline Rose, Lacan opens up a way in which women can be seen to have particular access to language, the unconscious and, in some privileged moments, to experience moments of truth buried in the unconscious that are 'only ever that moment of fundamental division through which the subject entered into language and sexuality, and the constant failing of position within both.'[75] Jacquie Swift, discussing women's practice as writers and artists, believes Lacan was able to see women as 'having a special capacity to experience pleasure, affect and understanding, what he expressed as *jouissance*, which was outside conventional, verbal language structures.' It is argued that this ability to step outside language and create different communication structures gives women an advantage over men.[76]

HYSTERIA

There is now a vast body of literature on hysteria and gender, so I cannot attempt to summarize it adequately here. However I will give a very brief outline of the way that hysteria was seen in nineteenth-century France.[77] Graeco-Roman medicine saw hysteria as a disease of the female reproductive organs, mainly due to lack of sexual activity. With Christianity, hysteria became a supernatural manifestation of evil, where the female sufferer was seen as an innocent soul possessed by a devil, or even as a witch. By the sixteenth and seventeenth centuries, as we saw in the case of Teresa of Avila, the Church decided who was a religious mystic and who was a heretic. In the eighteenth and early nineteenth centuries hysteria was considered an affliction of the leisured classes and associated with an easy lifestyle and a rich diet.[78] By the mid-nineteenth century it was shown that working-class women could also suffer from hysteria, largely due to the fact that most of the patients available for doctors to study were poor women in public hospitals, whose treatment enabled psychiatrists to 'specialise' in

hysteria.[79] By the 1880s, the two sections of society seen as likely to be affected by hysteria were women and male manual workers. Charcot wrote in 1887 that 'Young boys, men of all ages, and among them manual workers whose intellectual capacities are very limited, and whose appearance expresses nothing effeminate, can fall prey to "la grande névrose"'.[80] In the aftermath of the Commune, the activities of its supporters were likened to an outbreak of mass hysteria on the part of working-class men and women, the latter in particular behaving in a most 'unfeminine' way by fighting alongside men against the French state forces.[81]

However some doctors felt that hysteria was a specifically feminine complaint and were reluctant to recognise its existence in male patients. One medical practitioner went so far as to voice the following opinion: 'Let us imagine a man endowed with the faculty of being affected in the same way as a woman, he would become hysterical and consequently unfit for his predestined role, namely, that of protection and of strength. Hysteria in a man means the overthrow of the laws constitutive of our society.'[82] Gradually hysteria became fixed as a gendered ailment, despite Freud's essays in the early twentieth century which described hysteria as a bisexual state, in which the subject experiences masculine and feminine sexuality at the same time. Freud saw hysterics as acting out unconscious sexual fantasies related to previous traumas, not through the psyche, but through the body. However in his 1909 essay he concluded that hysterical attacks in women are related to the revival of a suppressed masculine element of their sexuality left over from childhood and severe attacks represent 'an excessive accentuation of the typical wave of repression which, by doing away with her masculine sexuality, allows the woman to emerge.'[83] It is probably no accident that the attempt by some doctors to see all women as potential hysterics coincided with increasing agitation by women for political and social equality. One doctor writing in 1847, for example, recommended keeping women away from libraries and studying lest they become hysterical. The woman was seen as dependent on her doctor.[84] Legrand de Saulle, a doctor at the same hospital as Charcot, La Salpêtrière, stated: 'As far as the hysteric is concerned, finally stripped of her borrowed halo, she has lost her rights to the stake or to canonization. She has the honour today of being a sick person and depends directly on the doctor.'[85]

Debates on whether saints and people supposedly possessed by devils in previous centuries were actually hysterics were carried on by doctors

engaged in treating contemporary hysterics.[86] In the 1870s and 1880s, La Salpêtrière was seen by the government as a centre of materialism and anti-clericalism. A spy was sent (by the Republican government!) to attend lectures at the hospital to keep an eye on the situation. According to a visitor to Charcot's consulting room in the mid-1880s, it was decorated with reproductions of pictures of Italian and Spanish paintings of saints in ecstasy, convulsionaries and the possessed. All were designated hysterics.[87] Certain members of the Catholic Church objected strongly to Charcot's work, one reason being that it removed sick women from the control of priests and placed them under the 'care' of doctors.

Charcot and Richer published their famous book on representations of possessed people in art in 1887. They argued that all these men, women and children previously thought to have been possessed by devils were in reality suffering from hysterical attacks.[88] They used 'evidence' from works of art to demonstrate their case. This may all seem bizarre from the perspective of the twenty-first century, but only recently the Vatican published a new version (in Latin) of the manual for use by those whose duties include driving out the devil from the possessed. Even the present Pope has carried out an exorcism. In 1982 he supposedly said mass for a woman brought to him screaming and she was cured. The source continues: 'A year later, she returned, totally cured, to tell the Pope that she was to become a mother.'[89]

Charcot writes in the book of his interest in the art of the baroque period and how the possessed people represented in artworks seem to him to be linked to the 'baroque' and 'picturesque' aspects of the postures of his own patients.[90] Charcot's treatment of his patients relied very much on the visual, hence his interest in photographing his patients. As far as I am aware he did not listen to their words, unlike Freud, for whom this was a key aspect of the cure. Indeed he hardly even spoke to his patients, according to an account by two of his students.[91] Another account tells of an incident where one of Charcot's female patients 'stole' the photographs of herself from a drawer, but was caught in the act, 'transformed into a statue, so to speak' in the grip of a cataleptic trance.[92] In whose interests were these photographs taken, if they did not belong to the person pictured in them? Sometimes the doctors claimed the photographing of the patients was therapeutic for the latter, but elsewhere it is stated that the patients were tricked into having their photographs taken by being told that these images were really portrait photographs.[93]

De Marneffe has noted that some of the photographs of Charcot's patient, Augustine, lying in her bed surrounded by sheets during a hysterical attack, have been touched up with white paint. This is no doubt partly to improve tonal contrasts and outline prior to printing in a book, but also de Marneffe sees it as an aesthetic choice. 'The application of paint to the drapery [of the sheets and hospital gown] creates a sculptural effect. . . They are made weighty and solid, and Augustine, surrounded by her heavy drapery, is imbued with static permanence.'[94] But not only is she made to look more like an artwork, alongside the reproductions of old paintings and prints that interested Charcot so much, she is made sculptural. Yet de Marneffe also notes how the increased sculptural weight of the drapery makes her skin seem all the more soft and seductive. The fabricated relationships between art and reality, history and the contemporary, are here very complex indeed, as Augustine performs (consciously or unconsciously) her femininity, sexuality and hysteria for the camera.

While St Teresa's writings remain for us to read, despite the fact that she was almost always represented by male artists, the words of Charcot's patients were relegated to an inferior status as compared with the photographic 'proofs' of the correctness of the doctor's diagnoses.[95] The more Augustine is made into a 'perfect example of hysteria', the less she seems an actual individual. The way that the patients are referred to by first names only, or even initials, supposedly to protect them, actually also robs them of their identities. After many attempts to run away from the hospital, Augustine succeeded, and on 9 September 1880 it was noted that she 'escaped from the Salpêtrière, disguised as a man.'[96]

SAINT ORLAN

The video and performance artist known as Orlan (born 1947) is best known for her 'carnal art' performances, which involve her being operated on by a plastic surgeon whilst receiving communications by fax in response to pictures of the operation transmitted live to various locations around the world. While being operated on under local anaesthetic, Orlan reads from texts such as the Lacanian philosopher Lemoine-Luccioni's book *La Robe*. This book, discussed earlier, in which the importance of skin as a clothing/covering for the body is emphasised, contains a chapter on Orlan's pre-surgical artworks, in which sheets and drapery played a large part. Lemoine-Luccioni

analyses Orlan's destruction of the sheets of her trousseau (given to her by her mother), as an attempt to rid herself of all maternal influence. Similarly the artistic medium of paintings on canvas is rejected in favour of performance, multimedia and the utilisation of new technologies such as video and computers. Lemoine-Luccioni states that 'It is through the study of "drapery" that Orlan moved on from what was properly called painting to performances.'[97] For example the sheets have, at various times, been used to wrap Orlan in drapery like a baroque saint, used to make supports for her paintings and then removed in a parody of a striptease. A series of photographs, *Occasional Striptease through the Sheets of my Trousseau* (1976), taken from a performance, shows Orlan gradually take off the draperies of a baroque saint and transform herself into a stripper, a whore or even a love goddess (like Boticelli's Venus) standing naked on a heap of drapery.[98] The disrobing of the woman typically signifies the revelation of knowledge, but Barthes argues that striptease is a process of clothing the woman in a whole series of coverings precisely as she pretends to bare herself – for example exoticism: 'all aim at establishing the woman *right from the start* as an object in disguise.'[99] In Orlan's performances, one of the aims is to re-present perceptions or 'disguises' of woman as constructions of social and religious ideology, which can then be reactivated and transcended by the artist along with the viewing public. The disrobing of the woman's body is a cultural event or performance around which cluster many meanings – too many to discuss in detail here. However an important aspect of the disrobing of the saintly woman in Orlan's performances of the 1970s has been pointed out by Goodall, who writes that 'Orlan's theatrical exhibitionism is an inversion of the ecclesiastically approved practices of veiling and retreat.'[100]

In one performance, some of the artist's trousseau sheets were cut up; in another, entitled *Art and Prostitution*, art dealers were invited to have sex with the artist on her sheets/canvas, while a large, 'undefiled' sheet was spread on a nearby easel. In a performance in Lyons in 1979, she washed the sheets which she wore as drapery during her performance (these were stained with the semen of her lovers) and the dirty water was bottled to be sold as holy 'relics'.[101]

Relics of her operations have also been offered for sale, for example, glass bottles of blood and liquefied fat, bloodstained gauze dressings, etc. One such gauze image, imprinted with a photograph of Orlan's face, is intended to resemble the veil of St Veronica, onto which the image

of the face of the suffering Christ was transferred as she wiped off the sweat.[102] Orlan's relics mock religion and the worship of saints, while at the same time fulfilling the practical purpose of raising money to finance her future work.[103] An important part of her work involves a critique of art world institutions, traditional aesthetic notions of female beauty and the prestige of the old masters and fine art.

In a recent essay on Orlan's surgical operation work, Parveen Adams has stated that the power of Orlan's work resides in its effect of opening up a space between skin and body, which results in the emptying out of the object, the exposure of a gap. Our psychic security is in ruins when we perceive this, but at the same time we experience an intense moment of Lacanian *jouissance*, according to Adams, when we are confronted with raw castration, a confrontation with the Lacanian Real which might swallow us up. Orlan's project of 'woman to woman transsexualism' (her own words) which is taking place at her direction in the operations, transforms the imaginary coherence of the body image, according to Adams, and lays bare the gap that representation covers over, ie it shows that the phallic and the castrated exist at the same time and do not exclude one another.[104] This view is clearly indebted to Lacan's discussion of St Teresa's image in Bernini's sculptural group.[105]

Like St Teresa, Orlan speaks and likes to be heard. Her public lectures are sell-outs in Britain and elsewhere, attended by fascinated students who see her pushing back the increasingly transgressive boundaries of body art and modification. I suspect that most of her audience is less interested in following up the artist's interest in Lacanian psychoanalysis or her subversion of art historical tradition. For Adams, this is the main interest of Orlan's work. She writes: 'The power of her work is here, in the surgical manipulation of her face, rather than in the conscious programme of art historical references which are really no more than rationalisations'.[106] However I think it would be wrong for us to dismiss the art historical references in Orlan's work, especially in the earlier part of her career, for it is through them that her critique of religious and ideological representations of femininity come to take shape, as well as critiques of art institutions and the art market. Her works dealing with images of saints and madonnas were inspired by Burgundian representations of draped female religious figures, Italian art and Bernini's sculptures which she saw during visits to Italy. Artistic precedents and references are crucial to Orlan's work, especially earlier in her career, since one of her aims is to engage with the ideological

premises of the art world and build positional critiques of this world into her performances.

In 1971 Orlan canonised herself as 'Saint Orlan' and for the next twenty years or so a significant part of her work was devoted to a critical restaging and consequent deconstruction of Catholic images of female saints and virgins, among which were baroque statues. The self-naming process is important, as her canonisation is a rejection of the 'name of the father' (the name of the Other) and the father's authority. Orlan has recently characterised her work as 'a break both with the body of the mother and the name of the father.'[107] She even constructed her own version of a baroque chapel akin to the Cornaro chapel which houses Bernini's St Teresa group.[108] This was a contemporary multimedia equivalent of the sensual overload of baroque sculptural chapels, involving plastic flowers, holograms, videos, vinyl draperies, real marble, photography, etc. The whole chapel was covered on the outside by black drapery. Orlan was attracted to the baroque due to her perception of baroque art as simultaneously good and evil, ecstatic and erotic, as in Bernini's St Teresa sculpture.[109] She also discerned a difference in representations of the Virgin in baroque art, as compared to art of earlier periods. She believes that baroque art often showed the Virgin with one breast exposed, as a kind of phallic monstrance, constituting her as a kind of model of female plenitude which can never be attained by real women.[110] Various performances were given in the 1970s and 1980s (some lasting four or five hours) on such themes as *Apparition and Glory of Saint Orlan* (1983), *Assumption of Saint Orlan* (1984) and one I want to discuss in more detail shortly, *Drapery –The Baroque*, performed at Venice and Aachen in 1979. In 1990, Orlan embarked on the 're-incarnation' of Saint Orlan, a project which involves the series of surgical operations for which she is best known today.

This 're-incarnation', the remaking of something in human flesh, is Orlan's anti-religious inflection of the notion of Christ as 'the word made flesh'. Orlan stresses that she is 'the flesh made word', a rejection of religious dogma, and at the same time a postmodern assertion that the word is more powerful than the material. The word can be detached from, and constitute, the body. Thus Orlan reads words during her operations to stress that the word is superior to flesh and its traumas (though she claims that the operations under local anaesthetic are not painful). The artist stresses that she is not interested in suffering and wants to oppose the religious view of bodily pain as redemption and

purification. For Orlan, the body in postmodernity is obsolete. We can be cyborgs, transform ourselves through surgery and genetic experiments. Carnal art, as invented and practised by Orlan, 'transforms the body into language and reverses the Christian principle of the word made flesh in favour of the flesh made word; only Orlan's voice remains unchanged, the artist [meanwhile] works on [transforming her] representation.'[111] However, I doubt whether a statement that the body is obsolete and language is paramount, can really do away with the materiality of the body. I shall return to this question later.

One of Orlan's aims is to destroy the binary oppositional way of thinking which, she claims, is central to a Judaeo-Christian world view. The opposition Virgin/Whore is one such example and in her photographic works representing herself as a black virgin and a white virgin, she drapes herself in vinyl and leatherette (with their connotations of sex-shop clothing) which can stand out from the body like the sculptured forms of cut marble, parodying the poses of baroque saints in ecstasy. Orlan, in an elliptical statement, relates the postmodern and the baroque:

Post modern and the terribly baroque. . . good and bad taste without
synthesis. . . likeness and illusory resemblance. . . winks towards art history. . .
sentimental and cultural clichés: the serious, the droll, the grotesque.[112]

In the photographs from a performance entitled *Occasional strip-tease through the sheets of my trousseau* (1976), Orlan is draped in her sheets like a baroque saint, gradually transforming herself in the course of the performance into the binary opposite of the saint, the naked woman who offers her body to the spectator. Other performances focused more on Orlan's role as an artist at the end of her performance. In the performance *Drapery – The Baroque* (1978–9), Orlan, draped like a saint in nun's robes, is carried into the room by four men as if in a religious procession. She stays still, like a statue, until she is deposited on some steps. Moving very slowly, she then picks up something wrapped in cloth, like a baby in swaddling clothes, and cradles it, in a Virgin and Child pose. Then she abruptly throws it away. As she goes through various poses resembling baroque statues, the plinth she is standing on is projected with slides of Ingres' paintings such as *The Turkish Bath* and *The Spring*. Slowly she begins to unwrap the drapery, starting with the cloth on her head. She holds a halo to her head with her back to the audience, and then we see her with a paintbrush in her teeth looking

through the hole in an artist's palette at the audience. She undoes the remaining drapery to reveal a black plastic dress on which is a photographic reproduction of herself naked. She paints the reproduction of her crotch on the plastic dress black and also paints out her eyes. She throws the palette and brush away, gets down from the top of the plinth and removes all traces of drapery. The performance ends.[113] Thus art historical references are important here. Orlan makes us aware of the way women's bodies are represented in art at the opposite poles of the virginal and the carnal, but we see the woman artist herself move from being the object of art to the creator of art. What is 'revealed' beneath the drapery is not, in this performance, a naked woman artist, but a reproduction of Orlan naked, made by her and further transformed by her art in the last part of the performance.

Although Orlan has distinguished her 'carnal art' from body art, since it does not seek the 'purification' and 'redemption' of the latter, recent interest in her work in Britain can be linked to a vogue for culture concerned with the body. Piercings and tattoos come together with an interest in the writings of Michel Foucault, whose work on the disciplining of the body and its construction by discourses on criminality and medicine have influenced a number of recent books on the representations of the body.[114] 'Other' bodies, bodies at the limit, even parts of bodies abound in visual culture.[115] No, the body is not obsolete. But what kinds of bodies are these bodies in vogue?

Terry Eagleton has written that: 'For the new somatics [study of the body], not any old body will do. If the libidinal body is in, the labouring body is out. There are mutilated bodies galore, but few malnourished ones.'[116] The body has supposedly changed in postmodernity, transformed from a natural body, to a constructed body – constructed both by discourse and by technology and scientific advance. Yet in this age of the supposed 'body without organs', the metaphorical body which is always forming and deforming itself, according to Deleuze, real bodies are being cut open and organs sold as commodities on an international market. China is one of the worst places for this trade, with prisoners being condemned to death in large numbers so that their organs can be removed a few hours before official execution takes place. In Brazil, poor people are afraid of being killed for parts of their bodies, and many now carry cards proclaiming that they are *not* organ donors.[117] In imperialist countries such as Britain, this is a less obvious problem, though a two-tier health care system undoubtedly exists with private and National Health Service provision. Yet it is not only the rich who

pay for surgery and body modifications. A survey carried out at a London clinic specialising in cosmetic surgery in 1999 found that more than 60% of the patients earned less than £25,000 a year and 35% less than £20,000. While these are huge sums in imperialised countries, they are not large by British standards. The main reason the patients gave for having their bodies modified was not to look beautiful, but to avoid looking strange, the very opposite of the aims of Orlan's more recent transformations.[118] It will be a long time before the example of Orlan's manipulated face with forehead implants or Joel-Peter Witkin's photographs of damaged bodies filter through to the psyches and self-images of 'ordinary' people who will pay money to surgeons to avoid being 'extra-ordinary'. It is rather noticeable that artists who engage in the 'making strange' of the face and the body are usually people who already have appearances that are socially accepted as 'attractive' before they embark on their alterations, whereas most of the people who already feel 'altered' just want to get rid of what makes them feel different. Of course one of the points of Orlan's work is to undermine socio-cultural notions of 'beauty', but the effect this has on a public unaware of avant-garde art must be negligible and the members of the public aware of avant-garde art would probably mind less if they looked 'odd' anyway.

While I entirely sympathise with Orlan's atheism and her artistic attacks on the Judaeo-Christian tradition's representations of women as virgins or whores, I feel that her reversal of the phrase, 'the word made flesh' into 'the flesh made word' is somewhat ambiguous. While at first sight it seems a witty riposte to religious beliefs which are necessarily concerned with idealism (in the sense that the materiality of the world is not primary but driven by the spiritual/intangible force of ideas or of God), in the present context it implies that the materiality of life is less significant than language. This is a favourite tenet of many theorists linked to postmodernism, such as Lacan, Derrida, Foucault, etc. Language cannot exist without our material bodies or human society. Orlan may certainly detach her words from her bodily experiences while she undergoes her operations, but they are still spoken by her and their utterance is the result of her agency. While Orlan's accomplished reenactment and deconstruction of baroque religiosity is artistically impressive and impelled by atheism, feminism and materialism, I feel less convinced by some of the theoretical approaches behind the later works which privilege the word over the flesh, or rather language over the human subject and her/his body.

CONCLUSIONS

The baroque and the postmodern have been seen as linked in their anti-rational and anti-Enlightenment approaches to culture and society by a number of scholars and artists. Ecstasy and hysteria have also been linked to the feminine. Similarly baroque drapery itself has been viewed as unscientific and irrational, split from the body it is supposed to relate to, in opposition to recommendations such as those of Leonardo in his comments on representing draped bodies. This indicates that baroque drapery was seen as something of a deviation from the development of drapery in fine art over the centuries. Usually drapery was linked to the nobility, grace and actual anatomy of the (idealised) body. In the baroque period, technical virtuosity coupled with the social and cultural context of the Italian Counter-Reformation meant that drapery became a much more important aspect of the artwork, especially in sculptural form. The apparently irrational ways in which drapery 'took over' sculptural figures, was actually based on technical dexterity and intricate knowledge of the material from which the sculptures were made. This apparent contradiction resulted in the production of some stunning sculptural works, as well as the condemnation of later writers who viewed the works with some unease. In the recent vogue for postmodernity and its theoretical underpinnings, baroque irrationality is seen as an attraction, a fruitful alternative to the derided model of Cartesian thought which has been so strongly rejected by key postmodern thinkers. This perceived irrationality in baroque art, ironically based securely on the rational technical expertise in the treatment of the material, was linked to the feminine, resulting in the representation of women as saintly visionaries, inspired by God, or perhaps possessed by the devil. The Church decided. In the nineteenth century, the medical profession took over the categorisation of who was sick or saintly and clearly they did not decide often, if at all, on the latter definition. Orlan, in 1971, declared herself a saint, wrapping herself in her trousseau sheets like a baroque statue and selling her own relics – pieces of her commodified body. While feminism and psychoanalysis have done much to demystify and criticise the representation of women and their treatment by the medical profession and the Church, there remains much to be done in a world where the bodies of women are subject to violence and those of the poor are attacked and mutilated so that their organs can be sold, or simply stolen.

The gulf between notions of the self, agency and identity, as seen in avant-garde culture and theory and in 'everyday' lives, is huge. Drapery

may be a way of linking the baroque and the postmodern, the spiritual and the material, truth and reality, history and the present, but the huge fissures opened up by serious debate on these issues are not so easily covered up by carefully arranged conceptual 'folds', which invite us to take refuge from the twenty-first century in the age of the baroque.

CHAPTER 5

DRAPERY AND CONTEMPORARY ART

In this chapter, I want to look at what has happened to the use and representation of drapery in contemporary art. With the demise of academic training in the representation of classical and religious subjects, and later the predominance of non-figurative modernism, the representation and presence of drapery in fine art seemed destined to occupy a very marginal role in the art of the late twentieth century. However things did not work out quite as straightforwardly as this scenario suggests. While discrete modes of fine art practice, such as painting, photography and sculpture are still produced, categories of art practice have become much more fluid. Mixed media and installation works utilise and sometimes combine paint, wood, metal, photography, aspects of sculpture, clothing, computer-generated images, video works and also actual pieces of cloth, which replace the two-dimensional representations of draped cloth or three-dimensional sculptured draperies found in earlier works. Whereas previously, designed cloth existed in a separate artistic sphere of craft or applied art, for example, interior decoration or even haute couture, now fine art practice can incorporate the drapery itself.

An interesting contemporary example of the ways in which installation work effectively crosses over fine art categories while creating multiple meanings concerning drapery is the work by the Slovenian artist Momčilo Golub, *Drapery Study. Gerard David: The Rest on the Flight into Egypt, 2000*, recently exhibited in Ljubljana. This work consists of a reproduction of two pages from a book discussing and illustrating Gerard David's old master painting of the Virgin and Child seated in a landscape, attached to a length of blue fabric that matches the drapery in the painting. Also attached to the drapery alongside the reproduction from the book is the receipt from the store where the cloth was purchased. The artist is concerned to interrogate issues of levels of reality and levels of reproduction, commodification and art historical

heritage. Golub usually selects reproductions of works depicting women for his installations and this has been interpreted as slightly voyeuristic. A recent reviewer remarked on the importance of Golub's 'acknowledgment of art as a special kind of craft in which the illusion of reality can only be replaced by a new and actual reality, not a simulated one'.[1]

In the book *Whole Cloth*, Mildred Constantine and Laurel Reuter show how fine art practice in the later twentieth century has become increasingly divorced from paintings on a canvas support on a stretcher and how cloth became an integral part of the works themselves in a number of ways.[2] For example Rauschenberg's *Bed* of 1955 (Museum of Modern Art, New York) used paints and a quilt. By the 1960s, the use of actual, not represented, cloth in art was quite common. In particular, the development of textile and fibre arts meant an increasing use of cloth, including draped cloth. The boundaries between fine arts and crafts were crossed, especially in works by women artists, whose traditional 'female' skills in working with cloth and textiles had been undervalued as manual, domestic work, supposedly devoid of any intellectual input. The concern of many women artists to emphasise and re-value the domestic in their work, has meant that clothing, household drapery and works involving the techniques of making and caring for these household textiles are now encountered in art galleries. While the majority of contemporary artists working with cloth and drapery are women, this is not exclusively the case, however. In a later part of this chapter, I want to look at the question of gender in relation to drapery representations in textile art in more detail by focusing on works by Murray Gibson and Lia Cook. In order to look at the different possibilities for the utilisation of drapery in contemporary fine art practice, I have selected artists working in painting and related imagery (including painted reliefs), lens-based media and weaving. These three areas have been interpreted broadly, more to apply some organisation and selection criteria to a huge field of study, than to imply that these are necessarily the most significant areas of art practice which concern drapery.

As part of my attempts to research drapery in contemporary art, I placed a request in *Make: The Magazine of Women's Art*, a leading British periodical publication devoted to contemporary women's art, inviting artists working with drapery to contact me. Both male and female artists did so, and I am very grateful for their help. What struck me was the wide range of media, (often mixed media) that these artists worked in and also the surprisingly large number of artists for whom

drapery was an important aspect of their work. I had initially, and mistakenly, supposed that drapery scarcely existed in contemporary art practice. What was to emerge, however, was that this drapery was rather different from previous drapery. As I continued to visit exhibitions and speak to artists about their work, I realised that draped cloth still played quite a significant role in fine art practice and actually related to many of the issues already studied in this book with regard to earlier visual culture. This is especially true of artists who consciously refer to 'old master' images of drapery in their work, for example Lia Cook, Jude Rae and Marianne Ryan. What tended to differ were the ways in which the drapery was approached, especially by women artists, and the increased variety of media used to create drapery and the illusion of draped cloth.

THE WRAPPED REICHSTAG

A useful example of contemporary 'draped' art, which gives a good idea of the complex meanings of contemporary drapery in fine art and the variety of materials utilised, is the project by Christo and Jeanne-Claude, a husband and wife team, to envelop the Reichstag building in Berlin in a wrapping of 100,000 square metres of aluminum coated polypropylene fabric.[3] After campaigning for more than 20 years, the Christos finally saw their proposal debated by German MPs and successfully approved by parliamentary vote. This was seen as a triumph for democracy in the newly re-unified German bourgeois state. The Christos viewed their work as continuing a great classical tradition of drapery, from Greek statuary through to Rodin's statue of the writer Balzac. 'When we give lectures on our work, we always start off with that [ie the drapery tradition]'. 'The drapery sets the measure of the project's ephemeralness.'[4] The Christos' projects are temporary installations and events, and the drapery sets them off like presents to be unwrapped, while the packaging is discarded.

The artists situated their project in a fine art tradition, despite its apparent controversial and radical nature:

Throughout the history of art, the use of fabric has been a fascination for artists. From the most ancient times to the present, fabric – forming folds, pleats and draperies – has played a significant part in paintings, frescoes, reliefs and sculptures made of wood, stone or bronze. The use of fabric on the

Reichstag follows that classical tradition. Fabric, like clothing and skin, is fragile. It expresses the unique quality of impermanence.

For a period of two weeks, the richness of the silvery fabric, shaped by the blue ropes, created a sumptuous flow of vertical folds highlighting the features and proportions of the imposing structure, revealing the essence of the Reichstag.'[5]

The draping of the building will reveal its essence and, when unveiled, it will 'stand before us freshly innocent'.[6] It is as if the history of the building in struggles between East and West, capitalism and 'communism' (more correctly Stalinism) will be obliterated by the wrapping process. This is explicitly stated by Christo: 'Today the site has so much more potential because the entire world questions the future of Europe and where Germany will go from now, in the East-West relations, sitting like a powerhouse of wealth, economic and political weight, and might, that will project tremendous meanings into the twenty-first century.'[7] In the process of being draped and unveiled, the Reichstag and the Germany it symbolises will be reborn, before the eyes of the thousands of spectators who come to witness this metamorphosis. It is interesting to compare this draping and unveiling process with the ceremonies which take place when public sculpture is inaugurated and unveiled. In these events, the draped figure of the statue is covered with an additional layer of real cloth, curtained off and then revealed to an invited public by some important public figure. The audience is thus offered access to something which was previously a secret, its essence only known to a few. The moment of revelation is thus linked to knowledge and the involving of a group of the public in a shared experience of sight and of evaluation of the undraped work. The public nature of the spectacle of wrapping and unwrapping the Reichstag, though not quite the same as the ceremonies to unveil statues, does mobilise the same cluster of meanings around knowledge, perception of value and shared social experience. The Reichstag becomes different in public social consciousness (at least that's the idea) basically because it has been draped, hidden and then revealed once more as 'reborn'.

While it is true that the Christos' main aim is not to make lots of money out of their works, since drawings, models and pieces of fabric were sold primarily to finance future projects, the 'wrapped Reichstag' did not escape the aura of commodification. The Christos' acts of

wrapping were likened to the packaging of consumer items. The packaging makes the object invisible, for it does not show the object – it makes the *process* of showing and displaying important to the viewer/ customer.[8] It is not the Reichstag building itself which is on show here, but its 'packaging' in a new Germany. With government transferred from Bonn, and now housed in a restored Berlin Reichstag building complete with new transparent dome designed by Sir Norman Foster (supposedly to show the transparency of the governmental process), the wrapping is a thing of the past, but which nonetheless attracted thousands of visitors to the city.[9]

The Christos' project cannot really be placed within any of the more traditional categories of fine art. It is not entirely sculpture or architecture. It could be described as a giant installation, or even a happening or performance. Nonetheless, its use of drapery on a grand scale, incorporating new technology and industrially produced fabric, is explicitly linked by the artists to a long fine art tradition. This is something that we will tend to find in the use of drapery by other contemporary artists also. Drapery is used in new ways, for example to allude to gender, to contemporary postmodern theories (such as those of Deleuze), or to exploit the possibilities of video or computer technology, but often the use of drapery is linked, whether explicitly or tacitly, to a past tradition of fine art representation of drapery. Little of this work is non-figurative modernism, and the postmodern return to figurative art has also enabled a revived interest in drapery to emerge in recent years. I want now to look at the use and meanings of drapery in some works by contemporary artists which I will deal with in three sections: painting and related imagery; photography and video; and textile art. In doing so I want to examine both what is new about drapery in these works and what links them to previous fine art tradition. Despite the radical nature and use of new media by many of these artists, I feel that in their works which use drapery, they situate themselves very much as 'fine artists'. This is sometimes more to do with the connotations of drapery itself, than the stated aims of the artists, which are often directed at questioning modes of art-making and gendered notions of art practice. It is as if the fine art academic traditions of drapery are so strong that they persist alongside quite different meanings, strategies, technologies and new materials. Drapery as an element in contemporary fine art practice remains as a reminder of the traditional 'artness' and 'fine' aspects of making and displaying artefacts.

DRAPERY AND PAINTING

Art students do paintings of drapery for a number of reasons. They can practice ways of representing different textures, different lighting effects and also the rendering of planes and depth. Traditionally, drapery forms a background and support for still-life groups. From my discussions with students, I concluded that students interested in drapery tended to develop this interest out of their still-life work by themselves, rather than be directed towards the study of drapery by tutors.[10] Life drawing still plays a much more significant role in fine art training than the study of arranged cloth. Drapery can be cloth, or it might be made of plastic carrier bags or bin-liners. Studies of drapery allow students to play with the ambiguity between non-figurative and realist representation in two dimensions. The material (understood as cloth and also as actual physical stuff) can be investigated or even redefined. This work in two-dimensional imagery such as painting and print-making co-exists with fine art practice which includes actual draped cloth in installations or sculptural projects.

Some common themes which recur in the representations of drapery include the relationship between drapery and the body (whether a body is actually present or not), notions of the feminine, eroticism, the pleasures and ambiguities of painting as a medium and references to the tradition of painting drapery. I want to look now at some works by contemporary artists relating to these themes.

The first two artists whose works I want to discuss briefly are Elga Heinzen and Jacqueline Morreau. Elga Heinzen's work is in fact discussed by Deleuze in a section of *The Fold*.[11] Situating Heinzen's painted works (acrylics on linen) in the tradition of baroque folds and de Clérambault's 'Islamic' draperies, Deleuze admires those paintings, for example the *Witnesses* series of 1986–7, which open out the shapes of draped figures across the canvas, showing back and side views of mysterious faceless people. In the *Flags* series (1982), the draped cloth is presented as devoid of any cultural and political associations. The artist has stated that her idea was to 'let their symbols and colours lose themselves in their folds and recesses to become something completely different – a painting.'[12] The human figure and social concerns are largely absent from Heinzen's work, which implies traces of the figure, but emphasises the inanimate in a body of work devoted to a formal interest in cloth.

Jacqueline Morreau's exhibition, *Fold upon Fold*, showed paintings executed in oil on canvas dating from 1993–4, which were executed at

the same time as her series of etchings *Disclosing Eros*. The etchings
explore the journey undertaken by Psyche (the human soul) during her
pregnancy through the dark side of desire, to her emergence into an
expansive world of mountains, water and air, all represented by sugges-
tions of folds. In these sensual works, sea and land suggest the folds
and crevices of beds, or of skin-covered human bodies. Desire must be
treasured, like the larger natural environment in which we exist to enjoy
our sensual natures. The structures of desire and fulfilment in the
paintings parallel the underlying fabric of the natural world. Draped
and folded structures are found in living and inanimate natural
organisms, as well as in human products such as clothing, bedlinen,
etc.[13]

The next group of painters I want to discuss includes artists who
emphasise the sensual nature of drapery in association with both the
feminine and the process of painterly representation itself. The process
of painting drapery here becomes the trace of sensual experience
without embodied desire. Sensuality is not represented through symbol
or narrative, but by the existence of the finished paintings.

Jude Rae, an Australian artist who has also worked in New Zealand,
is best known for her large paintings of draped or folded cloth. These
developed from earlier works where she took still lives apart, painting
individual objects one at a time against stark backgrounds. Then the
draped cloth, which often accompanies still lives, became the main
subject of the painting. What was marginalised, became the centre. The
emphasis on drapery here is even more intense than in the work of
Alison Watt, discussed previously. While Watt, at that period of her
career, still related enlarged fragments of drapery to the body, although
representing the body in a different image, Rae focuses exclusively on
large draperies which almost seem to engulf the viewer. Most of her
paintings are very restrained in colour, using greys, grey blues and
greens. Sometimes a line of red writing, mixed up and indecipherable,
crosses the drapery and disappears off to one side, for example in *Arras*,
1994, oil on canvas, 120 x 182 cm. The cloth which fills the canvas is
ambiguous in scale, no margins or figures give a hint of its implied size.
These works are indeed sorts of still lives – without the body, without
any sign of life. Yet these works have been interpreted as representations
of the feminine, a femininity which cannot be articulated in traditional
symbolic ways, through the male language of 'the father'. The
unreadable, scrambled text in some of Rae's works has been interpreted
as an example of 'feminine writing' (écriture féminine), in which the

female subject struggles to articulate her desires, stifled by the weight of an alien language and culture.[14] The drapery suggests the folds of skin and hidden creases of the body. However even though no body is present, we are faced with a gendered absence, of a kind of repression of the feminine, which seems to struggle for expression behind the cloth that both hides and suggests it.[15] Like drapery in the corner of an 'old master' painting, feminine language is marginalised and overlooked, until it appears centre-stage in Rae's paintings and undermines traditional hierarchies.

Similarly in the North American artist Ruth Trotter's work, drapery alludes both to absent bodies and a painterly tradition of illusionistic representation. Trotter's exhibition of 1998, *Draped: New Paintings*, grouped her recent work around two themes taken from Charles Baudelaire's collection of poems, *Les Fleurs du Mal* – 'Spleen' and 'Ideal', the polar opposites of creative emotional life, according to the poet. Trotter also wants to link her work to the period in the mid-nineteenth century when Parisian artists began to construct what was to be seen as the beginnings of modernism in the visual arts. This is significant both in terms of the development of modernist painting and also, as we have seen in earlier chapters, in terms of the development of new meanings and presences of drapery in visual culture in Paris at this time, such as in department store window displays. In one version of this modernist trajectory, painting became interested in itself as painting, more than in its subject matter.[16] Trotter's paintings, oil on silk, canvas or linen, show sensual drapery with clearly delineated folds, in front of which seem to hover globules of painted shapes suggesting biological presences such as sperm, eggs or embryos and generative power. The drapery suggests curtains and an anticipated spectacle, as well as a convincing, yet perhaps ultimately disappointing, invitation to see what lies behind the cloth. The floating shapes in front of the drapery imply that different depths exist in this illusionism, yet at the same time we know it is paint on a flat surface. Like other painters who use drapery, Trotter wants to shift this marginalised and lowly form of drapery representation to become the main subject of the work. She wants to bring into play the different connotations of the drapery tradition, suggesting spaces articulated by curtains, the presence of the body and sensuality and references to classicism. However her main interest is in investigating painting as a representational strategy and in this she combines elements of a particular kind of modernism with contemporary concerns, much in vogue, regarding the body.[17]

The use of drapery to investigate illusionism and the practice of painting as a representational mode is also found in the work of the British painter Marianne Ryan. Her works are three-dimensional paintings, in which the canvas is wrapped around five sides of a cube-like structure and hung on the wall (plate 29). In the work illustrated, *Painting no 35*, 1996, oil on canvas, the illusion of deep gold drapery, highlighted with white and creased with shadow, suggesting a satin cloth, allows Ryan to explore the sensual properties of paint, for the pleasures of which the painted cloth becomes a sign. Her works seek to embody the vigour of the painterly tradition of drapery. 'The power of paint is recognisable across the centuries and speaks to me today with as much resonance as contemporary work.'[18] Ryan's small jewel-like paintings intentionally refer to 'old master' works and her interest in Renaissance draperies, while by their arrangements as canvas folded and tucked in on itself around the support, they also relate to contemporary concerns with the folding of space and the problematisation of traditional Renaissance or later Cartesian space, as we have seen in the many references to Deleuze's musings on 'the fold' as an alternative means of conceptualising the material and spiritual world. The colouring and tonal values of Ryan's works are specifically intended to make the works look 'old', as if they are details cut from a larger old painting and then wrapped around a new frame to take on a new life – the detail becomes the whole, the flat, illusionistic drapery becomes a three-dimensional structure which ironically advertises its own lack of reference to real bodies and clothing. The wrapping around of the painted canvas also suggests a different kind of painted space and tantalisingly hints at other spaces 'behind' the construction. The structures created as the painted canvas is wrapped around its support also suggest little boxes, within which something might be concealed by the illusionistic drapery (on the real canvas cloth) which surrounds it.

Marianne Ryan explains some of her working procedures and aims as follows. She sets up still lives of fabrics, photographs them and then selects details of the photographs to make each painting, wanting to add layers of visual ambiguity and illusionism.

To paint directly from life would be too literal. . . This distancing of the painting from the apparent 'subject' allows allusion and illusion to take over from pure representation. . . Using cloth as a starting point, my paintings play with reality, examining the nature of the surface and the fold, the continuous and the invisible, and causing us to reflect on what we perceive. The paintings

29. Marianne Ryan, Painting No. 35, *oil on canvas, 10 x 10 x 7.5 cm, private collection, 1996, courtesy of the artist.*

are contemplative, treating cloth as signifier, welcoming and exploring its allusions. Cloth is highly charged in this respect: redolent of grief or loss, of warmth and tenderness, of protection and seduction.[19]

The sensuality of her work is apparent, suggested not through the body but through paint itself. She admits 'I am in love with paint. . . It has its own richness and variety, it is seductive, it invites and is at the same time yielding.'[20] In this it is similar to the luxurious cloth it represents.

While works like the paintings mentioned above recognisably mobilise traditions of 'old master' and/or 'old mistress' drapery paintings, some other artists seek to address more 'everyday' manifestations of the presence of drapery in their art. In works by artists such as Penelope Downes or Sarah Cawkwell, for example, drapery is situated in the domestic sphere, where it is worked on and cared for by many women in their daily lives. In Cawkwell's drawings, paintings and sculptures, women fold laundry, put washing in machines, repair and iron clothes, arrange their hair, plait it, or wrap it in towels to dry. The draperies in Cawkwell's works are part of everyday life, not examined as formalistic metaphors for the illusionism of painting or sculpture. Drapery in old master paintings played a subsidiary role, albeit one

which added to the seductive appearance of the images. Perhaps we can compare this to domestic labour which contributes so much to the appearance of homes but is often marginalised and overlooked. Cawkwell's work brings this labour, these processes, to the fore. Her works are all about doing – movements and processes, arranging, folding, pressing, cutting, ironing, covering, wrapping. Many of these actions involve the care of cloth and clothing before it can be made into drapery in the kind of traditional paintings mentioned in earlier chapters, for example Hesse's drawing for a figure of Christ in the Garden of Olives which I discussed in Chapter 1. In Cawkwell's work the everyday tasks of caring for household textiles are the subject of the artwork, not relegated to invisibility. In an amusing comment she refers to her series works which show, for example, a woman folding a sheet: 'However, when men fold things, wrap things up, sew, it's as though sometimes they need a manual to do it. The series pictures, like tying apron strings behind your back, show how it's done. It's easy if you only just try!'[21] One of Cawkwell's series works is illustrated here, plate 30, *From Start to Finish*, 1998, painted relief 160 x 122cms. A figure almost draped in a sheet herself gradually folds it into a manageable shape, ready to be put away.

Many of the titles and themes of Cawkwell's work recall Deleuze's folds and pleats, but might as well be in a completely different world; a world where real people do real work and folds and pleats are not abstract processes of thought but embodied in useful, everyday objects and our own bodies. In some examples of her work we see brought together the two different meanings of drapery as, firstly, household textiles and, secondly, the fine art tradition of drapery as cloth made into art. Deleuze's folds are metaphors for abstract thought processes and concepts of being, conceptual rather than actual folds. Cawkwell is interested in concepts such as drapery and folding, but is also concerned to relate these concepts and processes to everyday life and contemporary events. She collects photographs from newspapers which are related to drapery and cloth, including for example photos of draped women in Taliban-controlled Afghanistan. She examines the meanings of drapery in a wide sense, from Renaissance art, through domestic labour to contemporary issues of international political and cultural significance. She recently worked on a project with Christ Church College Gallery, Oxford, in which she selected 'old master' drawings from the collection which were exhibited in 2001 with her own specially created works examining the visual ramifications of the Renaissance images.

30. *Sarah Cawkwell,* From Start to Finish, *painted relief, 1998, 160 x 122 cm, courtesy of the artist.*

I want to conclude this section by discussing a photo-screen print of 1985 by the British artist and writer Pen Dalton, (plate 31) *The Dress.* This five-colour print represents a swirling mass of draped cloth, pink and yellow like shot silk, on which writing in two colours is

superimposed. The words emphasised in red are insertions by the artist into a piece extracted from a letter written to *Brides* magazine. The artist's insertions give voice to the repressed of the wedding process and the fetishism, desire, narcissism and fear of castration underlying the rituals of religion and dress which are such fixed parts of the event. In the right-hand margin is an extract from the artist's local paper, a typical description of an 'ideal' wedding day: 'The bride, wearing a white taffetta crinoline style dress was given away by her father. Nifty needlewoman Shirley P. . . made sure her daughter was a radiant bride. . . She also wore an elbow length veil. . . The bride made the wedding cake herself. . .' and so on. The time-honoured womanly skills of sewing, food-making and looking desirable for men are emphasised here. Noticeable is the very traditional nature of the wedding and its role of maintaining the dominant ideologies of appropriate femininity and family values. The dress could just as well be from the nineteenth century in Baudelairean Paris or made from cloth purchased from one of the big new department stores.

The artist felt fascinated by the erotic language and secrecy of the whole process. The names of the fabrics, 'silk, satin organza, taffeta, slubbed raw and shot in kaleidoscopic colours. Layers of tulle, watered silk and sparkling diamanté. . .' We could be an entranced female customer in the department store, *Au Bonheur des Dames*, lured by the fetishism of commodified luxury textiles and their seductive names. The bride's letter continues 'The full skirt was puffed out with endless metres of net, my veil, a cloud of silk tulle, the bodice was very carefully boned and stood up by itself.' The artist has pointed out the way in which the language of the letter alludes to the phallic nature of the bride, an object of supreme desire and epitome of 'otherness' to the male but who at the same time has to reassure her male partner that she does not threaten him. The fetishistic bodice which 'stands up by itself' makes good the woman's destabilising lack and deflects her sexual threat. Yet all this seems to be for her father: 'I said "Look now daddy, What do you think now?"'

Pen Dalton's print imaginatively brings together many of the aspects of drapery which I came across researching this book; desire, fetishism, the touch and sight of the cloth, commodification and social ritual. In appreciating Pen Dalton's image, I was struck by how strongly the erotic desires around cloth and gender relations which were apparent in nineteenth-century culture are still strongly embedded in the con-sciousness (and unconscious) of a large number of women at the end

The Dress
The Dress
The Dress became my first preoccupation. Until
'The Day' I had not tried it on with my veil down.
Perhaps it is special because, like female desire
and sexuality, it is a secret carefully hidden.
I found the material in a wholesalers in the depths
of the city, an Alladin's cave, lined from floor
to ceiling with rolls of silk, satin organza, and
taffeta, slubbed, raw and shot in kaleidoscopic colours.
"Layers of tulle, watered silk and sparkling diamanté were
beautifully combined with attention to those important
details which strengthen recognition of the ego ideal
and both conceal and yet prettily fetishise and displace
any hint or reminder of female castration for that special
day. The full skirt was puffed out with endless metres of net,
my veil, a cloud of silk tulle, the bodice was very carefully
boned, and stood up by itself."
This is the opportunity to indulge yourself
be looked at, be admired in knowing and willing
exhibitionism, an orgy of narcissism and repressed
desire
"This was It, and I found myself trembling and I was
relieved that my quivering lips were hidden beneath my
veil and my shakey hands could grip my bouquet. For an hour
I had been coiffed by Trisha my hairdresser, manicured by
her assistant and pandered to by a host of handmaidens"
I am sure I will never be so deliciously spoilt again
Perhaps the essence of a wedding dress is that it
belongs so much to one's engagement and those
few extraordinary hours, and because it singles
one out as the centre of attention"
I found it rather overwhelming when I snatched a
glimpse of myself looking so unlike the image
that usually met me. My father was so proud and
happy then. And I said, "look now Daddy, What
do you think now?"

31. Pen Dalton, The Dress, *photo-screen print in five colours, 1985, courtesy of the artist.*

of the twentieth and beginning of the twenty-first centuries. In a sense, the traditional wedding dress and its meanings can be viewed as a metaphor for the development of drapery in art. It seems to change so little for such a long time, precisely because it functions as a means of

securing certain cultural values which are perceived as unchanging but, at the same time, in need of preservation and reinforcing. This is what drapery did in fine art for centuries.

PHOTO AND VIDEO WORK

Many of the themes dealt with in paintings and prints of drapery re-appear in photo and video work; the ambiguities of visual represen-tation, the play of flatness and depth, the suggestion of touch through sight, the ways in which drapery functions as an interface between concealment and revelation. However there are clearly going to be ways in which photography as a medium has the potential to deal with drapery in a different manner from traditional fine art practice.

The first artist whose drapery photographs I want to discuss is the North American photographer James Welling. Welling worked on photo-graphs of drapery from 1981 to 1989, some of which were polaroids. The use of polaroids is interesting, because, for the most part, polaroids are unique photographic images and the results of polaroid camera shots can be seen almost immediately. Thus polaroids have been popular with fine artists, who use them to experiment. Polaroids are interestingly situated between the artistic 'unique' image and the everyday uses of 'cheap' photography as for example in photo-booths.[22] With the inven-tion of instant colour film in 1963, prints could be ready in seconds. Different camera sizes exist to produce prints of varying dimensions. Polaroid cameras which also produce negatives have been developed.[23] Thus some artists use small instant photos assembled on a larger sur-face, or, say, four larger prints arranged into a composition. Liz Rideal, whose work I shall discuss shortly, also specialises in photo-booth photography for her drapery works.

Welling's photographs of drapery which he exhibited in 1988, were lushly coloured dark brown silky draperies, mounted in plain wooden frames. There are no suggestions of the human figure, simply cloth. Depth, space and scale are all ambiguous, as the cloth fills the whole frame. With vague suggestions of 'all the things drapery connotes, a feeling of mortality, of elegy and also of sails, flags, bunting. . .', Welling also refers to a nostalgic farewell to the 'nineteenth century', again linking drapery and representation with the period when the emergence of modernist art has been located.[24] Of course this period was also when photography really began to take off as an artistic and commercial medium. The use of the deep, rich brown fabric hints at nostalgia and

past opulence. His images seem like still lives where everything but the drapery has disappeared and also play with our expectations of truth and illusion, since the photographic images seem so materially present, yet we know by the frames that they are constructed images, not reality. This play of illusion and reality is not the same in photographs as it is in paintings and the new, bright photographic prints do not work the same way as brushstrokes mimicking cloth on canvas. Also the ironic framing of the images and the use of polaroids undercuts the multiplicity and reproducibility (and hence supposed cheapness and accessibility) of the photograph. Welling's sumptuous photographs of drapery are like advertising images where a particularly desirable commodity is presented as a luxury item, surrounded by artistically arranged cloth, but here there is no commodity displayed, just its means of presentation. The apparatus to display desire is present, but since there is no object for us to possess, our desire is thwarted. Only by buying Welling's photograph could we approach a satisfactory solution, and perhaps not even then.

While Welling's images suggest dialogues on representation and desire, the use of drapery in Alexis Hunter's photo series works of the later 1970s links these issues with more socially engaged positions, as in *Approach to Fear: XIX: Voyeurism-Exposure*, 1978. (plate 32) Hunter's works were produced in Britain at a time when there was considerable debate concerning radical art practice, which included feminist and socialist approaches to fine art. The elitist nature of much fine art was questioned and many artists were concerned to address different kinds of audiences and represent issues which had been largely overlooked, for example, issues of cultural imperialism, sexism and exploitation. Welling, on the other hand, produced his photographs years later in the context of a New York avant-garde interested in post-modernity and notions of the simulacrum (the representation of something of which there never was an original). Also, as a woman, Hunter is concerned to start from a woman's response to drapery, though she states that the male spectator is also addressed. Because of the position of the camera/look, the spectator is invited to identify with the subject whose hands we see in the series of images. The hand explores the cloth through touch, caressing it and manipulating it to discover what lies beneath. The artist has stated that this caressed cloth is to suggest to the viewer (either male or female) that the drapery must hide a penis because of the way the feminised hand lavishes endearments on whatever is concealed.[25] As we/she watch/es this

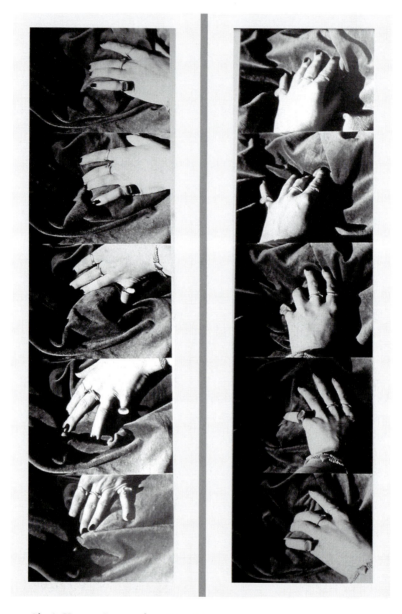

32. *Alexis Hunter,* Approach to Fear: XIX: Voyeurism-Exposure: Panels A and B, *black and white photographic sequence, 1978, courtesy of the artist.*

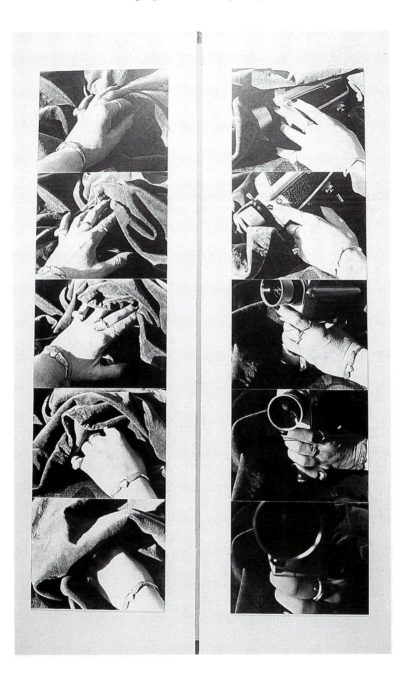

process, a film camera is uncovered and the women's hands turn the camera round to face us. From a voyeuristic pleasure (which many film and visual culture theorists have argued is male, even when experienced by female spectators), induced by watching the caresses of the manicured and decorated hand (nail-varnish, jewellery), we gradually identify with the woman, who then turns things around so that we are the photographed and she is the photographer: the object becomes subject through the voyeur being brought out into the open, captured on film and ultimately 'exposed'. The drapery is drawn aside and not only do we see what is behind it, but what is behind it sees us. So it is not the penis (or the powerfully symbolic phallus) behind the cloth; the expected object of desire or of reassurance does not appear. Instead we are confronted by a camera which will reproduce our image instead of the image of the 'other', which was supposed to position us (in)securely in relation to desire, sexuality and cultural identity. It is also important that the hand belongs to a woman who is transformed from objectivity into a participant in subjectivity.

The impressive mixture of agressiveness and sensuality is typical of Hunter's works of this period. Some of this comes from references to advertisements, which often use women's hands to make us desire commodities, to experience them through touch and possession. Hunter felt that her use of photographs which mobilised some of the same responses as advertising photographs would enable an 'easier' access to the works. There is not a lot of point in making artworks which people find incomprehensible and just cannot relate to. Hunter wanted to reach an audience used to watching TV programmes and decoding advertising images. She also manipulated the photographs' focus and depth of field in order to invite an involvement on the viewer's part in terms of changes of emotion, awareness and closeness of identification. The artist's own comments on *Approach to Fear: XIX*, refer to the abrupt blocking of the fetishistic process on the viewer's part, by the emergence of the camera's returning gaze, instead of a penis. This caressing of desired objects, or their empty packaging, occurs often in advertisements and especially in TV game shows such as *The Price is Right*, where the hands of the game-show host's conventionally beautiful male and female assistants touch the prizes in a parody of loving manipulation. The hands in *Approach to Fear: XIX* also play out a masquerade of femininity, which is then 'unmasked' as the decorated/decorative woman with hand make-up and jewels becomes liberated in the final frames by her use of the camera and her emergence as an active subject.

Themes of revelation, the sensuality of cloth and voyeurism are also important in the photographic works of Liz Rideal. Her current photo-booth works developed from her work in the 1980s, when she was involved with making public artworks. She became interested in the photo-booth at that time and went on to experiment with tossing her hair around in the booth, or throwing lengths of Indian silk fabric in the air. This resulted in interesting formal effects, which, combined with bright colour, produced striking imagery. The size and construction of Rideal's recent works varies. Sometimes over 200 small passport-size photo-booth images are combined to create a larger pattern (eg *Arras Suite Cream (Series A)*, 1996), or 2000 images can be combined to create large public works measuring 2 x 5 metres. Originals are collaged and sometimes photographically enlarged.[26] The work illustrated here is *Mme Lev* (1999), which is made up of a large C-type photograph taken from two collaged photo-booth originals. (plate 33) This work belongs to a series, entitled *Boudoir*, which comprises photographs of deep purple and red draperies, sometimes being pulled aside by a hand. *Mme Lev* has purple-pink drapes and a gold-tasselled chord which ties up the fabric like a curtain. This extremely rich and sensual image is subtly enticing, promising us an experience behind the surface with its luscious curtains. The split down the middle of the image disrupts our total belief in this seductive illusionism. The word boudoir first appeared in eighteenth-century France to designate a small room to which one can retire to sulk, a private space where you can be yourself, rearrange your personality, or just feel angry. Like the photo booth, it is a semi-private place, where people can confront or manipulate their own images and identities. One of Liz Rideal's interests is to subvert the conventions and uses of the photo-booth, designed to provide identity and passport photos, a photographic genre viewed as highly 'unartistic'. The machine itself appears to function without any human intervention in the actual production of the photographs. All the customer has to do is rearrange the drapery in front of which s/he will sit on an adjustable chair and put the money in the slot. Yet in Rideal's photo-booth works the body of the 'sitter' is hardly there at all and certainly can't be identified in the few instances when it appears partially as hair, or a hand. The *Boudoir* series was originally intended for a submission for a commission to design a safety curtain for the Birmingham Hippodrome theatre. The titles of Rideal's works are given by the artist in order to help her remember the identity of the work. Mme Lev was a neighbour, who gave the tasselled cord used in the

photograph to the artist. However by the time the cloth has been
arranged and photographed, the heavy sensuality of the colour and
visual weight of the cloth suggests an overwhelmingly claustrophobic
interior, secrecy and mystery, perhaps of a richly decorated old-
fashioned brothel, whose delights cannot be fully revealed without
payment.

The final work I want to discuss in this section is the video *Folds*
(1999) by Alicia Felberbaum. (plate 34) Felberbaum was trained in
Jerusalem and then in London, working with various different media
before she became interested in textiles. By a coincidence, a friend
inherited Anna (daughter of Sigmund) Freud's loom and this has been
used by Felberbaum in some of her work. Her interest in cloth stems
from her own experience of making fabric. The idea for *Folds* dates
from 1995, and the work was done on video and computer. As a hand
manipulates silky fabric, squeezing it and leaving an imprint on it, a
text about dressmaking appears and then fades away again. A voice
speaks, but we cannot make out the words. The shapes of cloth seem
strangely alive and material in contrast to the indistinct voice and the
imprecise text. Shapes seem to move under the drapery. The moving
images enable Felberbaum to represent processes and change, rather

33. Liz Rideal, Mme Lev, *polaroid photographs, 56 x 76 cm, 1999, courtesy of
the artist.*

34. Alicia Felberbaum, stills from Folds, *video, 1999, courtesy of the artist.*

than fixed and clear meanings. We struggle to decipher what the hand and the cloth might mean, and the language cannot fix the meanings for us. Knowledge is elusive, as the cloth is folded and manipulated, concealing or revealing. Felberbaum's idea is to create a sensual experience of sight and sound which focuses on touch, but that is the very thing we cannot do. It is no use to us to touch the screen on which the video is projected, because we will not touch the cloth whose image is projected onto the surface. It seduces us and invites us to know more, but then tantalisingly makes knowledge elusive and impermanent. The space in-between, the disjunction of language and image is where the possibility of knowledge must be searched for and worked on, according to the artist. The video is shown in a darkened space, heightening the sensuality of the experience and its potential voyeurism. Clearly with the use of sound and movement, increased opportunities to investigate aspects of draped cloth are opened up. I am somewhat surprised that more work like this has not been done. I suspect it is because the sight and touch have been much more associated with draped cloth in the past than has sound.

Photographic media allow artists to exploit another layer of visual representation and also to utilise new types of colour film which can achieve a visual sensuality perhaps even more striking than in paintings. For drapery, this is important and accentuates its seductive appeal. The invitation to touch is tantalising, either because film and video do not mimic the touch of the actual cloth, or because touching the photograph in a gallery will leave fingerprints which spoil the pristine image without delivering up the feel of the actual fabric. The photographic series, and more so the video, can suggest the movement of draped cloth as a process in time, where a kind of endless loop of drapery creates its own kind of space. For the artists, the sensual properties of artistically draped cloth continue to suggest luxury, sensuality and the fascinating nature of revelation and concealment which drapery has fulfilled in art for centuries.

WEAVING AND DRAPERY

Some of the most interesting recent work on drapery has been in artworks produced by weaving specialists. This is not surprising, as in this type of work actual cloth is used to represent drapery, in contrast to paintings or lens-based media. However recent examples of women's art concerned with drapery do not just present cloth as drapery, but

interrogate levels of representation, knowledge and gendered experience of creativity in an impressively complex way.

Weaving is part of a larger group of textile, or fibre arts, which has grown considerably in the last 25 years or so. The increase in works using fabric, textiles, threads, wool, old clothes and other associated materials is due to a number of factors. The demise of high fine art modernism, the growth of installation work and, above all, the modern women's movement and accompanying growth of feminist art from the early 1970s onwards have resulted in the re-evaluation of the possibilities of textiles and fibres in art-making. The inferior status of these materials, previously used in constructions designated as craft, as handwork rather than intellectual creations, has been largely revalidated. In addition, the nature of artworks made of fibres has been seen as quintessentially postmodern, since they are designated as hybrid, in-between con-structions – neither art nor craft, male or female.[27]

Janis Jeffries, Head of Textiles at Goldsmiths College of Art, London, which has an internationally famous MA programme in textile art, sees fabric art as linked to the feminine in its ambiguity, its lack of 'pre-occupation with correct meanings and a unified subject'. She links this to the ideas of French feminist philosophers like Luce Irigaray and Julia Kristeva, whose work is concerned to argue for a different female language (text) which can articulate the feminine in new spaces that avoid the symbolic field of male-dominated culture. Textile art is seen by Professor Jeffries as a kind of material equivalent of the fluid, productive incoherence of this feminine language, which transgresses boundaries and defies rigid frameworks. She writes that 'I do remember ideas that argued for a women's language as plural, auto-erotic, diffuse and indefinable within the structured rules of a masculine logic. It is one reason why I started to weave and then, as now, I am haunted by the spaces of an inner, dream life where the potential specificity of writing in the feminine resides.'[28] Jeffries sees the influence of feminist art practice as liberating for some men, adding 'Many male artists using cloth would appear to be in rebellion against a form of conceptual art, Law of the Father kind, which abrogated the aesthetic. Any material and intimate engagement between hands-on making, gendered bodies and partial objects seemed denied.'[29] The destabilisation of gendered practices which is embodied in textile arts, according to writers and practitioners such as Jeffries, has led them to conclude that this hybridity is enabling for men who are interested in questioning gender ideologies in society and in the field of art practice and theory.

Also interesting is the discussion on gender and textile/fabric art which can be found in the short essay by Gill Nicol, 'Fabric and Femininity'.[30] Rejecting the view that there is nothing more to say about fabric and femininity, Nicol argues that a new development has taken place in the use of textiles. Now textile work is being done by men. She speculates as to whether more men are now working with 'feminine' materials because their social and economic position has undergone important changes in recent years, with many households composed of unemployed men with working female partners. Also, more men appear to be working from home (a traditionally feminine, domestic sphere), or taking on childcare responsibilities while the mother goes out to work. Spinning, weaving and sewing were traditionally gendered as feminine domestic activities, yet it is worth remembering that the industrial revolution destroyed much domestic economic production and both male and female workers were then more or less forced to undertake textile production in factory conditions. The nature of textile production as an economic activity, rather than as a hobby, a pleasure or to keep old clothes serviceable, is not gendered in a simple, clear-cut way in any case.

However, in the present context, Nicol is concerned that the current visibility of men as practitioners of textile and fabric arts (eg Yinka Shonibare, Christo, Robert Gober) means not so much that textile arts are no longer marginalised, but that men are appropriating them – they may now be seen as valid because men do them.[31] This is an interesting point to raise, but I wonder whether this whole argument is still entrenched in the binary oppositional thinking of masculine and feminine as opposites which can be found in certain kinds of feminism. Particularly in the debates about 'feminine writing' taken over from French feminist philosophers, femininity is still seen in an essentialist way – in touch with itself, ambiguous, auto-erotic, diffuse and indefinable. Men who do textile arts are thus 'getting in touch with the feminine side of themselves' and questioning stereotypes of masculinity, but if we remain within this particular feminist framework to investigate such questions we forget that it is only *one* particular type of approach to the understanding of the relationship between artworks and gender. Male and female 'languages' of art are not innate but learned. Men who work with textiles make a decision to do so, for various reasons, not necessarily because they feel drawn to the idea of an incoherent and hybrid feminine language. For example Yinka Shonibare's use of textiles is much more to to with a critique of colonialism and imperialism than

gender. This whole debate is a complex one. However I feel that we are no nearer to breaking down gender stereotypes if we go along with the theories of Kristeva and Irigaray, who merely offer a more creative and (to some) empowering version of femininity than many other more traditional ones. I will return briefly to these issues later in relation to the textile work of the Canadian (male) artist Murray Gibson.

Even in quite ordinary families, the relationship between gender and textiles is not straightforward. When my Dad died, we were asked by my Mum which of his possessions we wanted to keep to remember him by. I wanted an embroidered tray-cloth with a woman wearing a crinoline in a garden full of flowers which he'd embroidered while in hospital during his time in the navy. I remember as a child being very impressed, because my few efforts at embroidery were pretty feeble (I much preferred playing 'cowboys' dressed up in a Davy Crockett hat my Dad made for me out of an old fur coat and a toy gun in a leather fringed holster, again sewed by my Dad). I asked him how he came to do it. He told me he was bored in hospital and that patients were encouraged at the time to occupy themselves with some therapeutic activities to while away the time during convalescence. In any case, sailors were expected to know how to sew and he showed me the little sewing and mending outfit that went with his old kit bag. However I didn't get the tray-cloth. My Mum told me that unfortunately it had been thrown away years before because it just 'wore out'. Instead, I asked for my Dad's medal he got from the former Soviet Union in recognition of the time he spent on convoys taking military supplies to Murmansk in the Second World War. I did not want this medal because of any interest in the British state's war effort, but because the medal was the only tenuous link between my Dad (a staunch Tory voter) and a workers' state, however bureaucratised and degenerate. I remembered the often heated arguments I had with him and my mother and even being told to leave the house with my two very young children after a particularly bad argument about Ireland. Of course he came out of the house after me to make sure we were all right, something my mother was too angry to do at the time. The embroidered tray-cloth and the medal weren't really principally about gender (despite the fact that the medal hadn't 'worn out' of course and had already been claimed by one of my brothers!) but were about the usual kinds of political antagonisms, ideologies and affections which sit together uneasily in most households, of which gender is only one aspect.

LIA COOK

In the next section of this chapter I want to look at examples of woven art by Lia Cook and Murray Gibson, briefly returning to a discussion of gendered notions of artmaking and also to an examination of the representation of draped cloth by means of woven cloth itself. Both Lia Cook and Murray Gibson share an interest in Renaissance art and 'old master/mistress' drapery in their woven artworks, and their approaches to this unite fine art and craft, past and present images of draped cloth.

Lia Cook was born in California in 1942 and at present works as a textile artist and teacher. Her frequent trips abroad and her research on textile history allow her to draw on an extensive knowledge of past and present work in fabrics, which she incorporates into her work. In the 1970s, her works were three-dimensional, but gradually she moved towards representing round objects and bodies in the flat format of the woven and painted image. She is interested in the way in which fabric works as a two-dimensional image (or the support for such an image) but is at the same time a three-dimensional form. Also in the process of weaving, the fibres which make up the cloth have to be manipulated in space to create the final two-dimensionality. The way in which Lia Cook constructs her recent works can be very complex. Materials include abaca (banana fibres), linen and rayon, as well as acrylic paints and polymers. Old as well as new technology is involved in the research and execution of her works, including study in textile archives, an examination of draperies in Renaissance and other historic paintings, the use of a Jacquard loom, an Apple computer with a software weaving programme and more traditional artistic tools.[32] As Cook herself remarks with regard to her works, 'Fabric is both the subject matter and the material object in itself'.[33] The way she makes her tapestries as an artistic process embodies the way representation of cloth, and cloth itself, is conceptualised. Her working process parallels the way visual knowledge is arrived at; constructing images in space, seeing things come in and out of focus, transposing concepts and images from one field to another, moving from the abstract to the concrete and back again, blending disparate elements together to achieve a totality, and so on.

The working processes for some of Cook's tapestries from the 1990s are described by the artist and by the art critic Chiori Santiago. Cook begins by painting an image of drapery with acrylics or oils on a linen or abaca surface. Abaca is a supple fibre which stands up well to shrinking and pressing, as well as being a good surface for paint. The

painting is then placed beneath warp threads (the ones which are stretched between the top and bottom) already set up on the loom. Cook paints selectively on the warp, echoing the original painted image. At this stage, by application of dark or light paint, the image can be changed, accentuating particular parts of it, or perhaps breaking it down completely. The next step is to remove the painting and cut it into thin strips which are used as weft in the finished work. (These are the threads which go across the loom.) The painting is reconstituted in the warp threads, which have been made into a pattern devised either by computer or by Jacquard loom punch cards – a practice invented in the Industrial Revolution. Thus another layer is built into the image. 'It's not just an applied image', states Cook, 'it's a physical structure.' As the painted image is rewoven into the tapestry, it almost matches up with what was originally painted, but not quite. This creates a sense of movement.[34] Cook is keen for spectators to approach the work to view it from close range, or to move away, to see the patterns change with distance like pointillist paintings or half-tone photography repro-ductions. The finished weavings are soaked in water to compact the weave and then pressed to give a burnish to the surface. Some of her tapestries representing drapery were exhibited against a mass of draped Jacquard fabric which fell from ceiling to floor of the gallery. Various levels of illusionism and representation were thus mobilised within and between the tapestries and woven fabrics and many connotations of drapery (as curtains, veils, surface, clothes) were alluded to. Plate 35 shows a 1996 version of an installation originally exhibited in 1993. The installation measured 398 x 976cm and was made up of six individual pieces framed by draped curtains of specially woven material representing drapery folds. These represented folds were then sub-sumed in the actual folds of the curtains as they hung in the gallery. The six pieces (clockwise from top centre) are *Material Pleasures: Artemesia*, 1993 (top centre), *Material Pleasures: Leonardo II*, 1993 (top right), *Material Pleasures: Leonardo I*, 1992 (bottom right), *Two Lovers*, 1993 (bottom centre), *Material Pleasures: Giulio R*, 1993 (bottom left) and *Material Pleasures: Dürer*, 1993 (top left). This impressive installation was intended to explore the meanings of drapery as subject matter in its own right, as opposed to merely a part of a larger image. The artist writes:

The *Material Pleasures* work has several meanings. . . First connecting to the history of painting and the hierarchy of subject matter by referring to Salon

style painting display and the draped painting. The second reading refers to
the sensuality (our experience) of cloth and the pieces can also be read as
windows providing glimpses into an erotic/sensual/perhaps bedroom scene.
The actual drapery was made especially for the piece and contains images of
drapery folds (these are not exactly readable when the drapery is drawn back
to expose the paintings/weavings).[35]

This implies that the installation can also be viewed with the drapery-
image curtains closed, when the viewer is confronted with a screen of
different levels of representation of folded curtains, denying her/him
the pleasure of satisfying the desire to look and enjoy. A distinctly voy-
euristic element is present in the work, as there is perhaps in viewing
any artwork, but this is heightened here by the ways in which the folds
in the tapestries mimic the folds of skin and orifices of bodies and by
the inclusion of the tapestry of *Two Lovers*, whose feet can only be
briefly glimpsed before a curtain seems to move to conceal them from
our gaze.

 Another example illustrated here, *Point of Touch: Bathsheba*, 1995,
(plate 36) measures 117 x 155 cm and is executed in a rich, but
restricted colour range. A nude female figure shown in various hues of

35. Material Pleasures, *drapery installation, 1996 version of 1993 original, 398
x 976 cm, acrylics on linen, dyes on rayon, Jacquard fabric, courtesy of Lia
Cook.*

pink, tentatively holds a drapery which is also pink with hints of apricot and cream. A repeating pattern of white hands with outstretched fingers on a darker ground crosses over the image until it reaches the body and drapery, when the dark ground seems to disappear. The elaborate process of making has meant that the different levels of imagery mesh together, having been painted, dismembered, reassembled and incorporated in a greater totality. One writer has referred to Lia Cook's work as an example of weaving as an epistemology, an investigation into knowing.[36] The play between two and three dimensions in the image becomes a way of articulating the different levels of knowledge and meaning. In turn, this can be exhibited against another larger drapery hung in the exhibition space which becomes an additional level. Cook incorporates elements of so-called craft (weaving) with fine art (painting) in the same image. Both are necessary for the finished image; neither is seen as inferior to the other. In her more recent and equally impressive work, Cook continues to investigate the sensuous ambiguities of drapery as embodied and represented in the woven image, for example in *Presence/Absence: In the Folds* (1997), where at one

36. Lia Cook, Point of Touch: Bathsheba, *linen, rayon, oil paint and dye, 117 x 155 cm, 1995, collection of Oakland Museum of Art, California, courtesy of the artist.*

point the artist's face emerges and dissolves in the crumpled folds of
the textiles.

It is useful to say something about the kind of subjects Cook has
represented in her drapery tapestries, in order to relate them to both
art historical traditions of drapery and to notions of what constitutes
the feminine. In the early 1990s, Cook began a series of tapestries
entitled *New Master Draperies*. This included representations of drapery
from works by Michelangelo and Dürer and Leonardo's drapery studies
which I discussed earlier in this book. These draperies seemed to float
in the representational system of the cloth weave, literally material, yet
curiously insubstantial, growing more or less plastic and three-
dimensional according to the viewer's distance from the image. Scale
and space became uncertain and shifting. The draperies themselves
were painted a mixture of blue, pink and orange. In 1992 a six-panel
frieze, entitled *Drapery Frieze: After Leonardo*, was completed, measur-
ing 165 x 610cm. The series *Material Pleasures*, from 1993, has already
been discussed above. A *Loin Cloth* series from 1995 included the
central regions of male bodies in draped loincloths and *Point of Touch:
Bathsheba*, is from 1995.[37] While Cook is interested in a number of other
drapery and fabric traditions, it is clear that one of her aims is to
mobilise the connotations of 'old master' and indeed also 'old mistress'
drapery, by alluding to Renaissance (and later) studies of draped cloth.
While some of these draperies are uninhabited, others cover the legs,
surround the waists and conceal the hips and genitals of male and
female bodies. Like many other artists who deal with drapery in their
work, Cook is concerned to bring the messages and meanings of cloth
from the background into the foreground and this is what her images
physically do. Reiterating a desire which is often expressed by drapery
artists she states 'I like taking drapery, which is usually in the
background and moving it to a position of centrality.'[38]

Some of the images relate to works by Artemesia Gentileschi, whose
impressive paintings representing Old Testament female biblical figures,
such as Judith and Susanna, and heroic classical figures, such as
Cleopatra and Lucretia, explore, among other things, the relationship
of draped cloth to the body. Gentileschi's traumatic experiences, rape
by one of her father's associates and an ensuing trial, as well as her
accomplished body of work, has made her a well-known icon for
modern women art historians.[39] Many of the female figures represented
in Renaissance and baroque paintings are ambiguous in their meanings.
Bathsheba, for example, was represented as a figure with unstable

meanings, either a slut or an innocent woman wronged, whose only 'crime' was to be lusted after by King David. The story is recounted in 2 Samuel, 11, verses 2–27. King David ogles a woman, unaware of his voyeuristic gaze, washing herself on the roof of her house. He summons her to the palace to sleep with him. When he discovers she is pregnant, he has her husband sent to the front in battle, where he is killed. In order for Bathsheba to be blameless, King David must appear a villain and this was clearly unlikely to happen in a predominantly Judaeo-Christian Europe. Bathsheba's beautiful body is the cause of her husband's death. In Cook's tapestry, her hands are shown pulling the drapery towards her in a gesture of concealment, rather than an attempt to display herself.[40]

Writing of her pleasure in viewing Lia Cook's works, Janis Jeffries describes her seduction by 'luscious' folds of drapery which allow her a place to enjoy feminine pleasures of looking, avoiding 'the single, climactic moment of male consummation which operated inside and outside the picture frame'.[41] It seems to me that this reading is a personal one, rather than one with a wider social or gender validity. The images based on drapery executed by Artemesia Gentileschi do not to me seem dramatically different in their composition when compared to those based on works by Leonardo or Dürer. 'Single climactic moments' appear in the narrative and spatial arrangements of Renaissance and baroque paintings due to workshop training and artistic conventions and thus they will look similar in the works of male and female artists. However Jeffries' comment does raise an interesting question about the ways in which Lia Cook's works can address different kinds of spectators, many of whom will bring their own experiences of art, work, sexuality and cloth to the readings of these intricate and absorbing works. Also interesting is the question of whether tapestry works by male artists can also embody examples of 'feminine language/writing'. The short answer is yes, if the concept is one anyone of whatever gender can read about and agree with in French femininist philosophy; or no, if 'feminine language/writing' can only be produced by actual biological women.

MURRAY GIBSON

Murray Gibson is a textile artist, now resident in Canada, who has been weaving tapestries since 1985. In 1992 he and his wife moved to London; she to work on a Ph.D. in Italian Renaissance art and he to

undertake an MA in Textiles from Goldsmiths College (1995). As a male
student, Gibson felt he had to rethink his approach to weaving and
engage with the theorisation of weaving practice as a potential example
of 'feminine language'. At first Gibson felt disorientated, but as a way
forward he began to explore basic questions of identity which enabled
him to 're-identify myself and participate, but still as male, within a
feminist dialogue of textile art practice.'[42]

It is worth pointing out here once again that it is by no means simple
to tease out the gendered relations of textile production, both artistic
and commercial. At various points in history and in different societies,
the relationship of men and women to the making of textiles has altered.
Perhaps it also matters what particular form of textile production we
are speaking of. Knitting, for example, appears to be much more firmly
associated with women, whereas weaving has been carried out by both
men and women in various historical periods. For example in early
Greece women produced clothes for the family, but men made cloth
for sale in the market. In Mexico and Latin America, both men and
women weave but use different looms.[43] Thus while many women are
employed in textile production, and are discriminated against in terms
of equality of opportunity and pay, this does not prove that the making
of textiles is intrinsically 'feminine'. Murray Gibson's research into
attempts to theorise textile arts as an example of 'feminine discourse'
resulted in a series of works on the theme of the *Annunciation* (plate
37) and a written dissertation, on which a later published article was
based.[44]

The series of five small tapestries by Gibson (each 50 x 35 cm) is in
blue wool with black borders top and bottom. Points of shiny gold
cotton seem to float on the surface and create an impression of another
transparent plane in front of the draped folds. Gibson intended the
different drapery arrangements to approximate the mental state of the
Virgin Mary as she passes from agitation to acceptance of God's will
during the process of the Annunciation, when an angel appears to her
announcing that she will bear God's son. (The five works/states of mind
are entitled (in Latin) 'Disquiet'; 'Reflection'; 'Inquiry'; 'Submission';
and 'Merit'.) In these works, the forms of the drapery express the mental
state of the holy woman touched by the divine, in a similar way to the
baroque drapery on Bernini's statue of Saint Teresa. It is at this very
time that she becomes pregnant, according to the Bible. The tapestries
also therefore are visual metaphors for the process of conception. The
titles are derived from the 'stages' Mary experiences according to a

37. Murray Gibson, Conturbatio, *first of a series of five* Annunciation *tapestries, wool and cotton, cotton warp, 50 x 35 cm, 1996, courtesy of the artist.*

sermon delivered by a fifteenth-century Italian priest.[45] The artist's interest in Renaissance art and the drapery found in paintings of the period is also important for the 'look' of these works. Blue is the traditional colour of the Virgin Mary's robe in Renaissance painting, and gold was often added to images representing her to connote veneration and majesty, as the pigment was very expensive. The flecks of gold which seem to hover over the surface could also be interpreted as semen. Gibson used photographs he took of arranged draped blue velvet in order to design his tapestries, which were intended to be small, precious objects of desire and consumption.

The tapestries were exhibited in a corridor illuminated by candles. Polished brass plaques hung opposite the tapestries and at both entrances/exits to the corridor. Viewers could see their own reflections in the plaques, as well as the tapestries hung behind them. Engraved on the plaques were words posing important questions of identity and address: 'WHO' 'ARE' 'YOU?' and 'WHO' 'AM' 'I?'. 'ARE' and 'AM' were on the same plaque, a coming together at the point of 'being', as the artist puts it. Some of the words were printed in reverse 'as if it was your own reflection posing the question from outside your corporeal identity'.[46] Thus questioning of identity, subjectivity, positioning and gender are built into the work.

In his article explaining his research for this project, Gibson investigates the construction of the feminine as 'other' and describes Luce Irigaray's proposals for an emergence of true feminine subjectivity through a distinctive feminine language. Part of this process involves a concept of 'the divine' which is made in woman's image. Then she can find a new identity and place from which to speak. This was clearly of interest to Murray Gibson, as he thought of how the Virgin Mary was instructed by a male God and did what she was told. How different would things have been with a female deity? As an atheist, I obviously do not go along with Irigaray's argument that female goddesses would be more progressive. However as a strategy for interrogating the nature of femininity and 'otherness' in textile art, Gibson's *Annunciation* tapestries are very successful. What is really interesting though is that the draperies are named after Mary's (supposed) mental states. But we don't see what they are, which would obviously be virtually impossible. These mental states are at the same time covered over and expressed by the movements of the cloth. But can we know what she thought? Did she ever exist anyway? Did the Annunciation ever happen? The draped cloth is still a curtain which hides mysteries which human beings make up to make sense of the world, rather than the prelude to a divine revelation. Perhaps the drapery also hides the essential femininity, the source of feminine creativity and language. Yet if the curtain were pulled aside, perhaps this femininity would prove to be a disappointment – merely another cultural construct rather than an essential truth.

CONCLUSIONS

Despite my initial suppositions, I discovered that drapery still played a significant role in many contemporary artworks. While some of this interest in cloth and drapery is specifically linked to women's art production, this is not exclusively so. An understanding of gender oppression and openness to rethinking ideological gender boundaries is far more important than biological gender in the production of interesting artworks dealing with masculinity and/or femininity in relation to drapery. Without a close consideration of the specifics of gender in relation to textile production in particular societies at particular historical periods, we can be left with generalities about women and textiles which are themselves somewhat ideological in nature. It was interesting to me that no writers bothered to discuss

textile and gender in relation to projects by Jeanne-Claude and Christo. Perhaps this was because they are a man/woman 'team', their work is not associated with the intimate or the domestic and it does not encourage an engagement with debates about public/private (their work is all public and usually on a large scale) or the hierarchies of art/craft production. Artists working in collaborative teams or couples, also disturb the notion that the artwork 'expresses' something personal about the maker, for example, the experience of being a man or a woman. The processes and techniques used in their projects are not obviously gendered, since they do not personally construct the large-scale works based on their sketches and models.

Other types of works concerned with drapery refer to art historical traditions and mobilise connotations of age, prestige and high culture, at the same time as engaging with contemporary issues and new media. However more significant in the use of drapery in contemporary art is an overt concern with eroticism and the body, whether the body is actually included in the image or not. The drapery becomes a focus for sensual investigations around voyeurism and fetishism. The drapery itself stands in for the absent body and at the same time can function as a 'surface' for the play of modes of representation and illusion, as we also saw in Chapter 2 in the paintings of Alison Watt.

Interestingly, this allows drapery to be both modernist and post-modernist, at the interface of figuration and non-figuration, in ways which are denied to images of the body itself. Drapery allows the artist to work with approaches to abstraction without becoming totally non-figurative. Thus the many connotations of drapery, eg luxury, excess, concealment, display, art historical tradition, can be offered suggestively to the spectator and further developed. The representation of drapery allows the sensual enjoyment (and production) of simple, yet rich, forms, without the emptiness of formalism. In weaving and textile art, cloth itself is used both to represent drapery and examine modes of representation, while re-thinking the uses and picturing of drapery from the past, sometimes in relation to perceptions of gender.

Perhaps surprisingly, drapery is far from dead in contemporary fine art and is of major concern in artworks in a variety of media. In the following, final, chapter, I want to look outside the contemporary fine art sphere, to investigate the meanings of drapery in contemporary news photography. This is where the tension between the civilised, classical heritage of drapery and the presence of drapery in representations of contemporary society reaches such a point that it can barely be contained.

CHAPTER 6

THE DRAPED BODY AND NEWS PHOTOGRAPHY

The photograph is positioned tantalisingly between reality and art, high and popular culture. The prestige of the fine art photograph exists in uneasy tension with the potential of its reproducability. Photographs displayed in the Tate Modern by artists like Cindy Sherman and Nan Goldin with their saturated colours remind us of films and seductive advertisements. Despite postmodernist theories of surface without depth, image without reality, there continue to exist photographs whose main purpose is to present us with images of what happens in the real world as it happens – news photographs.

It is a generation now since John Berger in the *Ways of Seeing* book and television broadcasts commented on the disjunction he perceived in magazines and newspapers between the world of advertising and the world represented by photojournalists documenting wars, torture, massacres, starvation and many other human and 'natural' disasters. As Berger and his co-authors put it in 1972, commenting on the juxtaposition of a photograph of Bangladeshi refugees and an advert for Badedas bath products: 'The shock of such contrasts is considerable: not only because of the coexistence of the two worlds shown, but also because of the cynicism of the culture which shows them one above the other.'[1] He argued that readers of newspapers, especially weekend supplements, have to make a conscious effort to dislocate these images from visual registers and contexts which make them look interchangeable, in order to understand why these images exist and how they are produced. Berger believed that it was possible to understand these different types of images and relate them to the real world where thousands of people die of starvation and curable illnesses every day, while distancing them from seductive images which address the spectator as consumer. In the early twenty-first century, not a great deal has changed in terms of the co-existence of glossy advertising fantasies and images of death and disaster. One thing that has changed, though, is that Berger's approach is not

considered radical any more, but old-fashioned and unsubtle. In the era of postmodernity, radicalism consists in being able to playfully construct our subjectivities through consumerism and marvel at the way in which globalisation has unified us all as international consumers of cigarettes, soft-drinks, etc.[2] Digital information technology and manipulation have displaced photojournalism. One key image is marketed world-wide, rather than a photo-story told in different ways. Photographers themselves doubt whether their photographs of tragedies and atrocities will change anything.[3] Investigative photojournalism and globalised postmodernity do not sit well together.

However in this postmodern kaleidoscope of playfully constructed and multiple subjectivities, it is ironic that the focus remains on the individual self who surveys the subjectivities of others – poor, tortured, murdered or just unlucky enough to be born in an imperialised country. In Roland Barthes' well-known meditation on photography as desire and death, *Camera Lucida*, written shortly before his own death in 1980, Barthes wonders why he doesn't care about the suffering of others he sees represented in news photographs:

Trying to make myself write some sort of commentary on the latest 'emergency' reportage, I tear up my notes as soon as I write them. What – nothing to say about death, suicide, wounds, accidents? No, nothing to say about these photographs in which I see surgeons' gowns, bodies lying on the ground, broken glass, etc. Oh, if there were only a look, a subject's look, if only someone in the photographs were looking at me! For the Photograph has this power – which it is increasingly losing, the frontal pose being the most often considered archaic nowadays – of looking me *straight in the eye*. . .[4]

Basically, if these people don't address us, don't notice us, why should we recognise their misfortunes? Barthes' own subjectivity needs to be acknowledged before he can feel engaged. But why should car-crash victims, refugees, survivors of an earthquake or those murdered in an attack motivated by so-called 'ethnic cleansing' care about some European philosopher's subjectivity, or his contention that all photo- graphs are about death? There are philosophical ideas about death and photographs, and there are real deaths and photographs.

DRAPERY, ADVERTISING AND PHOTOGRAPHY

In advertising photography, drapery still connotes class, high culture

and taste. Commodities associated with drapery in advertising photo-graphy are like meticulous still lives painted in oils, where the draped cloth sets off the products and presents them as elegant and tasteful. The body can be treated in this way as well. In an advert which appeared in 1999 for Vivienne Westwood's perfume *Boudoir*, a naked woman with the central area of her body covered by a silken sheet of fabric, seems to float in the sky with her eyes closed. The pinky-mauve coloured sheet billows out behind her head in carefully draped folds. Is this the assumption of some saint, an apotheosis, or an ecstatic vision or dream brought on by the use of Boudoir perfume? The perfume bottle appears in the lower right of the image, its stopper formed in the shape of an orb surmounted by a cross. A kind of baroque sensual ecstacy surrounds the woman and the commodity.[5]

Adverts for *Silk Cut* cigarettes have for years exploited the associations of silk – elegance, softness to the touch, natural good taste and so on. The slashed fabric stands in for the name of the cigarette, but also hints at a damaged body, violated by an attack. Alternatively readings by those concerned about smoking might include a view of the cut fabric as a body opened by a surgeon's knife. Despite this, the advertising campaign has succeeded in giving Silk Cut cigarettes an elegant and tasteful image, although they are at the cheap end of the market.

On the other side of John Berger's famous dichotomy hinged on advertisements in magazine and newspaper images, are photographs of disasters, acts of horrific barbarism, victims of famine and persecution of various kinds. They are clothed in rags, blankets or shrouds, covered with sheets of cloth or plastic. They are the draped bodies of the post-modern world. They no longer connote civilisation and high culture but poverty, barbarism and 'third-worldness'.

In past times, dead bodies were draped and shrouded, carefully attended to in better-off families, or thrown into paupers' graves. In the present-day, in richer imperialist countries, dead bodies are normally carefully tidied up, put in coffins and hardly seen. However in many other countries civil wars, famine, disease and 'natural' disasters mean that dead bodies are much more visible. There is a new kind of Orientalism which includes all non-imperialist countries, including Africa and Latin America, as well as the poorer countries of central Europe and the Balkans. Indeed Orientalism was always really about imperialism, despite Edward Said's argument that it was all about East and West.[6] Algeria, Kosova and Rwanda are only three cases which I'll be looking at briefly here, but clearly there are many more. When

drapery appears in images of these countries, its connotations of elite culture and classical values are seriously destabilised.

CIVILISATION AND BARBARISM

Walter Benjamin, the German cultural historian and critic, wrote on two occasions in the later 1930s after the Nazis had come to power in his homeland that 'There is no document of civilisation which is not at the same time a document of barbarism'.[7] Benjamin argues that under capitalism, every cultural product examined by the cultural historian exists on the basis of the suffering and exploitation of others. 'For without exception the cultural treasures he surveys have an origin which he cannot contemplate without horror. They owe their existence not only to the efforts of the great minds and talents who have created them, but also to the anonymous toil of their contemporaries.'[8] To Benjamin, writing under the shadow of fascist repression, this politicised view of culture, its origins and its transmission, did not seem at all exaggerated. It corresponded to was what was actually happening at the time. However even in 'normal' bourgeois society and culture, civilisation and barbarism co-exist. This contradiction and co-existence does not depend on an extreme political situation. This is why I want to use Benjamin's thesis, although interpreting it in a slightly different way, and argue that, in representations of the draped body and drapery in contemporary adverts and news photographs, what we see are representations of civilisation *and* barbarism. There is one kind of barbarism in the photographs of massacred bodies and grieving victims, but there is another which exists behind the glossy images of commodities in contemporary advertising. In the cigarette adverts we obviously do not see the suffering of cancer victims (they choose to smoke but the cigarette companies do not pay for doctors, drugs or hospitals to treat them), the effects of pesticides on the workers in the tobacco plantations, the experiments on animals, or the way thousands upon thousands of new addicts are created in imperialised countries by the marketing strategies of the big tobacco monopolies. Drapery epitomises for me the co-existence of civilisation and barbarism in contemporary mass culture and its representations.

HOCINE'S PHOTOGRAPH: 'THE MADONNA OF BENTALHA'

On 24 September 1997, newspapers published a photograph by Hocine

accompanied by accounts of the latest in a long series of massacres in
the Algerian civil war. (plate 38) In the Bentalha neighbourhood of
Baraki, an eastern suburb of Algiers, at least 200 people were murdered
and another 100 were wounded. Many of the victims had their throats
cut. Allegedly a massacre carried out by Islamic fundamentalists
opposed to the government, this attack took place over a period of four
hours within a short distance of an army barracks. No soldiers arrived
to protect the civilians.[9] The Algerian photographer, Hocine, explained
how he came to take this photograph of a grieving woman outside the
Zmirli hospital where the dead and wounded had been taken. A crowd
consisting mainly of screaming women had gathered outside. A woman
slid down a wall, almost fainting, as she heard of the death of several
relatives. 'It was then, just before 12.30pm on September 23rd, that I
photographed the anonymous woman who later became known as "the
Madonna of Bentalha". As I took her picture – five or six frames in all
– amidst many other crying women, my only concern was to produce
a photographic document about the pain of the Algerian mothers in
the face of the massacres we are living through.'[10] The press had been
forbidden to take photographs, and a security guard removed Hocine's
film, fortunately after he had swapped the film in his camera for a blank
one. The image, shot without the woman's permission, which in the
circumstances was not surprising, was soon transmitted around the
world. The woman herself, Um Saad Ghendouzi, later explained the
problems that had been caused by the image. When the picture was
broadcast on the Algerian news, a commentator mistakenly stated that
she was mourning her eight children. Her neighbours became
suspicious, since they knew her children had not been killed and in
the atmosphere of suspicion and fear, some even accused her of being
a terrorist sympathiser.[11]

The jury of nine professionals from the field of press photography
selected the photograph as 'World Press Photo of the Year'. The chair-
man of the jury wrote 'The winning photograph has been praised as a
masterful, painterly image of great skill and vision. But it becomes even
more important if we see it as a tool which can help prize the truth
from the tragedy that is Algeria today – a truth which many would
prefer to keep hidden.'[12] World Press Photo is a non-profit-making
organisation, founded in the Netherlands in 1955 to promote the work
of photojournalists. The photographs entered in the annual competition
are shown in an exhibition which travels to more than 35 countries
every year. While the organisation is nominally independent, it should

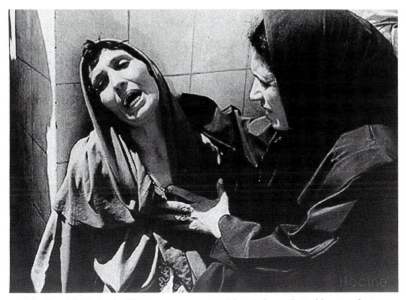

38. Hocine, El Harrach: Woman overcome with grief comforted by another woman who lost her parents in a Massacre, Algeria, *1997, copyright Hocine, Agence France Presse.*

be noted that it is sponsored by Canon, Kodak Professional and KLM Royal Dutch Airlines.

By the time the photograph arrived in exhibition (*Eyewitness 1998*) in New York and Los Angeles, it was referred to in the press release as *The Madonna of Bentalha.*[13] The grieving Muslim woman has become a Christian religious figure, as if mourning a murdered child like the Virgin mourning Christ. She is likened to figures in Renaissance artworks, in Pietàs where the dead Christ is accompanied by his mother, or perhaps slumped at the foot of the cross conforted by one of the other New Testament holy women. It is not clear if Hocine himself had referred to the woman as a Madonna first, or took up the name when the photo became known elsewhere. One admirer wrote: 'It [the photograph] uses the cloaks and hoods of the women, lushly textured, warmly coloured, as though it were a renaissance painting. Hocine – whether knowingly or not – saw reality echoing art.'[14]

It is not difficult to see how this image recalled Renaissance art for many European and North American viewers. The look on the woman's face and the gesture of her companion seem as if they have been taken from some pattern book of facial and bodily gestures representing emotions in all their essential purity.[15] The headscarves and long coats

of the women in blue and shades of brown resemble drapery far more than do 'western' fashions and tailored clothing. The women are at the same time part of a specific event and yet removed from it by the photographer's selected view and isolated against a neutral background. This scene, akin to classical tragedy, is not classical at all though, despite its appearance. The barbarism which lurks within culture in class society is present, though not represented. It is not my intention here to criticise the photographer or his work, for which I have great admiration. As we shall see shortly, it is a life-threatening occupation to be a journalist in Algeria. However if we contrast this with one of the runners-up in the competition, an anonymous photograph of the body of a dead child with its throat cut being pulled out of a well with ropes, it is hard to see how anyone could compare this to a document of 'civilisation' like a Renaissance painting. The child was one of seven women and children who had been murdered and thrown down the well after being decapitated or having their throats cut.

In Hocine's photograph, the draped women look similar to those seen in works by such painters as Giotto and Leonardo and thus, for Western viewers perhaps more so than others, a whole tradition of 'artistic' drapery and its connotations is mobilised. The viewer oscillates between meanings associated with high art, Biblical narrative and European cultural tradition and those associated with contemporary violence, political terrorism and Orientalism.

THE CIVIL WAR IN ALGERIA

Despite, or perhaps even because of, the way in which it was compared to Renaissance Madonnas, Hocine's photograph did contribute to an increase in the reporting of the events in Algeria. Despite the fact that a civil war had been going on since the early 1990s, most people in Europe had ignored it. The context in which Hocine's photograph was taken is, of course, vitally important to understanding its meanings, which vary according to a number of factors. Clearly, different viewers will bring different perspectives to the image. Also the reading and designation of the image as 'a Madonna', which seems to have happened mostly outside Algeria, contrasts with the response of some in the woman's local community, who seemed very suspicious about her appearance on the national news and did not particularly see her as a tragic figure. Perhaps this is because she is only one among thousands of bereaved relatives in Algeria.

The political violence in Algeria can sometimes appear totally incomprehensible. To people outside Algeria without much knowledge of Algerian history and politics, recent events in the country cannot really be understood. It is necessary, therefore, for me to briefly provide some information on the recent political and economic history of Algeria, the position of women and the situation of the press and news photographers.

After Algeria gained its independence from France in 1962, the FLN government formed what was virtually a one-party state. The economy was capitalist, but with many enterprises owned by the state. The increasing lack of any political voice for many in Algeria, accompanied by growing unemployment, resulted in a large number of people turning to Islamic opposition parties. The main Islamic opposition, the FIS (Islamic Liberation Front), is a deeply reactionary party, seeking to reduce the role of women in society to producing Muslim men and staying at home. In a situation of massive unemployment for young men, there were thus powerful material reasons why many espoused Islamic politics. Furthermore, the FIS leaders (such as Ali Belhadj) condemned notions of social and political freedom as 'a poison put about by Freemasons and Jews' and continued: 'If the Berber is allowed to speak, the communist will speak too, along with everyone else. . .'[16] In the first genuine multi-party elections since independence, the FIS gained popular support and the government cancelled the second round of elections.[17] From 1992 until the present, a civil war has been taking place in Algeria, with probably around 100,000 people being killed. Many of these have been murdered by Islamic terrorists, but there is also evidence that the military have been responsible for massacres, as well as the torture and murder of people suspected of being terrorists.[18] By now, most of the population trust neither the Islamic opposition nor the government.

Under pressure from international capitalist organisations, the World Bank and the International Monetary Fund, the Algerian President Abdelaziz Bouteflika offered an amnesty to opposition militants and has been persuaded to incorporate so-called 'moderate' Islamic oppositionists into the government.[19] The Armed Islamic Group (GIA) has rejected the deal and has vowed to carry on fighting, whereas the AIS, the military wing of the Islamic Salvation Front (FIS), has largely accepted. Demonstrators, mostly women, have objected to amnesty for those whom they strongly suspect of having killed their families.

The position of women in Algeria, even without an Islamic party in government, is dismal. The family code of 1984 discriminates against

women, giving them the legal status of minors. A divorced woman becomes homeless and has no right to her previous dwelling. Divorced and separated women can have custody of their children up until the age of ten for boys and 18 for girls. If the woman remarries, she loses custody of her children. Abortion is illegal except in a few extreme cases such as rape and incest.[20] The majority of illiterate people in Algeria are women. During the civil war, large numbers of women have been abducted and raped by armed terrorists (an estimated 2,000) and usually ostracised by their families if they manage to escape. The fate of another 319 abducted women is unknown.[21] Thus Hocine's photograph, focusing as it does on women as central victims of the conflict, is accurate in its emphasis.

Although Algeria has large gas and oil resources and should be a wealthy country, its people are mostly poor and many are unemployed. The foreign debt is huge – US$32.6 billion in 1995, 83% of GDP. Western petrochemical companies, Agip, BP, Mobil, Total, Elf and Exxon exploit the world's 14th-largest reserves of oil and fifth-largest reserves of natural gas.[22] Large numbers of workers have not been paid for months, and there have been many strikes against the privatisation of state-owned industries decreed in response to IMF pressure. Increasingly common is the practice of selling human organs to pay off debts. According to one newspaper, *El Moudjahid*, this is happening even in middle-class families.[23]

The conditions for news reporting in Algeria are abysmal. Journalists have to work in a fortified old barracks and even then do not feel safe. Seventy journalists, photographers and associated staff have been killed since May 1993 by Islamic terrorists. In addition, the government censorship and persecution of independent papers makes work almost impossible. One woman working for the paper *El Khabar* pretends to her family she works as a hairdresser. A woman journalist, Saihi Horria, who made a programme about another woman who had been tortured and gang-raped by Islamic terrorists, has received death threats. Since she lives with her partner and is not married, extreme right-wing religious activists find her doubly offensive.[24]

In the context of the suffering of the Algerian people, especially the many women and children who have been killed in the civil war, Hocine's photograph could indeed be seen as having a religious significance. However it is interesting that, as Hocine himself has pointed out, the woman has become referred to as 'a Madonna', a figure from Christian religious mythology, rather than as an Islamic figure.

While a number of accounts of the Algerian situation which appear in news reports in imperialist countries imply that the war and killings are the fault of Islamic beliefs and equate Islam with terrorism and barbarism, less attention is paid to the economic and political pressures from international capitalism which are at the root of the problem and created the conditions in which many turned to Islamic political parties. Despite Hocine's aims, the danger is that viewers in imperialist countries will view his image of Um Saad Ghendouzi through 'Orientalist' eyes, feeling sympathetic and shocked but not realising that this draped, 'Renaissance' figure is grieving due to a situation brought about primarily by European and US exploitation of her country's natural and human resources, not because of some inherent barbarism of Oriental cultures.

KOSOVA

I want to look now at a photograph taken of massacre victims from the town of Prekaz, which was bombed and then invaded by Serbs between 6 and 8 March 1998. (plate 39) This particular photograph was published in newspapers and journals and was also available for viewing on a website.[25] Over 80 people including children were killed, houses burned and many homeless people became refugees and fled from the town. The Serbs removed the bodies, whom they claimed were all dead KLA fighters, before they allowed any foreign journalists into the town. The bodies were numbered and lined up in a construction material depot in Srbice where this photo was taken. Serb officials claimed the children were shot by the local KLA leader as he did not want anyone to surrender. 'That story was hard to believe, looking at the traumatised features of a dead toddler wrapped in a woollen blanket and laid out on the floor of the shed.'[26] Relatives of the dead wanted independent observers to examine the bodies and perform autopsies in the hope of finding evidence to confirm that a massacre of civilians had taken place. The Serbs had threatened to throw the bodies into a communal grave pit unless the funerals were arranged quickly.[27]

Alex Majoli's photographs of the dead resemble the images taken of dead Communards after their defeat by the French state forces in Paris in 1871. The photographs of these dead were put to various uses and their meanings changed according to developments in the social and political situation in France and, not surprisingly, the political sympathies of those who bought copies of the photographs.[28] Similarly,

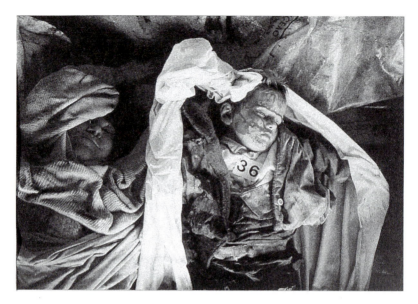

39. Alex Majoli, Victims of the Massacre at Prekaz, Kosovo, *1998, copyright Magnum Photos.*

various meanings were also constructed around the photos of the massacred Kosovars, including that illustrated here, where Blerim Zemë Jashari, a six-year-old boy, lies dead with the number 36 stuck on his bloodstained clothing, surrounded by drapery composed of a length of cloth and plastic sheeting. Sometimes evidence of Serb massacres was used by Western politicians and their press spokespeople to gather support for NATO bombing of Serbia, or to argue that arming the KLA would only result in more deaths of innocent civilians. However the website where this photograph and many other more horrific ones were displayed was mainly intended to demonstrate to the outside world that these and many other massacres had taken place. The website was an attempt to circumvent the press censorship and intimidation of journalists by the Serbian police and military. Interviews with survivors and eyewitnesses, details of the dead wherever known, maps and statistics accompany the images. In situations where the Serbs tried to remove bodies and obscure what had actually happened (as was also the case with the massacre at Recak in January 1999), the bodies and visual images of them become crucially important. This is why the website and photographs are so significant. They are literally bodies of evidence. The relatives also put themselves at risk to come and

identify the bodies and demand their return, despite assurances of safe passage by the Serbian authorities.

However awful this photograph of two murdered children is, it is not the worst. The small bodies look quiet in death, surrounded by draped cloth and plastic. (The bodies lined up on the floor had already been by the Serbians and all covered with a long piece of cloth.) It might be compared to some Renaissance source, if it was my intention to relate it to some stylistic and artistic precursor.[29] However what comparisons can I make with art when I look on page 17 of the website and see a photograph of Rukie Nebihu, pregnant mother of two (the caption states), with her face blown off? Or page five where a man's dead body lies next to a charred stumpy thing, which is all that remains of a burned person?

Given the large numbers of people in Bosnia and Kosova attached to a greater or lesser degree to the Islamic faith, it was always likely that some European observers would view the conflict as a typical 'Balkan' issue with lots of little nations squabbling, or even through Orientalist eyes. Some, even on the left, maintained that the KLA, the Kosovan Liberation Army, were terrorists and drug-runners. However other journalists were more to the point when they stated that 'the basic paradigm should not be that Kosovo is a typical "Balkan" issue. It is colonialism in the heart of Europe.'[30] When UN peacekeepers were sent in to police the situation some of their senior personnel showed this colonial mentality quite openly. As a British national newspaper reported:

Western states are being pulled into a Bosnian-style operation where an almost colonial-style rule has been imposed on people who cannot live together.' I call it adult supervision,' said one senior British observer with experience in Bosnia. . . 'Our attitude is not patronising to either the Serb units or the guerillas,' said Brig[adier] Hunter-Choat. . . 'We are simply trying to persuade them not to do something silly.'[31]

This all seems rather familiar. Oppressed people who are not allowed political independence, or independent military power, have to be 'looked after', because they are immature, by those who know better. Orientals, Balkans and children (and the British government's perennial 'problem children', the Irish) have to be prevented from doing themselves damage. Throughout the fighting in Kosova, this involved serious efforts on the part of the European and American governments to ensure that the KLA were never provided with up-to-date weaponry to defend

themselves and their communities against increasingly barbarous attacks by the Serbian military and police force. To make sure that Serbian attacks did not escalate too much and totally destabilise the region, NATO forces also bombed targets in Serbia during March and April 1999, including the Serbian TV centre in Belgrade.[32]

BODIES SHROUDED IN MYSTERIES?

As I look at photographs like this, of grieving draped women, or of dead bodies, crudely shrouded, I recall the theories of Michel Foucault and books I have read which seek to apply them to photographs of the body. I remember reading in them how power and domination is not about oppression, but about production. As Suren Lalvani puts it:

In contrast to the liberal and Marxist view of power as possessed by the subject (individual or class), as centralized (state or economy), and as fundamentally repressive, Foucault proposes a model of power that is exercised rather than possessed, decentralized rather than centralized, and positive and productive rather than repressive. . . Power is not possessed by the ruling classes whose ideas become the ruling ideas of an age; rather, power is a strategy in which the dominated as much as the dominating are part of the network and matrices of power.[33]

I wonder how the power of the Serbian police and army that murdered Blerim Zemë Jashari and his family was not repressive and what this dead lad's role in the network of power was. I wonder if I live in the same world as some of these scholars and philosophers.

I read over my annotated copy of Barthes' *Camera Lucida* and ponder on how easy it is to be seduced by Barthes' sensitive writing about death, the photographic image, his mother and why he is untouched by photos of death and wounds. Of course the photograph is a powerful site of memory, desire, fetishism and struggles over meaning. That's why photographs are so interesting. But when Barthes speaks of death, he's speaking of himself and his own demise. His plaintive plea '. . . if only someone in the photographs were looking at me!' is such a giveaway.[34] We do not have to be recognised as a subject by the dead Blerim in order to achieve some conscious awareness of what happened in Kosova and continues to happen elsewhere. What a ceaseless focus on individualism all this postmodernist questioning of subjectivity and the body turns out to be, after all, despite the so-called 'death of the subject'.

Barthes' belief in the relationship of the photograph to death is a recurring refrain in his book. He writes of 'that rather terrible thing which is there in every photograph: the return of the dead.'[35] He seeks Death in photographs of himself (p15) and sees photographs as 'tableaux vivants', motionless faces behind which 'we see the dead'. (p32) Yet when we look at photographs of corpses, says Barthes, we are presented with an image that certifies the corpse as alive, a living image of a dead thing. According to Barthes, the photograph confuses the Real and the Live:

> by attesting that the object has been real, the photograph surreptitiously induces belief that it is alive, because of that delusion which makes us attribute to Reality an absolutely superior, somehow eternal value; but by shifting this reality to the past ('this-has-been'), the photograph suggests that it is already dead.'[36]

But it seems to be Barthes who is confusing reality and representation, not the photograph *per se.* (In any case how can an inanimate object confuse two abstract concepts?) While he sees death in all photographs, perversely he finds life in photographs of corpses. This is clearly more a personal meditation on death and the visual image written from Barthes' subjective standpoint, than a historical analysis of actual photographs of dead people.

I am also reminded of the continuing vogue for all things to do with the body in visual culture at the present time, in particular of Serrano's large colour photographs in the *Morgue* series of 1992, which have achieved an almost cult status. Some of these photographs include drapery, as if the details of the bodies were like sumptuous still lives. These large aestheticised images of partial views of dead bodies, created for gallery display in saturated colour prints, are entitled according to cause of death such as 'fatal meningitis', 'drowning' and so on. These photographs conflate the notion of the photograph as a document of the dead person and the essence of the 'photograph as death' argument, put forward by Barthes and others. The image of death becomes an object of desire, in psychic and economic terms.[37] But why can't the photograph of the dead Kosovar children become an image of a different type of desire – a desire to enable people to live a life free from exploitation and oppression before they die? Amid a revival of interest in writings on photography and death by such as Barthes, Susan Sontag and Raymond Bazin, it has sometimes been forgotten that the photograph is also about life.[38]

In *On Photography*, Susan Sontag remarks that 'The best writing on photography has been by moralists – Marxists or would-be Marxists – hooked on photographs but troubled by the way photography inexorably beautifies.'[39] Well, I don't know if I produce the best writing on photography, or am a moralist and I don't want to be a would-be/ wannabe Marxist, but I think Sontag has a point here about the troublesome nature of photography for Marxists. If something is troubling, then the source of the trouble needs to be investigated. And by investigating, you uncover the way things work and your positioning in relation to them. You don't necessarily find 'answers', but you do find out what the underlying complexities are and what makes them uneasy and contradictory. But it is not the photograph in itself, I would argue, that aestheticises such scenes as massacres and famines, nor is it the presence of drapery in the form of shrouds of dirty cloth or plastic sheeting. It is a whole cluster of factors involving learned responses to visual culture of various kinds, the context of the photograph, the knowledge we bring (or don't bring) to the image and so on. The photograph in itself does not guarantee beautification, or the intimation of death either. There are contradictory potentialities within the photographic images which are mobilised when the photographs are looked at in a social context. Paradoxically, many of the writers who see 'the photograph as death', endow it with a kind of life of its own, as if it can generate meanings and create human relationships without human agency – this is the true fetishism of the photograph in critical writing on visual culture.

In Benjamin's essay 'A small history of photography', he writes of how the photograph can reveal aspects of the natural world that cannot be normally perceived by the human eye, for example the movement of a running horse's legs. He argues that a different nature speaks to the camera from that which speaks to the eye. Slow motion and enlargement reveal optical secrets and thus we discover the existence of an 'optical unconscious'.[40] Modifying Benjamin's argument somewhat, I want to suggest here that photographs like Alex Majoli's image of the Prekaz massacre victims also bring to the surface an 'optical unconscious'. We come across images like this all the time on the television screen and in newspapers, but often we do not really see them, because visually (and mentally) we repress them and our eyes move on to something else. These images can function to fix a repressed scene or incident so that we consciously consider it. Photographs of massacres, famine victims and so on are not so much there to show us what we did not know about,

because, at this stage in the development of media culture and technology, we do know about most of these things – they can function to make us look at what we already know, but do not want to consider. The fashionable and seductive writings of photographic critics and philosophers on the photograph as death, fetishising a lost moment or person, ultimately present us with a pessimistic individualism. What I would argue is not that the photograph has nothing to do with fetishism, death or the loss of past time. It can embody all of these things. But what is also potentially present within it is the contradictory awareness of a living present and future, the way that a still image paradoxically implies that things don't stand still but go on, that things are not fixed but can be changed. Just as the dialectics of civilisation and barbarism are present in cultural productions, so too are death and life.

The horrific testimonies of images and words on the *Kosovo Crisis Center* website could certainly create a deeply pessimistic response. But this is not the intention. The website is prefaced by the slogan 'The world divided us, the net brought us together, therefore the future shall keep us together. . .' It cannot be guaranteed that the internet will always be used for progressive ends, of course, but it is heartening to read this address to the world which attempts to break down national boundaries to create international awareness and knowledge, going beyond the restrictive ideology that even a progressive nationalism can foster.

AT HOME AND ABROAD

In a half-built college at Murambi in Rwanda, tattered clothing of genocide victims hangs on ropes suspended between the walls of a large hall. In Murambi 50,000 people were killed in three days during the genocide of 1994, when an estimated 800,000 people lost their lives. Most of these Murambi victims were Tutsi refugees, taking refuge in this half-built technical college. Now the college is a genocide memorial, where the remains of 27,000 people lie, exhumed from mass graves nearby. Their clothes are draped across the hall, a reminder of the bodies that no longer inhabit them. This looks like some avant-garde installation, but was probably not created by artists, nor funded by some cultural organisation. There are no figures available, but I imagine its cost is considerably less than the Berlin holocaust museum designed by Daniel Liebeskind. The drapery which hangs in Murambi has no connotations of high culture, classical civilisation or ideal beauty; on the contrary, it functions as a testament to acts of barbarism.[41]

Another image of drapery in contemporary life shows imprints of a departed body. (plate 40) On a city street, somewhere in Britain, some homeless person has been sleeping. Taken by Eamonn McCabe, this image shows a folded and creased blanket, left unoccupied on the pavement. Our eye is drawn to the arrangements of the folds, the effects of light and shade, the formal possibilities of the composition. Yet the everyday banality and squalidness of the scene undercuts these attempts to look for aesthetic formal configurations.

Drapery may be able to aestheticise and elevate the commodity, but since the homeless are worthless in our society and a drain on profits, this blanket cannot make them tasteful or desirable – just less visible, or a little bit warmer. The cultural gulf between this makeshift sleeping space and Tracey Emin's *Bed* is immense, not to mention the difference in economic value. While it is present on a far more restricted scale, the tension between civilisation and barbarism exists 'at home' as well. We do not have to go to Algeria, Kosova or Rwanda to find examples of it, nor of the new kind of drapery which shrouds the poor, the murdered and the homeless in contemporary society.

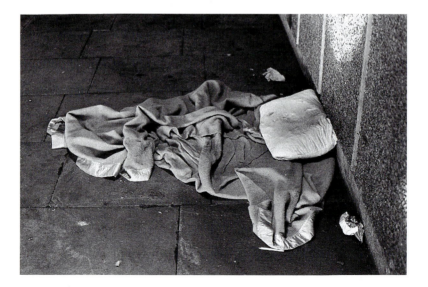

40. Eamonn McCabe, Makeshift bed on pavement, *photograph, published in the* Jobs and Money *section of the* Guardian, *12 February 2000.*

CONCLUSION

In this book, I have attempted to look at aspects of drapery in various art media and at different historical moments. One of the key findings of my research is how little drapery seemed to change over a period of hundreds of years. This is partly due to the enduring attraction of classical art as a model for artists and also to the practice of studying the nude, often accompanied by drapery, in teaching institutions.

Even in the nineteenth century, artists like Alexandre Hesse were producing drawings of draped figures which were not unlike Renaissance examples. (plate 4) However by the nineteenth century, a developing urban society based on increasingly industrialised capitalism meant that drapery appeared in a variety of new aspects of visual culture. Industrially produced textiles proliferated in the new department stores and drapery (seen by many artists as a survival of ancient civilisation) could be studied in the clothing of peoples colonised by the French and other European states. In the twentieth century, with the ascendancy of non-figurative art and the almost total demise of historical and religious subjects in art, the draped figure began to undergo changes and decreased in importance in fine art practice. Draped figures in the 1920s and 30s were much more likely to be met with in haute couture salons and fashion photography, as we have seen from examples of work by Mmes Vionnet and Grès.

With the erosion of high modernism as *the* art of the mid-twentieth century, the emergence of a return to figuration and the increasing interest in women's art, textiles and installation pieces, drapery seemed to make a return to the world of fine art, but it was a different kind of drapery. Often it was not represented by other media, but cloth itself was included in the works.

While arranged cloth made a noticeable reappearance in fine art practice, drapery in the form of textiles, plastic sheeting or old tarpaulins could be found in news photography, covering the bodies of the poor, the dead, the grieving and the homeless.

Drapery has existed in art on its own, as an accompaniment to the human body, and as a presentation device for commodities, whether in still life painting or advertising photography. Basically, the existence of the notion of drapery depends on the existence of a concept of art; without this, drapery is just cloth. What happens when drapery is found in images of massacres, the aftermath of earthquakes and so on, is that the connotations of aestheticisation and ennoblement associated with drapery come into an almost unresolvable conflict with the actual material situations represented in the photographs. In addition, the photographic medium, although now recognised as an art form, is not primarily viewed through an aestheticising gaze when seen in news-papers. Of course certain viewers may, nonetheless, read images of dead refugees, for example, as primarily aesthetic compositions.

Aestheticisation is associated with civilisation, and drapery is the aestheticisation of cloth. The aestheticisation of murdered bodies, grieving victims and people dying of starvation, the draping of these bodies, is thus a move to civilise these events, as well as a pragmatic solution for hiding the bodies from view. Aestheticisation implies sub-limation and catharsis. The viewer of an artistic image of violent death turns her/his thoughts on the meanings of the image into appreciation and resolution. In the eighteenth century, writers such as the German authors Winckelmann and Lessing discussed the famous antique statue of *Laocoön*, which represented a priest and his sons being killed by huge snakes.[1] It was argued that the bodies of the priest and his sons were not distorted by intense emotion, therefore the work was beautiful. Pain and death became expressive pathos, instead of corporeal misery and torture.

I would argue that it is basically impossible to 'civilise' images of massacre and torture. Yet, according to Walter Benjamin, civilisation and barbarism are present in all examples of culture. Thus this leads me to conclude that barbarous events are actually placed outside culture. They probably shouldn't be in my book and some may find their inclusion questionable. But isn't this how culture defines its field, excluding some things and including others? Pickled parts of dead animals can be culture, but massacred children are not. So what does this mean? Art can be about formal patterns, drapery, some kinds of bodies (not all) but not pain, exploitation and oppression. If art represents something too horrific, too upsetting, then it is in danger of being defined as not art at all. If drapery is bloodstained clothing or plastic sheeting or grubby blankets, it is not 'drapery'. By the time I

came to the end of this book I decided it was necessary to redefine drapery. I concluded from this that it was also necessary to redefine art and am not altogether sure that the new term 'visual culture' will solve the problem, despite the fact that I chose to call myself a Professor of the History and Theory of Visual Culture, believing it was more progresssive than 'art history'. While visual culture as a term is definitely more inclusive, and allows for the study of many examples of visual images and products which are not fine art, it still seems to imply that we are dealing with something called culture, which all civilisations produce and possess. This still does not solve the problem of that which appears to fall outside civilisation and its relation to culture. The meanings of civilisation itself also need to be questioned. It is still the case, though, that, as Benjamin wrote decades ago: 'There is no document of civilisation which is not at the same time a document of barbarism.'[2]

NOTES

INTRODUCTION

1 N. Bryson, *Looking at the Overlooked*: *Four Essays on Still Life Painting*, Reaktion Books, London, 1990.

2 For example, *Seeing and Consciousness*: *Women, Class and Representation*, Berg, Oxford, 1995 and *Black Visual Culture*: *Modernity and Postmodernity*, I.B.Tauris, London, 2000.

3 G. Woolliscroft Rhead, *The Treatment of Drapery in Art*, George Bell, London, 1904.

4 Rhead, ibid., pp 4–5.

5 Rhead, ibid., p7, emphasis in original. Baroness Burdett-Coutts (1814–1906) was a philanthropist who spent a proportion of her fortune on such projects as shelters for 'fallen' women, model housing and churches. See the entry on her in *Chambers Biographical Dictionary*, Chambers, Edinburgh, 1990.

6 Rhead, ibid., p33.

7 Rhead, ibid., p101.

8 A.L. Baldry, 'The Treatment of Drapery in Painting', *Art Journal*, 1909, pp231–7 and 'The Treatment of Drapery in Sculpture', *Art Journal*, 1909, pp263–7.

9 Baldry, 'The Treatment of Drapery in Painting', p232.

10 'The Treatment of Drapery in Sculpture', p263.

11 Baldry, ibid., p264.

12 Baldry, ibid., p266.

13 H. Osborne, ed., *The Oxford Companion to Art*, Clarendon Press, Oxford, 1970, pp326–8.

14 For example, the *Guide to Art*, Bloomsbury, London, 1996, edited by S. West and *The Grove Dictionary of Art*, Macmillan, Basingstoke, 1996.

15 *The Dictionary of Art*, Grove, vol.9, pp211–3, entry on 'drapery painter' by Liz Allen. J. Van Aken (c1699–1749) had two brothers who were painters, one of whom, Alexander (d.1757), was also a drapery specialist. See the entry on van Aken in *The Dictionary of Art*, Grove, Macmillan, London, 1996, vol.1 pp504–5.

16 Quoted in M. Rosenthal, *The Art of Thomas Gainsborough*, Yale University Press, New Haven and London, 1999, p124.

17 ibid., p124. Gainsborough, helped by his nephew and apprentice Gainsborough Dupont, once worked through the night by lamplight to complete the drapery on their portrait of *Mrs Hatchett*, 1786, ibid., p80.

18 C. Gould, *The Draped Figure*, National Gallery, London, 1972.

19 Gould, ibid., p4.

20 Gould, ibid., p3.

21 Gould, ibid., p24.

22 Anne Hollander, 'The Fabric of Vision: The Role of Drapery in Art', *Georgia Review*, vol.29, part 2, 1975, pp414–65, quote p427. Unfortunately, this interesting article is totally lacking in footnotes and proper references. Much of the material also appears in the chapter on drapery in Hollander's book *Seeing Through Clothes*, University of California Press, Berkeley, Los Angeles and London, 1993 (first published 1975) with more illustrations and a few referenced sources.

23 Hollander, 'The Fabric of Vision', p431. Liz Rideal has pointed out to me that the appearance of expensive cloth in such paintings may also have been to advertise the wares of these drapery family businesses.

24 Hollander, ibid., p441.

25 Hollander, ibid., p455.

26 An exception to this is the special issue of *Kunstschrift*, year 37, no 6, 1993 (ISBN 9 0 6515098 6), entitled 'Doek op Doek' (cloth on cloth, or cloth on canvas), which has various articles on the representation of drapery in art. Though interesting, the overall approach is more related to that of earlier publications on the topic.

27 M. Potvin with S. Descamps-Lequime, *Plis et Drapés dans la Statuaire Grecque*, Louvre, Service Culturel, Paris, 1992. My grateful thanks are due to Manon Potvin for sending me a copy of this book and other relevant material.

28 *Starke Falten*, Museum Bellerive, Zurich, 1995.

29 B. Fer, 'The pleasure of cloth' in *Liz Rideal: New Work*, exhibition catalogue, Angel Row Gallery, Nottingham; Rochester Art Gallery, Kent; Ferens Art Gallery, Kingston upon Hull, 1998–9, pp10–13. Liz Rideal's artworks and her studies of drapery as a curator and lecturer are also significant in refocusing attention on drapery in recent years.

30 Fer, ibid., p10.

31 See in particular the essays in the exhibition catalogue of works by the painter Alison Watt, *Fold: New Paintings 1996–97*, Fruitmarket Gallery, Edinburgh, 1997 and in the catalogue *Textures of Memory: The Poetics of Cloth*, Angel Row Gallery, Nottingham, 1999.

32 For an example of this approach applied to the study of paintings see J.P. Mourey, *Philosophies et Pratiques du Détail. Hegel, Ingres, Sade, et Quelques Autres*, Editions Champ Vallon, Paris, 1996.

33 F. Dagognet, *Rematérialiser: Matières et Matérialismes*, J. Vrin, Paris, 1985, seeks to write about cloth, art and materialism against 'le courant dématérialisateur', but I feel his book, with whose project I greatly sympathise, is too philosophical in approach to really accomplish his stated aims.

34 G. Banu, *Le Rideau ou la Fêlure du Monde*, Adam Biro, Paris, 1997.

35 For other discussions of real and painted curtains, illusion and reality, see chapter 1 of S. Bann, *The True Vine: Visual Representation and Western Tradition*, Cambridge University Press, Cambridge, 1989 and V.I. Stoichita, *The Self-Aware Image: An Insight into Early Modern Meta-Painting*, Cambridge University Press, Cambridge, 1997, pp60ff.

36 Quote (slightly modified) from note 52 p290 of Stoichita. I changed 'all in one go' to 'all at once', since I thought this might be more in keeping with seventeenth-century usage. Quote from *Correspondance de Nicolas Poussin publié d'après les originaux par Ch. Jouanny*, 2nd ed., Paris, 1968, p168.

37 Stoichita, p63. He refers in his discussion to a work by Metsu, *Young Woman reading a Letter*, National Gallery Dublin, ca 1664,

where a female servant looks at a painting of a seascape by lifting a curtain which covers it, while her mistress reads a letter. Clearly the painting is all about looking and knowledge and also relates to social position in relation to women who look/learn. Stoichita also points out that seventeeth-century optics uses the curtain as a metaphor, eg the eyelid as a curtain, sight as the opening of this curtain (note 61, p290).

38 P. Sparke, *As Long as it's Pink: The Sexual Politics of Taste*, Pandora, London, 1995.

39 Sparke, ibid., p64. In their book *Old Mistresses: Women, Art and Ideology*, Pandora, London, 1989, p51, R. Parker and G. Pollock quote the eighteenth-century aesthetic theorist Lord Shaftesbury, who wrote in 1713: 'So that whilst we look on paintings with the same eyes as we view the commonly rich stuffs and coloured silks worn by our Ladys and admir'd in Dress, Equipage or Furniture, we must of necessity be effeminate in our Taste and utterly set wrong as to all Judgement and Knowledge in the kind'. Thus Shaftesbury is arguing that there is a particularly appropriate way of looking at fine art, which is distinct from ways of pleasurably appreciating the 'applied arts' such as dress and furnishings, ie draperies, the latter of which is linked with the feminine. Such attitudes clearly persist in the later period discussed by Sparke.

40 Sparke, ibid., p64.

41 Sparke, ibid., p117.

42 Sparke, ibid., p231. Sparke illustrates examples of these contemporary draped curtains on pp2 and 230 of her book. For rather more up-market ones see J. Gibbs, *Rideaux et Draperies*, Flammarion, Paris, 1994, pp135, 203 (English version *Curtains and Drapes*, Cassell, London 1994).

43 *Guardian Weekend*, magazine, 30 October 1999, p93.

44 The photographer is referred to as both Benard and Bernard in the Bibliothèque's documentation, so I have given both in the caption to the photograph.

45 The photograph is from the collection in the volume Kc 164 t.6.

46 Sparke, *As long as it's Pink*, p40. There are many similar examples, as on p63 where she quotes Eastlake who writes 'How often do we see in fashionable drawing-rooms a type of couch which seems to be composed of nothing but cushions!. . . I do not wish to be ungallant in my remarks, but I fear there is a class of young ladies who look upon this sort of furniture as 'elegant'.'

47 Sparke, ibid., p64.

48 Sparke, ibid., p67.

CHAPTER 1

1 A. Hollander, *Seeing through Clothes*, University of California Press, Berkeley, 1993. Chapter 1, 'Drapery', is an expanded and more fully illustrated version of her article on the same topic from the *Georgia Review*, vol.29, part 2, 1975, referred to in my introduction to this book.

2 Hollander, *Seeing through Clothes*, p36.

3 Hollander, ibid., p78.

4 Hollander, ibid., p47.

5 Hollander, ibid., p2.

6 Hollander, ibid., pp2–3.

7 W. Hogarth, *The Analysis of Beauty*, Scolar Press, Menston, 1971, pp90–91 (originally published 1753) and J.J. Winckelmann, *Reflections on the Painting and Sculpture of the Greeks*, Scolar Press, Menston, 1972, pp24–5 (originally published 1765).

8 J. Reynolds, *The Complete Works of Sir Joshua Reynolds*, 3 vols, Thomas McLean, London, 1824, vol.2, p22.

9 Reynolds, ibid., vol.1, pp70–71. This seems to lend weight to the (somewhat over-generalised) argument of Patrice Hugues in his books *Le Language du Tissu: Textile, Art, Language*, Editions Médianes, Rouen, 1982 and *Tissu et travail de Civilisation*, Editions Médianes, Rouen, 1996, where he puts forward the view that when cloth itself becomes the main support for paintings (as opposed to plaster or wood), patterns and motifs in the cloth painted on the canvas disappear in favour of plain cloth with which the painter can display more interest in painterly techniques, for example the rendering of light and shade. Hugues detects a move away from painting motifs on textiles within pictures in the sixteenth century, which signals the conflict between the language of cloth (symbols on the cloth) and the language of painterly representation. (Hugues, 1996, pp219–37) In his earlier book he wrote that the decorative motifs on drapery disappear when manual gestures of the painter are no longer considered those of a craftsman executing a task, but take on a value of their own. (Hugues, 1982, p304).

10 G.W.F. Hegel, *Aesthetics. Lectures on Fine Art*, 2 vols., Clarendon Press, Oxford, 1975, vol.1, p165.

11 Hegel, vol.2, p746.

12 Hegel, ibid., p746.

13 Hegel, ibid., pp746–7.

14 Hegel, ibid., p747.

15 For two examples of nude famous men draped in classical style, see Horatio Greenough's statue of *George Washington*, 1832–41 in the National Museum of American History, Washington DC (illustrated on p105 of T. Flynn, *The Body in Sculpture*, Everyman Art Library, London, 1998) and Max Klinger's *Beethoven*, 1897–1902, Museum des Bildenden Künste, Leipzig (on p133 of the same book).

16 Hegel, vol.2, p745.

17 For women in classical times, see M. Arthur 'From Medusa to Cleopatra: Women in the ancient world' (chapter 3, pp79–106) and J.A. McNamara 'Matres Patriae/Matres Ecclesiae: Women of the Roman Empire', (chapter 4 pp107–130) in R. Bridenthal, C. Koonz, S. Stuard eds, *Becoming Visible: Women in European History*, Second Edition, Houghton Mifflin, Boston, 1987.

18 M. Greenhalgh, *What is Classicism?*, Academy Editions/St.Martin's Press, New York, 1990, p 11.

19 Greenhalgh, ibid., p7.

20 For examples of classicising Italian and German art and architecture, see the exhibition catalogue *Art and Power: Europe under the Dictators 1930–45*, Council of Europe Exhibition, Hayward Gallery London, 1996.

21 See the important argument by B. Buchloh in his essay 'Figures of Authority, Ciphers of Regression: Notes on the Return of Representation in European Painting', in B. Buchloh, S. Guilbaut

and D. Solkin eds, *Modernism and Modernity*, Vancouver Conference Papers, Press of Nova Scotia College of Art and Design, Halifax, 1983, pp94–119.

22 See the special issue of *New Formations*, no.28, Spring 1996 on conservative modernism. For a colour reproduction of the painting (oil on canvas 148 x 123 cms, Pinecoteca Civica, Vicenza), see the exhibition catalogue *Les Réalismes 1919–1939*, Centre Georges Pompidou, Paris 1981 and Staatliche Kunsthalle Berlin, 1981 p83.

23 Mary E. Braun-Anderson, 'Artists' professional handbooks from the sixteenth and seventeenth centuries' in *Children of Mercury: The Education of Artists in the Sixteenth and Seventeenth Centuries*, Department of Art, Brown University, Providence, Rhode Island, 1984, p120. For a modern reprint of Alberti's treatise *On Painting*, see the edition by J.R. Spencer published by Yale University Press, New Haven and London, 1956.

24 Braun-Anderson, ibid. p130.

25 See G.B. Leeke-Byrne, 'The Education of the painter in the workshop', ibid., p38.

26 Leeke-Byrne, ibid., p96.

27 C. Goldstein, *Teaching Art: Academies and Schools from Vasari to Albers*, Cambridge University Press, Cambridge, 1996, p22.

28 *Children of Mercury*, p98.

29 J. Ruskin, *The Elements of Drawing in three Letters to Beginners*, reprinted by Scholarly Press, Michigan, 1972, originally published 1857, p61.

30 ibid., p63.

31 For a description of similar drawing instruction in nineteenth-century France see A. Boime, *The Academy and French Painting in the Nineteenth Century*, Phaidon, London, 1971, especially chapter 11.

32 *The Concise Oxford English Dictionary*, 7th edition, defines naked as 'without clothes', but nude as 'naked and bare but unclothed and draped', ie both the nude and drapery are artistic, but the body and cloth are not. The different approaches to the terms naked and nude by art historians Kenneth Clark and John Berger are discussed by Lynda Nead in her book *The Female Nude: Art, Obscenity and Sexuality*, Routledge, London and New York, 1992, pp12–16. Nead states that 'Nakedness is a mark of material reality; whereas nudity transcends that historical and social existence and is a kind of cultural disguise', but in her (postmodern) view there really is no 'naked' because the body is always within codes of representation and therefore 'naked' can never be perceived as devoid of cultural 'clothing'. (p16) Thus the body is always clothed in some discourse or another. Hollander, *Seeing through Clothes*, was writing before the currency of postmodern theories on discourse and stated 'Common nakedness is thus transformed into artistic nudity simply by the very presence of drapery' (p169) and 'drapery automatically creates art out of life' (p185).

33 A.A. Braun, *Figures, Faces and Folds. A practical reference Book on Woman's Form and Dress and its application in past and present Art for Artists, Students and Designers*, (with sections on drapery and anatomy by D. Hartley), Batsford, London, 1928, p33.

34 Braun, ibid., p33 and E. Lanteri, *Modelling and Sculpting the Human Figure*, Dover, New York, 1985, originally published in the USA in 1902 and 1904 (drapery section), p23.

35 For example, Hegel referred to the folds and wrinkles of skin in his
 discussion of drapery, Hegel, *Aesthetics*, op.cit., vol.1, p165 and
 vol.2, p744 and Burne Hogarth entitled his recent 'how to draw
 drapery' book *Dynamic Wrinkles and Drapery: Solutions for
 Drawing the Clothed Figure*, Watson-Guptill, New York, 1995.

36 See the catalogue edited by F. Viatte, *Léonard de Vinci. Les Etudes
 de Draperie*, Réunion des Musées Nationaux, Paris, 1989 and
 reviews of this exhibition in *The Burlington Magazine*, vol.132, Feb.
 1990, pp151–4 by David Scrase and Ewa Kuryluk, 'Metaphysics of
 Cloth: Leonardo's Draperies at the Louvre', *Arts Magazine*, vol.64,
 May 1990, pp80–2.

37 E. Birbari, *Dress in Italian Painting 1460–1500*, John Murray,
 London, 1975, p45.

38 Leonardo da Vinci, *Treatise on Painting*, translated by A.P.
 McMahon, Princeton University Press, Princeton, 1956 (Codex
 Urbinas Latinus 1270), p204. The section on draperies is on
 pp203–8. This section is entitled 'On draperies and on the manner
 of gracefully clothing figures and of garments and of the nature of
 draped cloth.' This heading has been left out by McMahon,
 according to p18 of the Louvre catalogue, *Léonard de Vinci*.

39 McMahon, ibid., p207.

40 McMahon, ibid., p208. This is a recurring theme in writings on
 drapery by artists, critics and art teachers. In the mid-nineteenth
 century, for example, the painter Delacroix was still complaining of
 the difficulty of representing modern subjects due to the lack of
 nudes, the unappealing costumes and the bad effects of fashionable
 tailoring and dressmaking on the clothed body. See E. Delacroix,
 The Journal of Eugène Delacroix, translated W. Pach, Grove Press,
 New York, 1961, pp543, 675.

41 Quoted by Jean K. Cadogan, 'Linen drapery studies by Verrocchio,
 Leonardo and Ghirlandaio', *Zeitschrift für Kunstgeschichte*, vol.
 XLVI, 1983, part 1, pp27–62, quote p27.

42 G. Vasari, *Vasari on Technique*, edited by G. Baldwin Brown, Dover,
 New York, 1960, pp150–151. In C. Cennini, *The Book of the Art of
 Cennino Cennini: A contemporary practical treatise on
 Quattrocento Painting*, George Allen and Unwin, London, 1922, a
 reprint of Cennini's treatise written in the late fourteenth or early
 fifteenth century, the artist discusses in detail how to paint drapery
 on different grounds including plaster, linen, banners and curtains,
 but does not mention the idea of draping models with clay-soaked
 cloth.

43 See the exhibition catalogue *La Sculpture française au XIXe siècle*,
 Grand Palais, Paris, Réunion des Musées Nationaux, Paris, 1986,
 p71 and p410 note 8. It was not a new practice to use actual cloth in
 the making of scuptures. Donatello's Renaissance bronze statue
 Judith and Holofernes, still shows traces of the fabric used in the
 modelling of the wax figure from which the final bronze was cast.
 See Cadogan, 'Linen drapery studies. . .' p41. For another example
 see the French sculptor Roubiliac, who was working in England in
 the eighteenth century on such commissions as the Lady Elizabeth
 Nightingale Monument in Westminster Abbey, erected 1761. His
 son describes his working procedure: 'Roubiliac seldom models his
 drapery for his monumental figures, but carved it from the linen
 itself, which he dipped into warm starch water, so that when he had

pleased himself he left it to cool and dry and then proceeded with marble. This my father assured me that he did with all the drapery in the Nightingale monument.' Cited by A. Cunningham in his discussion of Roubiliac in *Lives of the British Painters, Architects and Sculptors*, 6 vols, 1829–33. Quoted in notes for a lecture on drapery 'From the cradle to the grave: Drapery: Form and Function' at the National Portrait Gallery, 25 November 1999 by Liz Rideal. Many thanks to Liz Rideal for kindly giving me a copy of her lecture notes and sharing her knowledge of drapery with me.

44 For sculptural models (not finished works) from the early twentieth century using cloth and paper to simulate clothing and drapery see p144 and cat. nos. 77 and 78 by Paul Dubois in *La Sculpture française au XIXe siècle*.

45 E. Lanteri, *Modelling and Sculpting the Human Figure*, Dover, New York, 1985, originally published in 1902 and 1904 (drapery section). In the preface, Nathan Cabot Hale refers to this manual's classic status, pointing out that many of these time-honoured skills are being forgotten in an age where abstract art is dominant.

46 It has been suggested that this technique was intended to relate to similar ways of approaching panel painting, ie drawing with a brush on a prepared surface. See F. Ames-Lewis and J. Wright, *Drawing in the Italian Renaissance Workshop*, University Art Gallery Nottingham and Victoria and Albert Museum, London, 1983. Thanks to Sarah Cawkwell for drawing this catalogue to my attention.

47 See Viatte, *Léonard de Vinci*, Cadogan, 'Linen drapery studies. . .' and F. Ames-Lewis 'Drapery 'Pattern'-Drawings in Ghirlandaio's Workshop and Ghirlandaio's Early Apprenticeship', *Art Bulletin*, vol.63, 1981, pp49–62.

48 The most famous example of a reading of Leonardo's draped figures in which the drapery is detached from its body is in Freud's essay on Leonardo and artistic creation. Freud sees the shape of the drapery around the middle the body of St Anne in the painting *The Virgin and Child with St Anne*, Louvre, Paris, as the shape of a vulture turned on its side. A reproduction of a study for this drapery is in Viatte, *Léonard de Vinci*, p79 cat. no. 18. Freud links this shape of a bird of prey to Leonardo's love of his natural mother, his homosexuality and his sublimation of that homosexuality into intense artistic creativity. See S. Freud, 'Leonardo da Vinci and a Memory of his Childhood', first published in 1910, in *The Pelican Freud Library*, vol.14, *Art and Literature*, Harmondsworth, 1985, pp143–232. Freud also comments on Leonardo's rather pedantic attention to details of household expenditure and interestingly quotes as an example of this his records of money spent on clothes for his young (male) pupils. He bought one of them a cloak, six shirts, three jackets and four pairs of stockings in a year and another pupil received a cloak with silver brocade, trimmed with crimson velvet, braid and buttons. (p195) Despite Leonardo's professed contempt for the excesses of contemporary fashion in his writings on art, he obviously liked to see his young assistants elegantly dressed.

49 Ames-Lewis and Wright, p146, quoted in their useful essay on 'The Draped Figure'.

50 Ames-Lewis and Wright, quoted on page 178.

51 The popularity of these print series, publication of which had
 reached some 150 per decade in Paris by the mid-nineteenth
 century, is noted by Anne Wagner in her useful essay 'Learning to
 Sculpt in the Nineteenth Century: An Introduction' in P. Fusco and
 H.W. Janson eds, *The Romantics to Rodin: French nineteenth-
 century Sculpture from North American Collections*, Los Angeles
 County Museum of Art and G. Braziller, 1980, pp9–20. A detailed
 study of these courses can be found in the thesis by D. Harlé, *Les
 Cours de dessin gravés et lithographiés du XIXe siècle conservés au
 Cabinet des Estampes de la Bibliothèque Nationale: Etude critique
 et catalogue*, Thesis, Ecole du Louvre, no date. There is a copy of
 this in the Print Room of the Bibliothèque Nationale.
52 Although written much later, the statement by the art student
 Lemaistre is interesting. He mentions the lessons on antique
 costume given by Heuzey (which I shall discuss in more detail
 later) at the Ecole des Beaux-Arts and points out that very little time
 was devoted to these because the administration of the school
 wanted students to concentrate much more on the nude. A.
 Lemaistre, *L'Ecole des Beaux-Arts dessinée et racontée par un élève*,
 Firmin-Didot, Paris, 1889, p156. As we shall also see later, the
 administration of the Ecoles des Beaux-Arts also decided to
 terminate the lectures on drapery given by de Clérambault in the
 1920s.
53 See Wagner, 'Learning to Sculpt. . .', pp10–11 and the essay by K.B.
 Hiesinger and J. Rishel, 'Art and its Critics: A crisis of Principle' in
 the exhibition catalogue *The Second Empire: Art in France under
 Napoleon III*, Philadelphia Museum of Art and Grand Palais, Paris,
 Réunion des Musées Nationaux, 1978, pp29–34.
54 See P. Grunchec, *The Grand Prix de Rome: Paintings from the Ecole
 des Beaux-Arts 1797–1863*, International Exhibitions Foundation,
 Washington DC, 1984, pp139–45. The School keeps the prize-
 winning entries, but not the drawings for them.
55 Grunchec, figs. 122, 123, 124 and 125.
56 See the very useful catalogue by E. Brugerolles and D. Guillet,
 *Dessins d'Alexandre Hesse conservés à l'Ecole nationale supérieure
 des Beaux-Arts. Etudes pour les décorations peintes*, Les Dossiers
 du Musée d'Orsay, Réunion des Musées Nationaux, Paris, 1988,
 p42, note 125. I am grateful to Mme Brugerolles and her assistants
 at the Ecole des Beaux-Arts library for their help in enabling me to
 study these drawings.
57 The commission was for the choir of the church and the chapel of
 the Brisson family at Chevry-en-Sereine, near Nemours. Mme
 Brisson, a landowner, gave Hesse the commission and the contract
 stipulates four religious subjects (life-size), cartoons for a stained
 glass window and nine figures of saints 1.25m high. Hesse was to be
 paid 20,000 francs for this work. See *Dessins d'Alexandre Hesse*,
 p20.
58 For examples of another large decorative scheme by Hesse, the
 allegorical subjects for the Stock Exchange in Lyons, 1868–70, see
 the catalogue *Dessins d'Alexandre Hesse* and Box 1 of the Hesse
 bequest in the Ecole des Beaux-Arts, Paris.
59 A. Lemaistre, *L'Ecole des Beaux-Arts dessinée et racontée par un
 élève*, Paris, Firmin-Didot, 1889, p151, 155. As noted previously,
 Lemaistre pointed out that the Ecole did not provide very much

time for these courses as they wanted students to concentrate more on the study of the nude (p156).

60 L. Heuzey, *Histoire du Costume Antique d'après des études sur le modèle vivant*, Champion, Paris, 1922, p36.

61 ibid., pp4–5.

62 ibid., introduction pxii. The Ingres painting was *Romulus Victor over Acron*.

63 ibid., ppxi–xii.

64 ibid., pp43–4.

65 ibid., pp203–4.

66 See G. Didi-Huberman, *Invention de l'hystérie: Charcot et l'iconographie de la Salpêtrière*, Macula, Paris, 1982 on Charcot and his assistants, photography and hysteria.

67 See A. Callen, 'The Body and Difference: Anatomy and training at the Ecole des Beaux-Arts in Paris in the later nineteenth century', *Art History*, vol.20, no.1, March, 1997, pp23–60.

68 A.T. Christ, 'The Masculine ideal of 'the race that wears the toga'', *Art Journal*, vol.56, no.2, Summer 1997, pp24–30, quote p28.

69 Heuzey, p253. For more on Quintilian and the 'male' toga, see Christ, pp28–30.

70 See R. Broby-Johansen, *Body and Clothes: An Illustrated History of Costume*, Faber and Faber, London, 1968, p56. In some respects this is a very useful book for information on draped and wrapped clothing, with explanatory diagrams and photographs. However the author sometimes expresses rather outdated views of women and (homo)sexuality, eg 'The draped material and wrapped garment clearly speak of their feminine origin. Masculine interest is concentrated on place, period, temperament and detail, whereas feminine interest centres around the overall effect.' (p33)

71 J. Repond, *Les Secrets de la Draperie antique*, Pontificio Institutio de Archeologia Cristiana and Société d'éditions Belles-Lettres, Rome and Paris, 1931, p156.

72 L. Heuzey and J. Heuzey, *Histoire du Costume dans l'Antiquité classique. L'Orient. Egypte – Mésopotamie – Syrie – Phénicie*, Les Belles Lettres, Paris, 1935, pvii. The firm of Rodier had a reputation for producing textiles specifically destined for 'haute couture' fashion and although made on machines, their cloth was said to be produced not by workers who were 'slaves of the machine', but who controlled it. Also Rodier's innovative textiles were said to have been inspired by examples from the Orient and the Far East, with special reference to examples of ethnic and French Colonial cloths such as those on display at the Marseilles Exhibition of 1922. See *Encyclopédie des Arts Décoratifs et Industriels modernes au XXe siècle*. Vol.VI, Textiles and Paper Products, Garland Reprint, New York, 1977, pp41–2. I will discuss Orientalism and drapery in relation to French culture when I look at de Clérambault's photographs of North African costume in Chapter 3.

73 ibid., notes to plate 111.

74 Note also the comments on plate XXVI, a photograph showing a young woman with one breast exposed, wearing a draped costume as an example of 'Ethiopian' drapery. J. Heuzey quotes the Orientalist novelist Pierre Loti, describing 'Hindu costume': 'light, vaporous, lends itself well to the envelopment of the body and the contrast of the brown skin with the whiteness of the cloth is not without beauty.'

75 Box 547E600 marked *Archéologie: Histoire de la Civilisation Prix Heuzey 1870–1945*. My grateful thanks to the staff member who told me about this box, while other more senior curators at the Ecole insisted that there was no visual material relating to Heuzey in their collections. The latter were more interested in drawings by famous masters. Researching themes, rather than famous individual artists, can still be a problem, even at the beginning of the twenty-first century.

76 See M. Sauer, *L'Entrée des femmes à l'école des Beaux-Arts 1880–1923*, énsb-a, Paris, 1990, pp35, 36, 48–50.

77 The prize-winners got 600 francs and a medal of whatever class deemed appropriate by the judges. Hence the prize-winner sometimes got a second class medal, although first in the competition. All the drawings are in the Heuzey prize box inscribed with the names of their authors.

78 A.A. Braun, *Figures, Faces and Folds: A practical reference Book on Woman's Form and Dress and its application in past and present Art for Artists, Students and Designers*, (with sections on drapery and anatomy by D. Hartley) Batsford, London, 1928, p1.

79 ibid., p3.

80 ibid., p33.

81 ibid., p71.

82 ibid., p109 (b).

83 The photographs in the catalogue *L'Art du Nu au XIXe siècle: Le Photographe et son Modèle*, Hazan/Bibliothèque Nationale de France, 1997, are mostly of this sort and show posed *académies* rather than painted or drawn ones.

84 The relationship of art nude photographs to pornographic photographs in later nineteenth century France, though often discussed, would repay some further study. While some writers see nude art photos and porn as simply positions on the same spectrum of female objectification, I would tentatively suggest that it is possible to argue for a qualitative break between one and the other – a break which has to take place in the subjective responses of the viewer for the image to function as an aide to arousal and/or masturbation. The ideological connotations of high art would work strongly against a direct use of the image for sexual puposes and rather work towards (learned) disinterested aesthetic appreciation. However this would probably vary according to the learned artistic and aesthetic responses, and probably therefore class, of the viewer. What would be really useful would be some written comments on viewing pornographic photographs by people who did this in the nineteenth century, and there aren't too many of these comments around. For the view that all photographs objectify women in an erotic way see for example A. Solomon-Godeau's essay 'Reconsidering Erotic Photography: Notes for a Project of Historical Salvage' (written in 1987), in *Photography at the Dock: Essays on Photographic History, Institutions and Practices*, University of Minnesota Press, Minneapolis, 1991, pp220–237.

85 On one of the photographs his address is given as 55 Avenue des Ternes, Paris. He also seems to have worked from 39 Rue de Constantinople.

86 My grateful thanks to Sylvie Aubenas of the Print and Photography Department of the Bibliothèque Nationale, for telling me about these photographs.

87 See the essays by R. Butler, 'Religious Sculpture in Post-Christian France', pp83–95 and Fred Licht, 'Tomb sculpture', pp96–108, in P. Fusco and H.W. Janson eds, *The Romantics to Rodin: French nineteenth-century Sculpture from North American Collections*, Los Angeles Country Museum of Art and G. Braziller, 1980.

88 P. McPhee, *A Social History of France 1780–1880*, Routledge, London and New York, 1992, p277.

89 R. Magraw, *France 1815–1914: The Bourgeois Century*, Fontana/ Collins, London, 1988, pp258–60.

90 From A. Bruel ed., *Les Carnets de David d'Angers*, Paris, 1958, vol.11, pp174–5, written in 1844, quoted by R. Butler in Fusco and Janson, p83.

91 Robert de la Sizeranne, quoted by M. Poivert, *La Photographie pictorialiste en France 1892–1914*, 3 vols., Doctoral Thesis, Université de Paris 1 – UFR03, 1992, vol.11, p439.

92 See P. Bergon and R. le Bègue, *Le Nu et le Drapé en plein air*, Paris, 1898, p43.

93 E. Muybridge, *Muybridge's complete Human and Animal Locomotion*, Dover edition, New York, 1979, vol.2, (reprint of 1887 edition) parts/vols. 6 and 7.

94 Vol.6 pl.105, 187, 194 and vol.7 pl.135, 199, 299. Particularly impressive is the series where a draped woman throws herself into a pile of hay (pl.455)!

95 See for example the series of the curtseying woman, vol.7 pl.199.

96 Quoted from *The Philadelphia Times*, 2 August, 1885, in *Muybridge's Complete Human and Animal Locomotion*, vol.1, pxxxi.

97 See introduction vol.1, pxxxi. Dr Dercum, Professor of Nervous Diseases at Philadelphia University, assisted with these experiments. See plates 544 and 545. These procedures and images can be compared to Charcot's photographic procedures recording hysterical women patients at La Salpêtrière.

98 In *The Psychology of Clothes*, Hogarth Press, London, 1966 (first published 1930), J.C. Flugel comments on the way in which clothing can be used to extend the space occupied by the body of the wearer, thus giving a sense of power and extension of the self (p34 and fig.3, illustrations of Loie Fuller dancing).

99 See the excellent catalogue by H. Pinet, *L'Ornement de la Durée: Loïe Fuller, Isadora Duncan, Ruth St Denis, Adorée Villany*, Musée Rodin, 1987. My grateful thanks to Hélène Pinet and Sylvester Engbrox at the Musée Rodin for showing me the photographs and providing me with a catalogue.

100 ibid., p13.

101 ibid., pp5–6.

102 See for example the quote from Pierre Roche on p39 of *Ornement de la Durée*.

103 J. Barcsay, *Drapery and the Human Form*, Corvina, Budapest, 1958.

104 M. Cooper, *The Art of Drapery: Styles and Techniques for Artists*, Van Nostrand Reinhold, New York, 1983, p63.

105 B. Hogarth, *Dynamic Wrinkles and Drapery: Solutions for Drawing the Clothed Figure*, Watson-Guptill Publications, New York, 1995, p5.

106 See for example A. Bricis, *Three Dimensional Simulation of Cloth Drape*, Ph.D. Loughborough University, UK, 1995.

CHAPTER 2

1 See K. Marx, *Capital: A Critique of Political Economy*, vol.1, introduction by Ernest Mandel, Penguin Books, Harmondsworth, 1976, pp132–163.

2 ibid., p165.

3 For example K. Dunseath ed., *A Second Skin: Women Write about Clothes*, The Women's Press, London, 1998.

4 F. Pacteau, *The Symptom of Beauty*, Reaktion Books, London, 1994, pp152–3.

5 ibid., p157.

6 ibid., p157.

7 ibid., p158.

8 Y. Papetti-Tisseron, *Des Etoffes à la Peau*, Séguier, Paris, 1996, p79.

9 Eugénie Lemoine-Luccioni, *La Robe: Essai psychanalytique sur le Vêtement*, Editions du Seuil, Paris, 1983. Lemoine-Luccioni is influenced by Lacanian psychoanalysis and her book is famous for being one of those read by the performance artist Orlan during operations on her face, when her skin is lifted up away from the flesh beneath. Lemoine-Luccioni states that drapery moves over the body, and is also fixed to it. Thus, she argues, the movement of the drapery 'betrays' less a living body than a penis becoming erect or the manifestation of an inflamed desire. (p102)

10 K. Silverman, quoted in J. Ash and E. Wilson eds, *Chic Thrills: A Fashion Reader*, Pandora, London, 1992, p6.

11 A. Warwick and D. Cavallaro, *Fashioning the Frame: Boundaries, Dress and the Body*, Berg, Oxford and New York, 1998, pxxiii. The authors undertake the project of relating postmodern theories on boundaries, subjectivity and the body to clothing. They see the body/dress relationship as 'a discourse that, being inscribed in no dominant metanarratives, escapes totalisation.' (p.48) Unfortunately, at times the authors' conclusions are rather banal.

12 See examples in the exhibition catalogue *Conceptual Clothing*, Ikon Gallery, Birmingham, 1987.

13 Y. Papetti-Tisseron, *Des Etoffes à la Peau*, p87. There is an interesting pressure discernable here in terms of stabilising gender identities from generation to generation. How much less likely is it that the woman would say 'I look just like my father in these trousers?'

14 K. Dunseath ed., *A Second Skin: Women Write about Clothes*, pp81–2.

15 For a look at cheap and second-hand 'fashion' see K. Jolliffe ed., *Cheap Date: Antidotal Anti-fashion*, Slab-o-Concrete Publications, Hove, 2000.

16 See G. Duveau, *La Vie ouvrière en France sous le Second Empire*, Gallimard, Paris, Second Edition, 1946, pp163ff, and W.M. Reddy, *The Rise of Market Culture: The Textile Trade and French Society, 1750–1900*, Cambridge University Press, Cambridge, 1984, on the textile industry, and also D. Roche, *The Culture of Clothing: Dress and Fashion in the Ancien Régime*, Cambridge University Press, Cambridge, 1994, p307.

17 Michelet, in *Le Peuple*, quoted by Roche, *The Culture of Clothing*, p180.

18 A. Corbin, *Time, Desire and Horror: Towards a History of the*

Senses, Polity Press, Cambridge, 1995, chapter 2 'The Great Century of Linen'.

19 P. McPhee, *A Social History of France 1780–1880*, Routledge, London and New York, 1992, p141.

20 See for example S. Rowbotham, 'A New Vision of Society: Women Clothing Workers and the Revolution of 1848 in France', in J. Ash and E. Wilson eds, *Chic Thrills: A Fashion Reader*, Pandora, London, 1992, pp189–198; M. Guilbert, *Les Femmes et l'Organisation syndicale avant 1914*, CNRS, Paris, 1996; and M. Albistur and D. Armogathe, *Histoire du Féminisme français du Moyen Age à nos Jours*, Des Femmes, Paris, 1977.

21 J.F. McMillan, *Housewife or Harlot: The Place of Women in French Society 1870–1940*, Harvester, Brighton, 1981, p60.

22 McMillan, ibid., p151.

23 McMillan, ibid., p157.

24 McMillan, ibid., p64. However their wages were still better than those of most women workers at about 800 francs a year, compared to 400 francs a year for a woman working in a small shop or two to three francs a day for a woman doing manual work. Often the latter were laid off for periods of three to four months and received no pay on Sundays. These figures are for the end of the Second Empire. See C. Becker and J. Gaillard, *Au Bonheur des Dames: Zola*, Hatier, Paris, 1982, p17.

25 For examples, see R. Fortassier, *Les Ecrivains français et la Mode de Balzac à nos Jours*, Presses Universitaire de France, Paris, 1988. There were considerable numbers of women novelists in France who mentioned clothing in their books, but the best known non-fictional texts on contemporary fashion were by male writers.

26 T. Gautier, *De la Mode*, Actes Sud, Arles, 1993, p16.

27 ibid., p18. I had not realised how important the folds in the clothes were in this painting till I read Gautier's essay. Bertin's portrait has usually been seen as an astute representation of a significant member of the new bourgeoisie of the July Monarchy (1830–1848). A recent essay by Richard Wrigley seeks to problematise this view, arguing that, not surprisingly, views of bourgeois identity at this period were not all the same. See 'The class of 89? Cultural aspects of bourgeois identity in France in the aftermath of the French Revolution', chapter 6 in A. Hemingway and W. Vaughan eds, *Art in Bourgeois Society 1790–1850*, Cambridge University Press, Cambridge, 1998, pp130–153; the painting is illustrated on p146.

28 Gautier, p21.

29 Crinolines consisted of about 20 metres of material, assembled over several underskirts and a metal frame which provided a support over which the cloth could be arranged. In a similar way, the bustle provided an artificial support for the draping of cloth around the woman's body. An important aspect of the use of such vast quantities of material was the sound of the stiff materials such as taffeta as the wearer moved around. Also, since cloth was becoming cheaper, a signifier of wealth and status was to wear more of it. As ready-made clothes and cheaper fabrics became easily available in the new department stores, modern haute couture developed (eg the rise to fame of the couturier Worth during the Second Empire), with the result that well-off women could distinguish themselves from others who only frequented department stores. See P. Perrot, 'Le

Jardin des Modes', in J-P. Aron ed., *Misérable et Glorieuse: La Femme du XIXe Siècle*, Editions Complexe, Brussels, 1984, pp101–116. For a discussion of fashion, crinoline and political satire in the Second Empire see T. Dolan, 'The Empress's New Clothes: Fashion and Politics in Second Empire France', *Woman's Art Journal*, Spring/Summer, 1994, pp22–28.

30 C. Baudelaire, 'The Painter of Modern Life' in J. Mayne ed., *The Painter of Modern Life and Other Essays*, Phaidon, London, 1964, p13.

31 Baudelaire, ibid., pp30–31.

32 Baudelaire, ibid., p36. It is interesting that Baudelaire locates this savagery in the image of the fashionably dressed female prostitute. This is rather different from the way in which Walter Benjamin discusses civilisation and barbarism in culture, as we shall see in a later chapter.

33 C. Baudelaire, *Art in Paris 1845–1862: Salons and other Exhibitions*, translated by J. Mayne, Phaidon, London, 1965, p118, from his review of 'The Salon of 1846'. In this case Baudelaire's comments preceed those of Gautier.

34 A. Debay, *Hygiène vestimentaire: Les Modes et les Parures chez les français depuis l'établissement de la monarchie jusqu'à nos jours précédé d'un curieux parallèle des modes chez les anciennes dames grecques et romains*, Dentu, Paris, 1857.

35 Charles Blanc, *L'Art dans la Parure et dans le Vêtement*, Loones, Paris, 1875, pp161–2, 188ff.

36 See *Oeuvres complètes de Stéphane Mallarmé*, H. Mondor and G. Jean-Aubry eds, Pléiade, Gallimard, Paris, 1945, pp5–847.

37 Quoted on p42 of the excellent essay by Jan Matlock, 'Masquerading Women, Pathologised Men: Cross-Dressing, Fetishism, and the Theory of Perversion, 1882–1935', in E. Apter and W. Pietz eds, *Fetishism as Cultural Discourse*, Cornell University Press, Ithaca and London, 1993, pp31–61, from Emile Blavet, *Le Petit Bleu*, cited in J. Grand-Carteret *La Femme en Culotte*, Flammarion, Paris, n.d. (1899) pp383–4.

38 From *Gay's Illustrated Circle of Knowledge*, by W. Gay, Gay Bros., New York, 1886, reprinted in *History of Photography*, XI/4, Oct./Dec. 1987, p333.

39 ibid., p334.

40 P. Courthion, *Ingres. Raconté par Lui-Même et par ses Amis. Pensées et Ecrits du Peintre*, Pierre Cailler, Geneva, 1947, p67.

41 L. de Geffroy, *Revue des Deux Mondes*, 1848, p448, quoted by A. Ribeiro, *Ingres in Fashion: Representations of Dress and Appearance in Ingres' Images of Women*, Yale University Press, New Haven and London, 1999, p152. Ribeiro also quotes this interesting advice offered to members of polite society from an 1833 source: 'When seated, [a woman] ought neither to cross her legs nor take a vulgar attitude. . . It is altogether out of place for her to throw her drapery around her in sitting down, or to spread out her dress for display, as upstarts do, to avoid the least rumple.' From E.F. Celnart, *The Gentleman and Lady's Book of Politeness*, Boston, 1833, p86; Ribeiro, p154. Yet looking at Ingres' seated female portraits, it is clear that he ignores the rules of polite behaviour and does spread out the dresses for display, thus making his high-class sitters similar to 'upstarts' in the way that their dresses occupy

space and attract spectators. Of course ideas on 'polite behaviour' may have changed by the later part of the nineteenth century.

42 See the interesting article by Ross Chambers, 'Pour une poétique du Vêtement', *Michigan Romance Studies*, vol.1, 1980, pp18–46.

43 Chambers, ibid., p30.

44 The use of heavily patterned cloth in portraiture is fairly unusual at this period, since it was probably thought that an over-emphasis on the decorative would detract from the sitter.

45 These remarks were made at a symposium held to accompany an exhibition of the artist's works in Edinburgh.

46 J. Calcutt quoting Derrida in his introductory essay in *Alison Watt. Fold: New Paintings 1996–97*, Edinburgh, Fruitmarket Gallery, 1997, p16.

47 ibid., p16. The Derrida quotes are from *Dissemination*, Athlone Press, 1981.

48 ibid., p18.

49 The other essay in the catalogue is written in a normal discursive style (rather than centred around an evocative use of quotes) and is a useful analysis of Watt's paintings in relation to Ingres' works: Jane Lee, 'A New Ingres-isme', ibid., pp21–28.

50 *Au Paradis des Dames, Nouveautés, Modes et Confections 1810–1879*, exhibition catalogue, Musée Galliera, Paris, Editions Paris Musées, 1992, see especially the essay by P. Da Silveira, 'Les Magasins de Nouveautés'. My thanks to the staff of the Musée Galliera for their help. Another tactic of the grands magasins was to drive the prices of their suppliers down by buying a certain number of, say, shoes, for five francs, selling them cheap to depreciate the article, then buying the remainder of the stock at rock-bottom prices from the desperate supplier, only to sell them for seven francs.

51 P.G. Nord, *Paris Shopkeepers and the Politics of Resentment*, Princeton University Press, Princeton, 1986, p61.

52 ibid., p64.

53 ibid., pp77–8. See also C. Becker and J. Gaillard, *Au Bonheur des Dames: Zola*, Hatier, Paris, 1982, which has useful information on the clientele of the grands magasins, the reasons for their development and success and the increased availability of fabrics such as silk which were previously only affordable by a rich minority. This was also due to increased industrialisation and the development of new chemical dyes which were cheaper than the old natural colours.

54 See M.B. Miller, *The Bon Marché: Bourgeois Culture and the Department Store, 1869–1920*, Allen and Unwin, London, 1981, p181.

55 ibid., pp120–21.

56 Miller, ibid., p211. For additional information on department stores and consumer culture see Rachel Bowlby's two books, *Just Looking: Consumer Culture in Drieser, Gissing and Zola*, Methuen, London and New York, 1985, especially chapter 5, and *Shopping with Freud*, Routledge, London and New York, 1995. For more recent material on shopping see the still photographs from video-recordings made in New York department stores by Merry Alpern, *Shopping*, Scalo Press, 1999, and the useful book by D. Miller, *A Theory of Shopping*, Polity Press, Cambridge, 1998. For an interesting short essay on the continuing attraction of the

department store to women and recent competition from shopping malls and out-of-town shopping parks, see L. Grant, 'The Ladies' Paradise', the *Guardian*, Weekend Magazine, 27 June 1998, pp42–45.

57 Quoted in the excellent introduction (pxii) by K. Ross to the English edition of *The Ladies' Paradise*, University of California Press, Berkeley, Los Angeles and Oxford, 1992.

58 ibid., pxvii.

59 ibid., p7.

60 P. Valéry, *Degas, Manet, Morisot*, introduction by D. Cooper, Pantheon Books, New York, 1960, p84.

61 Quoted by T. Gronberg, *Designs on Modernity: Exhibiting the City in 1920s Paris*, Manchester University Press, Manchester and New York, 1998, p42. This is a somewhat different slant on the gendering of modernity from that found in Penny Sparke's book, *As Long as it's Pink: The Sexual Politics of Taste*, discussed above.

62 ibid., p70, quoting Janneau, 'Visage de la Rue Moderne', 1924. For more on window displays see the useful chapter 4 'The Art of the Shop-window' in Gronberg's book.

63 See for example the materials on window-dressing in the Bibliothèque Forney, Paris, including *Présentation 1927: Le Décor de la Rue, les Magasins, les Etalages, les Stands d'Exposition, les Eclairages*, Les Editions de Parade, Paris, 1927. This book advises window-dressers to display textiles in the window arranged in soft curves, just as they would appear on a woman's body. (p55)

64 H. Gibson, *The Art of Draping*, Blandford Press, London, 1936, author's preface, no pagination.

65 Quoted from the journal *Illustration*, by N. Parrot, *Mannequins*, Academy Editions, London, 1982, p90.

66 ibid., p147. These are fashionable areas of Paris where 'haute couture' is based.

67 ibid., p148.

68 One of his photographs showing the Grès design is illustrated in L. Benaïm, *Grès*, Editions Assouline, Paris, 1999, p42.

69 'The Uncanny' in S. Freud, *Art and Literature*, in the Pelican Freud Library vol.14, Penguin Books, Harmondsworth, 1985, pp335–376. On Surrealism and Freud's 'uncanny' see B. Fer 'The 'uncanny'' pp189–203 in B. Fer, D. Batchelor and P. Wood, *Realism, Rationalism, Surrealism: Art Between the Wars*, Yale University Press and the Open University, New Haven and London, 1993.

70 ibid., p372. Freud gives an example of such 'primitive' fears as a belief that dead people can return to life. The uncanny is linked to a questioning of the material reality of phenomena, as Freud puts it. (p371)

71 M. Constantine and L. Reuter, *Whole Cloth*, The Monacelli Press, New York, 1997, p202.

72 J. Deitch, quoted in S.K. Schneider, *Vital Mummies/Performance Design for the Show-Window Mannequin*, Yale University Press, New Haven and London, 1995, p41. For an illustration of one of Colette's draped boudoirs see M. Constantine and L. Reuter, *Whole Cloth*, The Monacelli Press, New York, 1997, p162, plate 161, *One View of Beautiful Dreamer: Bed 11*, 1980. See also P. Selz, 'The Coloratura of Colette', *Arts Magazine*, vol.53, no.4, December 1978, pp103–5.

73 Schneider, p43.
74 For illustration see J. McCullagh, 'Image to Collage, Part two: Fashion', *Arts Magazine*, LX1, 5, Jan.1986, pp74–7, illus. fig.14 p77.
75 A photograph of the daughters wearing 'delphos' dresses is reproduced in D. Desveaux, *Fortuny*, Thames and Hudson, London, 1998, see page 76. On Fortuny see also the exhibition catalogue *Mariano Fortuny (1871–1949)*, Brighton Museum, 1980.
76 In 1938 the turnover for the French clothing industry was 25 billion francs.
77 R. Lynam, *Paris Fashion: The Great Designers and their Creations*, Michael Joseph, London, 1972, p93.
78 Lynam, p94.
79 B. Kirke, *Vionnet*, Kyceryudo Art Publishing Company, Tokyo, 1991, p212. An English edition, *Madeleine Vionnet*, was published by Chronicle Books, San Francisco, 1998.
80 *Madeleine Vionnet: Les Années d'Innovation 1919–1939*, Musée des Tissus, Lyon, 1994–5, p12. Another client, Mme Revel, bought 59 items in 1924 and 63 in 1938. This information is from Vionnet's accounts and sales books preserved in the library of the Musée de la Mode et du Textile, Rue de Rivoli, Paris.
81 Kirke, Japanese edition, p218. It is not clear how many items these bills covered, though Mme de Carbuccia bought twenty-five items a season from Vionnet, including daytime and evening dresses, furs and lingerie. She always brought her jewels with her for fittings and sometimes ordered dresses to complement them: 'A purple dress was bought to wear with my circle of diamonds; together they were the height of elegance and refinement.' (p217)
82 See *Madeleine Vionnet: L'Art de la Couture*, Centre de la Vieille Charité, Marseille, 1991, p45.
83 C. Evans and M. Thornton, *Women and Fashion: A New Look*, Quartet Books, London, 1989, p112.
84 ibid., p118.
85 C. Evans, 'Masks, Mirrors and Mannequins: Elsa Schiaparelli and and Decentered Subject', *Fashion Theory*, vol.3, no.1, pp3–32, quote p14 and illustration p12, fig. 3.
86 On Vionnet and her use of new materials see *Madeleine Vionnet: Les Années d'Innovation 1919–1939*, and also Betty Kirke, *Madeleine Vionnet*; J. Demornex, *Madeleine Vionnet*, Thames and Hudson, London, 1991; and C. Evans and M. Thornton, *Women and Fashion: A New Look*, Quartet Books, London, 1989, pp111–121; and L. Kamitsis, *Vionnet*, Thames and Hudson, London, 1996.
87 Kirke, English Edition, p221.
88 I am very grateful to Mme Poix for showing me this collection of photographs and for the warm welcome she gave to me in Paris. She made my visit to her archives most productive and enjoyable.
89 The example illustrated here is design number 4013, August 1935.
90 P. Villiers le Moy, interview with Grès, 'The Timeless Fashions of Madame Grès', *Connoisseur*, August, 1982, pp94–99, quotes from pp96–7. My enquiries at the Maison Grès in Paris failed to discover whether any sculptural works by their founder still existed.
91 *Alix Grès: L'Enigme d'un style*, exhibition catalogue, Villa de Noailles, Hyères, 1992, p5.
92 ibid., p60.
93 L. Benaïm, *Grès*, Editions Assouline, Paris, 1999, p8.

94 ibid., p13.
95 Interview with Alix, *Connoisseur*, p98.
96 ibid., p99.
97 It has been pointed out the the apparent looseness of the bodices in
 Alix's work is sometimes deceptive. The fluted surfaces of the
 bodices are anchored to a sheath of nude fitted shell to keep them
 in place. See the notes to plate 15 in R. Martin and H. Koda,
 Madame Grès, Metropolitan Museum of Art, New York, 1994.
 Vionnet did not do this with her bodices, nor with her heavy taffeta
 dresses of the later 1930s, where the stiff shapes and bulk of the
 dresses come not from a concealed structure underneath but from
 the twisting and knotting of the material itself. Compare for
 example the amazing fetishistic ball gowns of Charles James from
 the 1940s and 1950s, where taffeta and silk are sculptured onto a
 framework of skirts and supports. The colour, sound and feel of
 these dresses being worn must have been truly impressive. See R.
 Martin, *Charles James*, Editions Assouline, Paris, 1997.
98 Interview with Alix, *Connoisseur*, 1982, p99.
99 In her book on Vionnet, Demornex mentions the importance of
 white clothes at the time, connoting purity, elegance and taste. She
 mentions a scene arranged by the photographer Horst for an edition
 of *Vogue* in 1935 where models were posed wearing designer
 dresses to suggest the different types of classical columns such as
 Ionic, Doric etc. *Madeleine Vionnet*, 1991, p115. For more examples
 of the 'classical moderne' photographs of Horst and Hoyningen-
 Huene see W.A. Ewing, *The Photographic Art of Hoyningen-Huene*,
 Thames and Hudson, 1998, especially plates 1–47 'Couture and
 Classicism'. Horst died only recently. See the obituary in the
 Guardian, Saturday 20 November 1999, p26.
100 Ewing, pp38–9 for an illustration from the book and the quote from
 Frenzel's introduction. This mixture of capitalist modernity and
 antique art was one which the Nazis eventually adopted for their
 official culture, combining autobahns and Volkswagen cars, with
 pseudo-antique sculptures. However Hoyningen-Huene does not
 appear to have espoused fascism. Though he was an anti-
 communist and joined the British invasion force in the USSR just
 after the 1917 revolution (ie he was a white Russian), he contributed
 photographs to a publication in aid of the Greek War Relief
 Committee during World War Two when he spent most of his time
 in the USA. (Ewing p137) Despite Hoyningen-Huene's homosexuality
 (which was eventually likely to have put him off supporting fascism
 anyway), his approach to fashion photography was to seduce the
 female model. 'I always insisted on complete silence, no noise, no
 muttering behind my back. The model had to be under my control
 completely. I was patient and always encouraging; even if she did
 not at first do what I wanted, I would make an exposure and praise
 her and then improve until we reached the desired climax, by
 which time the model was elated and after the last shot felt a let-
 down. . . One psychological expedient was to make them conscious
 of their femininity. Someone once said that in many of my stills the
 models looked as if they were about to be kissed.' (Ewing p102)
 Thus the seduction of the model into a masquerade of pure sexual
 femininity is a culturally learned process which can be staged, not a
 biologically 'natural' fact.

101 R. Barthes, *The Fashion System*, Hill and Wang, New York, 1983, first published 1967, pxii.

102 ibid., p226. Interestingly, Barthes says that 'rustling' connotes autumn leaves or fabric like taffeta, and 'participates in a certain stereotype of feminine erotics'. (p228) He does not say why this is so, but I did notice in the course of my research for this book the number of times that the 'rustling' of still fabrics seemed to be employed in a sensual evocation of a particular 'high class' eroticism.

103 ibid., pp255–6. *Vogue* sometimes showed actual 'high society' individuals wearing the designer clothes.

104 Barthes, pp258–60.

105 Barthes, p302.

106 Barthes, p303.

107 Barthes, p303.

108 Marx, *Capital*, vol. 1, Pelican, Harmondsworth, 1976, pp163–4.

CHAPTER 3

1 See S. Freud, 'Fetishism' in volume seven *On Sexuality* of the Pelican Freud Library, Harmondsworth, 1991, pp347–357.

2 From 'Female Sexuality', quoted by B. Fer, 'Surrealism, Myth and Psychoanalysis' in B. Fer, D. Batchelor, P. Wood, *Realism, Rationalism, Surrealism: Art between the Wars*, Yale University Press, Open University, 1993, pp170–249, on p214.

3 The literature is extensive but see for example L. Gamman and M. Makinen, *Female Fetishism: A New Look*, Lawrence and Wishart, London, 1994; E. Grosz, 'Lesbian Fetishism?' in E. Apter and W. Pietz eds, *Fetishism as Cultural Discourse*, Cornell University Press, New York, 1993, pp101–118; and E.L. McCallum, *Object Lessons: How to do things with Fetishism*, State University of New York Press, 1999. For a recent, mainly post-Freudian analysis of fetishism and culture, see H. Krips, *Fetish: An Erotics of Culture*, Free Association Books, London, 1999.

4 R. von Krafft-Ebing, *Psychopathia Sexualis with especial reference to antipathetic sexual Instinct. A medico-forensic Study*, Aberdeen University Press, London, 1899 (translated from the 10th German edition).

5 See Kraft-Ebing, pp240, 242, 520.

6 ibid., pp262–3.

7 H. Ellis, *The Psychology of Sex*, Heinemann, London, 1948 (first published 1933) p158.

8 For this information I am grateful to Michael Molnar, curator of the Freud Museum, London.

9 For a photo of the original see plate 1 in volume seven of the Pelican Freud Library, facing page 256.

10 See the useful discussion of *Gradiva* and the French Surrealists in Fer, pp231–7.

11 Freud 'Delusions and Dreams in Jensen's *Gradiva*', in Pelican Freud Library vol.14, *Art and Literature*, Harmondsworth, 1985, p36.

12 Note the resemblance between the fascination for the walk of the woman lifting her draped clothing and Baudelaire's poem 'A une passante' referred to in Chapter 2.

13 ibid., p41, Freud quoting Jensen.

14 It has been suggested that Freud was so interested in Jensen's work
 because he (unconsciously) sought a symbolic union with his
 mother through his own visit to an important site of classical
 culture, the Acropolis at Athens, two years before he wrote the
 essay. I am not entirely convinced by this argument. See H.
 Slochower, 'Freud's Gradiva: Mater Nuda Redivia: A Wish-
 fulfilment of the 'Memory' on the Acropolis', *Psychoanalytic
 Quarterly*, 40, 1971, pp646–662.

15 J. Romney, 'Double exposure', the *Guardian*, Friday Supplement, 19
 March 1999, p24.

16 For illustrations and comments on these, see the catalogue
 Fetishism: Visualising Power and Desire, edited by A. Sheldon,
 South Bank Centre and Lund Humphries, London, 1995, pp122–3.

17 C. Metz, 'Photography and Fetish', in C. Squiers ed., *The Critical
 Image*, Lawrence and Wishart, London, and Bay Press Seattle, 1990,
 pp155–164.

18 My grateful thanks to Christine Barthe of the Photography Library,
 Musée de l'Homme, for her help with my research on the
 photographs, and for her kindness in alerting me to the papers kept
 upstairs in the library.

19 The most useful material on de Clérambault includes the brochure
 from the exhibition of his photographs at the Pompidou Centre,
 Paris in 1990, *Gaëtan Gatian de Clérambault: Psychiatre et
 Photographe*; E. Renard, *Le Docteur Gaëtan Gatian de Clérambault:
 Sa Vie et son Oeuvre (1872–1934)*, Synthélabo, Le Plessis-Robinson,
 1992 (originally published 1942, needs to be treated with care, since
 it tends to glorify its subject); A. Rubens, *Le Maître des Insensés:
 Gaëtan Gatian de Clérambault [1872–1934]*, Synthélabo, Le Plessis-
 Robinson, 1998 (the best biography); S. Tisseron ed., *Gaëtan Gatian
 de Clérambault: Psychiatre et Photographe*, Les Empêcheurs de
 Penser en Rond, Delagrange, Paris, 1990 (a well illustrated book
 with a selection of de Clérambault's photographs and accompanying
 essays – my grateful thanks to the publishers for sending me a
 complementary copy of this book); M. Balsamo, 'Clérambault, les
 femmes et la passion des étoffes' in J. André ed., *La Féminité
 Autrement*, Presses Universitaire de France, Paris, 1999, pp115–
 139; B. de Freinville, Y. Papetti, S. Tisseron, F. Vallier, *La Passion
 érotique des étoffes chez un Neuropsychiatre*, Solin, Paris, 1981 (a
 useful illustrated book with essays and a selection of de
 Clérambault's own writings). In the last few years examples of de
 Clérambault's photographs have been illustrated in a number of
 books as his rediscovery permeates English-speaking artistic and
 academic circles, however the only real attempt to look closely at
 his work which has been published in English is the essay 'The
 Sartorial Superego', in Joan Copjec, *Read my Desire: Lacan against
 the Historicists*, MIT Press, Cambridge, Mass. and London, 1994,
 pp65–116. While I do not agree entirely with elements of her
 heavily psychoanalytic reading of the photographs, I feel this is still
 a very useful essay.

20 Rubens, pp238–9.

21 ibid., p242.

22 Reproduced on a whole page of the brochure for the de Clérambault
 exhibition, Pompidou Centre, Paris, 1990 (no pagination). The letter

is on the headed paper of the Préfecture de Police, marked 'République Française, Liberté, Egalité, Fraternité'.

23 Rubens, p162.

24 Rubens, p141.

25 Rubens, p123. How different from the attitude to North Africans in the writings of revolutionary psychiatrist and activist Frantz Fanon, who used his skills to treat mental patients in North Africa and to train freedom fighters to attempt to withstand French torture and stay calm while carrying bombs.

26 For more detail on these points see P. O'Brien, 'The Kleptomania Diagnosis: Bourgeois women and theft in late nineteenth-century France', *Journal of Social History*, Fall, 1983, pp65–77. There is a section in Matlock 'Masquerading Women, Pathologised Men', pp54–61, which deals with shoplifting and fetishism.

27 These have recently been reissued with a preface by Yves Edel who has worked on de Clérambault's medical archives, *Passion Erotique des Etoffes chez la Femme*, Synthélabo, Le Plessis-Robinson, 1997.

28 'Du tissage comme mode de travail pour les malades', *Presse Médicale*, 12 January 1929, p61.

29 For example P.-E. Garnier, *Les Fétichistes*, Baillière, Paris, 1896; A. Binet, 'Le fétichisme dans l'amour', *Revue Philosophique*, 24, 1887, pp143–67; and E. Laurent, *Fétishistes et Erotomanes*, Vigot, Paris, 1905.

30 *Passion érotique. . .*, p46.

31 Rubens, p69.

32 Fer, 'Surrealism, Myth and Psychoanalysis', p212.

33 Fer, ibid., p219.

34 M.E. Chevreul, *Théorie des Effets Optiques que présentent les Etoffes de Soie*, Paris, Didot, 1846. Chevreul later became famous for his work on simultaneous colour contrasts which interested pointillist artists such as Seurat and Signac.

35 *The Ladies' Paradise*, University of California Press, 1992, p79.

36 Mme P. Doresse, *Les Tissus féminins*, 3e edition, Paris, 1933.

37 M. Chapsal, *La Chair et la Robe*, Fayard, Paris, 1989, p185.

38 E. Renard, *Le Docteur Gaëtan Gatian de Clérambault: Sa vie et son Oeuvre (1872–1934)*, Synthélabo, Le Plessis-Robinson, 1992, originally published 1942.

39 Rubens, *Le Maître des insensés*, p116.

40 See A. Williams, *Britain and France in the Middle East and North Africa*, Macmillan, London and St Martin's Press, New York, 1968, pp63–74.

41 E. Wharton, *In Morocco*, Cape, London, 1920, dedicated to General and Mme Lyautey.

42 Rubens, p166–7. Copies of some of his invitations are in his papers in the Musée de l'Homme library.

43 There is a large literature on Orientalist photography, of which the following examples are a few. C-H. Favrod, *Etranges Etrangers: Photographie et Exotisme, 1850/1910*, Centre National de la Photographie, Paris, 1989; exhibition catalogue, *Photographes en Algérie au XIXe siècle*, Musée-Galerie de la Seita, Paris, 1999; S. Graham-Brown, *Images of Women: The Portrayal of Women in Photography of the Middle East 1860–1950*, Quartet, London, 1988; M. Alloula, *The Colonial Harem*, Manchester University Press, Manchester, 1987.

44 Compare the photographs and the description of his house in Rubens, p125.

45 This concept of the body-element is discussed in relation to early twentieth-century fashion photography and photography of workers by A. Rouillé and B. Marbot, *Le Corps et son Image: Photographies du dix-neuvième siècle*, Contrejour, Paris, 1986, pp84–5.

46 See de Clérambault Box no. 1, notes in the folder marked 'Le Mobilier Normand' and Box no. 2, notes in small blue envelope, library of the Musée de l'Homme.

47 De Clérambault papers, text of his lecture at Congrès d'histoire de l'art, 28 September 1921, Paris, library of Musée de l'Homme. The study of his papers has been greatly facilitated by the efforts of a previous researcher, Danielle Arnoux, in making typed copies of de Clérambault's documents. My grateful thanks to her.

48 Letter to P. Léon, 4 September 1922, on pp9–10 of typescript of de Clérambault's documents.

49 Letter of 25 October 1922, pp11–13, typescript of his papers.

50 ibid., p20.

51 De Clérambault, typewritten documents, p24.

52 Rubens, pp177–185. Another scandal concerned a young pilot, Soulier, interned for 17 days at the police infirmary by de Clérambault. When a high-placed friend secured his release, de Clérambault drily commented that the man was clearly insane since he had shot down ten aircraft when he was only 20. (p187)

53 Metz, 'Photography and Fetish' in Squires ed., *The Critical Image*, pp155–164.

54 Typewritten transcription of de Clérambault's documents, library of the Musée de l'Homme, p9.

55 See A.T. Christ, 'The Masculine Ideal of 'the race that wears the toga'', *Art Journal*, 56, no. 2, Summer 1997, pp24–30.

56 Quotes from, and summary of, pp111–16 of J. Copjec, *Read my Desire: Lacan against the Historicists*, MIT Press, Cambridge, Mass. and London, 1994.

57 Letter in de Clérambault's papers, Musée de l'Homme.

58 E. MacAskill, 'Britain pressed to return aboriginal bones', *Guardian*, 5 July 2000, p4.

59 For more on this and discussions of examples of works by Black and Asian British artists see my book, *Black Visual Culture: Modernity and Postmodernity*, I.B.Tauris, London, 2000, chapter 3, 'Objectified Bodies or Embodied Subjects?'.

60 S.L. Gilman, 'Black Bodies, White Bodies: Towards an Iconography of Female Sexuality in Late Nineteenth-Century Art, Medicine, and Literature', in H.L. Gates Jr. ed., *'Race': Writing and Difference*, Chicago and London, 1986, pp223–261, p259 note 19.

61 For a useful recent discussion of Cuvier and definitions of black female sexuality see chapter 1 'Writing Sex, Writing Difference: Creating the Master Text on the Hottentot Venus' in T. Denean Sharpley-Whiting, *Black Venus: Sexualized Savages, Primal Fears and Primitive Narratives in French*, Duke University Press, Durham, 1999.

62 C. Peres, ''Veiling' as an artistic and metaphysical principle', paper read at the Congress of the International Association of Empirical Aesthetics, Rome, September 21–4, 1998, p4. I am grateful to Pen Dalton for drawing this paper to my attention.

63 Marx, *Capital*, vol. 1, Harmondsworth, 1976, p173.
64 L. Jordanova, *Sexual Visions*: *Images of Gender in Science and Medicine between the Eighteenth and Twentieth Centuries*, Harvester Wheatsheaf, New York and London, 1989, chapter 5 'Nature unveiling herself before science', note 3, p176. Jordanova discusses the gendering of material nature as feminine, while the unveiling of her secrets is to increase the knowledge of masculine science. There are many references to veiling and veils which are too numerous to discuss in detail here. There are literary works, for example, George Eliot's story *The Lifted Veil*, Virtue and Co. London, no date, which is set in 1850. The veil is lifted when the husband realises his wife is going to poison him. There is also the use of the veil to symbolise religious revelation. Drawing aside curtains in churches or religious imagery signifies a vision of divinity, and curtains in churches can divide different degrees of holiness eg separating the holy from the almighty. See J.K. Eberlein, *Apparition Regis – revelatio veritatis*: *Studien zur Darstellung des Vorhangs in der bildenden Kunst von der Spätantike bis zum Ende des Mittelalters*, Ludwig Reichert Verlag, Wiesbaden, 1982. See also E. Kuryluk, *Veronica and her Cloth*: *History, Symbolism, and Structure of a 'True' Image*, Blackwell, Oxford, 1991.
65 See the very interesting essay by M.A. Doane, 'Veiling over Desire', in R. Feldstein and J. Roof eds, *Feminism and Psychoanalysis*, Cornell University Press, Ithaca and London, 1989, chapter 6, pp105–141. This is also available in M.A. Doane, *Femmes Fatales*: *Feminism, Film Theory, Psychoanalysis*, Routledge, New York and London, 1991, chapter 3, pp44–75. I will return to this essay in chapter four when I discuss drapery and postmodernity.
66 Recounted by M. Iversen 'What is a photograph?', *Art History*, vol.17, no.3, September, 1994, pp450–64, on page 461, and by M.A. Doane, 'Veiling over Desire: Close-ups of the Woman', in R. Feldstein and J. Roof eds, *Feminism and Psychoanalysis*, Cornell University Press, Ithaca and London, 1989, chapter 6, p126. See also my introduction to this book.
67 Lacan writes: 'This lack is beyond anything which can represent it. It is only ever represented as a reflection on a veil.' The desire that the veil reflects cannot be represented. See M. Yegenoglu, *Colonial Fantasies*: *Towards a feminist reading of Orientalism*, Cambridge University Press, 1998, chapter 2, 'Veiled Fantasies: Cultural and Sexual Difference in the discourse of Orientalism', p47. Yegenoglu's discussion of the veil and fantasy is excellent.
68 N. Naghibi, 'Bad Feminist or *bad-hejabi*?: Moving outside the *Hejab Debate*', in *Interventions*: *International Journal of Postcolonial Studies*, vol.1, no.4, 1999, pp555–571. This is a very useful special issue devoted to the subject of 'The Veil'.
69 Quoted by H. Naficy 'Veiled Vision/Powerful Presences: Women in Post-revolutionary Iranian Cinema', in M. Afkhami and E. Friedl eds, *In the Eye of the Storm*: *Women in Post-revolutionary Iran*, I.B.Tauris, London and New York, 1994, pp131–150, quote p141.
70 *Guardian*, 'The Editor' supplement, 30 January 1999, p18, report from Pakistan by Olenka Frenkiel.
71 Maggie O'Kane, 'A holy betrayal', *Guardian Weekend*, 29 November 1997, pp28–45, p43.
72 S. Goldenberg, 'Veiled Threats', the *Guardian* supplement, 21

December 1999, p6. Due to the numbers of men killed in wars with
the Soviet Union and the Taliban, widows formed a large part of the
workforce in Kabul and by 1996 77% of its teachers were women.
This is no longer the case, as it is only recently that the Taliban
have (unofficially) allowed a small number of private schools to
reopen in teachers' homes.

73 Quoted from the interesting article by D. Hirst, 'Educated for
 Indolence', *Guardian*, 3 August 1999, p12.

74 For a discussion of the veil and national struggles see chapter 5,
 'The battle of the veil: Women between Orientalism and
 nationalism' in M. Yegenoglu, *Colonial Fantasies*. Fanon's essay is
 reprinted in his book *A dying Colonialism*, Grove Press, New York,
 1967, chapter 1. For additional reading on Algeria, Orientalism and
 the veil see N. MacMaster, T. Lewis, 'Orientalism: From unveiling to
 hyperveiling', *Journal of European Studies*, March-June, 1998,
 vol.28, nos 1–2, pp121ff; R.A. Faulkner, 'Assia Djebar, Frantz
 Fanon, women and land', *World Literature Today*, Fall 1996, vol.70,
 no.4, pp847ff; K. Dennis, 'Ethno-Pornography: Veiling the Dark
 Continent', *History of Photography*, vol.18, no.1, 1994, pp22–28;
 and the excellent article by W. Woodhull, 'Unveiling Algeria',
 Genders, no.10, Spring 1991, pp112–131.

75 An interesting article on the so-called 'chador' affair of 1989, when
 three French school students were asked to remove their
 headscarves or go home, is D.R. Blank, 'A Veil of Controversy: The
 Construction of a '*Tchador* Affair' in the French Press',
 Interventions, vol.1, no.4, 1999, pp536–54.

76 Yegenoglu, *Colonial Fantasies*. Also rather bizarre, but not
 uncommon, is the equation of the obligation for women to wear
 veils with wearing bras and cosmetics: 'Emphasizing the culturally
 specific nature of embodiment reveals, however, that the power
 exercised upon bodies by veiling is no more cruel or barbaric than
 the control, supervision, training and constraining of bodies by
 other practices, such as bras, stiletto heels, corsets, cosmetics, and
 so on.' (p116) While it is true that women in imperialist countries
 often feel obliged to change their bodies by wearing certain
 garments or even undergoing plastic surgery, the majority of them
 do so through ideological pressure, not coercion which can include
 death-threats.

77 F. El Guindi, *Veil: Modesty, Privacy and Resistance*, Berg, Oxford
 and New York, 1999, pp6ff.

78 Paul O'Kane in the leaflet accompanying the exhibition, March
 1999. See also his review of the exhibition in *Third Text*, no.43,
 Summer 1998, pp101–3.

79 See Naficy, in *In the Eye of the Storm*, pp140–143, and on the gaze
 and the veil see chapter 2 of Yegenoglu, *Colonial Fantasies*.

80 The book accompanying the exhibition is by F. Lloyd ed.,
 Contemporary Arab Women's Art: Dialogues of the Present, The
 Women's Art Library, London, 1999.

81 Yegenglu, *Colonial Fantasies*, p119. Italics in the original.

82 Lloyd, p216.

83 Illustrated in Lloyd, *Contemporary Arab Women's Art*, p68, and
 colour plate 49. Another work by Sedira, *Self Portrait*, 1998, is on
 p214. This shows two computer generated images projected on
 slide, of Sedira wearing the floor length chador which covers her

hair. She is also wearing a face veil so that only her eyes are visible confronting the camera. There is a back and a front view as she stands covered with draped cloth.

84 This is also seen in the excellent video work by the Turkish/German artist Kutlug Ataman, *Women who wear Wigs*, 1999. Woman number three is a devout Muslim woman whose solution to the state's ban on headscarves in universities is to wear a wig to classes.

85 Yegenoglu's book, *Colonial Fantasies*, is very good on the individual subject, but rarely speculates on any collective subjectivity or agency with respect to women and veiling in contemporary society.

CHAPTER 4

1 Review of the exhibition devoted to baroque architecture at the Stupinigi Hunting Lodge, Turin, in the *Guardian*, review section, 12 July 1999, p12. See also, P. Hugues, *Tissu et Travail de Civilisation*, Editions Medianes, Rouen, 1996, p292. S. Calloway, *Baroque Baroque: The Culture of Excess*, Phaidon, London 1994, (just published in paperback version, July 2000) refers to the twentieth-century baroque as a 'curious, hybrid, referential, highly-strung and self-conscious baroque', p15. Unfortunately the text of this book is almost totally useless, though the numerous illustrations do testify to the persistence of formal elements of baroque style throughout the twentieth century.

2 Reaktion Books catalogue, New Books, Autumn, 2000, entry for *Reflections on Baroque*, no pagination.

3 G. Celant, 'Framed: Innocence or Gilt?', *Artforum*, Summer 1982, pp49–55, quote on p53.

4 Published by The University of Chicago Press, Chicago and London, 1999.

5 See especially pp6–7.

6 On the social history of art as a method of studying visual culture, see my *Materialising Art History*, Berg Publishers, Oxford and New York, 1998, chapters 2 and 3.

7 J.R. Martin, *Baroque*, Pelican Books, Harmondsworth, 1977, p12.

8 See R. Saisselin, *The Enlightenment against the Baroque: Economics and Aesthetics in the Eighteenth Century*, University of California Press, Berkeley and Oxford, 1992, pp3, 5, 104.

9 ibid., p66.

10 J.A. Maravall, *Culture of the Baroque: Analysis of a Historical Structure*, University of Minnesota Press, Minneapolis, 1986, p227. Maravall is concerned to investigate and define what he calls the baroque 'mentality', which seems to me pretty much like a 'spirit of the age' and, although he describes the power basis of Spanish baroque society, he does not locate the 'crisis' negotiated by baroque culture in social conflicts, but more in the struggle of ruling classes faced with changing situations to come up with new solutions to developments in society and the economy.

11 In Britain, most of the press coverage was concerned with a portrait of the child-murdress Myra Hyndley, and in the States the main complaints were about Chris Ofili's supposed blasphemy in associating a (black) virgin with pornographic images of women.

12 C. Buci-Glucksmann, *La Folie du Voir: De l'Esthétique Baroque*,
 Galilée, Paris, 1986, pp35 and 141.
13 C. Buci-Glucksmann, *Baroque Reason: The Aesthetics of Modernity*,
 introduction by B.S. Turner, Sage, London, 1994, p98.
14 ibid., p155.
15 O. Calabrese, *Neo-Baroque: A Sign of the Times*, Princeton
 University Press, Princeton, 1992, p15.
16 ibid., intro., pxii.
17 See 'The Greenberg Effect: Comments by younger artists, critics and
 curators', *Arts Magazine*, December 1989, pp58–61, Reed's comments
 are on p60. For comments by the artist on baroque drapery see also
 David Reed Paintings: Motion Pictures, essays by E. Armstrong, P.
 Auster, M. Bal, D. Hickey, touring exhibition catalogue from the
 Museum of Contemporary Art, San Diego, 1998, p12.
18 For colour photographs of Reed's works and his techniques, see
 A.C. Danto, 'Bedside Manner', *Artforum*, Summer 1999, pp120–125.
19 ibid., pp123, 125.
20 M. Bal, 'Second-Person Narrative', *Paragraph: A Journal of Modern
 Critical Theory*, vol.19, no.3, November 1996, pp179–204, quotes
 from Deleuze on pp196–7.
21 Bal, p201. D. Carrier's article is 'Artifice and Artificiality: David
 Reed's recent paintings', *Arts Magazine*, January 1986, pp30–33.
 Carrier notes the absence of a 'handmade' quality from Reed's
 paintings, situating his work in the second of two types of
 paintings: 'A deictic image draws attention to the presence of the
 artist before the represented scene; a diegystic representation
 appears as if made without the intervention of the artist.' (p32) He
 remarks on Reed's fascination with baroque painting, but proposes a
 distinctly non-baroque way of reading art works, ie by breaking
 carefully orchestrated baroque totalities into fragments and details:
 'As a spectator, I need not compose a Caravaggio or Cavallino into
 an organic whole but may rather break that picture down into eye-
 catching units.' (p33) Here we definitely enter the realm of the neo-
 baroque/postmodern.
22 Bal, p196.
23 Danto, p122.
24 J. Gilbert-Rolfe, 'Painting Movement: The Work of David Reed', *Arts
 Magazine*, September 1991, pp36–7, quote from p37. In a previous
 article, Gilbert-Rolfe had discussed at length his enthusiasm for
 non-representational postmodern painters, his dismissal of the
 Enlightenment and its values and his admiration for Deleuze, *Arts
 Magazine*, May 1988, pp30–39, eg 'I should like to remind the
 audience that by and large the Enlightenment was, especially with
 regard to visual arts but not only with regard to them, by no means
 an unequivocally good thing from any point of view which one
 might nowadays describe as enlightened.' (p30) This view of the
 Enlightenment as a huge 'mass' of history extending from the
 eighteenth century to the mid-twentieth, is simply crude and
 ahistorical, ignoring the various phases, developments and conflicts
 undergone by the European bourgeoisie and its culture (and
 different fractions of it) during the historical period in question.
25 D. Carrier and D. Reed, 'Tradition, Eclecticism, Self-Consciousness:
 Baroque Art and Abstract Painting', *Arts Magazine*, January 1991,
 pp44–49, quote from p47.

26 I used the excellent translation by T. Conley, *The Fold: Leibniz and the Baroque*, The Athlone Press, London, 1993.

27 T. Conley, 'From Multiplicities to Folds: On Style and Form in Deleuze', in I. Buchanan ed., *A Deleuzian Century?*, Duke University Press, Durham and London, 1999, pp249–266, quote from p260.

28 On chaos theory and postmodernism see chapter 7 in A. Sokal and J. Bricmont, *Intellectual Impostures*, Profile Books, London, 1998. For an excellent Marxist discussion of the debates on postmodernism and science, with special reference to North American academic publications, see J. Tully, 'Taking Sides in the Science Wars', *Workers Power* newspaper, February 1999, pp14–15.

29 W. Benjamin, *The Origin of German Tragic Drama*, New Left Books, London, 1977, p48.

30 B.S. Turner, introduction to Buci-Glucksmann, *Baroque Reason*, p24. The universe is made up of individual substances which are soul-like entities (the monads) which are immaterial. Leibniz treated material objects as appearances of collections of monads.

31 ibid., p24. For a selection of Leibniz' writings see G.W. Leibniz, *Philosophical Writings*, Everyman, London, 1995 with an introduction by G. Parkinson.

32 J. Marks, *Gilles Deleuze: Vitalism and Multiplicity*, Pluto Press, London, 1998, pp15–6.

33 See the entry on Deleuze in J. Lechte, *Fifty Contemporary Thinkers: From Structuralism to Postmodernity*, Routledge, London and New York, 1994, p104.

34 From *Cinema – 2: L'Image-temps*, Editions de Minuit, Paris, 1985, quoted in Marks, p157.

35 See the introduction to *Intellectual Impostures*, and also D. Christy, 'The Science of Nonsense', *Guardian*, Saturday supplement, 27 June 1998, p8, where Sokal is interviewed.

36 Sokal, *Intellectual Impostures*, p148.

37 'Veiling over Desire: Close-ups of the Woman', in R. Feldstein and J. Roof eds, *Feminism and Psychoanalysis*, Cornell University Press, Ithaca and London, 1989, chapter 6.

38 Doane, p120, from the 1974 edition published by Vintage, New York, 1974.

39 Quoted from Nietzsche's book *The Will to Power*, by A. Callinicos, *Against Postmodernism: A Marxist Critique*, Polity Press, Cambridge, 1989, p67, in the course of a useful discussion of Nietzsche and Postmodernism.

40 Lacan, 'God and the *Jouissance* of the Woman', quoted by Doane p133.

41 For examples see L. Jordanova, *Sexual Visions: Images of Gender in Science and Medicine between the Eighteenth and Twentieth Centuries*, Harvester Wheatsheaf, New York and London, 1989.

42 For more on this, see the opening sections of my book *Seeing and Consciousness: Women, Class and Representation*, Berg Publishers, Oxford, 1995.

43 For example Polly Apfelbaum, 'From Fold to Fold', *New Observations*, Jan-Feb. 1996, p12 (a short piece on her own work with 'folds, piles and heaps' of textiles, which refers several times to Deleuze's book), and Jeff Perrone, 'Working through, Fold by Fold', *Artforum*, xvii/5, January 1979, pp44–50 (an article discussing philosophy and the folded work of artist Dorothea

Rockburne). This explains her work as destroying 'the perfect coordinates of traditional (Cartesian) space' and the author refers to Barthes, Derrida and Nietzsche, though he does mention Freud as well.

44　J. Key, 'Unfold: Imprecations of obscenity in the fold' chapter 12 in J. Steyn ed., *Other than Identity: The Subject, Politics and Art*, Manchester University Press, 1997, pp185–197.

45　ibid., p188.

46　Published in *Third Text*, no.32, Autumn 1995, pp43–58. Also useful is the interview with Yve Lomax by H. Gresty, '"The World is indeed a Fabulous Tale": Yve Lomax – A Practice around Photography', in N. Wheale ed., *The Postmodern Arts: An Introductory Reader*, Routledge, London and New York, 1995, pp150–162. Also available in Y. Lomax, *Writing the Image*, I.B.Tauris, London and New York, 2000.

47　Interview in *The Postmodern Arts*, p160.

48　'Folds in the Photograph', p54.

49　For a more detailed discussion of the principles of materialist dialectics in relation to visual culture, see my book *Materializing Art History*, Berg, Oxford and New York, 1998.

50　I don't mean to say here that these postmodernists are really unconscious dialecticians; I mean that there are dialectical methods of understanding the concepts and phenomena they discuss (they also seem to think they have newly discovered them, incidentally) but they choose to ignore them.

51　*The Postmodern Arts*, p155.

52　See for example the amazing concealing/revealing drapery on the figure of *Modesty*, by A. Corradini, 1745–52, Sansevero Chapel, Santa Maria dei Sangro, Naples, illustrated in colour as plate 15 in B. Boucher, *Italian Baroque Sculpture*, Thames and Hudson, London, 1998, or G. Sanmartino's *Dead Christ lying in the Shroud*, 1753 in the same church, plate 182 in Boucher.

53　For a selection of writings on Bernini, see G.C. Bauer ed., *Bernini in Perspective*, Prentice Hall, Englewood Cliffs, 1976, for example the extracts from Boselli, Winckelmannm and Lessing.

54　Quoted from S. Fraschetti's book, p74 of *Bernini in Perspective*. For an illustration see Boucher p107, figure on the left. The previous reference to the American visitor is from *Bernini in Perspective*, p62, from G.S. Hillard, *Six Months in Italy*, 1853.

55　See G. Eliot, *Middlemarch*, Zodiac Press, London, 1967 edition, chapter 19, p183, 184.

56　ibid., p189.

57　Information here is from the useful essay by C.F. Black, 'Exceeding every expression of words: Bernini's Rome and the Religious Background', in the exhibition catalogue A. Weston-Lewis ed., *Effigies and Ecstacies: Roman Baroque Sculpture and Design in the Age of Bernini*, National Gallery of Scotland, 1998, cost of the Cornaro Chapel is on p200, note 28. Also useful on the religious background, in particular on religious writings of the period, is G. Careri, *Bernini: Flights of Love, the Art of Devotion*, University of Chicago Press, Chicago and London, 1995 and S.K. Perlove, *Bernini and the Idealizaztion of Death: The 'Blessed Ludovica Albertoni' and the Altieri Chapel*, Pennsylvania State University Press, University Park and London, 1990.

58 Careri, *Bernini: Flights of Love*, pp71, 73. For a colour illustration of the *Blessed Ludovica Albertoni*, 1672–4, Altieri Chapel, San Francesco a Ripa, Rome see Boucher, plate 124. While these saintly, ecstatic women are usually represented by men, it is worth noting the presence of women artists living in convents and as uncloistered nuns in seventeenth-century Rome. See F.T. Camiz, ''Virgo-non sterilis. . .'': Nuns as artists in seventeenth-century Rome', chapter 6 in G.A. Johnson and S.F. Matthews Grieco eds, *Picturing Women in Renaissance and baroque Italy*, Cambridge University Press, Cambridge, 1997, pp139–164.

59 M. Perniola, 'Between Clothing and Nudity', in M. Feher and R. Nadaff eds, *Zone 4: Fragments for a History of the Human Body*, part 2, Zone Books, New York, 1989, pp237–65, quotes from pp253–4. See also the discussion of the St Teresa statue in G. Bruno, 'Written on the Body: Eroticism, death and hagiography', chapter 20 in H.J. Nast and S. Pile eds, *Places Through the Body*, Routledge, London and New York, 1998.

60 There is also the issue of the sculptor's 'triumph' over his materials. In an interview, the sculptor Stephen Cox discussed his use of drapery in works such as *Figura Femminile Impudica 1–1V*, and *Ecstasy: St Agatha*, of 1983: 'In a way it's quite baroque to take a piece of stone which weighs about a quarter of a ton and make it look effortless as if it was flying – it's what Bernini did. . . But I think there is a very strong feeling of wanting to be defiant, of taking a very resistant material and just throwing it up into the air – it's like being a magician really.' See R. Martin ed., *Stephen Cox: 'We must always turn South'. Sculpture 1977–85*, Arnolfini Gallery, Bristol, 1985, p45.

61 The essay is reprinted in H. Foster ed., *Postmodern Culture*, Pluto Press, London, 1985, pp126–134. Thanks to Nicholas Zurbrugg for drawing this essay to my attention.

62 ibid., p129.

63 Baudrillard locates this development in the rise of the commodity, as analysed by Marx. However Baudrillard mistakenly states that in the commodity its exchange value is paramount, thus resulting in pure exchangability and circulation (as sign). Baudrillard calls this '(potentially) ecstasy'. (p131). In fact Marx stresses both the use value and the exchange value of the commodity. Baudrillard has to downplay this, in order to argue for the pure interchangeablity of commodities 'beyond all use value'.

64 Information on St Teresa from R.J. Petersson, *The Art of Ecstasy: Teresa, Bernini and Crashaw*, Routledge and Kegan Paul, London, 1970. See also *The Life of Saint Teresa of Avila by Herself*, Penguin, Harmondsworth, 1957, introduction by J.M. Cohen, who points out that Teresa was always on the lookout for novices with large dowries to ensure the financial security of her convents. (p19) See also P. Ranft, *Women and the Religious Life in Premodern Europe*, Macmillan, Basingstoke and London, 1996, pp109–112.

65 She mentions in her autobiography that women are likely to make more progress on the path to union with God, but that this path is strewn with difficulties and possible dangers from those who suspect that the women are not pure: 'It is certainly a great trial to undergo, and requires cautious treatment, especially from those in charge of women. For we are very weak and could come to great

harm if we were told outright that the devil was deluding us. These cases should be very carefully considered, and women should be removed from all possible dangers. They should be advised to keep their experiences to themselves, and their advisers should keep them secret too. I speak as one who has suffered grave trials from the indiscretions of certain persons with whom I have discussed my prayers.' *The Life of Saint Teresa of Avila by Herself*, translated J.M. Cohen, Penguin, Harmondsworth, 1957, pp167. See also p309. Cohen himself, however, describes the pre-visionary Teresa as 'a self-willed and hysterically unbalanced woman' who was profoundly affected and transformed by her religious experiences.

66 See extract from Weibel's book in *Bernini in Perspective*, especially pp81–2.

67 For this information see chapter 7 of P. Ranft, *Women and the Religious Life in Premodern Europe*, Macmillan, Basingstoke and London, 1996.

68 M. Bernstein, *Nuns*, Collins, London, 1976, p70, 196.

69 ibid., p124.

70 See the article by S. Michelman, 'Breaking Habits: Fashion and Identity of Women Religious', *Fashion Theory*, vol.2, no. 2, June 1998, pp165–192. It is interesting to note at a time when much postmodern theory asserts the death of the individual subject, women in particular situations continue to assert their desire for individual subjectivity and self-expression.

71 V. McKee, 'The Colour of Sanctity', the *Independent Magazine*, 13 February 1993, pp34–6.

72 *The Life of Saint Teresa*, pp210–211.

73 See the interesting article by S. Short 'Come Again? Bernini's *St Teresa* as a Site/Sight for the writing of Male Desire', *Australian Journal of Art*, vol.8, 1989–90, pp78–95.

74 C. Baudelaire, 'The Salon of 1846' in *Art in Paris 1845–1862: Salons and other Exhibitions*, translated by J. Mayne, Phaidon, London, 1965, pp68–9. 'a Museum of Love, where there would be a place for everything, from *St Teresa*'s undirected affections down to the serious debaucheries of the ages of ennui.' (p68)

75 J. Rose, *Sexuality in the Field of Vision*, Verso, London, 1986, p77.

76 J. Swift, 'Reciprocal Passions: The Power of Practice', unpublished paper, 1997. My thanks to Jacquie Swift for a copy of this, where she discusses Bernini's sculpture, St Teresa's writings and Lacan's psychoanalytic work as practices. However in a critical response to Lacan, the philosopher Luce Irigaray argues for the female Christian mystics' privileged access to the unconscious and the unspeakable realms of women's desire, and mocks Lacan for his inabiility to step outside phallic logic. See the chapter 'La Mystérique' in *Speculum of the Other Woman*, Cornell University Press, Ithaca, 1985 (originally 1974). A more recent piece of creative writing by Adèle Olivia Gladwell explores themes of female sexuality, religious ecstasy and abjection in the essay 'Pleasure/Abjection/Pain: Santa Teresa in Estasi', *Bridal Gown Shroud*, Creation Press, London, 1992, pp156–163. It might be interesting to explore certain aspects of baroque statuary and the mixture of different media in many of them in relation to the concept of the abject, referred to by Julia Kristeva as 'What does not respect borders, positions, rules. The inbetween, the ambiguous, the composite.' (Quoted by Gladwell, p116)

77 There is a very useful entry on hysteria in E. Wright ed., *Feminism and Psychoanalysis: A Critical Dictionary*, Blackwell, Oxford, 1992, pp163–6, by Ellie Ragland-Sullivan, which summarises modern psychoanalytic approaches to hysteria. In terms of earlier material see G. Didi-Huberman, *L'Invention de l'Hystérie: Charcot et l'Iconographie photographique de la Salpêtrière*, Macula, Paris, 1982; J. Clair et al eds, *Autour des 'Etudes sur l'Hystérie': Vienne 1895, Paris 1995*, L'Harmattan, Paris and Montreal, 1998; J. Goldstein, *Console and Classify: The French Psychiatric Profession in the Nineteenth Century*, Cambridge University Press, Cambridge, 1987; E. Ender, *Sexing the Mind: Nineteenth-Century Fictions of Hysteria*, Cornell University Press, Ithaca and London, 1995; C. Mazzoni, *Saint Hysteria: Neurosis, Mysticism and Gender in European Culture*, Cornell University Press, Ithaca and London, 1996. See also S.L. Gilman et al., *Hysteria beyond Freud*, University of California Press, Berkeley, 1993, and the essay by J. Carroy 'L'hystérique, l'artiste et le savant', in the exhibition catalogue edited by J. Clair, *L'âme au corps: Arts et Sciences 1793–1993*, Grand Palais, Paris, 1993.

78 Goldstein, p334.

79 ibid., p335.

80 J.M. Charcot and P. Richer, *Les Démoniaques dans l'art*, Macula, Paris, 1984, first published 1887, p91, my translation. See also J. Clair et al eds, *Autour des 'Etudes sur l'Hystérie*, p58. Among the treatments available in more enlightened establishments than Charcot's were fresh country air, sports activities and hydrotherapy. (p67) This could entail the patient being wrapped in wet sheets soaked in cold or warm water and rubbed more or less vigorously. See for example the pamphlet by Dr F. Bottey, *De l'Emploi du drap mouillé en Hydrothérapie*, Paris, 1890.

81 See J. Carroy, p447.

82 Dr Briquet, quoted in E. Ender, *Sexing the Mind*, p37.

83 See Freud, 'Some general remarks on hysterical attacks', 1909, Penguin Freud Library vol.10, *On Psychopathology*, Harmondsworth, 1993, p102, and the slightly earlier essay 'Hysterical Fantasies and their Relation to Bisexuality', 1908, in the same volume.

84 The first woman doctor to study hysteria, Hélène Goldspiegel, presented her doctoral thesis in 1888, under Charcot's direction. It did not differ from her tutor's approach to the illness. However the second doctoral thesis, presented in 1898 by Mlle Georgette Déga, placed much more emphasis on education for women as a help in preventing hysterical attacks. Thus women would be able to interpret and understand their experiences and not be overwhelmed by them. See J. Clair et al eds, *Autour de 'Etudes sur l'Hystérie*, pp70–71.

85 Quoted in Mazzoni, p14.

86 See Mazzoni for material on Teresa and other mystics as hysterics, pp37–53 and his, 'Postscript: Reading the symptoms (Freud and Teresa of Avila)', pp190–96.

87 Goldstein, p372.

88 *Les Démoniaques dans l'art*, Macula, Paris, reprint 1984. In Charcot's series of case studies illustrated with photographs of his patients and others, *L'Iconographie de la Salpêtrière*, an illustration of St Teresa in ecstasy can be found, vol.1, 1876, fig.24, with

commentary pp69–71. Given that Charcot believed that this ecstatic stage was a prelude to 'erotic delirium', it is clear why the church was unsympathetic to his work, and, as mentioned above, banned a book by a Jesuit priest who claimed that St Teresa was a hysteric.

89 J. Hooper, 'Vatican lays down new rules for exorcism', *Guardian*, 27 January 1999, p15. Rather predictable, I feel. But then if the woman had returned to tell the Pope she had become a lesbian, then presumably the miracle cure would have failed!

90 *Les Démoniaques*, p159.

91 See the interesting article by D. de Marneffe, 'Looking and Listening: The Construction of Clinical Knowledge in Charcot and Freud', *Signs*, Autumn 1991, pp71–111, p78. As de Marneffe notes, however, Freud was only interested in hearing the speech of 'sympathetic' patients, who were normally those who could afford to see him: 'The procedure is laborious and time-consuming for the physician. It presupposes great interest in psychological happenings, but personal concern for the patients as well. I cannot imagine bringing myself to delve into the psychical mechanism of a hysteria in anyone who struck me as low-minded or repellent, and who, on closer examination, would not be capable of arousing human sympathy.' (quoted on p98 of this article)

92 Gilman et al, *Hysteria Beyond Freud*, chapter 5, from the essay by Gilman, 'The Image of the Hysteric', pp349–50.

93 G. Didi-Huberman, *Invention de l'Hystérie*, p284, appendix 18, extract from the medical photographer Londe's book *La Photographie Médicale*: 'The hysterics were brought before the camera under the pretext of having their portraits taken. At that moment a gong was struck, and the women all fell into a cataleptic trance, as the sketches of the event by Dr. Richer demonstrate.'

94 De Marneffe, p84.

95 Details of Augustine's sexual traumas, including rape, are however given in the *Iconographie Photographique de la Salpêtrière* accompanying photographs of her, but Charcot does not see these sexual traumas as likely causes of the hysterical attacks. See de Marneffe, pp87–8. Works by female artists dealing with aspects of hysteria have been concerned to deconstruct notions of hysteria, femininity and the subordinate position of women. See for example Mary Kelly's *Interim* (1984–89), which consists of photographs and texts on laminated plexiglass panels, showing creased and folded clothing (leather jacket, blouse etc) representing the 'passionate attitudes' of Charcot's analysis of hysterical attacks. These include 'ecstasy' and 'threatened'. The texts relate to the suppressed voices and desires of women. On *Interim* see M. Kelly, *Imaging Desire*, MIT Press, Cambridge Mass., and London, 1996, and P. Adams 'The Art of Analysis: Mary Kelly's *Interim* and the Discourse of the Analyst', in *The Emptiness of the Image*: *Psychoanalysis and Sexual Differences*, Routledge, London and New York, 1996, chapter 6, pp71–89. Also of interest is Louise Bourgeois' sculpture *Cell (Arch of Hysteria)* 1992–3, which is a plastercast of her (male) assistant's body. Charcot also had plastercasts made of some of his patients in his efforts to create a museum of pathological material, composed of inanimate objects, as a parallel to what he called the '*musée pathologique vivant*', ie all the inmates of his asylum. See Appendix 1, p295 in Didi-Huberman, *Invention de l'Hystérie*.

96 Quoted by D. Bowen, 'Hysteria and the Helio-trope: On bodies, Gender and the Photograph', *Afterimage*, vol.26 no. 4, Jan/Feb 1999, pp13–16, on p14.

97 E. Lemoine-Luccioni, *La Robe: Essai psychanalytique sur le Vêtement*, Editions du Seuil, Paris, 1983, p144, my translation.

98 This series of photographs is illustrated in M. Featherstone ed., *Body Modification*, Sage, London, 2000, p156. In Roland Barthes'essay 'Striptease' he writes: 'The end of the striptease is then no longer to drag into the light a hidden depth, but to signify, through the shedding of an incongruous and artificial clothing, nakedness as a *natural* vesture of woman, which amounts in the end to regaining a perfectly chaste state of the flesh.' Barthes also argues that French culture works to 'nationalise' striptease, for example at the Moulin Rouge nightclub. See *Mythologies*, Vintage, London, 1993, pp84–87, first published 1957.

99 Barthes, ibid., p84.

100 J. Goodall, 'An order of pure decision: Un-natural selection in the work of Stelarc and Orlan', in *Body Modification*, p155.

101 See K. Ince, 'Operations of Redress: Orlan,the Body and its Limits', *Fashion Theory*, vol.2, issue 2, pp111–28, p124. See also pp11–12 of the essay by S. Wilson 'L'Histoire d'O, Sacred and Profane', in D. McCorquodale ed., *Ceci est mon Corps. . . Ceci est mon logicel/This is my body. . . this is my software*, Black Dog, London, 1996. See also the essays by J. Goodall, 'An order of Pure Decision: Un-Natural Selection in the Work of Stelarc and Orlan', pp149–170, and J. Clarke, 'The Sacrificial Body of Orlan', pp185–207 in M. Featherstone ed., *Body Modification*, Sage, London, 2000.

102 See the illustration *Reliquiary from the 7th surgical Operation*, 1993, blood and photo-transfer on gauze, on p73 of the article by D. Moos, 'Memories of Being: Orlan's Theater of the Self', in *Art and Text*, part 54, May 1996, pp66–73.

103 On saints' relics and the notion of the commodity, see the essay by P. Geary 'Sacred Commodities: The circulation of medieval relics', in A. Appadurai ed., *The Social Life of Things: Commodities in Cultural Perspective*, Cambridge University Press, Cambridge, 1986, pp169ff. Strictly speaking, not all saints' relics were really commodities during the medieval period, but they played an important economic role since they attracted pilgrims to visit the towns in which they were located and thus generated profits for local tradespeople and the church.

104 P. Adams, chapter 11 'Operation Orlan' in *The Emptiness of the Image: Psychoanalysis and Sexual Differences*, Routledge, London and New York, 1996, especially pp153–9.

105 See chapter 6 'God and the *Jouissance* of The Woman: A Love Letter', in J. Mitchell and J. Rose eds, *Jacques Lacan and the Ecole Freudienne: Feminine Sexuality*, Macmillan, Basingstoke, 1982, from Lacan's seminar XX, 1972–3.

106 Adams, *Emptiness of the Image*, p153.

107 Unpublished interview with Professor Nicholas Zurbrugg, January 1999.

108 *Mise en Scène pour une Sainte*, 1980–81, for the Espace Lyonnais d'art Contemporain, illustrated and discussed in the catalogue *Orlan: Skaï et sky and Vidéo*, Galerie J. and J. Donguy, Paris, 1984, in the section 'Dualisme du baroque', no pagination.

109 Interview of January 1999.

110 Actually the artist is mistaken here in associating this pose of saintly women specifically with the baroque, as there are many earlier representations of the Virgin Mary with one bare breast. See M.R. Miles, 'The Virgin's one Bare Breast: Female Nudity and religious meaning in Tuscan early Renaissance Culture', in S. Rubin-Suleiman ed., *The Female Body in Western Culture*, Harvard University Press, Harvard, 1986, pp193–208.

111 Quote from the text of Orlan's lecture, p11, my translation. Many thanks to the artist for providing me with a copy of this and for all her other help.

112 Quoted next to the illustration of *The Metamorphoses of the Sacred*, in L. Lublin, *Orlan: Histoires Saintes de l'art*, La Certidé, Clergy-Pontoise, 1985(?), no pagination.

113 My thanks to Odile Burluraux of the Musée d'Art Moderne de la Ville de Paris, who helped me to view this performance on an old Betamax tape which caused us considerable technical difficulties, hence the impossibility of taking a still photograph from it to illustrate here.

114 See for example, the heavily Foucauldian study by S. Lalvani, *Photography, Vision, and the Production of Modern Bodies*, State University of New York Press, 1996, and J. Stratton, *The Desirable Body: Cultural Fetishism and the Erotics of Consumption*, Manchester University Press, Manchester, 1996.

115 Notably in the TV series and book which accompanied it, C. Townsend, *Vile Bodies: Photography and the Crisis of Looking*, Prestel and Channel 4 TV, London 1998, featuring, among others, the fashionable images of 'damaged bodies' by Joel-Peter Witkin.

116 T. Eagleton, *The Illusions of Postmodernism*, Blackwell, Oxford, 1996, p71.

117 See the special issue of *New Internationalist*, no.300, April 1998, 'The Body: The world made flesh', article on 'The new cannibalism' by N. Scheper-Hughes, pp14–17.

118 'Under knife to conform', *Guardian*, 1 March 1999, p8.

CHAPTER 5

1 A. Bassin, review of Golub's exhibition *Drapery Study 2000*, in *Contemporary Visual Arts*, Issue 29, 2000, p67. My thanks to Kathy Fawcett for drawing this work to my attention.

2 M. Constantine and L. Reuter, *Whole Cloth*, The Monacelli Press, 1997. This is a very well illustrated book with a large number of examples of works using cloth.

3 See press release by Christo and Jeanne-Claude in Christo and Jeanne-Claude, *Verhüllter/Wrapped Reichstag, Berlin, 1971–1995*, Taschen, Köln, 1995, pp92–3.

4 Interview with Jeanne-Claude and Christo in *Domus*, no.790, February, 1997, special issue on 'The Object Clothed'.

5 Christo and Jeanne-Claude, op.cit., p93. On another occasion Christo stated that the drapery on the building 'will create very rich angular folds, almost Gothic, incredibly beautiful.' J. Baal-Teshuva, *Christo and Jeanne-Claude*, Taschen, Köln, 1995, p10.

6 Dieter Ronte, Director of the Bonn art museum, in J. Baal-Teshuva, *Christo and Jeanne-Claude*, Taschen, Köln, 1995, p11.

7 Baal-Teshuva, p85. For an interesting article on the ideology of the 'wrapped Reichstag' project see Esther Leslie, 'Wrapping the Reichstag: Re-Visioning German History', *Radical Philosophy*, 77, May-June 1996, pp6–16. Very many thanks to Esther Leslie for giving me a copy of this.

8 Editorial in 'The Object Clothed' special issue of *Domus*, 790, February 1997, p5.

9 Local businesses offered special wrapped dresses, wrapped hairstyles and food wrapped in filo pastry and cabbage leaves, while shops stayed open late into the night as the 6pm closing time was suspended. See D. Galloway, 'Packaging the Past', *Art in America*, vol.83, November 1995, pp86–9, these details p86.

10 In *Still Life Drawing*, by P. Stanyer and T. Rosenberg, Arcturus, 1996, chapter four is devoted to drapery as a still life practice, rather than as a way of representing clothed figures. Projects include drawing a jacket on a coat-hanger and a piece of furniture draped in a sheet. The authors, who teach drawing at the City Literary Institute and the Chelsea School of Art and Design, London, include these projects in their still life instruction 'because they are useful subject matter on which to practise creating the illusion of form and texture.' (p46)

11 *The Fold*, pp37–8.

12 Artist's statement, 1991, kindly provided by Wildenstein and Co., London.

13 My grateful thanks to Jacqueline Morreau for sending me information on her work, including the brochure on her 1994 exhibition *Fold upon Fold*.

14 See P. Pitts, 'Not just a pretty face: Feminine wiles in New Zealand women's art practice', in C. Barton and D. Lawler-Dormer, *After/Image: Femininism and Representation in New Zealand Art 1973–1993*, City Gallery Wellington, and Auckland City Art Gallery, 1993, pp18–19. However it should be noted that not all the words which appear in Rae's drapery paintings are unreadable.

15 My thanks to the Jonathan Smart Gallery in Christchurch, New Zealand, for sending me material on Jude Rae.

16 This is the Greenbergian view of modernism, especially influential in the 1960s, which has since been widely criticised. For a useful discussion of modernism in nineteenth-century French painting, see B. Fer's introduction to F. Frascina, N. Blake, T. Garb and C. Harrison, *Modernity and Modernism: French Painting in the Nineteenth Century*, Yale University Press and Open University, New Haven and London, 1993.

17 My thanks to Ruth Trotter for sending me information on her work, including the useful exhibition review by V. Rutledge, 'Ruth Trotter: Draped', *Art Papers*, July-August 1998, p28.

18 Quote from Marianne Ryan, in the exhibition catalogue *Textures of Memory: The Poetics of Cloth*, Angel Row Gallery, Nottingham, 1999, p38.

19 Information kindly supplied by the artist, written September 1999.

20 Statement by the artist, written September 1999.

21 From an interview with the artist in the catalogue *Sarah Cawkwell: Selected Work 1985–1998*, Fermoy Gallery, King's Lynn Art Centre, 1998, no pagination. Very many thanks to Sarah Cawkwell for sending me a copy of this, and for all her other help and hospitality.

22　Technically the polaroid has developer on the surface of the print which is activated by the pulling away of a layer of covering. In the photo-booth, the sensitised strip is positive (no negative) but goes through a traditional developing process (developer, fixative and wash) in sequence. Thanks to Liz Rideal for telling me about photo-booth processes.

23　*Innovation/Imagination: 50 Years of Polaroid Photography*, with an essay by D.M. Kao, Harry N. Abrams, New York, 1999.

24　See the review of Welling's exhibition by C. Burgin, in *Art in America*, July 1988, p135, and the review article by A. Cueff in *Beaux-Arts Magazine*, no.75, June 1990, pp68–75.

25　Letter from the artist. My grateful thanks to Alexis Hunter for all the help she gave me with reproductions and discussions of her work.

26　For an excellent survey of Rideal's recent work see the exhibition catalogue, *Liz Rideal: New Work*, Angel Row Gallery, Nottingham, and Ferens Art Gallery, Hull, 1998.

27　See for example the article by Janis Jeffries, 'Text, Textile, Sex and Sexuality' in *Women's Art Magazine*, no.68, January/February 1996, pp5–9.

28　ibid., p8.

29　ibid., p9.

30　This is included in the brochure edited by F. Russell, *Sampled: The use of Fabric in Sculpture*, published by the Henry Moore Institute, Leeds, 1999, pp8–10.

31　ibid., p10.

32　Exhibition catalogue *Lia Cook: Material Allusions*, Oakland Museum of California, 1995, pp11–12.

33　ibid., p11.

34　This description of Cook's working processes is taken from the article by C. Santiago, 'Lia Cook: Material Allusions', *American Craft*, vol.56, April/May 1996, pp44–9, especially p49.

35　Written communication from the artist, August 2000. My very grateful thanks to Lia Cook for all her help.

36　Chelsea Miller Goin in *Lia Cook: Material Allusions*, catalogue, p11. See also Miller's useful article in *Fiberarts*, vol.22 Jan/Feb.1996, pp43–7.

37　All these works are illustrated in colour in the *Lia Cook: Material Allusions* catalogue.

38　Lia Cook quoted by C. Santiago in *American Craft*, p49.

39　The main book on her is by Mary Garrard, *Artemesia Gentileschi: The Female Hero in Italian Baroque Art*, Princeton University Press, Princeton, 1989.

40　For an interesting collection of essays relating to the subject of Bathsheba and its different meanings, see A.J. Adams ed., *Rembrandt's 'Bathsheba Reading King David's Letter'*, Cambridge University Press, Cambridge, 1998.

41　*Lia Cook: Material Allusions*, essay by Janis Jeffries, pp15–17, quote from p16.

42　Quotes from a letter from Murray Gibson to me.

43　See the essay by Chelsea Miller Goin in *Lia Cook: Material Allusions*, pp10–11.

44　M. Gibson, 'Mary, Mary, quite contrary: Meeting the Other', *International Tapestry Journal*, vol.3 no.2, Summer 1997, special issue on 'Tapestry and the Body', pp12–16. My thanks to Murray Gibson for sending me a copy of his article.

45 Murray Gibson used the translation of the speech from M. Baxandall, *Painting and Experience in Fifteenth Century Italy*, Oxford University Press, Oxford, 1974.

46 All this information from letter from Murray Gibson, to whom I am most grateful for the generous way he answered my queries and provided me with material on his work.

CHAPTER 6

1 J. Berger et al, *Ways of Seeing*, BBC and Penguin Books, Harmondsworth, 1975 (first published 1972), p152.

2 For an example of the playful and creative consumerism argument see A. Partington, 'Perfume: Pleasure, Packaging and Postmodernity' in P. Kirkham ed., *The Gendered Object*, Manchester University Press, Manchester 1996. For an alternative view critical of globalised 'brand' culture, see N. Klein, *No Logo*, Flamingo, London, 2000.

3 See P. Preston, 'The Last Picture Show', *Guardian Weekend*, 28 November 1998, pp24–35. One recent book on photojournalism which continues, as I do, to deal with concepts like truth, knowledge and reality is John Taylor, *Body Horror: Photojournalism, Catastrophe and War*, Manchester University Press, Manchester, 1998. Taylor's useful book deals with similar kinds of images to those discussed in this chapter, though not from the point of view of the presence of drapery in them.

4 R. Barthes, *Camera Lucida: Reflections on Photography*, Vintage, London, 1993, p111.

5 It is not only in advertising photography that we see the body, or parts of it, displayed in this way. In some of Andres Serrano's *Morgue* photographs, 1992, such as *Fatal Meningitis II*, where a child's face is surrounded by white drapery, parts of the body are 'set off' by the drapery as if they are objects on display in richly coloured advertising images, special and desirable objects to be coveted. This photograph is illustrated in the exhibition catalogue *The Dead*, National Museum of Film, Photography and Television, Bradford, 1996, p55.

6 For an attempt to look at Orientalism as Imperialism see Z. Sardar, *Postmodernism and the Other: The New Imperialism of Western Culture*, Pluto Press, London, 1998. This is slightly disappointing however. Sardar says very little about class in imperialised countries and never seems to break out of a Saidian mind-set of East vs. West. He seems to think that non-European religions, eg Islam, are very progressive and offer a way out of imperialist exploitation. However he does not discuss capitalism and Islam.

7 W. Benjamin, Thesis no.VII, 'Theses on the Philosophy of History' (1939), *Illuminations*, Fontana/Collins, London and Glasgow, 1977, p258. He says virtually the same in his essay 'Eduard Fuchs, Collector and Historian', (1937), *One Way Street and Other Writings*, Verso, London, 1992, p359: 'The historical materialist understands that the abstract mode in which cultural history presents its material is an illusion, established by false consciousness. He approaches this abstraction with reserve. He would be justified in this reserve by the mere inspection of the

actual past: whatever he surveys in art and science has a descent that cannot be contemplated without horror. It owes its existence not just to the efforts of the great geniuses who fashioned it, but also in greater or lesser degree to the anonymous drudgery of their contemporaries. There is no cultural document that is not at the same time a record of barbarism.' My thanks to Esther Leslie for sending me a copy of her shortly-to-be-published essay on Walter Benjamin's critique of bourgeois notions of progress, which begins with a discussion of the civilisation/barbarism quotes.

8 'Theses on the Philosophy of History', p258.
9 See for example *The Times*, 24 September 1997, and the front page of the *Guardian* for the same day.
10 Interview with Hocine in *1998 World Press Photo*, Thames and Hudson, London, 1998, p7. My very grateful thanks to Jennifer Greitschus, Visual Arts Assistant at the Royal Festival Hall, for her kind help in providing me with information about Hocine's photograph.
11 See *Hello* magazine, 25 October 1998, 'An image and its untold story: A woman whose grief moved the world reveals the facts behind the award-winning photo'.
12 Neil Burgess, foreword to *1998 World Press Photo*, p9.
13 Hocine's photograph was shown with other examples of his excellent work from Algeria and Somalia at *The Newseum*, in Arlington Va., USA. *The Newseum* is devoted to the history and development of news reporting and promotes press freedom. Very many thanks to them for sending me a catalogue of their Hocine exhibition (*Hocine*, The Newseum, Arlington, Virginia, 1998) and answering my queries. They have an informative website through which I located Hocine's exhibition.
14 P. Preston in *Guardian Weekend*, 28 November 1998, p27.
15 These pattern books consisted of drawings or prints which formed a catalogue of different expressions from love to hate, ecstasy to despair, and were used by both students and qualified artists to help clarify the narrative meanings of their pictures. The artist most commonly associated with these 'expressive' heads was the President of the French Academy, Charles Le Brun, some of whose seventeenth-century works were recently exhibited in *Spectacular Bodies: The Art and Science of the Human Body from Leonardo to Now*, catalogue by M. Kemp and M. Wallace, Haward Gallery, University of California Press, Berkeley, Los Angeles and London, 2000, cat. nos.176–182.
16 See E. Gallet, 'The Menace of Islamic Fundamentalism', *Trotskyist International*, no.9, Sept/Dec 1992, pp12–20, quotes from p16. Berbers, the original inhabitants of Algeria, are discriminated against and their languages are not permitted in schools.
17 However it is important to note that the FIS only won 3.25 million votes out of an electorate of 13 million people. See D. Hirst, 'Iran to lead new era of secular reform', *Guardian*, 15 February 2000, p18.
18 See Amnesty International website on Algeria.
19 See 'Large take-up for Algeria Amnesty', BBC homepage/world service/education, http://www.news.bbc.co.uk/hi/english/world/middle_east.
20 On the Family Code and Algerian women see the useful article by W. Woodhull, 'Unveiling Algeria', *Genders*, no.10, Spring 1991,

pp112–131, and the very informative website *Troubles: Lettre de la Commission Socialiste de Solidarité Internationale (CSSI), Genève*, http://www.home.ch/~spawl1265/ecosoc.htm#Code. This is made up of extracts from Agence France Presse news reports and is an invaluable source of information about the current situation in Algeria.

21 *Troubles* website, p35, quoting the daily paper *El Khabar*.

22 F. Aubenas and J. Garçon, 'Killers close in on Algiers', *Guardian*, 24 September 1997, p16.

23 *Troubles* website, p34.

24 For information on journalists in Algeria see websites 'Truth under Seige' wysiwyg://194/http://www.mojones.com/news_wire/algeria.html and http://www.cpj.org/pubs/attacks97/mideast/algeria.html.

25 Website *Kosovo Crisis Center* http://www.alb-net.com/warcrimes-img/prekaz.htm. Another website from Amnesty International, on 'Deaths in custody, torture and ill-treatment' in Kosova, consists of case studies accompanied by photographs of the marks of torture and beatings on the bodies of the victims who are still alive and able to bear witness. http://www.ddh.nl/fy/kosova/reports/1998/ai0698-3html.

26 A. Gumbel, 'Survivors of Serb massacre refuse to bury their dead', *Independent*, 10 March 1998, p9.

27 T. Walker, 'Albanians defy Serb order for quick funerals', *The Times*, 10 March 1998, p12.

28 There are many discussions of the photographs of the dead Communards. See for example C. Phéline, *L'Image Accusatrice*, Les Cahiers de la Photographie, Paris, 1985, pp28–35, and chapter 4 'Women, Class and Photography: The Paris Commune of 1871' in my book *Seeing and Consciousness: Women Class and Representation*, Berg, Oxford and Washington DC, 1995. The most recent publication on photography and the Paris Commune is *La Commune Photographiée*, exhibition catalogue, Musée d'Orsay/Réunion des Musées Nationaux, Paris, 2000

29 Greg Hobson in his essay 'A Horrible Exhibition' finds Louis Jammes' photographs of dead bodies from the morgues of Sarajevo in 1993 'sculptural heroic portraits in the style of religious paintings. Swaddled in tattered body bags, the subjects in these iconographic works are not depicted as victims of war, but sacred beings.' See the exhibition catalogue *The Dead*, National Museum of Photography, Film and Television, Bradford, Yorkshire, 1995–6, p25, essay pp19–26.

30 J. Steele, 'The Lethal Engine of Ethnic Cleansing', *Guardian*, 3 February 1999, p15.

31 C. Bird, 'Unarmed, unflappable, but unable to keep peace in Kosovo', *Guardian*, 5 January 1999, p11.

32 See the articles by Nicholas Watt and Richard Norton-Taylor in the *Guardian*, 24 April 1999, p3. The colour photograph on this page shows fire and rescue personnel trying to find survivors and bodies in the severely damaged building. A dead body at the scene has been draped in a green tarpaulin.

33 S. Lalvani, *Photography, Vision, and the Production of Modern Bodies*, SUNY Press, New York, 1996, pp34–5.

34 *Camera Lucida*, p111.

35 *Camera Lucida*, p9.

36 *Camera Lucida*, p79.
37 For a view of Serrano's photographs as 're-circulated Catholic baroque iconography' see D.A. Mellor, 'From the carnal to the virtual body', *Art and Design Profile* no.44, *Photography and the Visual Arts*, 1995, pp88–96, and for more on death, the body and photography see S. Brown and S. Hobson eds, *Intimations of Mortality*, Available Light, Tiverton, 1995, and *The Dead*, exhibition catalogue, National Museum of Photography, Film and Television, 1995–96.
38 S. Sontag, *On Photography*, Penguin, Harmondsworth, 1977; R. Bazin, *What is Cinema?*, vol.1, University of California Press, Berkeley and London, 1967, discussed in Paul Edwards' article 'Against the photograph as *Memento Mori*', *History of Photography*, vol.22, no.4, Winter 1998, pp380–84. See also C. Metz 'Photography and Fetish', in C. Squiers ed., *The Critical Image: Essays on Contemporary Photography*, Lawrence and Wishart, London, 1990, pp155–64.
39 *On Photography*, p107.
40 W. Benjamin, 'A Small History of Photography', in *One Way Street and other Writings*, Verso, London, 1992, pp240–257, see page 243. The essay was written in 1931. A different view of Benjamin's concept of the 'optical unconscious' is used in an interesting article by E. O'Connor, 'Camera Medica: Towards a Morbid History of Photography', *History of Photography*, vol.23, no.3, Autumn, 1999, pp232–244.
41 For an illustration see the photograph by Richard Hanson accompanying the article by D. Gough, 'The miracle children', *Guardian*, 22 December 1999, p14.

CONCLUSION

1 The aesthetician and historian of antique art J.J. Winckelmann discusses the sculptural group in his *Gedanken über die Nachahmung der Griechischen Werke in der Malerei und Bildhauerkunst*, published in 1755. The priest does not open his mouth and shriek with pain, therefore his suffering expresses nobility of soul. G.E. Lessing's essay *Laokoon*, published in 1766, sought to distinguish between poetry and the visual arts in their treatment of human experience. Lessing stated that sculptors should represent beauty and choose 'fruitful' moments, the *Laocoön* group being a particularly successful example. At this time, baroque art was thought to be inferior due to its lack of restraint and penchant for ugly and extreme poses and sensations.
2 W. Benjamin, *Illuminations*, Fontana/Collins, London and Glasgow, p258.

SELECT BIBLIOGRAPHY

Adams, P., 'Operation Orlan', chapter 11 in *The Emptiness of the Image: Psychoanalysis and Sexual Differences*, (Routledge, London and New York, 1996) pp140-159

Allen, L., 'Drapery Painter', *The Grove Dictionary of Art*, ed. J. Turner, vol. 9, (Macmillan, Basingstoke, 1996) pp211-3

Anon., 'The Thing is: French Drapes', *Guardian Weekend* magazine, 30 October 1999, p93

Ames-Lewis, F., 'Drapery "Pattern"-drawings in Ghirlandaio's Workshop and Ghirlandaio's early apprenticeship', *Art Bulletin*, vol. 63, (1981) pp49-62

Ames-Lewis, F. and Wright, J., *Drawing in the Italian Renaissance Workshop*, exhibition catalogue, (University Art Gallery, Nottingham and Victoria and Albert Museum, London, 1993)

Au Paradis des Dames: Nouveautés, Modes et Confections 1810-1879, exhibition catalogue, (Musée Galliera, Paris, Editions Paris Musées, 1992)

Bal, M., 'Second-Person Narrative', *Paragraph: A Journal of Modern Critical Theory*, vol. 19, no.3, November (1996) pp179-204

Bal, M., *Quoting Caravaggio: Contemporary Art, Preposterous History*, (University of Chicago Press, Chicago and London, 1999)

Baldry, A.L., 'The Treatment of Drapery in Painting', *Art Journal*, (1909) pp231-7

Baldry, A.L., 'The Treatment of Drapery in Sculpture', *Art Journal*, (1909) pp263-7

Banu, G., *Le Rideau ou la Fêlure du Monde*, (Adam Biro, Paris, 1997)

Barcsay, J., *Drapery and the Human Form*, (Corvina, Budapest, 1958)

Barthes, R., *Camera Lucida: Reflections on Photography*, (Vintage, London, 1993)

Barthes, R., *The Fashion System*, (Hill and Wang, New York, 1983, first published 1967)

Baudelaire, C., *The Painter of Modern Life and Other Essays*, (Phaidon, London, 1964)

Bauer, G.C. ed., *Bernini in Perspective*, (Prentice Hall, Englewood Cliffs, 1976)

Becker, C. and Gaillard, J., *Au Bonheuar des Dames: Zola*, (Hatier, Paris, 1982)

Benaïm, L., *Grès*, (Editions Assouline, Paris, 1999)

Benjamin, W., *Illuminations*, (Fontana/Collins, London and Glasgow, 1977)

Benjamin, W., *One Way Street and Other Writings*, (Verso, London, 1992)

Benjamin, W., *The Origin of German Tragic Drama*, (New Left Books, London, 1977)

Berger, J. et al, *Ways of Seeing*, (BBC and Penguin Books, Harmondsworth, 1975, first published 1972)

Bergon, P. and le Bègue, R., *Le Nu et le Drapé en plein Air*, (Paris, 1898)

Bernstein, M., *Nuns*, (Collins, London, 1976)

'The Body: The Word made Flesh', special issue of *New Internationalist*, no. 300, April (1998)

Boime, A., *The Academy and French Painting in the Nineteenth Century*, (Phaidon, London, 1971)

Boucher, B., *Italian Baroque Sculpture*, (Thames and Hudson, London, 1998)

Bowen, D., 'Hysteria and the Helio-trope: On Bodies, Gender and the Photograph', *Afterimage*, vol. 26, no.4, Jan/Feb (1999), pp13-16

Braun, A.A., *Figures, Faces and Folds: A practical reference Book on Woman's Form and Dress, and its application in past and present Art for Artists, Students and Designers*, (with sections on drapery and anatomy by D. Hartley) (Batsford, London, 1928)

Brugerolles, E. and Guillet, D., *Dessins d'Alexandre Hesse conservés à l'école nationale supérieure des Beaux-Arts. Etudes pour les décorations peintes*, (Les Dossiers du Musée d'Orsay, Réunion des Musées Nationaux, Paris, 1988)

Buchloh, 'Figures of Authority, Ciphers of Regression: Notes on the Return of Representation in European Painting', in B. Buchloh, S. Guilbaut and D. Solkin eds, *Modernism and Modernity*, (Vancouver Conference Papers, Press of Nova Scotia College of Art and Design, Halifax, 1983) pp94-119

Buci-Glucksmann, C., *La Folie de Voir: De l'esthétique baroque*, (Galilée, Paris, 1986)

Buci-Glucksmann, C., *Baroque Reason: The Aesthetics of Modernity*, introduction by B.S. Turner, (Sage, London, 1994)

Cadogan, J.K., 'Linen drapery studies by Verrocchio, Leonardo and Ghirlandaio', *Zeitschrift für Kunstgeschichte*, vol. XLVI, part 1, (1983) pp27-62

Calabrese, O., *Neo-Baroque: A Sign of the Times*, (Princeton University Press, Princeton, 1992)

Callen, A., 'The Body and Difference: Anatomy and training at the Ecole des Beaux-Arts in Paris in the later nineteenth century', *Art History*, vol. 20, no. 1, March (1997) pp23-60

Callinicos, A., *Against Postmodernism: A Marxist Critique*, (Polity Press, Cambridge, 1989)

Carrier, D., 'Artifice and Artificiality: David Reed's recent Paintings', *Arts Magazine*, January (1986) pp 30-3

Carrier, D., and Reed, D., 'Tradition, Eclecticism, Self-Consciousness: Baroque Art and Abstract painting', *Arts Magazine*, January (1991) pp44-9

Sarah Cawkwell: Selected Work 1985-1998, intro. by J. Joseph, exhibition catalogue (Fermoy Gallery, King's Lynn Art Centre, 1998)

Charcot, J.M. and Richer, P., *Les Démoniaques dans l'Art*, (Macula, Paris, 1984, first published 1887)

Chevreul, M.E., *Théorie des Effets optiques que présentent les Etoffes de Soie*, (Didot, Paris, 1846)

Children of Mercury: The Education of Artists in the Sixteenth and Seventeenth Centuries, exhibition catalogue, (Department of Art, Brown Univeristy, Providence, Rhode Island, 1984)

Christ, A.T., 'The masculine Ideal of "the race that wears the toga"', *Art Journal*, vol. 56, no. 2, Summer (1997), pp24-30

Christo and Jeanne-Claude, *Verhüllter/Wrapped Reichstag, Berlin 1971-1995*, (Taschen, Cologne, 1995)

Clarke, J., 'The sacrificial Body of Orlan', in M. Featherstone ed., *Body Modification*, (Sage, London, 2000) pp185-207

Clérambault, G.G. de, *Passion Erotique des Etoffes chez la Femme*, (Sythélabo, Le Plessis-Robinson, 1997)

Gaëtan Gatian de Clérambault: Psychiatre et Photographe, exhibition brochure, (Centre Georges Pompidou, Paris, 1990)

Constantine, M. and Reuter, L., *Whole Cloth*, (The Monacelli Press, New York, 1997)

Lia Cook: Material Allusions, exhibition catalogue, (Oakland Museum of Art, California, 1995)

Cooper, M., *The Art of Drapery: Styles and Techniques for Artists*, (Van Nostrand Reinhold, New York, 1983)

Copjec, J., 'The Sartorial Superego', in *Read my Desire: Lacan against the Historicists*, (MIT press, Cambridge, Mass., and London, 1994) pp65-116

Corbin, A., *Time, Desire and Horror: Towards a History of the Senses*, (Polity Press, Cambridge, 1995)

Cueff, A. 'Point de Vue' (Review of Leonardo and James Welling exhibitions) in *Beaux-Arts Magazine*, no. 75, June (1990) pp68-75

The Dead, exhibition catalogue, (National Museum of Photography, Film and Television, Bradford, 1995-6)

Debay, A., *Hygiène vestimentaire: Les Modes et les Parures chez les français depuis l'établissement de la monarchie jusqu'à nos jours précédé d'un curieux parallèle des modes chez les anciennes dames grecques et romaines*, (Dentu, Paris, 1957)

Deleuze, G., *The Fold: Leibniz and the Baroque*, translation and introduction by T. Conley, (The Athlone Press, London, 1993)

Demornex, J., *Madeleine Vionnet*, (Thames and Hudson, London, 1991)

Dennis, K., 'Ethno-Pornography: Veiling the Dark Continent', *History of Photography*, vol. 18, no. 1, (1994), pp22-8

Desveaux, D., *Fortuny*, (Thames and Hudson, London, 1998)

Didi-Huberman, G., *L'Invention de l'Hystérie: Charcot et l'Iconographie de la Salpêtrière*, Macula, Paris, 1982)

Doane, M.A., 'Veiling over Desire', chapter 6, in R. Feldstein and J. Roof, eds, *Feminism and Psychoanalysis*, (Cornell University Press, Ithaca and London, 1989) pp105-41

Doy, G., *Materializing Art History*, (Berg, Oxford and New York, 1998)

Doy, G., *Black Visual Culture: Modernity and Postmodernity*, (I.B.Tauris, London, 2000)

Edwards, P., 'Against the photograph as *Memento Mori*', *History of Photography*, vol. 22, no. 4, Winter (1998) pp380-84

El Guindi, F., *Veil: Modesty, Privacy and Resistance*, (Berg, Oxford and New York, 1999)

Ellis, H., *The Psychology of Sex*, (Heinemann, London, 1948, first published 1933)

Ewing, W.A., *The Photographic Art of Hoyningen-Huene*, (Thames and Hudson, London, 1998)

Fanon, F., *A Dying Colonialism*, (Grove Press, New York, 1967)

Fer, B., 'Surrealism, Myth and Psychoanalysis' in B. Fer, D. Batchelor, P. Wood, *Realism, Rationalism, Surrealism: Art between the Wars*, (Yale University Press and Open University, New Haven and London, 1993) pp170-249

Fer, B., 'The Pleasure of Cloth' in *Liz Rideal: New Work*, exhibition catalogue (Angel Row Gallery, Nottingham; Rochester Art Gallery, Kent; and Ferens Art Gallery, Kingston upon Hull, 1998-9) pp10-13

Flugel, J.C., *The Psychology of Clothes*, (Hogarth Press, London, 1966, first published 1930)

Freinville, B. de, Papetti, Y., Tisseron, S. and Vallier, F., *La Passion érotique des étoffes chez un Neuropsychiatre*, (Solin, Paris, 1981)

Freud, S., 'Delusions and Dreams in Jensen's *Gradiva*', in vol. 14, *Art and Literature*, (Pelican Freud Library, Penguin, Harmondsworth, 1985) pp27-118

Freud, S., 'Leonardo da Vinci and a Memory of his Childhood', in vol. 14, *Art and Literature*, (Pelican Freud Library, Penguin, Harmondsworth, 1985) pp143-232

Freud, S., 'The Uncanny', in vol. 14, *Art and Literature*, (Pelican Freud Library, Penguin, Harmondsworth, 1985) pp335-76

Freud, S., 'Fetishism', in vol. 7, *On Sexuality*, (Pelican Freud Library, Harmondsworth, 1991) pp347-57

Gautier, T., *De la Mode*, (Actes Sud, Arles, 1993)

Gibson, H., *The Art of Draping*, (Blandford Press, London, 1936)

Gibson, M., 'Mary, Mary, quite contrary: Meeting the Other', *International Tapestry Journal*, special issue on Tapestry and the Body, vol. 3, no. 2, Summer (1997) pp12-16

Goldstein, C., *Teaching Art. Academies and Schools from Vasari to Albers*, (Cambridge University Press, Cambridge, 1996)

Goldstein, J., *Console and Classify: The French Psychiatric Profession in the Nineteenth Century*, (Cambridge University Press, Cambridge, 1987)

Goodall, J., 'An order of pure Decision: Un-natural selection in the work of Stelarc and Orlan', in M. Featherstone ed., *Body Modification*, (Sage, London, 2000) pp149-70

Gould, C., *The Draped Figure*, (National Gallery, London, 1972)

Graham-Brown, S., *Images of Women: The Portrayal of Women in Photography of the Middle East 1860-1950*, (Quartet, London, 1988)

Greenhalgh, M., *What is Classicism?*, (Academy Editions/St. Martin's Press, New York, 1990)

Alix Grès: L'Enigme d'un Style, exhibition catalogue, (Villa de Noailles, Hyères, 1992)

Grunchec, P., *The Grand Prix de Rome: Paintings from the Ecole des Beaux-Arts 1797-1863*, (International Exhibitions Foundation, Washington DC, 1984)

Hegel, G.W.F., *Aesthetics: Lectures on Fine Art*, 2 vols., (Clarendon Press, Oxford, 1975)

Heuzey, L., *Histoire du Costume Antique d'après des études sur le modèle vivant*, (Champion, Paris, 1922)

Heuzey, L., and Heuzey, J., *Histoire du Costume dans l'Antiquité classique. L'Orient. L'Egypte- Mésopotamie - Syrie - Phénicie*, (Les Belles Lettres, Paris, 1935)

Hocine, exhibition brochure, (The Newseum, Arlington, Virginia, 1998)

Hogarth, B., *Dynamic Wrinkles and Drapery: Solutions for Drawing the Clothed Figure*, (Watson-Guptill, New York, 1995)

Hogarth, W., *The Analysis of Beauty*, (Scolar Press, Menston, 1971, first published 1753)

Hollander, A., 'The Fabric of Vision: The Role of Drapery in Art', *Georgia Review*, vol. 29, part 2, (1975), pp414-65

Hollander, A., *Seeing through Clothes*, (University of California Press, Berkeley, Los Angeles and London, 1993, first published 1975)

Hugues, P., *Le Language du Tissu: Textile, Art Language*, (Editions Médianes, Rouen, 1982)

Hugues, P., *Tissu et Travail de Civilisation*, (Editions Médianes, Rouen, 1996)

Ince, K., 'Operations of Redress: Orlan, the Body and its Limits', *Fashion Theory*, vol. 2, no.2, June (1998), pp111-28

Interventions: International Journal of Postcolonial Studies, special issue on the Veil, vol. 1, no. 4, (1999)

Jeffries, J., 'Text, Textile, Sex and Sexuality', *Women's Art Magazine*, no. 68, Jan/Feb (1996) pp5-9

Jordanova, L., *Sexual Visions: Images of Gender in Science and Medicine between the Eighteenth and Twentieth Centuries*, (Harvester Wheatsheaf, New York and London, 1989)

Kamitsis, L., *Vionnet*, (Thames and Hudson, London, 1996)

Key, J., 'Unfold: Imprecations of Obscenity in the Fold', chapter 12, in J. Steyn ed., *Other than Identity: The Subject, Politics and Art*, (Manchester University Press, 1997) pp185-97

Kirke, B., *Madeleine Vionnet*, (Chronicle Books, San Francisco, 1998)

Krafft-Ebing, R. von, *Psychopathia Sexualis with especial reference to antipathetic sexual Instinct: A medico-forensic Study*, (Aberdeen University Press, London, 1899, translated from the 10th German edition)

Kuryluk, E., *Veronica and her Cloth: History, Symbolism, and Structure of a 'True' Image*, (Blackwell, Oxford, 1991)

Lacan, J., 'God and the *Jouissance* of ~~the~~ Woman: A love Letter' chapter 6, in J. Mitchell and J. Rose eds, *Jacques Lacan and the Ecole Freudienne: Feminine Sexuality*, (Macmillan, Basingstoke, 1982) pp137-61

Lalvani, S., *Photography, Vision and the Production of Modern Bodies*, (SUNY Press, New York, 1996)

Lanteri, E., *Modelling and Sculpting the Human Figure*, (Dover, New York, 1985, first published 1902, 1904)

Lemaistre, A., *L'Ecole des Beaux-Arts dessinée et racontée par un Elève*, (Firmin-Didot, Paris, 1889)

Lemoine-Luccioni, E., *La Robe: Essai psychanalytique sur le Vêtement*, (Editions du Seuil, Paris, 1983)

Leibniz, G.W., *Philosophical Writings*, introduction by G. Parkinson, (Everyman, London, 1995)

Leslie, E., 'Wrapping the Reichstag: Re-visioning German History', *Radical Philosophy*, no. 77, May-June (1996) pp6-16

Lloyd, F. ed., *Contemporary Arab Women's Art: Dialogues of the Present*, (The Women's Art Library, London, 1999)

Lomax, Y. in dialogue with H. Gresty, 'The World is indeed a fabulous Tale: Yve Lomax: A Practice around Photography', in N. Wheale ed., *The Postmodern Arts: An Introductory Reader*, (Routledge, London and New York, 1995) pp150-62

Maravall, J.A., *Culture of the Baroque: Analysis of a historical Structure*, (University of Minnesota Press, Minneapolis, 1986)

Marneffe, D. de, 'Looking and Listening: The Construction of Clinical Knowledge in Charcot and Freud', *Signs*, Autumn, (1991) pp71-111

Martin, J.R., *Baroque*, (Pelican Books, Harmondsworth, 1977)

Marx, K., *Capital: A Critique of Political Economy*, vol. 1, introduction by E. Mandel, (Penguin Books, Harmondsworth, 1976)

Matlock, J., 'Masquerading Women, Pathologised Men: Cross-Dressing, Fetishism, and the Theory of Perversion, 1882-1935', in E. Apter and W. Pietz eds, *Fetishism as Cultural Discourse*, (Cornell University Press, Ithaca and London, 1993) pp31-61

McCorquodale, D., ed., *Ceci est mon Corps... Ceci est mon logicel/This is my body... This is my Software*, (Black Dog, London, 1996)

Mellor, D., 'From the Carnal to the Virtual Body', *Art and Design Profile*, no. 44, *Photography and the Visual Arts*, (1995) pp88-96

Metz, C., 'Photography and Fetish', in C. Squiers ed., *The Critical Image*, (Lawrence and Wishart, London, and Bay Press Seattle, (1990) pp155-64

Miller, M.B., *The Bon Marché: Bourgeois Culture and the Department Store, 1869-1920*, (Allen and Unwin, London, 1981)

Moy, P. Villiers le, 'The timeless fashions of Madame Grès', *The Connoisseur*, August, (1982), pp94-9

'The Object Clothed', special issue of *Domus*, no. 790, February (1997)

Pacteau, F., *The Symptom of Beauty*, (Reaktion Books, London, 1994)

Papetti-Tisseron, Y., *Des Etoffes à la Peau*, (Séguier, Paris, 1996)

Parrot, N., *Mannequins*, (Academy Editions, London, 1982)

Perniola, M., 'Between Clothing and Nudity' in M. Feher and R. Nadaff eds, *Zone 4: Fragments for a History of the Human Body*, part 2, (Zone Books, New York, 1989) pp237-65

Pinet, H., *L'Ornement de la Durée: Loïe Fuller, Isadora Duncan, Ruth St. Denis, Adorée Villany*, exhibition catalogue, (Musée Rodin, Paris, 1987)

Poivert, M., *La Photographie pictorialiste en France 1892-1914*, 3 vols, (Doctoral Thesis, Université de Paris 1 - UFR03, 1992)

Potvin, M, with S. Descamps-Lequime, *Plis et Drapés dans la Statuaire Greque*, (Musée du Louvre, Service Culturel, Paris, 1992)

Rafaele, A., director, *The Veil*, film, UK, 2000

Ranft, *Women and Religious Life in Premodern Europe*, (Macmillan, Basingstoke and London, 1996)

David Reed Paintings: Motion Pictures, essays by E. Armstrong, M. Bal, D. Hickey, touring exhibition catalogue, (Museum of Contemporary Art, San Diego, 1998)

Reynolds, J., *The Complete Works of Sir Joshua Reynolds*, 3 vols, (Thomas McLean, London, 1824)

Rose, J., *Sexuality in the Field of Vision*, (Verso, London, 1986)

Rhead, G. Woolliscroft, *The Treatment of Drapery in Art*, (George Bell, London, 1904)

Rubens, A., *Le Maître des insensés: Gaëtan Gatian de Clérambault, 1872-1934*, (Synthélabo, Le Plessis-Robinson, 1998)

Ruskin, J., *The Elements of Drawing in three Letters to Beginners*, reprint, (Scholarly Press, Michigan, 1972, first published, 1857)

Russell, F., ed., *Sampled: The Use of Fabric in Sculpture*, (Henry Moore Institute, Leeds, 1999)

Saint Teresa, *The Life of Saint Teresa of Avila by Herself*, introduction by J.M. Cohen, (Penguin, Harmondsworth, 1957)

Saisselin, R., *The Enlightenment Against the Baroque: Economics and Aesthetics in the Eighteenth Century*, (University of California Press, Berkeley and Oxford, 1992)

Santiago, C., 'Lia Cook: Material Allusions', *American Craft*, vol. 56, April/May (1996), pp44-9

Schneider, S.K., *Vital Mummies/Performance Design for the Show-Window Mannequin*, (Yale University Press, New Haven and London, 1995)

Selz, P., 'The Coloratura of Colette', *Arts Magazine*, vol. 53, no. 4, December (1978), pp103-5

Sheldon, A. ed., *Fetishism: Visualising Power and Desire*, exhibition catalogue, (South Bank Centre and Lund Humphries, London, 1995)

Sokal, A. and Bricmont, J., *Intellectual Impostures*, (Profile Books, London, 1998)

Sontag, S., *On Photography*, (Penguin, Harmondsworth, 1979)

Sparke, P., *As Long as it's Pink: The Sexual Politics of Taste*, (Pandora, London, 1995)

Starke Falten, exhibition catalogue (Museum Bellerive, Zurich, 1995)

Stoichita, V.I., *The Self-Aware Image: An Insight into Early Modern Meta-Painting*, (Cambridge University Press, Cambridge, 1997)

Taylor, J., *Body Horror: Photojournalism, Catastrophe and War*, (Manchester University Press, Manchester, 1998)

Textures of Memory: The Poetics of Cloth, exhibition catalogue, (Angel Row Gallery, Nottingham, 1999)

Tisseron, S. ed., *Gaëtan Gatian de Clérambault: Psychiatre et Photographe*, (Les Empêcheurs de Penser en Rond, Delagrange, Paris, 1990)

Viatte, F. ed., *Léonard de Vinci: Les Etudes de Draperie*, (Réunion des Musées Nationaux, Paris, 1989)

Vinci, L. da, *Treatise on Painting*, translated A.P. McMahon, (Princeton University Press, Princeton, 1956)

Madeleine Vionnet: Les Années d'Innovation 1919-1939, exhibition catalogue, (Musée des Tissus, Lyon, 1994-5)

Madeleine Vionnet: L'Art de la Couture, exhibition catalogue, (Centre de la Vieille Charité, Marseille, 1991)

Alison Watt: Fold: New Paintings 1996-97, exhibition catalogue, (Fruitmarket Gallery, Edinburgh, 1997)

Weston-Lewis, A. ed., *Effigies and Ecstacies: Roman Baroque Sculpture and Design in the Age of Bernini*, (National Gallery of Scotland, Edinburgh, 1998)

Wharton, E., *In Morocco*, (Cape, London, 1920)

Winckelmann, J.J., *Reflections of the Painting and Sculpture of the Greeks*, (Scolar Press, Menston, 1972, first published 1765)

Woodhull, W., 'Unveiling Algeria', *Genders*, no. 10, Spring (1991), pp112-31

1998 World Press Photo, (Thames and Hudson, London, 1998)

Wright, E. ed., *Feminism and Psychoanalysis: A Critical Dictionary*, (Blackwell, Oxford, 1992)

Yegenoglu, M., *Colonial Fantasies: Towards a Feminist Reading of Orientalism*, (Cambridge University Press, Cambridge, 1998)

Zola, E., *The Ladies Paradise*, introduction by K. Ross, (University of California Press, Berkeley, Los Angeles and Oxford, 1992)

INDEX